THE CULTURE VULTURE

THE CULTURE VULTURE

A GUIDE TO STYLE, PERIOD, AND ISM

Carol Dunlap

The Preservation Press
National Trust for Historic Preservation

The Preservation Press
National Trust for Historic Preservation
1785 Massachusetts Avenue, N.W.
Washington, D.C. 20036

Support for the National Trust is provided by membership dues, contributions, and a matching grant from the National Park Service, U.S. Department of the Interior, under provisions of the National Historic Preservation Act of 1966. The opinions expressed here do not necessarily reflect the views or policies of the Interior Department.

Printed in the United States of America
5 4 3 2 1 98 97 96 95 94

This book is dedicated to my mother.

Library of Congress Cataloging-in-Publication Data
Dunlap, Carol, 1943–
 The culture vulture: a guide to style, period, and ism/ Carol Dunlap.
 p. cm.
 Includes bibliographical references (p.) and index.
 ISBN 0-89133-216-2
 1. Art—Themes, motives. I. Title.
N7560.D86 1994
700—dc20 93-1394
 CIP

Designed by Sharri Harris Wolfgang, AURAS Design, Inc., Washington, D.C.
Printed by Thomson Shore, Dexter, Michigan

INTRODUCTION

ould you identify a Chippendale chair to save your life? Can you distinguish expressionism from impressionism? Are baroque and rococo, existentialism and minimalism all Greek to you? Would you like to be able to differentiate between colonial and Federal architecture, Meissen and majolica ceramics, Bokhara and Baluchi rugs?

Every way you turn, you run into style. Pick up a novel of any period, even a recent one: the protagonist's home may be described as a museum of Louis furniture and Aubusson rugs. Read a movie review, and the lead actor is credited with "Edwardian assurance." Design magazines issue bulletins from the front lines where fashion strives to become style, reporting that Elizabethan is back and Biedermeier is "in." Even television has become style-conscious. In one recent cops-and-robbers series, a burglar gave himself away by his upscale tastes. "This isn't just a B & E—this guy knows the difference between Baccarat and Lalique," one character noted.

Whether you consider such style recognition pretentious or *de rigueur,* there is no question that it is trickling down. It used to be that museums were largely deserted and wonderfully peaceful places in which to browse. Now you have to get a ticket, as if you were going to a rock concert, and stand six deep to see the Matisse retrospective (12 deep for King Tut's treasures). Who are all these people? They are the culture vultures, and you and I are among them. We may be dilettantes (from the Italian *dilettare,* to delight, charm), without the time or ability to become scholars, but we want to learn more.

The Culture Vulture: A Guide to Style, Period, and Ism will focus on key concepts and identifying characteristics in art and architecture, history, philosophy, music, literature, and the decorative arts, with particular reference to the American experience. A polyglot people with a pragmatic, eclectic bent, we Americans live in a veritable carnival or Babylon of styles, taking fantastic historical liberties, tossing every conceivable style into the melting pot. Explore any major city and you may find a train station resembling a Roman bath, banks and churches with Greek temple facades, Tudor mansions and Victorian cottages, a Pueblo-inspired shopping plaza or condominium complex, even an occasional luncheonette in the (vernacular) shape of a hot dog. You may find several styles in the same building, as for example an Italianate High Victorian Gothic home.

And this is just architecture; step inside, and you are in the realm of the arts and decorative arts, possibly also literature and music, with their own myriad stylistic designations.

One school of cultural history holds that all forms interact, that a single style may infuse or inform all media from a building to a bowl, but the student of style learns right away that it is at best an untidy business, with lots of imprecision, overlap, and detail in which you can drown. Books on style frequently offer a descriptive narrative or catalog of specific manifestations, broken down by time and place, medium and craft, from art and architecture all the way down to weaving and wallpaper.

Read cultural history and you will find that style moves at different speeds in different countries, here running ahead and there behind; that it is often asynchronous or out of phase in different media (music and literature, in particular, seem to evolve at their own speed), or significant in some media and not in others; and that the difficulty of identifying any particular style is compounded by its coexistence with older, newer, even competing contemporary styles.

Difficulties soon become apparent. You may learn to recognize an Italian Renaissance palazzo, but this will avail you very little with respect to Renaissance-style architecture in Holland; and when you get to England you will find it called Elizabethan, still very medieval. Or you may be confounded by the stylistic connections scholars of mannerism have mapped between the works of Bruegel and El Greco, Shakespeare and Cervantes. You will sometimes find the same artist, or different works by the same artist, claimed by different schools or styles. And what possible connection can there be between style in art and music, between representational and nonrepresentational media? Here the bridge is the whole history of ideas, the library of philosophy, even religion, the ultimate philosophic worldview. Hence the inclusion here of *isms*.

In case this all seems daunting, let me indicate my bias toward simplification. As historian Johan Huizinga once wrote, our perception of history is primarily visual, artistic rather than intellectual, based on remembered images and forms rather than dates and facts. Think of Rome, and a triumphal arch may come to mind; the Middle Ages, a Gothic cathedral. The Culture Vulture will try to enrich your understanding of history as well as the arts by fleshing out these images with background on the common beliefs, values, and prejudices that inform and animate stylistic periods. Wherever possible, the writer tries to trace the lines of influence between ideas and the arts, politics and culture, indicating, for example, the influence of Christianity on art, of Freudian analysis on literature, of fascism on architecture. By exploring these connections I hope to give you a rich, varied sense of what the Germans call *Zeitgeist*, the spirit or genius of an age as expressed stylistically.

What can I possibly hope to accomplish in a short space that scholars take volumes to describe? First, let me emphasize that *The Culture Vulture* is a reference work, pointing you to the standard or most accessible works in the field. If you want to be able to identify every permutation of Georgian architecture, you will have to invest considerably more time and effort. What I offer you are essentials, historical context, and an American perspective, the sources and manifestations of style in melting-pot America. I hope you will be interested to know that the Brooklyn Bridge has Gothic arches; that the U.S. Capitol is Greek revival with a neo-baroque dome; or that Thomas Jefferson in remodeling his Monticello copied a Palladian villa in Italy.

Finally, I would like to tickle your sense of discovery, prompting you to question and delight (*dilettare*) in the American carnival of style. As novelist Henry James once

wrote of the advantages of being American, "We can deal freely with forms of civilization not our own, can pick and choose and assimilate and in short (aesthetically and culturally) claim our property wherever we find it."

A word on cultural perspective: the closer you get to any culture, of course, the more detail you perceive. Since *The Culture Vulture* is concerned with the American cultural inheritance, the emphasis is primarily Western and disproportionately British (Tudor, Jacobean, Victorian, Edwardian) in preference to French (François Ier) or Italian (Risorgimento). No slight is intended in summarizing Chinese or African culture in a few pages, taking a very selective long-range fix on a subject that can and does fill entire libraries. (You will probably find that the Chinese or African view of America is also telescopic.)

Another obvious difficulty relates to fads or fashions and spinoffs that may or may not achieve the status of style. The *Oxford English Dictionary* defines style as a manner of expression characteristic of a person, group, or period, sanctioned by usage, while fashion, from the verb to make, refers to a particular make or cut. In general, we differentiate style from fashion by its duration: Fashion is ephemeral, while style endures (although we Americans are such consumers of style that it tends to revert to fashion). Style also tends to splinter, to fade, to recur, to recombine. History is full of stylistic revivals. The coronation of George IV in 1821, for example, was staged as a historical pageant in the Tudor style. And as a curious example of recent recombination, one finds in rural Bavaria, Germany, new construction in a style that can best be described as "Pizza Hut"—itself a marriage of Swiss chalet and Tokugawa Japanese.

Why didn't I include the Brandywine school, or Texana? Perhaps next time. When asked why I chose this or that topic, I could only reply that it's my book, so I get to decide. One rule I followed was to keep "post" and "neo" entries to a minimum (for neo-expressionism, see EXPRESSIONISM; neoclassicism, CLASSICISM). I also deliberately included one or two contemporary styles (see NEO-GEO) that will be completely forgotten in a generation, as an example of how the whole process works. And some fairly recent styles in *The Culture Vulture* are actually lifestyles, such as hippie and yuppie, leaving little in the way of enduring cultural artifacts. One is tempted to infer that, approaching another fin de siècle, life itself is the ultimate art.

As you read you will find that styles and periods define themselves by reference to their predecessors and also have implications for contemporaneous and future styles and periods. As a result, some subjects are cited repeatedly in *The Culture Vulture*. We considered different systems of cross-referencing to call your attention to other relevant entries, only to end up with an impossibly cluttered text. The reader is therefore encouraged to use the index to clarify and trace the geneaology of styles, periods, and ideas. The index also includes vital biographical statistics (for instance, Andy Warhol, American pop artist, 1930–87), giving it an extra dimension of usefulness.

Finally, a note on sources. *The Culture Vulture* is a bookworm's ultimate indulgence, the distillation of a lifetime of reading. My primary justification or qualification for undertaking such a vast project, one that any sensible scholar would scorn (to be frank, most scholars will dislike my book intensely), is that I read and I know a good read. In writing this book, I went back and reread a great many old books of mine, some dating back to Sarah Lawrence College days, ragged paperbacks with prices like $1.25 and $2.75. I found that my tastes have changed—many of my favorites as a student no longer hold my interest, while other studies that I would have called pedantic then—notably

works by the great central European cultural historians and scholars such as Heinrich Wölfflin, Erwin Panofsky, and Arnold Hauser—opened my eyes anew. I also read decades worth of "coffee-table books," the kind that one tends to leaf through but rarely to actually read, and found many of them surprisingly good.

The most accessible reference works for the student or generalist are series on art history. Some excellent ones have come and gone in the past generation of publishing. The Praeger World of Art series, a good, inexpensive line of books on art history, is now available only in used bookstores. The idea, however, and some of the better titles, survived and are available in an attractive and reasonably priced ($15 or less) format from the British publisher Thames & Hudson.

Somewhat more advanced, as well as more expensive and harder to find, is the Pelican History of Art series on art and architecture. These are now available from Yale University Press as $25 paperbacks. Pelican/Penguin also used to have a line of books, Style and Civilization, some of the best titles of which (Linda Nochlin's *Realism* and Hugh Honour's *Neoclassicism*) are still in print. Other series that you may find useful are those by Horizon Publishers and the Connoisseur period (British) guides. I also found valuable for my purposes the old Oxford University Legacy series, especially the volumes on Rome and Islam.

In the pursuit of style, you will also find some standard reference works more helpful than you might imagine. If you want to know just what a Morris chair is, there is no more expeditious place to look this up than the *Encyclopaedia Britannica Micropedia*. I myself am partial to the *Columbia Encyclopedia*, which, in one large volume, is almost but not quite portable. (Author Aldous Huxley is said to have possessed a portable *Britannica* that fit into a suitcase—but in those days one traveled a good deal heavier than we do now.)

If I had to recommend a single book on the subject of style in general, I would not hesitate: Hugh Honour and John Fleming's *The Visual Arts*, available as a large paperback. In general, I find art histories, such as the much reprinted textbooks by H. W. Janson and Frederick Hartt, a chore to read, but Honour and Fleming are full of original and provocative insights.

You will find a complete list of sources at the end of the book, in alphabetical order. My hope is that this will make it easier to find works mentioned in passing in the text. Titles of the author's favorite books and special recommendations are set in boldface type.

Special thanks to my good friends Anni Stroh, Edward Vernoff, and Marjorie Broadstreet, who read parts of the manuscript and suggested corrections or changes. Marjorie in particular took exception to my lack of religious conviction, prompting me to say in closing that all biases, prejudices, outrageous opinions, and—alas—errors are my own. I would also like to express appreciation to editor Janet Walker, who handled a difficult project with grace.

This book is dedicated to my mother.

How are books born? *The Culture Vulture* is the offspring of my entirely accidental encounter (appropriately, in a museum) with a former editor, now a young publisher with a sense of adventure and whimsey. Thank you, Buckley Jeppson. —**C.D.**

Art is long, and Time is fleeting.

H. W. Longfellow

ABSTRACT EXPRESSIONISM

In the years after World War II, New York City for the first time replaced Paris as the world capital of modern art—as if, in the words of modern art historian Kenneth Baker, the war had resolved by brute force America's longstanding cultural inferiority complex. The new style that emerged from the war took a while to define itself; a 1945 exhibit was entitled *A Problem for Critics*—namely, what to call it. Some called it the New York school, as if the style were defined primarily by the accident of geography; others suggested action painting. But the name that stuck was abstract expressionism, although it was not always abstract and had little in common with expressionism (except perhaps in the sense that some expressionists painted abstractly). In short, the new movement included a range of individual styles.

One of the primary influences feeding into the new style was French surrealism, from which abstract expressionists borrowed "strategies of spontaneity"—automatic painting rather than automatic writing. But in other respects abstract expressionism was an American reaction against the French tradition in art, the tendency to domesticate and make intimate. As artist Robert Motherwell put it, "We replaced the nude girl and the French door with a modern Stonehenge."

To put abstract expressionism in cultural context, this is the early era of synthetics, supermarkets, TV, and the revolution in mass communications; politically, the key

events are the Korean War, the Cold War, Eisenhower, and McCarthyism; on the literary front, novelist Norman Mailer is quickly superseded by William Gaddis, John Barth, and Thomas Pynchon with their "mirrored textual codes"; and sociologists David Riesman and William H. Whyte are writing classics about alienation and the organization man.

The abstract expressionists were inclined to extremely large formats, favoring flatness as a means to destroy illusion. Their "language of surface" emphasized rhythms, spatial intervals, and color. Early works were filled with a whirlpool of hermetic signs, ideograms, and biomorphic forms—sometimes different modes of representation, such as abstract and symbolic, simultaneously. Gradually these referents were purged, leaving purer fields of color.

Students of the movement divide it into at least two groups: the "gestural painters," who include Jackson Pollock and Willem de Kooning; and the "field painters" such as Mark Rothko, who merged figure and ground into a totality into which the viewer peers as if into infinity. A great deal has been written, much of it pompous nonsense, about the meaning of this amorphous space, about the religious experience of this portal into the immense void. (For example, "...metaphor in transition from the icon to the antireferentiality of the mystic oxymoron," and "signifiers of a transcending non-referential function....")

If one were to range the abstract expressionists on a spectrum from representational to abstract, one would have first the gestural painters, Arshile Gorky (sometimes called the last surrealist) and de Kooning, with Pollock somewhere in the middle and Rothko at the end. There was also an abstract expressionist school of sculpture in the person of David Smith, a former welder whose large constructions included diverse ready-made metal parts. As they worked—with vigor, rawness, and chaos—so they died, Gorky and Rothko by suicide, Pollock and Smith in auto accidents. Pollock, in particular, became a legend in his own time—"the Marlboro man as artist."

In the past half century, abstract expressionism has gone in and out of fashion. When New York's Museum of Modern Art purchased a de Kooning in 1953, supermarket heir Huntington Hartford took out full-page newspaper ads to denounce the acquisition. The most Pollock received for a painting in his lifetime was $8,000, although Rothko's income eventually increased so much he limited his production for tax reasons and hired an accountant whom he paid in art. The top price reported as of 1991 for an abstract expressionist painting was $220,000 for a Hans Hofmann purchased in 1977. At best, the movement never commanded the popularity or prices of impressionism or expressionism. Despite a 1955 *Fortune* magazine article about abstract expressionism as a growth stock, buyers seemed afraid to get caught with egg on their walls. By the 1980s culture maven Tom Wolfe (in *The Painted Word*) was calling the style "a beached whale commercially....depreciating faster than a Pontiac Bonneville."

In their study *Isms*, the Altendorfs argue that abstract expressionism should be downgraded to a decorative art, "since the most it offers is a pleasing arrangement of color, line and form." Art historian Abraham Davidson dismisses it as "art barely rescued from chaos," with no conscious process between conception and execution. But a swing in the opposite direction may be shaping up for the 1990s. "Even conservative opinion now concedes," according to a 1992 article in *House & Garden*, "that this movement generated not only the most original painting ever produced in America but arguably the most important in the West since the dazzling cubist meridian...." The final verdict is not yet in.

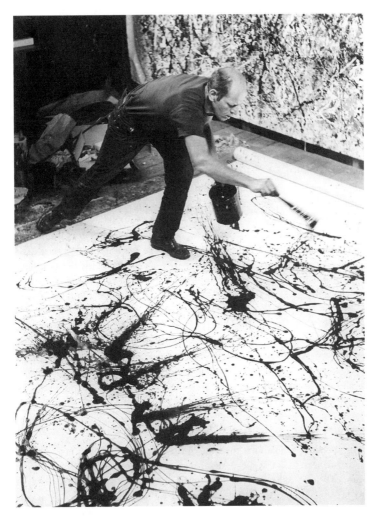

Jackson
Pollock,
abstract
expressionist
and action
painter, in
the act of
creation in
1950
(© 1990
Hans
Namuth)

In the Thames & Hudson series, David Anfam's *Abstract Expressionism* puts the style in cultural context. Aficionados will want to find *Abstract Expressionism: The Critical Developments* by Michael Auping, which relates to but is not limited to the important collection at the Albright-Knox Art Gallery in Buffalo, New York. For the perspective from the Old World, see Serge Guilbaut's *How New York Stole the Idea of Modern Art*.

ACTION PAINTING

This is another name for abstract expressionism, or for the branch of it staked out by Jackson Pollock. Born in Cody, Wyoming (as he liked to point out), Pollock was an archetypal American loner who brought all the chaos, rawness, vigor, and violence of the frontier to his art. Photographs and a film have captured Pollock working on his notorious "drip paintings," locked in earnest combat with paint cans and a massive can-

vas stretched out on the floor—not just a painting but an event or a happening, involv-ing an arena and a performer. Whether you consider this stuntsmanship or art, be aware that by working with gravity instead of on a wall or easel, Pollock increased the area of travel of his paint, shifted his own center of gravity from his shoulders to his hips, and in the process freed both imagery and technique, the technical and the aesthetic, from academic self-consciousness.

Yes, but is this art, or just a giant put-on? Poet John Ashbery probes the great fas-cination Pollock aroused, a compound of reckless gamble and outrageous daring. "There was just a possibility that he wasn't an artist at all," Ashbery writes in *Avant-Garde Art*. "But this…is paradoxically just what makes the tremendous excitement in his work [and] keeps his work alive for us." In the same vein, art critic Harold Rosenberg describes action painting as the result of an existential confrontation of will and fate.

Repeatedly hospitalized for alcoholism, Pollock tried the fashionable psychother-apies of the day. His was a relatively short career, from the famous exhibit of 17 drip paintings in 1948 to his death by auto accident in 1956, whereupon he was immortal-ized by *Time* magazine as "Jack the Dripper." After his death, his Jungian therapist tried to sell his paintings, presumably received in payment, over the objections of his widow.

Action painting also had a literary analogue, in the opinion of cultural historian Theodore Roszak, who describes beat generation author Jack Kerouac as Pollock's coun-terpart in print.

Several good biographies of Pollock are available. That by Steven Naifeh and Gregory W. Smith, *Jackson Pollock: An American Saga*, won a Pulitzer prize. Ashbery's essay is in *Avant-Garde Art*, coedited by Thomas B. Hess. Harold Rosenberg's key articles on the subject are collected in *The Tradition of the New*.

ADAM

The fashionable high style in England at the time of the American Revolution was called Adam, after the Scottish architect Robert Adam and his brother James. Robert Adam was one of the first of a long line of architects who believed in designing every detail of a room, down to the keyhole of the secretaire, and it is for such interiors that he is pri-marily remembered. Having studied in Rome, he had acquired a great fund of classical forms and motifs, which he infused with a light, airy, delicate artistry, slightly rococo, in contrast to the more ponderous neoclassicism prevalent elsewhere at the time.

In furniture, Adam is credited with developing the sideboard and with first favor-ing chairs with slender, tapering legs. He is also known for his side tables and mirrors. These and other of his ideas were disseminated by the publication in 1773 of his *Works in Architecture* and by the example of the many English country manors and London town houses he was commissioned to remodel.

Adam's particular genius was to harmonize forms, colors, and textures. He favored oval and octagonal rooms, their walls typically stuccoed, plastered, or painted with friezes, swags, garlands, scrolls, panels, roundels, and medallions. The same motifs may also be repeated in the rugs that Adam had woven to his specifications, the furniture that he inspired (Chippendale, Hepplewhite, and Sheraton all profited greatly from Adam's ideas), and in other furnishings (he influenced Wedgwood pottery design, for example).

British styles became politically unpopular in the United States during the American

revolutionary period, and Adam was a trifle too refined (some would say effeminate) for the American taste and beyond the reach of all but the wealthiest. The ceiling of George Washington's dining room at Mount Vernon, dating to 1775, is early American Adam. Because of the coincidence in time—the early years of American independence—the Adam strain in America is usually called Federal. (The design and decor of the White House, particularly the Oval Office, is Adam-influenced.)

See Steven Parissien's *Adam Style*.

ADVENTISM

For Seventh-Day Adventists, 1844 was the year of the Great Disappointment. Citing a biblical reference in the book of Daniel, a passionately devout New York farmer named William Miller had predicted that the second coming or advent of Christ would occur in 1844. The Millerite movement did not survive the Great Disappointment but soon gave rise to the Seventh-Day Adventists under prophet Ellen White, who established her Seventh-Day Adventist headquarters in Battle Creek, Michigan, in 1855.

Chief among the tenets of Seventh-Day Adventists are the Saturday or seventh-day sabbath; baptism by immersion; and the imminence of Christ's second coming, when both the just and the unjust will be raised. Pending that day, however, members are exhorted to follow the strict principles of diet (no meat, alcohol, tobacco, coffee, or other stimulants) and decorum (modest dress, no jewelry) revealed to Mrs. White in prophecy.

The Seventh-Day Adventists became active missionaries, at home and abroad, and educators. They now have the third largest parochial school system in the United States and have been especially concerned with the education of medical evangelists. One of the first and most famous of these was John Harvey Kellogg, head of the Adventist sanitarium at Battle Creek and cofounder of a breakfast-food empire. (The Adventist movement broke with Kellogg in 1903, however, and moved its headquarters to the Washington, D.C., area.) More recently, the church has attracted attention for its medical school at Loma Linda, California, which pioneered in such procedures as fetal monitoring, baby heart transplant, and proton beam acceleration.

The Seventh-Day Adventist empire also includes publishing houses, homes for the elderly, and stop-smoking clinics. As religious historian Edwin Gaustad remarks, "seldom, while expecting a kingdom of God from heaven, has a group worked so diligently for one on earth."

Another aggressive American Adventist group, the Jehovah's Witnesses, was founded late in the 19th century by a Pennsylvania haberdasher who predicted the second coming for 1874. Witnesses have no churches or ministers because they consider each believer a minister of the gospel. By refusing to salute the flag or to register for the draft they separate themselves from the mainstream. They also believe that repentant sinners will have a second chance for salvation, good news that they spread from door to door and by means of their publication, *The Watchtower*.

Anne D. Jordan's *The Seventh-Day Adventists: A History* is a reasonably objective account written on a secondary school level.

AFRICAN

African art burst like a revelation onto the modern art scene in 1905. Europeans had been exploring and exploiting Africa for over 400 years, but in the process had collected little art—and that chiefly as evidence of native backwardness, calculated to prompt contributions for missionary activity. In 1897 the British launched a punitive expedition against the kingdom of Benin, seizing a great quantity of bronze sculpture and ivory carvings, presumably considered of some value. Then French artist Maurice de Vlaminck received an African mask, which Picasso and Matisse happened to see too; bowled over by the wooden mask, which is credited with launching the cubist revolution, they had it cast in bronze.

The way had been prepared by the work of Charles Darwin and Sigmund Freud in the late 19th century for Western man to take a new interest in his "primitive" beginnings. The concept of primitive continues to hang like a racial bugbear over African art; suffice it to say that for Picasso and Matisse (as for Gauguin, who traveled to the

● ———————————— ●

Some Important Cultures and Tribes

ASHANTI or ASANTE (Ghana, Ivory Coast): gold work (including a famous gold-encrusted stool, symbol of tribal sovereignty), brass, and colorful Kente cloth, made of strips of woven rayon and silk sewn together, and fertility dolls with flat, disk-like faces

FANTE (Ghana): textile art, including flags (appliqué, embroidery, and patchwork) reflecting colonial and local influences

DOGON (Mali): statues with cylindrical torsos, schematic masks, snake figures, mounted riders, body art, highly developed mythology

BAMBARA (Mali): striking wooden headdresses

BAGA (Guinea): snake carvings, masks, and drums supported by caryatids

PORO (Liberia): large, colorful masks

BAULE (Ivory Coast): beautiful masks with carefully incised details and an almost metallic patina, and seated and standing figures

BAMUN (Cameroons): wooden memorial statues encrusted with pearls, glass beads, and shells

FANG (Gabon, Cameroons): spoons, drums and other musical instruments; expressive ancestor statues, and the mask so highly prized by the cubists and fauves

BAKOTA (Gabon): wood and metal reliquaries

BAKONGO (Congo): ancestor figures

BASONGYE (Central Africa): masks with concentric striations anticipating op art; fetishes decorated with brass nails

KUBA (Zaire): famous series of kingly statues; well-designed and richly decorated creations in many media, basket and textile designs adapted to wood carving, 10 different styles of masks, colorfully decorated with beads and shells, and carved and sculpted heads that are typically triangular

LUNDA and LUBA (Zaire, Angola, Zambia): naturalistic, rounded, polished forms including seats and stools supported by caryatids and ancestor carvings

Two faces of Africa: below, a royal
bronze oba of Benin from Nigeria,
16th century *(Nelson-Atkins Museum
of Art)* and right, a Fang mask of the
type that inspired Picasso and
Matisse *(St. Louis Art Museum)*

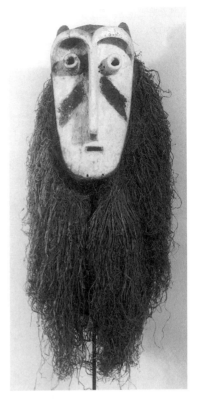

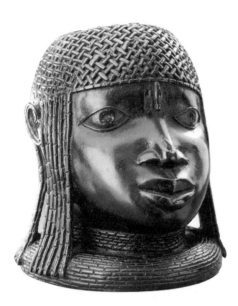

South Pacific island of Tahiti on a similar quest), it meant a trip back in time to the childhood of man, a fascinating voyage that yielded rich formal and expressive possibilities. Certainly European art has never been the same since.

Africa has more distinctive peoples and cultures than any other continent, but in contemporary usage, "African art" means work from south of the Sahara (northern Africa falling within the Islamic orbit), chiefly West African art. (East Africa, particularly the Swahili-speaking areas, tends to be treated separately or not at all.) As a subject of study, even sub-Saharan art is disputed territory, with ethnologists, anthropologists, linguistic experts, and aestheticians all vying for authority. For most of this area even the basic historical facts are sketchy, and some regions have seen little or no archeological research. A major difficulty for the layman is that the same tribe may be classified differently based on linguistic, historic, or geographic criteria. Inhabitants of the above-mentioned kingdom of Benin are known as Bini and belong to the Edo language group; the kingdom itself now lies in Nigeria, although there is also a neighboring modern state named Benin. The Ashanti or Asante, likewise, are also known as Akan-speakers and now as Ghanaians. Further complications are the continual movement of tribes, ignoring arbitrarily imposed colonial boundaries, and the perishability of most cultural artifacts.

The main subject of African art is man, naked and alone, his anatomy "reinvented" rather than naturalistically represented; frequently, the head constitutes up to one-third

of body length ("African proportions"), as compared with one-seventh in the classical Western canon. Sculpture is further characterized by rigid frontality, symmetry, and lack of facial expression. The main media are bronze and other copper alloys, ivory, and wood, fashioned into statues, masks, and fetish figures. Delving further into the literature, one soon gets lost in specifics ("the Segu substyle of the Bambara") and theories of what it all really means. Masks, fetishes (both malevolent and benevolent), and reliquary figures, anthropologists argue, are incomprehensible when divorced from the tribal functions involving both dance and theater, of which they were a vital part.

Nigeria has the richest and oldest-known tradition of sculpture, going back to the Nok tribe, which flourished there from 500 B.C. to A.D. 200. (The Nok also smelted iron, even before the Egyptians did.) Best known of the Nigerian art-producing cultures are the former kingdom of Benin (which peaked in the 16th to 17th centuries) and its predecessor, the Ife kingdom (13th to 14th centuries). Both produced highly stylized images of man in copper, brass, ivory, and bronze, capitalizing on a plentiful supply of the latter. (Benin animals, on the other hand, are more naturalistic.) These pieces, including some 2,400 objects seized by the British in 1897, are highly prized by Western museums and collectors. The Metropolitan Museum of Art in New York has a particularly fine collection. Characteristic of the Benin warrior culture (which enthroned its 38th oba or leader in 1979) are bronze sculptures of soldiers wearing neck bands.

Another art-producing culture, identified only in the last generation, was based at Jenne in the Niger delta. So far archeologists have unearthed numerous terra-cotta statues of kneeling men, equestrian figures, and couples, often with snakes winding around their bodies, dating back to the 11th to 18th centuries A.D.

Frank Willett's *African Art* is a good basic study reprinted in the Thames & Hudson series. Werner Gillon's *A Short History of African Art* is handsomely illustrated and covers more territory, including Tanzania and East Africa. For historical background, all of Basil Davidson's books are excellent. Laure Meyer's *Black Africa*, recently available in English translation, contains exquisite photos and a good map of tribal boundaries.

ALEATORY

Derived from the Latin for "dice," aleatory has come to mean art created on the principles of chance ("the aesthetics of undifferentiated experience," as art critic John Russell puts it). The automatic writing practiced by the surrealists ("a magical procedure by which we could transcend the barriers of causality and conscious volition," Russell quotes them as saying) ranks as aleatory. Marcel Duchamp's random "readymades" and Jackson Pollock's action paintings might also be considered accidental in method. But the medium that has taken the principles of chance the furthest is music. Jazz improvisation certainly had aleatory elements, and even earlier the futurists were declaring that random noise and nontraditional sound were music if you knew how to listen. Then came the high priest of aleatory, American composer John Cage, who dominated avant-garde music for two generations after World War II.

Starting from the theory that all sound, and even its absence, has validity, Cage began by experimenting with a "prepared piano," attaching extraneous materials to the strings to create different effects. In the 1950s he composed pieces for "12 radios tuned simultaneously" and for four and a half minutes of silence relieved only by random envi-

ronmental noise. Once he chose notes for a composition from the *I Ching* or *Book of Changes*. Doors slamming, engines turning over, the wind, heartbeats—even the roar of a landslide—were all incorporated in Cage compositions.

Other more scientifically inclined aleatory composers relied on mathematics and computers to choose their notes. In general, however, most composers proved reluctant to relinquish control of the process of creation. Cage's ideas have been influential (more so than his actual compositions) mainly on formerly strict serialists like Karl-Heinz Stockhausen and Pierre Boulez, who occasionally incorporated elements of chance into otherwise highly determined compositions.

AMISH

Similar to but even stricter than the Mennonites are the Amish, followers of a Swiss Anabaptist named Jacob Ammann who believed in religion as a total way of life. Called "Amish," the followers of Ammann were exhorted to live strictly separated from the outside world, in order to remain "unspotted." In the American communities that they established in the 18th and 19th centuries, the Amish still practice excommunication and "shunning" of those who do not share their views down to the minutest detail. To cite one major point of difference between the Amish and the Mennonites: the Amish are known as Häftler or "hook-and-eyers," while Mennonites are Knöpfler or "button people," buttons being somehow more progressive.

Modern conveniences considered taboo by the Amish in their efforts to maintain a traditional rural lifestyle are electricity, telephones, central heating, cars, tractors, and even public high school education. Many Amish still speak a sort of pidgin Swiss-German and maintain traditional dress and grooming: wide-brimmed black hats, beards, and bangs for men; long dresses, long hair, and organdy caps for women. Their horses and buggies are familiar on the rural back roads of Pennsylvania, Ohio, and Indiana, and their farming, with horse-drawn plows, is noted for high yields. (Among other government measures rejected by the Amish, who are considered superlative farmers, are farm subsidies.)

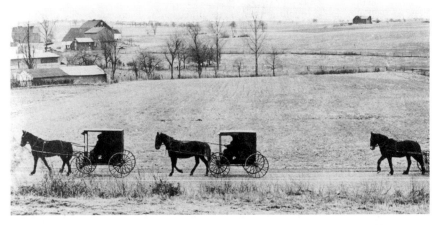

Traditional Amish customs persist in 20th-century Pennsylvania *(Library of Congress)*

In 1980 the American Amish numbered around 85,000, living mostly in Pennsylvania, Ohio, and Indiana. Communities farthest west are said to be more liberal, sometimes permitting the use of English and automobiles. But one cannot generalize across the board: the Amish of Lancaster County, Pennsylvania, one of the oldest established communities, are conservative in doctrine but innovative in agriculture.

In Pennsylvania and elsewhere we have the inevitable phenomenon of pseudo-Amish commerce for tourist consumption, from restaurants and cookbooks (the cuisine is more American than Old World, everything is fried, and the portions are enormous) to knick-knacks and quilts. Authentic Amish quilts (an American craft tradition with no European analogue) are highly prized, extremely expensive, and quite modern in their abstract designs. (One of the great collections, owned by Doug Tomkins, was exhibited at San Francisco's De Young Museum in 1990.)

John Hostetler, author of *Amish Society*, is Amish by birth and a social scientist by training, the optimum background for producing a sensitive, discerning account of his people. *Amish: The Art of the Quilt* by Robert Hughes is a handsome, expensive book related to the 1990 San Francisco exhibit. See also MENNONITE.

ARISTOCRACY

In their book on *Isms* Alan and Theresa von Altendorf go so far as to list "aristocratism," or rule by the "better people," usually members of a hereditary class. We are more accustomed to the noun form aristocracy, with the suffix -*cracy* derived from the Greek verb "to be strong." But however you render it, the concept of aristocracy is historically un-American (the U.S. Constitution expressly prohibits hereditary titles) and somehow suspicious. As etiquette expert Miss Manners points out, anyone in the United States who insists on a title probably runs a boutique.

Most of us are mildly intrigued but generally ignorant of the nuances of Old World superiority. For example, a $64,000 question: Louis XIV gave the title of marquise to two mistresses, while two others (one of whom the king eventually married) became duchesses; which is the superior title?

In the tables of European nobility, the title of duke (from the Latin *ducere*, to lead; hence a leader of men, usually armed) takes precedence. Next comes the marquess, whose wife is a marchioness in England, a marquise in France. Earl, or count in the continental version, is followed by a junior group of viscounts, with the baron bringing up the bottom of the ranks. These titles are general throughout Europe, with slight spelling differences in the romance languages. The French say *duc* and *comte*, the Italians *duce* and *conte*, the Spaniards *duque* and *conde*. In German, duke is translated literally as *Herzog* or "draw-er forth (of men)," while count is *Graf*.

These are just the titles; with them go whole systems of privilege, deference, and forms of address ("my Lord") which make Americans glad to forget the whole business. Then there are national peculiarities. France abolished titles in 1789, but they were revived by Napoleon, who also awarded new ones for personal service—creating a schism in the French nobility that persists to this day. Austria also abolished titles of nobility, after the First World War, but this does not prevent their use; one of the authors in our bibliography is an Austrian archduke, Dr. Geza von Habsburg, a working appraiser of valuables.

And how do you know when a title is real or of the boutique variety? You could check *Burke's Peerage* or the *Almanach de Gotha*, the blue books of European aristocracy, but these seem to be written in a kind of genealogical code. Somehow the aristocracy business strikes most egalitarian Americans as devious by definition. At the turn of the last century, when American heiresses by the scores were marrying into the European nobility, the novelist Henry James wrote several tales of American innocents abroad, bamboozled by the more subtle and sophisticated Old World aristocrats.

Besides the enjoyment of power and privilege, aristocracy may also entail wealth and culture in the hands of the few—the aristocrat as culture-bearer. Music and art were often produced specifically under courtly patronage for elite consumption. To the privileged traditionally belonged wit, refinement and distinction in all things, as the French nobleman Alexis de Tocqueville remarked when visiting the United States in the 1830s to study democracy. Thomas Jefferson would have replied that we Americans enjoy a natural aristocracy, leaving every man free to develop his abilities and personal culture to the utmost.

To Marry an English Lord by Gail MacColl and Carol M. Wallace amusingly describes the American quest for titles at the turn of the last century. Robert Lacey's *Aristocrats*, based on a BBC series of the same name, demystifies the concept by following some titled Europeans through the real world of the late 20th century.

ARISTOTELIAN

The first professional philosopher, Aristotle was the world champion categorizer of all time, devising layer on layer of classifications in which to order great and often undigested masses of observations. He is credited with writing in a dull, uninspired style as many as 400 volumes (some possibly compilations by students) which have been called the *Encyclopaedia Britannica* of ancient Greece.

To cite some of his more accessible works, for example the *Poetics*, Aristotle made the first analytic distinction between comedy, tragedy, and epic, describing the properties of each and their cathartic effect. In his *Politics* he discussed the various types of government, which we still call by their Greek names: aristocracy, monarchy, and democracy; and in his *Historium Animalium*, he categorized animals by method of reproduction, evolution, and other such characteristics.

In the short run, Aristotelianism led to the stultifications of Scholasticism, for which it set the terms of debate. Some of Aristotle's beliefs have been discredited—for example, that the sun revolves around the earth, that intelligence is located in the heart, and his preferences for oligarchy and slavery. In the long run, we are indebted to Aristotle for the concepts of catharsis and mimesis; the postulate that nature abhors a vacuum; a tricky device called a syllogism (a trio of propositions in logic); and the very notions of mean, maxim, motive, principle, and form.

ART BRUT

During World War II Jean Dubuffet, a 40-year-old French wine dealer, began searching for an art that would start from zero. His own canvases, representing humanoid-type figures, tended to look like mud pies (he used an impasto thickened with asphalt, peb-

bles, and glass) mixed with a stick. Dubuffet decided to call this "art brut," meaning "raw" or crude art. He found his inspiration in the art produced by criminals, the insane, and children, their creativity unrepressed by the normal processes of socialization. Paintings by Dubuffet are to be found in the world's great museums (New York's Museum of Modern Art had a retrospective in the 1960s), while his extensive personal collection of art brut is in the Château de Beaulieu in Lausanne, Switzerland. The artist also created free-standing structures that have been called painted sculptures. One of these stands in Chase Manhattan Plaza in New York City.

Dubuffet participated with Mildred Glimcher in the preparation of the book *Jean Dubuffet: Toward an Alternative Reality*.

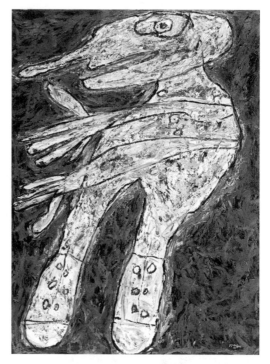

Jean Dubuffet's *Bonne Mine* **(1961), an art brut version of the "happy face"** *(San Diego Museum of Art)*

ART DECO

Art deco, so called after a 1925 international exhibit of decorative arts in Paris, is a more modern, machine-age successor to art nouveau, with straight lines, zigzags, and repetitive geometric motifs replacing round, sinuous, asymmetric forms. Art critic Hilton Kramer calls it a vulgarization of modernism, its function being to assimilate and popularize such innovations as cubism for mass consumption.

This is another of those grab-bag periods (extending roughly from World War I to World War II) during which innovations and borrowings from earlier periods, similar in spirit if not in appearance, are jumbled together. The difficulty of identifying art deco is compounded by the fact that it influenced everything from fashion to furniture, art to architecture, even automotive design. But it is worth the effort to become familiar with the various manifestations of art deco, if only because this style reached its ultimate expression in the United States and we have a wide variety of it, widely dispersed geographically.

The art deco period is sometimes subdivided into 1) zigzag moderne, during the 1920s, with exotic shapes such as the Babylonian (Mesopotamian) ziggurat (rising in stages) and abstract, geometric, and sometimes astrological motifs; 2) streamline moderne, during the 1930s, featuring forms that are futuristic and aerodynamic, with rounded corners, speed stripes, and a horizontal thrust; and 3) classical moderne, also 1930s, typ-

ified by modernism, neoclassicism, mass-production (by that time the Depression had begun, and economy had replaced luxury). John L. Marion, head of Sotheby's auction house and author of *The Best of Everything*, calls moderne "Hollywood chic," the "distinctive Jean Harlow style."

Art deco may be difficult for novices to identify for several reasons. Some art deco objects combine elements of zigzag, streamline, and classical moderne. Other typical art deco motifs adopted from Aztec and Assyrian art may have little in common except that they appealed to the same people at the same time in history. Finally, art deco tends to merge with other contemporary styles, such as the nascent International Style in high-rise architecture, or Frank Lloyd Wright's Maya revival.

The 1920s were a period of widespread construction in urban America. Kansas City and Tulsa, both oil boom towns, have many buildings in the art deco style, as do Los Angeles and Miami. In Los Angeles, check out the downtown Coca-Cola Bottling Plant, shaped like a ship with portholes; the former Samson Tire Factory, an Assyrian temple next to the Santa Ana Freeway (see p. 171); and, of course, "movie palaces" by the scores. In Miami Beach some 400 buildings in the downtown hotel district have been grouped into a "tropical deco" historical zone.

In New York, architectural historian David Handlin points out, a 1926 zoning ordinance favored the stepped or ziggurat skyscraper by requiring buildings of more than a certain height to be set back to allow light into the street. New York's Rockefeller Center, with its wealth of sculpture and ornamentation, is a prime example of art deco, as are the Empire State Building (1931), topped with a dirigible mooring mast, and the Chrysler Building (1930), with a chromed steel dome resembling the "combs" crowning Maya temples. In the 1930s architecture became more conservative, thanks at least in part to federal financing; this period produced many state capitols (Nebraska, 1932; Oregon, 1938) and city halls. (Many of these are decorated with murals that are a capitalist version of socialist realism.)

It was typical in the art deco period for architects to coordinate interior and exterior decor. In some buildings you will find that architectural motifs have been repeated in rugs, light fixtures, elevators, railings, even dishes. In Frank Lloyd Wright's Johnson Wax Building (1939) in Racine, Wisconsin, exterior curves are repeated in the reception area, in the columns, even in the oval desks and chairs.

Art deco lent itself particularly to the graphic and commercial arts. Characteristic are the highly stylized illustrations by the Frenchman Erté in *Harper's Bazaar* and the portraits by Polish émigré Tamara de Lempicka. Sculpture was important as an accessory to architecture. Some art deco creations dated quickly and have remained out (blond furniture), but design was generally so futuristic as to become timeless, subject to repeated revival (as during the 1960s).

Art deco may be on the downswing now, as evidenced by actress Barbra Streisand's decision in 1993 to auction off her considerable collection.

Eva Weber's *American Art Deco* is a handsomely illustrated, well-written coffee-table book. In the Thames & Hudson series, Alastair Duncan wrote *Art Deco*. For regional American variants on the style, see *Tropical Deco: The Architecture and Design of Old Miami Beach* by Laura Cerwinske and *Pueblo Deco* by Carla Breeze.

ART NOUVEAU

Art nouveau, which had spread all over Europe by the 1890s, arose out of a conscious effort to create an authentically new style, in reaction to the pompous and prolix historicism of the 19th century. Its immediate origins were in the British pre-Raphaelite and Arts and Crafts movements, but it is called, curiously, by its French name. (The French originally called it by English names, "Yachting style" or "Modern style.")

Art nouveau is characterized by sinuous lines, tendrils and swirls, snakes, and other botanical forms. "The natural fecundity of the botanical world becomes a treasury of visual artifice," as art critic Hilton Kramer put it. Historian Wylie Sypher called art nouveau a neo-rococo form of ornamentation, delicately asymmetric and dependent on mannerist artifice. The Paris subway entrances, which have been described as "cast-iron orchid stalks," are perhaps the most familiar signature of the era.

Buffet (c. 1905) by the designer of the Paris subway entrances, Hector Guimard *(Los Angeles County Museum of Art)*

The typical art nouveau forms were particularly well suited to expression in wrought iron, plate glass, and reinforced concrete, but are found in all media, from cloth and jewelry to graphic arts and architecture, for the leaders of the movement believed in the unity of all the arts. The Belgian architect and designer Henry van de Velde, for example, even designed his wife's clothes and planned menus to harmonize with their interior decor. Hector Guimard, who created the Paris metro entrances, was a trained architect who designed furniture and even hat pins. In southern Europe the Spanish architect Antonio Gaudí designed fantastic spires, encrusted as if with barnacles, and grotto-like interiors. Thanks to Gaudí, Barcelona ranks along with Paris, Vienna, Budapest, and Prague as European capitals of art nouveau. (For other national variants on the style, see SEZESSION and JUGENDSTIL. The Spanish called their movement *arte joven*. For art nouveau jewelry, see LALIQUE.)

In the United States Tiffany made a highly original contribution to art nouveau, and James McNeill Whistler's Peacock Room in the Freer Gallery in Washington, D.C., is practically an art nouveau shrine. In architecture Louis Sullivan was adorning midwestern banks and skyscrapers with lush ornamentation even before this caught on in Europe. (The Watts Towers in Los Angeles, designed by a self-taught architect, are a modern descendant of Gaudí's famous Barcelona cathedral.)

Informed by contemporaneous developments in symbolism and Freudian psycho-analysis, art nouveau is a fin-de-siècle art, tending to phantasmagoria and decadence, the erotic and the exquisite. A typical subject of interest was Salomé, a figure of ambivalent eroticism in Oscar Wilde's play of the same name, Aubrey Beardsley's drawings, and later the Strauss opera *Salomé*. Few male figures were represented in art nouveau. Other feminine icons of the era include Loie Fuller, the veil dancer (later imitated by Isadora Duncan), and actress-vamp Sarah Bernhardt, whose theater posters by Alphonse Mucha have enjoyed lasting popularity.

In fact, it may be in the field of graphics that art nouveau found its most appropriate expression, and had its most lasting influence. With the inevitable swing of the pendulum, the art nouveau style came to seem simply too exquisite, too precious. Some denigrate its sinuous curves as "tapeworm style," or point out the incongruity of such high aesthetics producing mundanities like subway entrances. In the 1990s art nouveau posters and jewelry are esteemed as kitsch icons while the style's grander pretensions are ignored.

There are numerous coffee-table books on art nouveau. One of the better ones is by Maurice Rheims, *The Flowering of Art Nouveau*. See also Wylie Sypher's *Rococo to Cubism in Art and Literature*.

ARTS AND CRAFTS

The distinction between "high" art and the more popular decorative arts and crafts is a modern one. The Arts and Crafts movement, which arose in England in the last half of the 19th century, tried to narrow the gap between the two by raising the standards of the decorative arts or crafts.

The protean figure in the movement was William Morris, a former member of the pre-Raphaelite Brotherhood whose real talent was for the decorative arts. Morris was also a socialist, deeply concerned with the improvement of working conditions and the restoration of dignity and standards of excellence to labor.

When Morris began to equip his first studio, he could find no satisfactory furniture, so he made it. Gradually he brought together talented potters, printers, carpenters, weavers, and others who shared his belief in the unity of all art. Morris and his colleagues, who were dedicated to the elevation of low Victorian standards of mass production, also tended to be romantics who saw in the medieval guild system a lost paradise, an antidote to the negative consequences of industrialization.

For its followers, the Arts and Crafts movement was a means to personal redemption as well as a vehicle of social reconciliation. Paradoxically, however, the fine handmade products produced by Morris & Co. were so labor-intensive that they were far too expensive for workers to buy. Indeed, Morris's clients were the very upper classes that were responsible for the social and economic conditions he deplored. To his credit, Morris was aware of these contradictions and became steadily more involved in socialist politics.

The Arts and Crafts movement proved incapable of reconciling aesthetics with social justice, but it did make significant contributions to fine design. For example, Morris published exquisite books printed on fine handmade paper in typefaces based on medieval models. His wallpapers and his rugs, in bold repeat patterns that antici-

pate art nouveau, are still highly prized today. (The so-called Morris chair, a wood-frame easy chair with padded armrests and detachable cushions, was designed by Phillip Webb and made by Morris & Co. from 1866.)

In America, where the consequences of industrialization were not so dire as in England, Morris and the Arts and Crafts movement had many offspring, from Louis B. Tiffany, who also found that only the privileged classes could afford his aesthetic standards, to Gustav Stickley, inventor, designer, and publisher of the chief American Arts and Crafts publication, *The Craftsman* (1906–16), the *Whole Earth Catalogue* of its day. Another was Elbert Hubbard, who even went to England to meet Morris, returning to upstate New York to establish his own publishing and crafts operation, called Roycroft, on the Morris model. (Like Morris, who inscribed his work with a personal mark, Hubbard used a 14th-century orb and cross as his hallmark.)

In American architecture Greene and Greene adopted Morris's unified approach in their handsome California bungalows, harmonizing rugs, stained glass, and even light fixtures with architectural motifs. So did Frank Lloyd Wright, who was not as unsympathetic as Morris to the machine (Wright considered it a "normal tool of our civilization").

In the great cyclical movements of cultural history, Arts and Crafts is again in vogue. The Greene and Greene houses still standing in Pasadena, California, are again held in high regard (one is now a museum run by the University of Southern California). The furniture of the period is also being reproduced, with original pieces commanding top prices at auction. (Barbra Streisand reportedly paid $363,000 recently for a sideboard by Gustav Stickley.)

The Craftsman: An Anthology (Barry Sanders, ed.) is a good introduction to the American branch of this movement. In the Thames & Hudson series, Elizabeth Cumming and Wendy Kaplan wrote *The Arts and Crafts Movement*.

ASHCAN SCHOOL ("THE EIGHT")

The history of art politics since the French Revolution has been characterized by a dialectic movement, with on the one hand an art establishment (often academically based, with control of teaching positions) whose access to exhibition space comes under increasing challenge by younger, usually more modern, outsiders. The successful challenging group then becomes the establishment, resisting in turn the next wave of new pretenders. (If the challenge proves unsuccessful, the outsiders may form splinter or "Sezession" groups.)

In the politics of American art, a key role was played just after the turn of the 20th century by a group called the Eight. United by friendship and geographic accident rather than style, the majority of the Eight were considered "New York realists." (However, the last addition to the group, Maurice Prendergast, painted in a distinctly postimpressionist style.) Four of the Eight were former newspaper artists from Philadelphia—William Glackens, John Sloan, Everett Shinn, and George Luks—who moved into art after photography put them out of work. Journalism, which had given them the city as a motif, also accounts for the anecdotal quality of much of their work. Their mentor and most important of the group was Robert Henri, who as an art teacher in Philadelphia and later New York influenced generations of students in the direction of urban real-

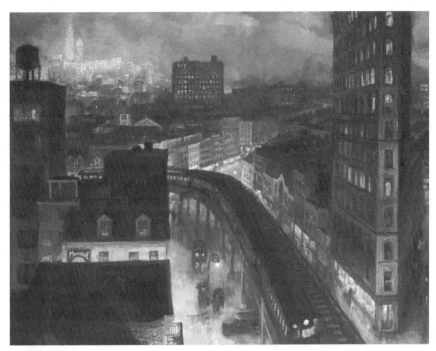

John Sloan's *The City from Greenwich Village* (1922), typical of the "New York realism" practiced by members of the Ashcan school *(National Gallery of Art)*

ism, with modified impressionist techniques. Because of their penchant for scenes on the seamier side of city life, the Eight were later (in the 1930s) dubbed the "Ashcan School" or "Ashcanners."

Finding their access to exhibition curtailed by the art establishment, led by the National Academy of Design, the Eight mounted their own exhibits in 1908 and 1910. These were successful, at least in part because of the artists' contacts in the press. But the group made its greatest impact on American art when the most obscure of its members, Arthur B. Davies, organized the 1913 Armory Show, another counterculture challenge to the art establishment. This show (eventually seen by more than 200,000 people) included contemporary works from French postimpressionism, fauvism, and cubism, all of which made the Ashcan Eight seem, by comparison, definitely old hat.

Painters of the Ashcan School: The Immortal Eight by Bernard B. Perlman is, as the subtitle suggests, adulatory.

AUBUSSON

Because Savonneries (the first hand-knotted rugs made in Europe) were so expensive and production so limited, in 1665 the French monarchy authorized the ancient tapestry works in Aubusson in south-central France to make rugs as well. Aubusson rugs feature the same delicate colors ("a rather feminine, boudoir effect," Honour and Fleming write in their excellent survey, *The Visual Arts*) and elaborate floral designs as Savonneries,

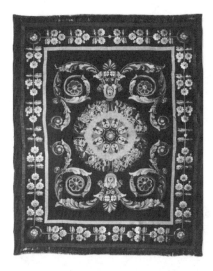

An early 19th-century Aubusson carpet, the tapestry-woven counterpart of a Savonnerie *(Metropolitan Museum of Art)*

but they are woven in a pileless tapestry style. Great quantities were produced in the 19th century, but none has been made since the 1930s. Since the tapestry weave never stood up to heavy wear anyway, antique Aubussons are scarce and generally quite worn. (Many became available during the Stalin era, when the Soviet government confiscated and sold off the wealth of the Russian aristocracy—a one-time windfall for collectors.) However, you can console yourself with a pristine new rug in the Aubusson style made in China, India, or Pakistan.

AVANT-GARDE

New, radical, experimental, innovative, revolutionary, possibly even shocking—these are more or less synonymous with the French concept of a cultural vanguard or advance outpost, based on a military analogy, or culture as a battlefield. As art critic Robert Hughes explains in *The Shock of the New*, the avant-garde was a spin-off of the French Revolution, which replaced the centralized taste of the ancien régime with a free, competitive market for style. The avant-garde is by definition an insecure position, its boundaries constantly shifting in time and space, subject to invasion from all sides; hence it is usually a matter of fashion rather than of style. If anything of substance survives the passing of the fashion or fad, that residue may become style. If not, the fad devolves from a concept into a thing—an "old hat."

An avant-garde may be defined in different ways. It may constitute a loose group—the impressionists, who were the first avant-garde according to theorist Renato Poggioli—or a tight group, such as the surrealists. It may take a position opposing the prevailing canons of style, as the romantics did, or it may be an authentically positive new development, like art nouveau. At its apogee, it may achieve all its ambitions (cubism), it may find its possibilities exhausted (op art), or it may be cut off by history (constructivism), possibly feeding into later developments. But the most common theme seems to be rejection of tradition and authority, sometimes resulting in nihilism, futurism, or artistic infantilism (dadaism).

In the United States avant-gardism is practically a ritual, with successive groups often consuming and negating themselves in the process. Our fast-paced society is so conditioned to accept cultural novelty that novelty becomes a tradition in itself. ("Yesterday's avant garde experiment is today's chic and tomorrow's cliché," as historian Richard Hofstadter put it in *Anti-Intellectualism in American Life*.) As each radical new outpost of artistic or intellectual endeavor achieves acceptance, acclaim, and often massive remuneration, instant oblivion is not far behind.

Will the treadmill stop when there is nowhere left to go? After abstract expres-

sionism, perhaps the last avant-garde movement to become a style, we had pop art and minimalism, fashions without a past or a future. As we approach another fin de siècle, cultural historian Hillel Schwartz points out, our avant-garde is creating little but "an art of fragments, displacements, dissolves, flashbacks, accidents of quotation and collision."

The Theory of the Avant-Garde by Renato Poggioli is highly philosophical. *Avant-Garde Art*, edited by Thomas B. Hess and John Ashbery, contains an interesting collection of articles. See also Hilton Kramer's *The Age of the Avant-Garde*.

AZTEC

In 1519, when the Spaniards landed in Mexico, Mexico City had a population estimated to be from 150,000 to 200,000, making it perhaps the most populous city in the world. At that time it was called Tenochtitlán, capital of the Aztec Empire, a loose organization of tributary states and military colonies extending south to Central America.

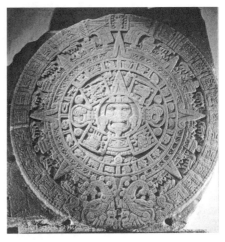

The Aztec were formidable warriors and highly disciplined, but they did not rule by force alone. They were also masters of power politics, the dynastic marriage alliance, and commerce. Historian Oswald Spengler calls them the Romans of Meso-America. As late arrivals (around A.D. 1200), they inherited and added to the many accomplishments of the peoples before them, the builders of the great ceremonial center at nearby Teotihuacán, as well as the Mixtec and Toltec.

The much copied Aztec calendar stone from Tenochtitlán, c. 1400 *(National Museum of Anthropology, Mexico City)*

The Aztec conceived of the cosmos as an order that required human blood for rejuvenation and survival. Put another way, they lived in fear of supernatural forces that they propitiated with human sacrifices, accomplished by heart excision. (Some anthropologists believe they sacrificed humans instead of animals, as Stone Age societies of the Old World did, because the last ice age had decimated the population of small animals in Mexico.) In any case, it is for their "bloodthirstiness" that we remember them rather than for their painted manuscripts, their expressive sculpture, or their famous calendar stone, which has been degraded to reproduction on ashtrays, key chains, and liquor bottle labels.

Aztec civilization ended abruptly in 1523, meeting violent death at the hands of a small group of Spanish adventurers who razed the city of Tenochtitlán.

Aztec Art by Esther Pasztory is highly recommended.

To be or not to be; that is the bare bodkin.

Mark Twain

BACCARAT

The story is told that the French glass industry languished until the 1840s, when a colored Venetian paperweight launched a new fad in glass. In any case, the chief form for which Baccarat (founded in 1765 in the Vosges Mountains of France) became known was the paperweight, first produced in small ($2\frac{1}{2}''$ diameter), medium ($2\frac{1}{2}$ to $5''$), and magnum (over $5''$) sizes. Most valuable are those with trademarks of 1846 to 1849, sometimes with a "B" beside the date. Designs include whorls, stardust clusters, honeycombs, and animal and flower forms, the best known being millefiore ("thousand flowers").

The fashion in paperweights died out after a generation, needless to say, but Baccarat (not to be confused with the French card game of the same name, once popular in fashionable casinos) has survived by producing fine crystal tableware and vases of high quality if not necessarily notable design. The Baccarat line for 1991, in a shameless bid for the dowager market, included glass figurines of cocker spaniels ($185 each) and Loch Ness monsters ($290).

BAHAISM

Founded in Persia in 1863, Bahaism is a world religion claiming to have been revealed by a series of historical figures including Moses, Christ, Muhammad, and Baha Ullah,

its founder. Bahaists preach the unity of all men and religions, seeking world peace through universal government and education. Because of its eclecticism and its appeal to minority groups such as Zoroastrians and Shi'a Muslims, to whom it offers allegiance to a universal church, Bahaism has earned the enmity of Islam in general. And in Iran, where Shi'a Muslims constitute the majority, the puritanical regime of the Ayatollah Khomeini considered Bahaism a heresy punishable by death.

According to 1991 statistics, the American Baha'i movement had 1,700 churches and 110,000 members. The church has its U.S. headquarters in Wilmette, Illinois. The Baha'i temple there (designed by a student of architect Louis Sullivan and dedicated in 1953) shares the properties of Baha'i temples throughout the world. While they may at first appear dissimilar—the Wilmette temple is neo-baroque, that in Panama is egg-shaped, and a spectacular new temple in New Delhi takes the form of a lotus blossom—they share certain Baha'i requisites. Each has a single dome (representing one god), has nine sides (nine being the highest single digit, symbolizing unity), and takes advantage of natural light. (A noninitiate, asked to find the common denominator, might say that Baha'i temples are all either phallic or breastlike in structure.)

BAPTIST

In the Christian tradition, baptism is a ritual washing or initiation rite going back to John the Baptist. As a group, the Baptists were an early left-wing offshoot of the Puritan movement who wanted to restrict church membership and baptism to believers. They also opposed central authority and insisted on church-state separation, which brought them into frequent conflict with the authorities in Mother England (John Bunyan, a Baptist, wrote *Pilgrim's Progress* while in jail) and encouraged their emigration. Basically Calvinist in outlook, they believed the key religious experience was conversion, leading to baptism (of adults only; infant baptism was rejected). According to an early American description, this pivotal ceremony consisted of "diping ye Body in ye Water, resembling Burial and riseing again."

The first Baptist church in America was founded in Providence, Rhode Island, in 1639 by Roger Williams (a major colonial figure who did not long remain with the Baptists). Providence, where the Baptists established Brown University in 1764, remained a church stronghold while the movement spread west and south with the frontier, sparked by revivalist fervor. Eschewing an educated, professional ministry, the Baptist movement was carried by farmer-preachers and their backwoods converts (who included Daniel Boone).

From the third largest American denomination in 1776 the Baptists had become the largest by the turn of the 19th century. They were particularly successful evangelizing slaves in the South. Like many other religions, in 1845 the Baptists split into northern and southern churches over the issue of slavery, and they remained divided for more than a century.

With the disappearance of the American frontier, the Baptist church gradually became more mainstream. In 1892 the University of Chicago was established as a Baptist super-university by such devout churchgoers as John D. Rockefeller and scholar William Rainey Harper. The better known of the two, Rockefeller was pious and dour, sharing Baptist suspicion of the high living and fancy ways affected by fellow American mogul J. P. Morgan, a cosmopolitan Episcopalian. In 1991 Baptists, in several different group-

ings, of which the Southern Baptist Convention counted the most members, were the largest Protestant denomination in the United States.

BARBARIAN

This is a loaded cultural concept that should be invoked only with great care, if at all. The word was coined by the ancient Greeks to designate all those who did not speak Greek, whose native languages sounded to the Greek ear like grunts—"bar-bar-bar." (William Shakespeare turned this around neatly in his *Julius Caesar*, which contains the famous line, "It's all Greek to me.") Although barbarian tends to be used to indicate a lower level of civilization or pagan religious affiliation, it originally had to do with communication, not civilization or religion. In any case, calling anyone a barbarian today conveys an attitude of cultural superiority, if not contempt.

Such culture-centricity was endemic in ancient China, where degree of civilization was considered a function of geographic proximity to the Middle Kingdom; the farther away, the more barbarian. It seems to be in the nature of things that nations look down on their neighbors; even barbarians designate their own barbarians. (The pre-Columbian Mexicans called theirs *chichimeques*. Wordsmith Hugh Rawson says the later expression *gringo* derives from the Spanish for *Greek*, signifying gibberish—or barbarian.) But egalitarian American culture vultures do not want to put their foot into this trap—like the major contemporary artist (who shall be nameless, but as a Princeton graduate he should have known better) who referred to Persian design motifs as barbarian decoration. (Never mind that it was their enemies, the Persians, whom the Greeks considered particularly "bar-bar-ian.")

There are in fact styles listed in this book (Celtic, for example) that were created by people considered barbarians by someone else. In *Dictionnaire des styles*, French scholar Germain Bazin suggests a definition of barbarian style. Barbarians tend to be nomadic or semi-nomadic, Bazin writes, with the result that they generally have no architecture; and their arts, which are small-scale and portable, usually eschew human representation in favor of zoomorphic motifs such as twisted and interlaced dragons and birds.

BARBIZON SCHOOL

According to popular legend, two French artists were searching in the Fontainebleau forest in the 1830s for a village they could only recall as ending in *-zon*, where they had heard other artists were painting outdoors. This may not seem very unusual to you today, but outdoor painting was a great novelty in those days, when landscape rated primarily as historical backdrop. The village turned out to be Barbizon, which found its population of 20 doubled by the artists, and which gave its name to this school of *plein-air* (fresh-air) painting. One of the two questing artists was Jean-François Millet, who settled and remained in Barbizon for 27 years. He is even buried there, along with Theodore Rousseau, the other leading light of the Barbizon school.

So what was the big attraction? Historically, the Fontainebleau Forest was where the kings of France held epic hunting parties, felling stag, wolves, and wild boar. The forest afforded the artists a picturesque tangle of trees (beech, hazel, ash, and, of course, great oaks with gnarled trunks) and moss-covered rocks. It was here, only 40 miles from Paris, that the Barbizon painters found their retreat into nature, inspired by Dutch and

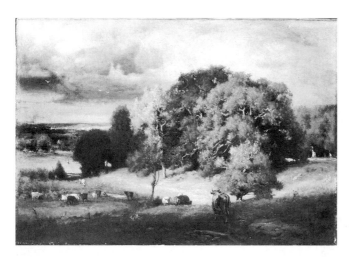

An American classic in the Barbizon tradition— George Inness's *Autumn Oaks* (1887) *(Metropolitan Museum of Art)*

English landscape painters (chiefly John Constable and J. M.W. Turner). By 1850 they had achieved recognition in France, but they are memorable to us today chiefly for sowing the seeds from which impressionism would soon grow. In fact, only a generation later Claude Monet and Pierre-Auguste Renoir made pilgrimages to Barbizon, painting the same scenes at different times of day and season as the Barbizon artists had done.

If you can't make it to France this year, you have only to go to Cincinnati, Ohio, to see Rousseau's *Valley of the Tiffauge*, or to Toledo, Ohio, for his *Curé*. There are also some famous canvases in the United States by Millet, who is best known for his "peasant cycle," which profoundly influenced Van Gogh. Millet's *Angelus* is in the Louvre, but *The Sower* is in Boston. Another of his paintings, *The Man with a Hoe*, caused a sensation in the United States when it was acquired by the Crocker family of San Francisco and inspired a vaguely socialist poem, widely reprinted by the Hearst press in 1899.

The Barbizon school also had its American adherents, including William Morris Hunt, who exhibited with the Frenchmen and was a witness at Millet's wedding; George Inness, considered the foremost American landscape painter of the 1880s; and William P. Babcock, whose name, incidentally, appears on Millet's death certificate.

Barbizon art went out of style during the first part of the 20th century ("people got tired of the cows and sheep," according to John L. Marion of Sotheby's) but is currently enjoying a comeback.

See Jean Bouret's *The Barbizon School and 19th Century French Landscape Painting.*

BAROQUE

Lavish, monumental, theatrical; extravagant, exaggerated, ecstatic; lots of pudgy-winged babies—these are the keynotes of the baroque, the style that dominated 17th-century Europe and that the Spanish brought to their New World colonies.

The baroque era was a time of relative prosperity and renewal after the dissension and destruction of the Reformation. The Roman Catholic monarchies as well as the church were anxious to restore their authority and grandeur, and the baroque style (the official style of the Counter-Reformation, the style in which absolute power found its

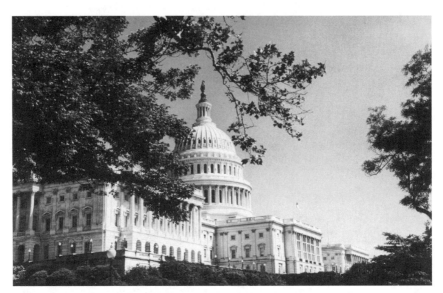

**The neo-baroque dome of the U.S. Capitol (1855–64), Washington, D.C., provided by
the structure's fourth principal architect, Thomas Ustick Walter** *(National Trust)*

greatest expression) offered an excellent means to arouse zeal and to excite wonder.

Like the Renaissance, from which it may be seen as a natural progression, baroque
was born in Italy. Consider the work of the multi-talented Giovanni Bernini, Italian
sculptor-architect of the fountains of both Trevi and the Piazza Navona; the colonnade
and baldachin at St. Peter's; and exquisite statues of Daphne turning into a laurel tree
as she flees from the amorous Apollo and of St. Teresa in an advanced stage of exalta-
tion. Where the Renaissance counseled balance and poise, the baroque era sought energy
and conflict, exuberance and the fantastic; where the Renaissance was oriented to the
here and now, the baroque era was concerned with the eternal; where the Renaissance
sought symmetry and repose, the baroque era explored mass and motion.

Baroque architecture begins with the many small churches of Francesco Borromini,
whose cupolas still dot Rome. Typically these rise in three tiers, each narrower than the
one supporting it, the second tier sometimes joined by curling volutes to the first floor;
superimposed columns give the impression of a great pipe organ. Borromini's greatest
innovation was the alternation of convex and concave surfaces, creating undulating
curves; architectural historian Nikolaus Pevsner (*An Outline of European Architecture*)
calls this the leitmotif of baroque. Later architects would capitalize on Borromini's grace-
fully curving lines, enlarge his scale, and add arcades, colonnades, and lavish flowery
decor for good measure. Square forms are elongated into oblongs, and circles into ovals.
In general, the facade is everything—sometimes the sides of a baroque church are not
even faced.

Baroque is found all over Europe and as far east as Russia. Vienna is a great baroque
city, as is Prague (the Charles Bridge with its statues of saints has been described as a
"royal processional way of the baroque"). National variations on the style are quite
instructive. French baroque is more austerely classical, less flamboyant than Italian; con-
sider those great 17th-century palaces, the Louvre and Versailles. English baroque also

seems restrained or lacking in enthusiasm, the English spirit not being given to monumental flights of fancy. (Actually, the English were a bit behind, only just progressing from medieval to classical architecture during the baroque.) At the other end of the scale, we have Germany, where baroque enjoyed a brilliant vogue before shading into the even greater excesses of rococo, and Spain, where baroque reached its most extravagant expression in Churrigueresque. This latter style, with its inflated decor, was carried to Mexico and Latin America, where ultrabaroque churches have facades that seem to be decorated in spun sugar and naves like "dazzling golden grottoes."

Washington, D.C., with its grand avenues, axial approaches, monumental siting, and dignified parks (nature stylized, you might say) was planned on standard baroque principles. Another great baroque city is St. Petersburg, Russia, conceived by Peter the Great after visiting Western Europe. In addition to his new capital city, Peter built great sprawling baroque palaces such as Peterhof, north of St. Petersburg, with its famous water park. (As Bernini's fountains suggest, the baroque had a special affinity for water.)

So much for architecture. Baroque art is characterized by the disruption of classical canons and contours. Figures that during the Renaissance were silhouetted against a light ground now begin to merge into a darker background, sometimes via a "quivering transition." Paintings reveal a population explosion, with a marked increase in the number of figures depicted and an increase in their velocity. "Saints no longer float in the air," art historian Heinrich Wölfflin remarks, "but rise upwards in feverish haste." Christ now ascends to heaven as if propelled.

Brief mention should be made of baroque developments in other media. New forms of the novel, theater, and music were being developed during this period. Opera, a combination of theater and music, born around 1600 in Italy, is an eminently baroque art. Baroque music in general, however, is generally considered the classical style in music history, somewhat out of phase with the visual arts where baroque follows classical.

Baroque is also used as a generic term to signify a fundamental attitude or stage. In his study, *The Nude*, art historian Sir Kenneth Clark calls the female bottom a baroque form, for example. Others invoke baroque to mean a late stage in the life cycle of any civilization, "a sort of magnificent malady of old age," as French art critic Claude Roy puts it, "the apogee of decomposition." By this reasoning the Honduran city of Copán constitutes the baroque stage of Mayan civilization, and the temple illustrated on p. 132 the same stage of Hinduism in India.

In the Thames & Hudson series, see Germain Bazin's *Baroque and Rococo*. Victor-Louis Tapié's *The Age of Grandeur* is a somewhat more personal consideration of the period. Wölfflin's *Renaissance and Baroque* is a classic.

BAUHAUS

Bauhaus ("house of architecture") is one of those deeply serious German movements that command respect if not always complete comprehension. This was the case, at least, until Tom Wolfe's iconoclastic study of the movement undermined its intellectual pretensions, mocking it as a modern case of the emperor's new clothes.

A reaction against the overblown excesses of Wilhelminian Germany, Bauhaus arose in the first days after World War I as a movement seeking the unity of art, technology, and socialist ideology. "Let us create a new class of craftsmen, without the class dis-

Starkly modern housing (1928) in Dessau, Germany, a collective Bauhaus project first inhabited by worker-gurus (*Bauhaus Archive*)

tinctions which raise an arrogant barrier between craftsman and artist," the Bauhaus manifesto proposed. So far, this sounds like a more technologically oriented version of the English Arts and Crafts movement. In the Bauhaus schools and communes in Weimar and Dessau, early-model gurus in sandals and smocks taught carpentry, ceramics, printing, weaving, and architecture, which was considered the primary art.

The basic Bauhaus idea was to create housing for workers that would be functional, economical, above all "honest." Rejecting the pitched roof as bourgeois, Bauhaus put flat roofs at strict right angles to unornamented, colorless facades; floors and ceilings were concrete slab, walls were plasterboard, and floor plans followed a strict grid. Inside, rooms were small, halls were narrow, ceilings were low, and the purity of the design ("cool and clean") was not supposed to be disturbed by anything as prosaic as a curtain or a colorful cushion.

Needless to say, workers loathed the dark, boxy Bauhaus housing projects, the roofs always leaked, and the Bauhaus schools were closed by the Nazis in 1933. A serious architectural treatise of the Nazi era even suggested that flat roofs were a Bolshevist plot. But that is not the end of the story. Most of the Bauhaus leaders emigrated to the United States, where they had a major influence on the course of modern architecture. As Wolfe points out, Bauhaus contained the seeds of the so-called International Style. What is the modern high-rise but a vertical extension of the functional Bauhaus box in glass, steel, and concrete? (This in fact is what the Germans built in the United States: Walter Gropius, the founder of the Bauhaus, was responsible for the Pan Am building atop New York's Grand Central Terminal.) And if the truth be told, who really likes these sterile, impersonal monstrosities, these "high-rise hives?" The ultimate irony, again according to Wolfe, is that this jumped-up worker housing became the standard for luxury high-rise apartments and the corporate headquarters of the world's malefactors of great wealth.

For Bauhaus you really have to go back to the source, in Germany, where there are numerous modest examples left. These include a large number of movie theaters, as the cinema was enjoying its first great wave of popularity during the early twenties when the movement was most active. (The original Bauhaus school in Weimar was housed, ironically, in an art nouveau building.) The school in Dessau, designed by Gropius and recently renovated, looks "like an enormous spacecraft just arrived from a distant planet," according to a *New York Times* travel writer.

From Bauhaus to Our House by Tom Wolfe is a great read even if you do not agree. For a more objective viewpoint, see Frank Whitford's *Bauhaus* in the Thames & Hudson series.

BEAT GENERATION

They were vagabonds by choice, self-declared outlaws from the materialism and conformity, anonymity, and apathy of the Eisenhower era. They drank excessively, experimented with drugs, and cursed copiously. They read Schopenhauer and discussed Zen Buddhism. They wrote novels and poetry, great autobiographical torrents of free association without forethought and without revision, full of excrement, intoxication, and the mystique of male bonding. They called themselves the beat (meaning exhausted) generation, but they also had pretensions to beatitude. (Studies of the movement tend to similar titles: *Naked Angels, Desolate Angels, Holy Barbarians*.) They were also popularly known, by the "squares" whom they held in contempt, as "beatniks"—perhaps suggesting alien, subversive origins.

The four very different leaders of the beat movement met at New York's Columbia University in the late 1940s: Jack Kerouac, aspiring author of working-class French Canadian background; William Burroughs, Harvard-educated pederast and drug addict from the family that made a fortune in cash registers; Allen Ginsberg, homosexual, from a dysfunctional New Jersey Jewish home; and Neal Cassady, juvenile delinquent from Colorado, who seemed to catalyze his friends' dreams.

The prime literary monuments left by the beats are Ginsberg's poem "Howl," his 1955 reading of which in San Francisco was a major beat happening; Kerouac's rambling novel *On the Road* (1957), celebrating travel as liberation and narcosis; and Burroughs's *Naked Lunch* (1959), a highly scatological and disconnected novel of drug addiction. Art unmediated by intellect, cultural historian Theodore Roszak calls this literature, comparing it to jazz improvisation.

Beat literature has aged badly, appearing to later generations as sloppy, self-indulgent, "ultimately boring and trivial" in the words of literary historian Marcus Cunliffe. (Cunliffe believes the beats had a greater influence on American slang than on American literature.) Literary scholar Leslie Fiedler dismisses beat writings as "bohemian-kitsch," a celebration of the "Good Bad Boy" ethic except that the beats mistook Tom Sawyer for Huck Finn. Journalist Norman Podhoretz called them "Know-Nothing Bohemians," ignorant of history and culture. Placing them in the general tradition of American anti-intellectualism, historian Richard Hofstadter described them as conformists to alienation.

It is primarily as cult celebrities that the beats survive in our consciousness, if at all. Kerouac drank himself into an early grave, but Ginsberg was reincarnated as an omchanting hippie guru in the 1960s. Cassady also reappeared on the psychedelic scene, before dying of a drug overdose in Mexico, while Burroughs survived decades of self-destruction by drugs to find a new role as a performance artist in the 1970s.

John Tytell's *Naked Angels: The Lives and Literature of the Beat Generation* is highly sympathetic to the beats.

BEAUX ARTS

So many leading American architects studied at the Ecole des Beaux-Arts in Paris at the end of the last century (Richard M. Hunt, Charles McKim, H.H. Richardson, Louis Sullivan, Bernard Maybeck, Julia Morgan—a total of about 500 before the school fell victim to the 1968 student revolution) that the Renaissance revival styles they learned and reproduced in the United States became known here as Beaux Arts style. The Europeans have no such designation; in France, this grand late 19th-century style of architecture, the most splendid example of which may be the old Paris Opera, is called Second Empire (pronounced *se-gond om-peer*); in Germany, historicism.

Beaux Arts is a synthesis of classical styles from Roman to Renaissance, with a dash of baroque. Experts call it a technique rather than a style, based on the rigid curriculum, method of instruction, and design principles taught at the world's premier school of architecture. Prizes were given for skilled draftsmanship, although most of the prize-winning drawings were never constructed. Above all the school taught a common vocabulary of design, thanks to which the large new American architectural firms could execute Gilded Age commissions on an assembly-line basis.

American Beaux Arts is essentially neoclassical, with lots of columns, arches, domes, rotundas, sometimes mansard roofs, always grandiose inside and out. It was well suited to such buildings as state capitols and museums. There are also many Beaux Arts railroad stations (the world over, for this was the era of railroad building), such as New York's Grand Central with its triumphal arches and concourse copied from the Roman Baths of Caracalla. Many American libraries were built in this style, from the New York Public Library at 42nd Street, where actually opening a book is an event, to the smaller Carnegie libraries all over the country. Finally, Beaux Arts was eminently suited to palatial mansions for the rich and socially pretentious.

Expensive and usually very inefficient in its use of space, Beaux Arts remained the style of conservative choice for large American commissions until the Depression, when its aura of wealth, power, and bravura was clearly out of tune with the time. Nonetheless, occasionally a building in this grandiose style crops up.

Beaux Arts was also represented in sculpture, monumental and classically idealized, typically serving as an adjunct to architecture. The two leading American sculptors in this school were Augustus Saint-Gaudens and Daniel Chester French.

New York's Museum of Modern Art published a handsome collection of Beaux Arts drawings in 1977 entitled *The Architecture of the Ecole des Beaux-Arts* (Arthur Drexler, ed.).

BELLE EPOQUE

The decade before World War I, which in English style and period goes by the name Edwardian, is known in France as *la belle Epoque*. In France as in England this was a superficially glamorous and glittering time, with ostentation and luxury only thinly masking growing political and socioeconomic unrest. In the arts, art nouveau still held sway, while architecture was dominated by neo-baroque. A particular center of Belle Epoque architecture was the French Riviera, which acquired a rash of new hotels and villas, a casino, and an opera house, all constructed in the grandest manner with sweeping stair-

cases, chandeliers, marble, and gilt. (As a friend of Princess Grace once remarked, "If you haven't seen Vegas, [Monte Carlo] looks good. But if you have, it's rather like Forest Lawn on a rainy night.")

BIEDERMEIER

Biedermeier is another of those grab-bag period-styles, encompassing all arts and crafts in Germany and Austria during the period 1815–48. This was preeminently a bourgeois era, a relatively quiet time between the Napoleonic upheavals and the revolutions of 1848, when the rising middle classes of Central Europe were cultivating a rather Victorian-style domesticity. And like the Victorian era, the Biedermeier tended to philistinism, Babbitry, and sentimental nostalgia.

Roughly translated, Biedermeier means "simple Smith," but manifestations of the style were simple only by comparison to the Empire style which preceded it. In furniture, for example, the most frequently encountered Biedermeier medium today, sofas and chairs are highly contorted and fanciful in form, cubic or curvilinear, and elaborately worked in rich, light fruit woods. Pieces in this style are currently very "in" in the United States, commanding top prices at auction.

The Biedermeier grab bag also includes, according to a 1989 museum exhibit in Munich, silver, glass, jewelry, fashion, even embroidered bell-pulls to call the servants. In art, this was the romantic era, and it is nearly impossible to differentiate romantic from Biedermeier paintings except perhaps by reference to subject matter. The landscapes tend to be called romantic, while genre paintings, cozy little domestic scenes, readily suggest Biedermeier.

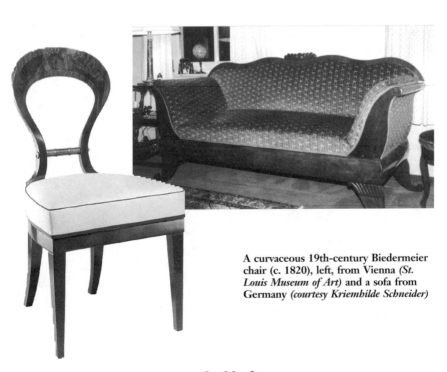

A curvaceous 19th-century Biedermeier chair (c. 1820), left, from Vienna (*St. Louis Museum of Art*) and a sofa from Germany (*courtesy Kriemhilde Schneider*)

Biedermeier fashion is most familiar from the engraved plates of *Godey's Lady's Book*: long hooped skirts, puffed bodices, precious little bonnets, and—don't forget—white gloves. Biedermeier literature is also a subgenre of romantic, typified by sentimental women's novels and tragedies of fate; its authors (the Austrian dramatist, Franz Grillparzer, or the German poet, Eduard Mörike) are not well known outside Central Europe. But in the domain of music, Biedermeier may ring a bell. Although generally classified as romantic, the lieder, piano, and chamber compositions of Franz Schubert, small in scale and highly domestic in feeling, are considered typical of the Biedermeier spirit.

Called "Louis Philippe" in France, the French version is readily identifiable as Biedermeier. (In Henri Rousseau's 1910 painting, *The Dream*, now in New York's Museum of Modern Art, a nude woman lies asleep on a Louis Philippe sofa in the midst of a tropical forest primeval, her curves reprised in the shape of the sofa.) There is even a German American Biedermeier, furniture faithfully and skillfully re-created by Germans who left their fatherland in the 1840s to settle in Texas.

Angus Wilkie's *Biedermeier* is a rich, expensive coffee-table book that your friends will covet.

THE BLUE RIDER

Explaining the name—*Der Blaue Reiter*—of this second phase of German expressionism, formed in Munich in 1910, Russian émigré artist Wassily Kandinsky said, "Franz Marc loved horses, and I loved riders, and we both loved blue. It was as simple as that." Developing the group's more philosophical focus, Kandinsky's essay "Concerning the Spiritual in Art" is still considered important, as are his efforts to create nonrepresentational or abstract art. (Kandinsky's early, intensely romantic representational work was dismissed by later expressionist Max Beckmann as "Siberian-Bavarian shrine posters.")

The Blue Rider group was more subtle, more oriented to the naive and exotic, and

Franz Marc's *The Large Blue Horses* (1911) *(Walker Art Center)*

more varied in membership than its predecessor movement, the Bridge. There was Marc, whose blue horses, green cows, and yellow deer symbolize a return to the animal in life; the para-surrealist Paul Klee, painting hieroglyphic messages from the subconscious; and Alexei Jawlensky, another Russian whose lurid colors and forms put him more in the expressionist mainstream.

In 1912 the Blue Rider published its influential *Almanac*, a collection of articles and illustrations in various idioms (including one article by serial composer Arnold Schoenberg). They held their last joint exhibit in 1913 before being scattered by World War I, in which Marc was killed. After the war, Kandinsky, Klee, and the German American Lyonel Feininger all joined the Bauhaus movement, also participating (with Jawlensky) in a 1924 exhibit, *The Blue Four*.

BOHEMIAN

During the Reformation, when gypsies with their colorful, unconventional ways first arrived in France, they were popularly mistaken for Protestant refugees from Bohemia and were called Bohemians. Although they were officially treated as undesirables and not allowed to enter Paris, somehow their mistaken identification as bohemians acquired the positive connotation of footloose and fancy-free. Gradually the concept of a "vie bohème" emerged, attracting struggling young artists and writers seeking freedom from convention. This lifestyle of poor, struggling artists is romanticized in one of the most popular operas of all time, Puccini's *La Bohème* (1896). In reality, the bohemian counterculture became an end in itself for some; others tended to drop out when their creative efforts proved unfruitful; still others, when successful, sold out.

The cliché of the struggling bohemian artist had great appeal in late 19th-century America, with each successive would-be counterculture becoming so chic that it ended up losing its boundaries and being swamped by the mainstream. In fact, Americans, with their greater freedom from convention and their historic lack of roots, may not have really understood what bohemianism was supposed to be all about. Bret Harte's two books about bohemianism in early California reflect a confusion of pioneer color, bustle, and hardship with the supposed gypsy life of artists. What San Francisco was proud to call its Bohemian Club was actually sort of an elite Rotary Club, its "high jinks" encouraged by alcohol. By the 1890s bohemianism had become such a fad that the conservative dean of American letters, William Dean Howells, felt obliged to satirize the subject in his *Seacoast of Bohemia* (1893).

If we ever had a domestic equivalent of Paris's Left Bank and Montmartre, it was probably New York's Greenwich Village before the First World War. But by the 1920s the Village had become a chic playground full of affluent slummers, Albert Parry reports. The bohemian scene then adjourned to Paris, but the Depression and the Second World War brought the curtain down on that so-called lost generation. In the 1950s the beat generation cultivated a bohemia of the open road, but as Richard Hofstadter points out in *Anti-Intellectualism in American Life*, the beats tended to dissipate their energies in self-indulgence and ultimately achieved a "conformity of alienation." The hippie movement of the 1960s promised to all dropouts the freedom bohemianism had once reserved for artists, but it acquired what culture maven Tom Wolfe calls "radical chic" and merged into the mainstream. Working American artists, in any case, tend to stake out their territory in a more exclusive neighborhood called the avant-garde.

Albert Parry's *Garrets and Pretenders: A History of Bohemianism in America* is clearly dated. The American bohemians he describes have been forgotten today except Edgar Allan Poe (whose bohemianism, Parry writes, was propelled partly by alcohol and insanity and partly by the "desire to escape from the painful reality of an uncertain social position"). For a contemporary fix on the subject, see Herbert Gold's *Bohemia: Where Art, Angst, Love, and Strong Coffee Meet*. As described by Gold, bohemians typically imitate the class below rather than the class above them.

THE BRIDGE

The Bridge—*Die Brücke*—is the first phase of German expressionism, a group that formed in Dresden in 1905 (at the same time fauvism was being launched in France). The main members of the Dresden group were Emil Nolde, Ernst Kirchner, Max Pechstein, Erich Heckel, and Karl Schmidt-Rottluff, who joined together to mount exhibits and to issue an annual portfolio (a very valuable collector's item today). Three of the five had studied architecture, which may have something to do with their choice of a name. The name also conveys the sense of a passage to the future.

The chief influences on the Bridge were the older Norwegian artist Edvard Munch, whose painting *The Scream* (1893) may be the central image of expressionism (see p. 89), and Vincent van Gogh, whose emotional dissonance and high-key color were much admired. Other influences were German medieval woodcuts and primitive art from Africa and the Pacific. (In his study of German expressionism Bernard Myers remarks that the French fauves were interested in primitive art forms, while their German contemporaries were fascinated by the primitive "spirit.")

The Bridge group produced dramatic landscapes and nudes and tortured religious and mystical pictures, all characterized by anguish, loneliness, and violent emotion. They also tried to make a political statement, calling their work "art for the people"—meaning primarily the underprivileged. The group dissolved in 1913 and its members drifted into the expressionist mainstream.

BRONZE AGE

The great advantage of bronze, which is created by smelting copper and tin, is that it can be poured and cast into shapes impossible to achieve with stone. The process is also quicker, and the results more durable. The Bronze Age, which followed the Neolithic or New Stone Age around 3500 B.C., therefore constitutes a considerable advance in the making of tools.

The ability to make bronze depended on the new charcoal-fed forced-draft furnace capable of achieving higher temperatures. This furnace also enabled artisans to fire better pottery and cooks to bake more bread. Another new invention increasing Bronze Age prosperity and creativity was the wheel, probably first used in making pottery and only later for transportation.

These new developments coincided with increasing urbanization and new forms of authority, including kingdoms, empires, and despotisms. One explanation for the rise of powerful central government is the need to regulate irrigation, for the great Bronze Age civilizations arose in the world's river valleys—the Nile, the Tigris-Euphrates, the Yangtze (the finest bronze-casting ever was in China during the Shang dynasty). The chief pro-

ponent of this "hydraulic" theory of history is German scholar Karl Wittfogel. In his classic work, *Oriental Despotism*, Wittfogel wrote that writing, counting, geometry, and astronomy arose because the new despots needed to keep records, regulate irrigation, and predict flooding. Wheeled vehicles, at the same time, facilitated transportation, communications, and conquest of ever more territory.

Others characterize the Bronze Age as a time of war, when man's inhumanity to man was facilitated by better weapons of destruction. In this vein, historian Lewis Mumford describes the Bronze Age as a time of hatred, obsession, suspicion, genocide, and fantasies of absolute power, rather than a period of progress.

Culturally, thanks to Bronze Age specialization of labor, a new class of artisans was freed from basic survival needs to create useful and decorative objects, from swords and helmets to statues, bas-reliefs, and jewelry. In architecture the Bronze Age tended to the monumental, like the pyramids of Egypt. Of the great pre-Columbian civilizations in the New World, only the Inca mastered the manufacture of bronze. Their massive stone constructions are sometimes called megalithic, as are the Mycenaean castles of ancient Greece and other Bronze Age constructions.

The Bronze Age ended around the first millennium B.C. with the introduction of iron. Used for many centuries chiefly for weapons and ornaments, iron did not become really useful until the industrial revolution. The ancient Egyptians had some iron, but it was of peripheral signifi-

The world's finest bronzes, such as this ritual vessel (type *feng-lei*), come from Shang China (Nelson-Atkins Museum of Art)

cance. (In West Africa, Honour and Fleming note, iron actually preceded bronze.) As Wittfogel points out, no great hydraulic (Bronze Age) civilization ever evolved spontaneously into an industrial society; the Mesopotamians even slipped backward when their tin deposits ran out. Rather, others would pick up where they left off.

For a good description of Bronze Age society, read the epics of Homer, the *Iliad* and the *Odyssey*. Gordon Childe's *What Happened in History* puts the Bronze Age in historical perspective. In his *Bronze Age America*, Barry Fell argues that a Scandinavian king traveled to North America to trade with the Indians during the Bronze Age.

BRUTALISM

Derived from the French *beton brut*, or unfinished concrete, brutalism (sometimes called new brutalism) began as a post–World War II British reaction to the purist tyranny of the International Style. Just as Jean Dubuffet's contemporaneous art brut is anti-art, brutalism is anti-architecture, or perhaps it represents the proletarianization of architecture. Given the major post-war job of reconstruction, limited material resources, and diminishing confidence in the future of the British Empire, the brutalists made a virtue of crude concrete construction with structural elements and innards exposed. (Le Corbusier's rough concrete constructions were a major influence, although his aesthetic was quite different.)

Boston City Hall (Kallman, McKinnell & Wood, 1968) rates as an American version of British brutalism *(National Trust)*

Heavy and monumental, brutalist architecture may be deliberately ugly. While the architects were talking about social justice, the tenants were complaining about gloomy bunkers. Some American examples include Boston City Hall and the Yale School of Architecture, the latter designed by Paul Rudolph, at that time dean of the school. The movement was neither very successful nor long-lived, but some of its ideas would enter the basic modern vocabulary. The Pompidou Center in Paris, arising out of a 1962 architectural competition, is a prime example of a (late-modern, according to architecture critics) structure wearing its innards on the outside.

Reyner Banham's *The New Brutalism* is the standard (and almost the only) work on the subject, by a staunch sympathizer.

BUDDHISM

An Indian prince who lived around 500 B.C., Siddhartha Gautama, later called the Buddha or Enlightened One, created a system of ethics responsive to fundamental human spiritual needs. Suffering arises through desire and delusion, the Buddha taught, and freedom from suffering comes through renunciation of desire and delusion. This is achieved by meditation, culminating in a state of enlightenment or immediate experience of truth, called nirvana.

Buddhism had no lasting importance in India, possibly because it rejected the Hindu concepts of caste and reincarnation, but in one of history's great missionary movements—actually, a great experiment in cultural transmission—the teachings of the Buddha were carried to the far corners of the East, from Ceylon to China and Japan, Southeast

Asia, and Indonesia. In China in particular, Indian scholars or intellectual go-betweens labored for generations to translate abstract Buddhist concepts and practices into images and analogies that could be more easily understood. (For example, Indian imagery proved too flowery for the practical Chinese, who also found it more natural to move around than to maintain the traditional Indian seated position for meditation.)

In the process of transmission, Buddhism split into two major and some minor branches. These include the Hinayana or Little Vehicle movement practiced in Ceylon, Burma and Thailand, where the emphasis is on Buddha as a teacher of ethical living; and the Mahayana or Great Vehicle version popular in China, a far more elaborate religion with a deified Buddha and heavenly hierarchy. Yet another version evolved in Tibet, the world's only Buddhist theocracy, where the Dalai Lama ruled over an enormous population of monks until forced into exile by the Chinese Communists in 1959.

Early Buddhists worshipped in cave-temples and built stupas or hemispherical mounds to enclose their religious relics. Some Buddhist sanctuaries had barrel-vaulted halls and a stupa on the end. Buddhist art is primarily sculpture that relates to the

The exquisite bodhisattva Kuan-yin, fashioned in polychromed wood in China between the 11th and 12th centuries (*Nelson-Atkins Museum of Art*)

Buddha himself. In the early history of the movement, the founder was represented only by symbols: the Bodhi tree, symbolizing enlightenment; footprints; an empty throne. The earliest statues of the Buddha in human form are found in northern India. They date to the second century A.D. and are a mixture of local and classical Greek (the region had been conquered by Alexander the Great) sculptural conventions.

From Mahayana areas where he was worshipped as a god we have many, sometimes monumental, statues of the Buddha (one in Afghanistan measures 175 feet). These are strictly conventionalized down to the last detail, such as clockwise curling hair. Whether seated, standing, or recumbent, the Buddha is always portrayed with classical serenity, radiating peace, his eyes downcast as if looking inward; he is usually shown wearing a monk's robe, its parallel folds "like a river of wavy curves"; and he has up to 32 magic marks, including prolonged earlobes, a circle between the eyes, and a cranial protuberance. Of his repertoire of *mudras* or hand gestures, the one with the open palm may be borrowed from statues of Roman emperors or Christian inconography (see opposite), while the teaching mudra, with the Buddha counting off on his fingers, will be comprehensible to students everywhere.

In the Buddhist pantheon, bodhisattvas are potential Buddhas, saints who renounce nirvana for the sake of humanity. They are depicted as Indian princes, worldly and gracious figures richly dressed and bejeweled (often so relaxed, according to one critic, that they look like dancing girls). Of indeterminate sex, rather inclining to the feminine, bodhisattvas represent virtues such as compassion or wisdom. The Nelson-Atkins Museum in Kansas City has an exquisite statue of the bodhisattva Kuan-yin (sometimes called "Kwannon"), shown on p. 35.

An important branch of Buddhism called Zen came from India to China at the end of the fifth century A.D. Called Ch'an in Chinese, from the Sanskrit for meditation, Zen Buddhism became widespread in China between the 10th and the 12th centuries, but it would have its greatest influence in Japan. Rejecting scholarship and good works, Zen seeks spontaneity, sudden insight, and sophisticated simplicity. Instead of sculptures of the Buddha, the great Zen medium is ink painting, charming landscapes, and portraits created by a few bold, expressive strokes of the brush—"an inspired shorthand." Other Zen forms include the haiku, or 17-syllable poem, and the koan or riddle ("what is the sound of one hand clapping?"). Zen, which peaked in popularity in Japan during the 15th century, pervades modern Japanese arts and crafts, according to scholar Hugo Munsterberg. (Another interpretation of Zen comes from Arthur Koestler, who calls it psychotherapy for a rigid, shame-ridden society.)

Buddhism reached the United States via two priests who arrived in San Francisco in 1898. By 1970 there were 100,000 American Buddhists, most of them on the West Coast. (This number includes two basically different groups: Asian immigrants and their descendants, and non-Asian converts forming small groups for discussion and meditation.) During the beat and hippie generations, Zen Buddhism was popular in the counterculture. An American bestseller called *Zen and the Art of Motorcycle Maintenance* told of writer Robert Pirsig's voyage of personal discovery.

Thames & Hudson recently published *The World of Buddhism* (Heinz Bechert and Richard Gombrich, eds.). The chief western interpreter of Zen is Alan Watts, one of whose books is *The Way of Zen*. Hugo Munsterberg's *Zen and Oriental Art* is a good, short introduction.

An 11th-century mosaic from Hagia Sofia in Istanbul called the *Zoe Panel*. Christ Pantocrator sits between Empress Zoe and her third husband, Constantine Monomachos

BYZANTINE

"How very Byzantine!" This expression usually describes a complicated deal or scenario involving devious or somehow suspicious means. The cultural referent here is the Byzantine Empire, the eastern Roman Empire based in Constantinople (now Istanbul), which survived by its wits for over a thousand years (A.D. 330–1453) as a small Christian enclave in a sea of Turks.

Because the emperor was elected, the position tended to be a hotbed of intrigue, corruption, flattery, duplicity, and threats. The history of the empire, a scholar writes, is an intricate tapestry of intrigue, conspiracy, betrayal, murder, and fratricide. Some remarkable empresses, chosen for their beauty and their sexual and diplomatic skills, ruled side by side with their husbands. Eyewitnesses describe these imperial couples presiding over sumptuous banquets and elaborate ceremonies, seated on mechanically operated thrones designed to give the illusion of levitation, enveloped in clouds of incense and cloth of gold before their prostrate subjects.

Such means served to intimidate potential rivals, for election was no guarantee of remaining in power. There were 65 coups d'état and 65 dethronements during the history of the empire, and an emperor was as likely to die as a result of poisoning, decapitation, or being buried alive as of natural causes.

When Byzantium fell to the Ottoman Turks in 1453, its main cultural legatees

were Russia and the Balkans, which inherited from Constantinople the Orthodox Christian religion and the Cyrillic alphabet. The chief Byzantine legacy to Western Europe was Roman law, which reached the West in the version codified by the emperor Justinian in the sixth century.

Byzantine art is a melding of classical, Roman, and Oriental traditions. The portraiture of the era, whether political or religious, features stiff figures and groups in frontal pose, hieratically stylized. The church having become rich and powerful, Jesus is portrayed as Christ Pantocrator, or ruler, and his disciples as dignitaries. In A.D. 431 Mary was elevated by the church to the official position of mother of God and was represented in several conventional manners: as the compassionate Mary, as the maternal Mary, and as the crowned queen. The most typical Byzantine art form is the icon, a painted or carved image of a holy figure, created for worship by the faithful. (Opponents of icons, known as iconoclasts, claimed that these "graven" images led to idolatry.)

The Byzantines were also skilled at mosaic work, some outstanding examples of which survive in Ravenna, Italy, and at metalwork, ivory carving, textile arts, and illustrated manuscripts. Byzantine art treasures are now scattered all over Europe, carried home as booty by the crusaders who pillaged Constantinople in the 13th century. (In the United States the Dumbarton Oaks Museum in Washington, D.C., takes pride in its Byzantine collection.) In architecture the great Byzantine church of Hagia Sofia survived in Istanbul (first as a mosque, now a museum). It is remarkable for its dome set on a square, as if it were floating in space, and for the contrast between its rather plain exterior and sumptuous interior, a quintessentially Byzantine dichotomy.

Another Byzantine survival in modern Istanbul is readily apparent to the average tourist rambling through the bazaars: the shopping. As historian Mark Girouard writes in *Cities and People*, "Byzantine Constantinople at its prime was the biggest luxury shopping centre in the world."

Art of the Byzantine Era by David T. Rice is available in the Thames & Hudson series. See also Steven Runciman's *Byzantine Civilization*.

Civilization exists by geological consent, subject to change without notice.

Will Durant, What Is Civilization?

CALVINISM

Calvinism is militant Protestantism, very Old Testament, righteous, and authoritarian in its subordination of civil as well as religious matters to the law as set down in the Bible. To the French lawyer-theologian John Calvin, God was inscrutable, omniscient, arbitrary, and angry, arousing fear rather than love, favoring justice over mercy. Man, for his part, was considered basically sinful. According to the rigid Calvinist doctrine of predestination, an elect few were to be saved, and to hell, literally, with the unregenerate multitudes, who had no influence or control over their fate.

Calvin (called "the lawgiver of Protestantism" by psychohistorian Erik Erikson) launched his radical program of religious reform in Geneva, Switzerland, turning the city into a "Protestant Sparta," a dogmatic, disputatious, and intolerant church-state (in their study of *The Western Intellectual Tradition*, Mazlish and Bronowski even call it totalitarian) in which dissenters were burned. After Geneva, the second most fertile ground for Calvinism, as a religious mind-set rather than a church itself, was Puritan New England. It was in the harsh, elitist, illiberal, and relentlessly righteous spirit of John Calvin that the Massachusetts Bay Colony persecuted and banished dissenters and sought to legislate private morality, harshly punishing all deviation from conformity.

On the level of aesthetics, Calvinism divorces art from religion, resulting in a practical ban on decoration of churches and the suppression of church choirs and instru-

mental music (only unaccompanied psalms were allowed). As to general intellectual climate, Calvinism was inimical to free inquiry, but curiously enough it (and other strains of Protestantism) proved conducive to economic enterprise, marshalling great practical and religious energies. In its encouragement of thrift, sobriety, and hard work, it appeared an ideal religion for the enterprising, tending to favor wealth but to discourage luxury. The accumulation of wealth even became identified with good works.

"Logically," as historian Henry Steele Commager put it, Americans "should have abandoned a religion which, in flagrant contradiction to all experience, taught the depravity of man and the corruption of society and subordinated this life to the next." But the grip of Calvinism on the American mind was only gradually relaxed in the course of the 19th century, having taken a heavy toll on the colonial generations. Even in hedonistic modern America, largely indifferent to doctrine, you get a whiff every so often of our Calvinistic heritage—as humorist H. L. Mencken once wrote, "the haunting fear that somewhere someone may be happy."

CAMP

The Eisenhower era produced such a flood of kitsch in the United States that social commentators felt the need for another stylistic category to designate deliberate kitsch for sophisticates. "Camp," the concept proposed in *Partisan Review* in 1964 by Susan Sontag, a writer with pretensions to high seriousness, seems to have done the job. Sontag's best example of camp is Anita Ekberg's performance in *La Dolce Vita* (1960), a superbly vulgar parody. The concept even became a verb, with Ekberg said to be "camping" (similar to, and of course rhyming with, vamping) it up. Camp typically involves exaggerated masculinity and femininity (other camp stars were Mae West, Victor Mature, and Jayne Mansfield), appealing particularly to homosexuals, according to Sontag.

Actress Anita Ekberg "camping it up" *(Academy of Motion Picture Arts and Sciences)*

Other examples of camp cited by Sontag do not seem so inspired: Tiffany lamps, the *National Enquirer* tabloid, Bellini operas. Fortunately we had the concept in place just in time for the pop art movement, which specialized in turning kitsch into camp.

Sontag's "Notes on Camp" is reprinted in her *Against Interpretation*.

CAROLINGIAN

The reign of Charlemagne (768–814) generally ranks in history as a bright, shining era akin to Camelot. King of the Franks, a Germanic tribe who in this version become a

Tho umbi thana neriendon krist nahor gengun sulike gesidos
so he im selbo gecos uualdand undar them uuerode · frodun uuisa
man gumon umbi thana godes sunu · gerno suudo uueros an uuil
leon · uuas im thero uuordo niut · thahtun ondithagodun huuat
im theforo thiodo drohtan uueldi uualdand selb uuordan cudien
thefum liudiun telobe · Than sat im the lander hirdi gegnuuard
for them gumun godes eganbarn uueldi mid is spracun spah

An example of the distinctive Carolingian cursive script, called "minuscule"

new chosen people, Charlemagne (you will recall) crowned himself Holy Roman Emperor in the presence of the Pope in the year A.D. 800. The Frankish state, stretching at its maximum from northern Spain to the North Sea, and from the Atlantic to the Danube and the Elbe, was the first successor to emerge from the collapse of the Roman Empire. It also marked a shift in Europe's political and cultural gravity from the Mediterranean to the continental heartland.

By all accounts (and we have a contemporary biographer, Einhard, who knew him well), Charlemagne was a larger-than-life personality. On the one hand he was passionate, cruel, opportunistic; on the other, magnanimous, vigorous, eager to learn, and above all, possessed of the ability to motivate others. Perhaps the most memorable image of Charlemagne, that from the *Chanson de Roland*, is pure fiction: written three centuries after his death, it casts him as a hero of chivalry, a strong man who dared to weep for his fallen knights.

Charlemagne's much-vaunted thirst for learning (he finally learned to read but not to write) had a significant effect on the sum total of world knowledge, for he set scholars and scribes to collecting and copying rare ancient manuscripts. Many of these survive only in beautifully lettered (we call this lower-case script "carolingian") and illuminated manuscripts, the chief product of an early medieval renaissance. Considered Christendom's finest goldsmiths, the Carolingians also bound these manuscripts in golden bejeweled covers, such as the Lindau Gospel at the Morgan Library in New York.

Charlemagne built colonnaded palaces in the manner of the Roman and Byzantine emperors. These have not survived, but from his palace at Aachen (Aix-la-Chapelle) we still have an octagonal chapel modeled after Ravenna's San Vitale. (A memorial panel there shows a scene from the *Chanson de Roland*, the weeping emperor.) From the few surviving Carolingian remains, we can trace the Roman and Byzantine heritage that soon gave rise to the Romanesque.

On the down side, Charlemagne (who is called Karl der Grosse by the Germans) established the "Holy Roman Empire of the Germans," the First Reich, which would later inspire nostalgic national chauvinists like Bismarck and Hitler to emulate it. Like its successors, the First Reich was forged by the sword in 30 years of incessant warfare (since ennobled as wars of religion, with Charlemagne as the standard-bearer of the Pope). And in fact, the First Reich disintegrated within a few generations. Beset by bar-

barian tribes, it was divided by Charlemagne's grandsons into three more manageable parts. The westernmost of these would become France, the easternmost Germany, and the middle, Alsace-Lorraine, a persistent bone of contention.

So hazy were the boundaries of the First Reich, a patchwork of sovereignty, suzerainty, and lordship, that it has been called a historical fiction. Yet so strong is this myth of Camelot that the premier modern prize for furthering European unity, awarded annually in Aachen, is named for "Charles the Great."

The Age of Charlemagne, by Donald Bullough, is a coffee-table picture book that proves to be a surprisingly good read.

CARTESIAN

Cartesianism is one of those intellectual constructs that has a certain cachet and, often, a false currency. "I am a Cartesian," a French interior decorator was quoted as saying in a recent issue of a tony decorating magazine, illustrated by photos of her "Cartesian collage." On a slightly more sophisticated level, the surrealists blamed Cartesianism for paralyzing Occidental thought, while minimalists admired the Cartesian view of "consciousness as pure self-awareness."

So what do we make of this mixture of consciousness, mental paralysis, and collage? René Descartes was a Frenchman and a Renaissance man, a philosopher and a polymath. It was Descartes who wrote "cogito ergo sum"—I think therefore I am—exalting man's rationality. His most important work, the source of current usage and confusion, was the introduction to a book on meteors and geometry, later published separately as the *Discourse on Method*.

The Cartesian (adjectival form of Descartes) method, which became a fundamental of French educational philosophy, the basic French intellectual stance, and the national sacred cow, is to doubt everything. Cartesian is synonymous with a highly developed critical faculty and the clarity of skepticism. In Cartesian logic, in fact, the method is more important than the results achieved, which are sometimes little more than "elegant nonsense." In the real world, intellectual historians Bronowski and Mazlish write, Cartesianism "has given a great deal of vitality to French life. It has also led to much trouble in forming stable governments, founding taxation systems to which the people would pay attention, and arranging other such mundane affairs of life."

In writing his famous study *Democracy in America* in 1835, the French observer Alexis de Tocqueville found Americans with their self-reliance to have created "one of the countries where the precepts of Descartes are least studied, and...best applied."

CAUCASIAN RUGS

As a racial designation, "Caucasian" is literally as well as politically incorrect. It was a German anthropologist who first decided to call all persons of white complexion "Caucasian," based on the erroneous assumption that the Caucasus was the original Indo-European homeland. This area between the Black and Caspian seas is, in fact, the historical home of diverse ethnic groups who weave brightly colored, geometric-patterned rugs known in the trade (correctly) as "Caucasians." One of the better-known of these rugs is the Daghestan (meaning "mountainland," from the northernmost of the Caucasian

rug-weaving districts), a predominantly red and blue rug in bold repeating patterns. Currently very popular are Kazak rugs (from the Caucasus; the area called Kazakhstan is farther east and specializes in felt rather than woven rugs), despite their relatively coarse weave, long pile, and synthetic dyes. Typical Kazak motifs look like eagles, sunbursts, clouds, and serpents. Probably the most celebrated of the Caucasians is the Shirvan, produced near the border with Persia whence it has adapted curvilinear motifs mixed with the more typical geometric ones, resulting in bold, brilliant designs. Thanks to the Persian influence, the Shirvan is considered the most "refined" of the Caucasians. Finally, there is the Soumak, more a type of weave (a pileless flat weave, made by a process called weft-wrapping, with loose ends on the back side) than a different design.

During the Soviet period, the Caucasus was divided between separate republics of Georgia, Azerbaijan, Armenia, Daghestan, and others. Except perhaps for the Turkoman nomads producing Kazak rugs, who were organized into collectives with red tents as headquarters, production of Caucasian rugs declined under Communist control. Many of the Caucasians on the market today are older, resales by estates or private collections. There are also many fine Daghestan rugs, for example, in museums. (Modern copies are produced across the border in Iran, particularly of the Shirvan rug.) Now with the different ethnic groups of the Caucasus jockeying for position in the wake of the breakup of the Soviet empire, production is unlikely to improve in the immediate future.

See Peter F. Stone's *Rugs of the Caucasus: Structure and Design.*

CELTIC

If you cannot remember whether to pronounce this with a hard or a soft *c* (a particular problem for basketball fans; Latin students and followers of Asterix, the comic book Celt, will do better), here is a clue. The Greeks called them *keltoi*, these barbarians who spread across Europe from Spain to Asia Minor. Peaking in the fifth and fourth centuries B.C., they succeeded in sacking Rome in 387. Finally Julius Caesar, who wrote about them at length (his Galli, or Gauls, were Celts), defeated them and started the process of their Romanization or decline (depending on your point of view).

The Celts are currently popular among archeologists, who study their tools, their place-names (many of which survive in Europe), their burial customs (warriors were interred with their chariots), their agricultural economy. Based on the piecing together of such bits of information, the Celts have been called "the first Europeans," primarily because they were dispersed so widely throughout Europe. Their heritage is not entirely praiseworthy, for they were mercenaries and invaders whose access to iron and skill in working it resulted in more deadly weapons of aggression. (The word *vassal*, as medieval historian Norman Cantor points out, is from the Celtic for "boy"—as in "the boys," or gangs of thugs.)

We generally prefer to remember the Celts for their artistic skills, for artifacts (like the grail, a Celtic vessel of plenty) which speak to us of a mystical magical world. Celtic motifs are abstract and geometric, typical for migratory barbarians, with tangled spirals, S curves and tendrils adorning swords and horse trappings, the neck rings worn by their warriors, ornate bronze brooches, and other fanciful decorative objects. These show a remarkable uniformity throughout Europe; pieces found as far afield as France

Ornate Celtic art with its swirls and spirals, curves and tendrils

and Romania are virtually identical. So popular has Celtic style become that American museum shops and catalogs now offer a range of gift items with trendy Celtic motifs.

The process of Romanization (which one might also call the process of civilization) was escaped only by those Celts beyond the fringes of the Roman Empire, chiefly the Irish. Only in Ireland did a Celtic (Gaelic) language and literature survive "uncontaminated" by Roman contact. This heroic oral tradition transmitted by tribal bards is considered the oldest vernacular literature in Europe after the Greek and Latin.

When the Irish converted to Christianity, their Celtic culture received a new impetus. As Christians the Irish also proved valiant warriors, missionizing the Swedes, Norwegians, and Germans. What we describe as Celtic is generally this Irish Catholic strain. Significant witnesses to the Celtic faith and heritage are their great sculptured stone crosses and illuminated gospels, both repeating and refining many of the same flourishes and swirls, the ornamental embellishment of birds, dragons, and other fantastic animals with which the pagan Celts adorned their arts and crafts. The single most famous Celtic creation is the *Book of Kells*, a 680-page illuminated gospel of elaborately designed and colored pages dominated by great ornate initial capitals.

Gaelic culture was among the richest in Europe until the English invasion in the 12th century, whereupon it went into decline. A 19th-century attempt to revive Gaelic as a source of Irish cultural identity faltered as a result of the hard facts of economic life; the Gaelic-speaking areas of western Ireland were the hardest hit by the great potato famine, resulting in massive emigration to the United States. (By "Celtic melancholy" is generally meant a kind of black Irish humor intensified by poverty and alcoholism.) The Irish renaissance was finally expressed primarily in English, thereby immeasurably enriching all of English literature.

Celtic Art from its Beginnings to the Book of Kells by Ruth and Vincent Megaw gives rather more detail than the general reader wants, while *The Celts* by T. G. E. Powell, in the same Thames & Hudson series, offers rather less. There is a handsome new picture book on the Celts by Barry Raftery, but the tome with the most cachet is that resulting from a highly acclaimed 1991 exhibit in Venice: *The Celts*, edited by Venceslas Kruta.

CHICAGO SCHOOL

Thanks to the accidental conjunction of two unrelated factors—technical advances in building technology, plus the Great Fire of 1873, which leveled half of its downtown area—Chicago became a laboratory of skyscraper design at the end of the 19th century. Architects just breaking away from the grip of the Beaux Arts style flocked to the city to try their hands at the new high-rise office building, a steel cage with curtain walls characterized by layered repetition of fenestration motifs. Chicago therefore has more than its share of fine early skyscrapers, from H. H. Richardson's Marshall Field Warehouse (1885–87), depicted on p. 237, to John W. Root's Monadnock Building (1889–92) and Louis Sullivan's Carson Pirie Scott department store (1899–1904). In *Cities and People*, Mark Girouard points out that the no-frills style was at least in part dictated by economics, with rents only a quarter of those obtained in New York City.

Sullivan, although he tended to exotic ornamentation and expression (he welcomed the skyscraper as "a proud and soaring thing, rising in sheer exultation"), is probably the most outstanding member of the group. Also sometimes included is Sullivan's former assistant Frank Lloyd Wright, who started his career in Chicago, although Wright would go on to develop an architectural grammar applicable anywhere, to everything from homes and churches to office buildings. (As if to return the favor, Sullivan and other Chicago school architects are sometimes also counted as members of Wright's "Prairie school," which put the emphasis on horizontality rather than on high-rise verticality.)

The Chicago style is best appreciated when you see it in another city, such as Washington, D.C., where it appears bold and uncluttered by comparison to the prevailing neo-baroque and Beaux Arts styles.

Carl Condit's *The Chicago School of Architecture* provides basic academic background.

CHINESE

China is not the world's oldest known civilization—generally Egypt and Mesopotamia are awarded that distinction—but it does rank as the oldest continuous civilization, going back more than 4,000 years. This assertion was repeated as recently as 1981 by scholar Hugo Munsterberg; one wonders whether communism rates as yet another historic Chinese dynasty, rather than a discontinuity as great as that between pharaonic and Islamic Egypt.

Chinese civilization, in addition to its longevity, has been characterized by a remarkable constancy, changing at a glacier-like pace. (Writing of Chinese fashion in clothing—arguably the most ephemeral of all styles—Quentin Bell finds as little change over the centuries "as though we in Europe had made no substantial alteration in our dress since the…Punic Wars.") This impression of timeless constancy is reinforced by the Chinese reverence for tradition, by the whole Confucian mind-set, and by the fact that during every period of Chinese history copying of earlier cultural forms and patterns has been encouraged. (Given the problems of preservation, particularly acute in China, sometimes these copies are all we have.)

Our tendency to see an unchanging river of Chinese continuity is also encouraged by what we in the West call Oriental inscrutability, really our own failure to penetrate

A high-rise pagoda at Kaifeng, capital of Sung China, mid-11th century

the cultural surface. This problem of cultural blindness, it is only fair to add, is shared by the Chinese and compounded by traditional Chinese notions of cultural superiority. As historian Adda Bozeman put it, Europe and China each "studiously nurtured an all-pervading sense of its own supremacy on earth." Going back as far as 1000 B.C. the Chinese believed their Middle Kingdom occupied the center of the earth, surrounded by barbarians whose degree of civilization waned with distance from the center. Europe, for its part, conceived of itself as the center, with China relegated to the "Far East." This notion was inherited by Americans, even though China lies to the west for a Californian.

Architecture is probably the most unchanging of all Chinese media, modification over time occurring mainly in details. The most distinctive indigenous Chinese architectural form is a rectangular wooden building with a beautifully tiled roof and upturned eaves, supported by lacquered pillars and colorfully painted beams and brackets. Most Americans are probably also familiar with the pagoda, which the Chinese modeled after the Indian stupa, piling stories up like a layer cake. Unfortunately, very little architecture of any age has survived in China, wooden structures being notoriously vulnerable to natural and man-made catastrophe. (In fact, the Buddhist temples at Nara, Japan, are the oldest surviving "Chinese" architecture, the Japanese having proven themselves better cultural custodians.)

In any case, the Chinese consider architecture utilitarian, not a major art form. The first great Chinese medium was bronze, which very early reached an unprecedented peak during the Shang dynasty. History's finest bronzes were formed by a highly complex casting method of a uniquely Chinese alloy (lead added to copper and tin), possessing a characteristic gray sheen. Typical forms were ritual storage and pouring vessels, elaborately decorated with geometric and abstract animal forms (described by some scholars as Pacific in origin). Over time, belying the argument of Chinese cultural immobility, the shapes began to change, becoming bolder in the Chou era. Then with the dissemination of Buddhism in the sixth century A.D., Chinese bronze casting was applied to religious statues, in relief and in the round, with somewhat Mesopotamian and Greek characteristics

(the archaic smile, drapery, and corkscrew curls of the Buddha). The Chinese also made mirrors of bronze, sometimes framed in a sort of bronze lace.

Early Chinese bronzes were often found buried together with jade, a stone highly prized in China for its supposed magical qualities, sometimes carved with the same motifs as the bronzes. In the Chou period artisans created wood carvings covered with brilliant lacquer, which would become another traditional Chinese medium. Chinese sculpture begins at about this time with grave effigies or figurines, often earthenware. A staggering find was made in the 1970s at remote X'ian of an entire life-size army in

● ——————————— ●

Important Chinese Dynasties

Chinese arts and crafts are generally identified by dynasty. Of the following, all but the Chinese Republic are included as separate entries with more detail.

SHANG (1800–1100 B.C.): great Bronze Age civilization; objects for cult use in bronze, jade, and other materials including bone, decorated in an ornate flat, linear style

CHOU (1000–200 B.C.): longest dynasty, era of Confucius, Lao-tse and the *I Ching*; continued bronze production; jade and lacquer carving in relief

HAN (200 B.C.–A.D.200): contemporaneous with Roman Empire; great geographic expansion; arrival of Buddhism and systematization of Confucianism; glazed ceramics

T'ANG (618–907): China's military and territorial peak; highly cultured and cosmopolitan era with flowering of literature, science, and the arts; discovery of porcelain; great influence on Japan

SUNG (sometimes rendered Song; 960–1279): on the defensive militarily; division into northern and southern empires, each with characteristic style of landscape painting; great era of Zen Buddhism

MONGOL (Yüan; 1279–1368): Marco Polo and silk road; ornate decorative arts; decline of Buddhism; introduction of cobalt blue and underglaze painting on porcelain; cloisonné enameling

MING (1368–1644): great native uprising against Mongols; consolidation behind the Great Wall, without Mongolia, Manchuria, and Turkestan; important surviving architecture and the oldest preserved rug are Ming; blue and white porcelain highly esteemed; love of richness and display; arrival of Western missionaries and traders

CH'ING (Manchu; 1644–1912): alien Manchu dynasty gradually sinicized; last and perhaps greatest porcelain, from blue and white to delicate colorization, inspiring rococo rage for chinoiserie in Europe; flowering of decorative arts: richly carved lacquer and cloisonné, luxury products for Western consumption; increasing Western intervention; political and economic decline, culminating in 1911 revolution

CHINESE REPUBLIC (1912–49): Chinese communism instituted 1949; repression of traditional Chinese culture and values in favor of conformity to Maoism

terra cotta, 7,000 men and horses buried in full battle order with a Chinese emperor who reigned briefly in the third century B.C. Over time such grave figures would be miniaturized and, as they became popular collectors' items in the West, counterfeited.

Painting with ink, brush, and paper (sometimes silk) became in the Han era the greatest of Chinese arts, especially delicately rendered landscapes, always frameless. Scholar William Watson writes that the landscape in Chinese art occupies a position comparable to the nude in Western art, a perennial theme with varying nuances. Specialists differentiate numerous schools of painting by time and region—for example, bird and flower painting, sometimes denigrated as decorative by the more scholarly bamboo and orchid painters; or the looser, more romantic "southern" school versus the more meticulous, realistic "northern" style. Other movements are identified by different brush strokes with names like the "chopping ax" or the "dragged dry" stroke, or the "boneless" style of color wash without outlining. Besides the medium (ink, silk) and subject matter— nature, with man figuring only as a small, insignificant atom—what is primarily identifiable to us as Chinese is a distinctive perspective. Chinese perspective (see p. 257 for example) involves a continuous raising of the eye level or recession from an already distant foreground, with no single focus or viewpoint. (A similar use of perspective was popularized in the United States in the 19th century by the Hudson River school.)

Chinese landscape painting is generally considered to have gone into decline around the 16th century, but its themes and motifs were carried over into the decorative arts. The Chinese art of porcelain, said by some to be the only great Chinese medium since the Ming dynasty, typically uses the landscape as a formless inscription, divested of pictorial value. The proverbial "blue willow" pattern, for example, is a Ch'ing era modification of Ming garden paintings. Over time Chinese porcelain has featured every indigenous historical motif from the Pacific scroll to the Han curve, from the T'ang dragon to Sung flowers and Ming landscapes. In the 18th and 19th centuries the Chinese began to produce export wares to customer specification, with biblical, armorial, and other Western motifs.

The same traditional decorative motifs and colors can be found in Chinese silks, brocades, and rugs. Rug weaving, which began in 17th-century China without a previous folk tradition, took a somewhat different course than in Persia and in Turkey. The Chinese use space, pattern, and color differently, with fewer, always complementary colors. Every dragon, phoenix, or other ornament has a symbolic meaning (for example, the Chinese swastika symbolizes good luck, the peach stands for long life, the carp for success in exams, and so on). These rugs only became known in the West in the 20th century, and they were generally considered inferior to Persian and Turkish "orientals." More recently the Chinese have been producing deep-pile pastel carpets in Savonnerie-style designs, outlined by carving of the pile around the design.

China remained remote and inscrutable to the West until the 16th century, when the first European missionaries and traders arrived. During the baroque and rococo periods Europe enjoyed an enormous vogue for *chinoiserie*—meaning anything Chinese, synonymous with exotic—which reached the United States in the mid-18th century. George Washington ordered a set of custom "China," while Thomas Jefferson designed a Chinese-type pavilion for his otherwise classically conceived Monticello. In the 19th century the Victorians went in for chinoiserie, too; and thanks to increasing European intervention in China, the great Western collections of Chinese art were put together at this time. Among the premier collectors was Charles L. Freer of Detroit, whose hold-

ings are in the gallery bearing his name in Washington, D.C. The Nelson-Atkins Museum in Kansas City has a fine Chinese sculpture collection, with other important holdings in Cleveland and Boston museums. In addition to Chinese art, the United States has Chinese kitsch, such as the former Grauman's Chinese Theater in Hollywood and innumerable pagodas.

As China begins once again to open to the West, commercial designers are banking on another revival of chinoiserie. Decorator and fashion magazines feature Fu dogs (ancient guardians of temple gates) and willow-printed wallpaper, temple-shaped evening bags and pagoda-inspired poufs. We are also seeing a lot of Chinese art and artifacts on the world market, especially goods confiscated during China's Cultural Revolution. Robert Ellsworth, an expert on Chinese furniture ("the king of Ming," he calls himself, tongue-in-cheek), reports that many good pieces are available in the $25,000–30,000 range ("peanuts compared to Western furniture"). Antique Chinese ceramics, on the other hand, have long been an excellent investment, their worth having multiplied 25 times in the 1950–69 period (second only to Old Master prints and modern art for appreciation value).

Ernest Fenollosa's two-volume *Epochs of Chinese and Japanese Art* is personal and impassioned, full of opinion and, some say, error, having been left unfinished on the author's death. *The Arts of China* by Hugo Munsterberg and *Style in the Arts of China* by William Watson are valuable. In the Thames & Hudson series, see Mary Tregear's *Chinese Art*.

CH'ING

The last Chinese dynasty (1644–1912) is recent enough that the events of its decline are familiar from high-school history: the Opium War (1839–42), whereby Western imperialist powers enlarged their sphere of influence in China; the Boxer Uprising (1898–1900) of Chinese nativists against the hated foreigners; the overthrow of the doddering dowager empress by the republican Sun Yat-sen in 1911. Culturally, however, it is the front end of the dynasty that is of chief interest.

Having no well-developed culture of their own, the Ch'ings (better known to us as Manchus for their former homeland in Manchuria) adopted Chinese administration and generally comported themselves as a Chinese dynasty. They took traditional Chinese art forms, but infused them with their own indigenous love of color and ornament. For example, they rebuilt and painted brightly the K'ang Hsi Palace in Peking. Ch'ing furniture, on the other hand, often borders on the monstrous, its handsome traditional forms overcome by elaborate decoration.

The great Ch'ing medium was porcelain, considered by some the finest the world has ever seen, certainly the most avidly collected and the highest priced. Ch'ing forms are more slender and graceful than Ming and are painted with increasingly bright landscapes, figures, birds, and flowers. (In the Chinese lexicon of popular symbols the hawthorn denotes winter; the peony, spring; the lotus, summer; and the chrysanthemum, winter.) In Europe Ch'ing wares became known by their predominant colors as *famille verte* (green), *famille jaune* (yellow), and *famille rose*, the last considered the most delicate.

Ch'ing porcelain production continued at high levels of quality and quantity throughout the 18th century, feeding the tremendous rococo vogue for chinoiserie in Europe.

Production of porcelain especially for export became significant; it was sometimes called *Chine de commande* or Chinese export wares and often made to European taste and design specifications. Two typical types of Chinese export ware were "Jesuit china," featuring biblical scenes instead of traditional landscapes, and armorial wares, which had coats of arms or ciphers. (In 1786 George Washington bought a set of armorial ware bearing the insignia of the Society of the Cincinnati—300 pieces for $150, not an inconsiderable sum in those days.)

By the late 19th century Ch'ing porcelain production was showing signs of overelaboration and declining quality control, living off its former splendor as the dynasty itself lapsed into terminal decrepitude.

CHIPPENDALE

If you were writing a recipe for Chippendale furniture, you might specify the following: take Queen Anne and rococo, add a generous dash of Chinese, and strain through a Gothic filter. The result is a mildly fantastic confection in wood that somehow, improbably, ranks as archetypically English, just the right period touch for an 18th-century historical novel or a paneled drawing room.

We call this style Chippendale because it was published and popularized, although not necessarily originated, by Thomas Chippendale. Chippendale was only one of several respected cabinetmakers in mid-18th-century England, but his name became a household word thanks to the comprehensive furniture design books he published, beginning with the *Gentleman and Cabinet-Maker's Director* in 1754. Chippendale's company became relatively big business, providing complete furnishings for the large houses of the aristocracy and gentry (in some of which, such as Harewood House in Yorkshire, England, you can still see Chippendale furniture in its original setting).

Mahogany highboy (c. 1765) inspired by the *Director*, Philadelphia *(Metropolitan Museum of Art)*

The period was, of course, rococo. Never capable of the refinement achieved by the French in furniture, the English took the basic rococo idea and merged into it the new fad for chinoiserie and the revived taste for Gothic. The great Chippendale form is the chair, with lattice or fretwork back, cabriole legs, and claw-and-ball foot, but the

style is also identifiable in mahogany four-poster beds, inlaid tables and commodes, sideboards, bookcases, and highboys. Typical to all such pieces are pagoda-like crestings, broken pediments, fretted cornices, and a profusion of curves, scrolls, shells, and flowers. (Some consider the finest Chippendale to be that produced after 1765, under the simplifying influence of neoclassical and Adam styles.)

The Chippendale style arrived in the American colonies with a lag of a decade or two. Philadelphia (then the capital) produced the most sophisticated domestic Chippendale, often copied exactly from the *Director*. New York Chippendale is considered heavier, squatter. Regional differences also show up in the wood used—cherry in Connecticut, for example, or walnut in the South. If you are really into Chippendale, you can impress others by identifying the different regional variations on the claw-and-ball foot.

Chippendale Furniture: The Work of Thomas Chippendale and His Contemporaries in the Rococo Style by Anthony Coleridge focuses on the old account books and correspondence that authenticate original Chippendale, since none of the firm's furniture was stamped. For American Chippendale, see Joseph Butler's *Field Guide to American Antique Furniture*.

CHOU

The longest reigning dynasty in Chinese history, the Chou (c. 1000 to 200 B.C.) is the great era of Chinese philosophy, the time when Confucius and Lao-tse lived (contemporaneous with Socrates and Buddha) and the *I Ching* (*Book of Changes*) was written. This is also when Chinese painting and sculpture began and the human figure first appeared in Chinese art. Chou artifacts that have survived are chiefly jade and bronze, the latter mostly ritual vessels (see also SHANG) with elaborate interlaced spirals and other abstract designs reminiscent of Celtic manuscripts. (Some scholars consider Chou bronzes overelaborate by comparison with Shang, a symptom of aesthetic decay.)

The study of geography received a new impetus around 600 B.C. when the Chinese began explorations to their west, giving rise to the legend of a mythical queen supposed to have reigned over a sort of Shangri-la in the general vicinity of Tibet.

CHRISTIANITY

The pivotal event in Western history, from which we date all subsequent events, is the birth of Christ. In the sixth century A.D. scholars recalculated the historical calendar, assigning the year 1 Anno Domini, the year of our lord, to Christ's birth. It is now thought that he was born a few years earlier, but the task of recalibrating two thousand years of history would be unimaginable. The "Christian" numbers are used even by atheists, although in communist East Germany it was customary to write "u.Z."—*unserer Zeit*, of our time, instead of A.D. You may also see in English "B.C.E.," before the common era, and "C.E.," common era.

Whether or not we are religious, and no matter what our particular creed, we in the West find the chronology of our lives, the rhythm of the week, the year, even the stages of our development, from birth and baptism to marriage and death, measured out and memorialized in terms superimposed by Christianity on pagan traditions. (Some pagan survivals include Sunday, or the Sun's day; Christmas, celebrated as Christ's birth-

day, the unknown day set to compete with the pagan celebration of the winter solstice; and Easter, named for an Anglo-Saxon festival of spring and featuring such fertility symbols as rabbits and eggs.)

Likewise, no matter what our religious training, few among us are not somewhat familiar with the great stories and parables of the Bible: Daniel in the lions' den, Jonah and the whale, Joshua and the Battle of Jericho. The very language of the Bible—the Judas kiss, the doubting Thomas, turning the other cheek, or casting pearls before swine—is an ineradicable part of the common idiom.

About Christianity per se one could of course write volumes. Suffice it to say that it arose in Roman Palestine among a group of Jews and developed in the Judaic tradition, modified by the life and teachings of Christ (so-called from the Greek for "messiah"); that it was carried to the Gentiles by the first great evangelist (from the Greek for "good news") and missionary, St. Paul, who modified Hebrew regulations and extended salvation from the chosen people to all believers. From a persecuted minority, living in expectation of the imminent return of Jesus, the early Christians became after A.D. 313 members of the state church of Rome. Christian writings were then organized into the New Testament of the Bible, to be translated and debated and propagated as sacred scripture. Then, as the anticipated end of the world proved slow in coming, Christians faced the necessity of forming a more organized religious culture, developing hierarchy and ritual, and converting unbelievers. This they did so successfully that one-third of the people in the world today consider themselves Christian.

In the realm of culture the Western world owes to Christianity its very concept of a church or cathedral, which was adapted from the early Roman basilica, an oblong hall divided by columns into a central nave with flanking aisles, arms forming a cross, and the tip of the cross rounded into the apse. In the Middle Ages, when Christianity was perhaps at its peak, church building reached its apotheosis in the Gothic cathedral, the ultimate visible, physical expression of the faith.

Christianity also rewrote the rules of pictorial or visual representation. For a thousand years after the fall of Rome, little art was created in Western Christendom that did not depict biblical events (chief among them the Annunciation and the Nativity, the Crucifixion and the Resurrection) and personages (from Adam and Eve to Christ and his apostles and saints). Not left solely to artistic initiative or caprice, Christian art was circumscribed by tradition and the rulings of church councils. At one time or another the church has ruled, for example, that in a depiction of the Crucifixion, Mary must stand to the right and John to the left of the cross, and Christ's body must be pierced from the right side; or that in a representation of the Nativity, the child must be placed on an altar and the three Magi must embody youth, maturity, and old age.

By tradition the representation of Christ has evolved from a beardless shepherd or philosopher into the bearded Byzantine Pantocrator or ruler of heaven and earth, then into the suffering Gothic Christ on the cross, redeemer of man's sins. Later artists such as Rembrandt endowed him with a gentler spirituality, but his seriousness has never been questioned. (In modern-day California, Forest Lawn cemetery held a contest for a smiling Christ, with ludicrous results.)

Christian representation has varied somewhat over time and place. In 12th-century France Mary was represented as the queen of heaven, in a blue robe, and so many churches were named for her that *Notre Dame* became practically synonymous with church. In contrast to the regal French Mary, the Italians of the Renaissance painted

Madonnas, as in
Raphael's *Alba
Madonna*
(c. 1510), are so
familiar to us
we forget the
word is Italian
*(National
Gallery of Art)*

her as a more human and intimate mother, and sculpted her as the grieving mother of
the Pietà (there is no such scene in the Bible). The Germans and northern Europeans
developed a special predilection for Crucifixion scenes arousing horror and pity.

The visual Vocabulary or lingua franca of Christianity enabled the pious illiterate
to "read" stained-glass windows, illuminated manuscripts, sculpture, and paintings—the
cathedral itself was a veritable sermon in stone. After Christ and Mary, the most impor-
tant Christian figures were the saints, usually identifiable by a nimbus or halo and their
personal attributes (Peter with the key, Catherine with her wheel) or traditional sym-
bols (the evangelists John as an eagle and Mark as a lion). The Holy Spirit is repre-
sented by a dove, and Christianity itself by a cross or a fish. (The fish is a rebus: the
Greek word for "fish" spells *Jesus Christ, son of God, savior.*)

Christianity had such a grip on the minds of men that for hundreds of years non-
biblical subjects were simply not painted or sculpted in Western art. Art historian H. W.
Janson dates the first Western landscape since classical times to the 13th century, which
may be early. Renaissance artists typically used classical (pagan) models and forms but
cast them in Christian garb; cupids became angels, for example, and Orpheus, David. A
1529 German depiction of the Battle of Alexander has been called the first major paint-
ing using non-Christian thematic material. The Reformation that began in 16th-century
Germany split the Western church (the Eastern or Orthodox church had been largely
separate since the eighth-century conflict over iconoclasm) into an ever increasing num-
ber of sects, gradually eroding this common cultural language or inheritance. Visually
most of us have become religious illiterates. Only in speech do Christian terms—*exodus*,
for example, or *genesis*, or *Armageddon*—remain common currency, even when we are
not entirely sure of their meaning.

This is the view from within the Western Christian world. If Christianity is a cultural language that most Christians understand with greater or lesser facility, consider how it strikes non-Christians. French culture maven André Malraux writes that Orientals find the suffering Christ on the cross painful and embarrassing, while art historian Erwin Panovsky suggests that to an Australian bushman, *The Last Supper* would merely look like a rather excited dinner party.

The *Horizon History of Christianity* by Roland H. Bainton is a good illustrated introduction to this vast subject. See also MONASTICISM, GOTHIC, MIDDLE AGES, ROMAN CATHOLICISM.

CHRISTIAN SCIENCE

The only major modern faith founded by a woman, Christian Science is the brainchild of Mary Baker Eddy, a self-made New Englander with little more qualification than a talent for self-dramatization. Mrs. Eddy was until mid-life a typical 19th-century invalid, given to writing effusive poetry and to "languishing as a form of self-expression," according to biographer Julius Silberger. In the early years after the Civil War, American medicine was still crude (the fashionable diagnosis was "neurasthenia," which we would today classify in the realm of psychosomatic illnesses), and organized religion had not yet discovered the appeal of "healing." A chronic sufferer from what she called "spinal inflammation," Mrs. Eddy finally found relief at the hands of a lay practitioner named Phineas Quimby, who convinced her to give up her belief in the reality of her illness. This simple notion of mind over matter became the kernel of the new religion. (In authorized church literature, Quimby is not mentioned; credit for Mrs. Eddy's inspiration goes instead to the biblical account of Jesus healing the palsied man.)

Mrs. Eddy began offering "parlor lectures on Practical Metaphysics," preaching that disease, pain, sin, even death are mere mental illusions. In 1879 she established her "mother church" of Christ (Scientist) in Boston. She also created the Massachusetts Metaphysical College, which included metaphysical obstetrics in its curriculum until the legal hazards became apparent. So successful were her activities that Mrs. Eddy's income from teaching in a five-year period in the 1880s is reported to have been $100,000.

Christian Science, which did not start out to be a religious sect, acknowledges the scriptures and belief in a supreme god. Services (typically in austere neoclassical and Greek revival churches) consist of readings from the New Testament and from Mrs. Eddy's magnum opus, *Science and Health* (1875). The church has no official clergy, only readers and practitioners or "healers," women playing a major role in the latter position. The church also developed its own publishing arm, producing (in addition to Mrs. Eddy's books) a newspaper, the *Christian Science Monitor*, which for many years enjoyed a high reputation for lucidity and humanity. The church has also traditionally provided attractive reading rooms for public use, a properly Bostonian approach to the improvement of religious literacy.

Christian Science enjoyed a great wave of popularity in the first third of this century, its membership expanding from an estimated 85,000 at the death of Mrs. Eddy in 1910 to 250,000 in the 1930s—despite periodic newspaper reports of children dying from curable conditions while their Christian Scientist parents were praying. The church now claims only 150,000 members, with 1,884 branches; the number of practitioners

has fallen by almost two-thirds since 1950, and church publishing has been severely cut back. A major crisis erupted in 1992 over the church's money-losing expansion into television and the publication of an extremely adulatory biography of Mrs. Eddy as a condition of a major bequest.

Julius Silberger, author of *Mary Baker Eddy: An Interpretive Biography*, is a psychoanalyst with a critical appreciation of his subject's accomplishments and complexes.

CHURRIGUERESQUE

This Spanish baroque style of architectural decoration, of which there are some authentic colonial survivals in Central and South America, enjoyed a revival of popularity in the United States after two West Coast expos in 1915. Named for a family of Spanish architects (José Benito de Churriguera, his brothers and sons), Churrigueresque is an extravagant reprise of the 16th-century system of architectural ornamentation called Plateresque for its connection to silver decoration.

Since the baroque was a period of economic and political decline in Spain, the popularity of the profusely ornate Churrigueresque style has been interpreted metaphorically as the pursuit of illusion to mask reality. Typically a sort of elaborate confection applied to cathedral altars and portals in Spain

Detail of the facade of the San Diego Museum of Man (Bertram Goodhue, 1913–15), relic from a 1915 expo *(Tony Russell)*

and the Spanish colonies, the style was reincarnated in 20th-century American movie theaters (prime dens of illusion) as well as churches. Two examples of modern American Churrigueresque are the RKO theaters in Flushing, New York (1928), and the Museum of Man in San Diego's Balboa Park, a leftover from the 1915 expo.

CLASSICISM

Classic, classical, classicism—these terms are so frequently and imprecisely used that it is best to go back to origins. The derivation is from the Latin *classici*, or the classification (of citizens, actually) of the first, best, or wealthiest. The classics are therefore the best (books, for example), while classical generally denotes better, purer, more perfect, or ideal representations (even more serious, such as classical music as opposed to popular).

In history classical means the period of Greco-Roman antiquity, the art, architecture, philosophy, and literature of which constitute the classical ideal—one of the basic or benchmark terms of reference in art history, by relation to which even opposing movements are defined.

In the yin-yang of cultural history, there has been a cyclical alternation of classical and anti-classical styles. Traditional classical values (balance, restraint, linearity, idealism, austerity, clarity) seem inevitably to give rise to their opposite (expressionism, emotionalism, romanticism). Thus the great classical revival called the Renaissance gave way to mannerism, baroque, and rococo, each movement progressively more unbalanced and anti-classical, before the pendulum swung back again in the late 18th century to neoclassicism. This latter revival, prompted by archeological discoveries in Italy, is generally called the neoclassical period (although there are many neoclassical periods).

French neoclassicism of the period 1770 to 1830 is closely associated with the French Revolution. According to Arnold Hauser, social historian of art, of all the stylistic possibilities available to them, the French revolutionaries chose classicism for its identification with Roman republicanism (Rome being at that time much more accessible than Greece). It also recommended itself by way of contrast to the baroque and rococo styles officially sponsored by the ancien régime. Under Napoleon, however, neoclassical ideals began to take on monumental proportions more reminiscent of the Roman Empire than of the republic.

Carried in part by Napoleon's armies, the neoclassical style spread all over Europe and to the New World, transcending ideology with distance. As Suzanne Massie points out in her book on Russia, neoclassical architecture became the symbol of aristocratic romanticism in England, of authoritarian autocracy in Russia, and of democracy in the United States. (Our first great American artist, Benjamin West, was a pioneer in the neoclassical style, investing American revolutionary events with the ideals of antiquity, although he stopped short of clothing historical American characters in classical robes as the French were wont to do.)

The 19th century experienced a great anti-classical wave in romanticism, which rejected classical rules and conventions as antithetical to creativity, freedom, and originality. In the 20th century, a long-term trend toward anticlassical abstraction and experimentation in the arts has been punctuated by neoclassical reactions, particularly in the 1920s, when the modernists Picasso in art and Stravinsky in music both retreated to neoclassical, representational, tonal forms. At the same time, the fascist dictatorships also found neoclassical styles consonant with their grandiose ambitions. We are now again in a period of neoclassic reaction against modernism, called postmodernism.

Classical is used generically to designate the ideal, peak, or mature phase of a style (such as "classical Maya"). This peak may be achieved in different media at different times: the visual arts are said to have achieved classical perfection in Renaissance Italy, music in Germany in 1770–1830. In practice, classical may also mean a reactionary phase. Cultural historian Oswald Spengler considers classicism a common stage of all "dying" cultures, when imitation replaces inspiration.

Hugh Honour's *Neo-classicism* is another of the author's excellent introductory studies. For latter-day manifestations, see *Modern Classicism* by Robert A. M. Stern.

COLONIAL

As a historical concept, American "colonial" generally designates the period between the arrival of the *Mayflower* and the Declaration of Independence from England. (There were, of course, other colonial powers with stakes on the North American continent,

so strictly speaking you would also have to differentiate French, Spanish, and even Dutch colonial periods.) When you carry the concept over into architecture, which is where you most frequently hear of "colonial" in the 20th century, you find no clear cut-off date. Some would restrict (English) colonial to buildings constructed in the 17th century, when the architectural model was medieval English, while others use it to embrace Georgian, Federal, even Greek revival movements. Certainly colonial influence did not end overnight with the transfer of power but lasted until the mid-19th century. Then a colonial revival began in 1876, prompted by the Philadelphia Centennial Exposition, leaving a general confusion between colonial survival, revival, and just plain knock-off. Regional variations contribute to making this an impossibly amorphous style category.

In the northeastern United States colonial architecture is typically rectangular wood-frame construction with clapboard siding, small casement windows, and a steeply pitched, shingled, gable roof. In the Mid-Atlantic states, wood begins to be replaced by brick and more irregular medieval shapes to become neoclassic Georgian. In the South, and particularly in areas that were sparsely settled before 1776, the later Federal and Greek revival styles are often nostalgically subsumed under colonial. This stylistic association seems to have wandered west with the frontier, so that today Southern plantations in Beverly Hills are advertised for sale as colonial. Thus you have the anomaly of a white-columned, temple-form house sharing the same stylistic designation as a red-brick Georgian town house, or in fact any traditional-style house painted white with green shutters, a picket fence, and elm trees in the yard.

The picket fence is a clue that we are dealing not with a specific style or period, but rather with an idealization of the past and of tradition—ancestor-worship as a form of popular aesthetics. (There is nothing more nostalgic for a homesick American expatriate than the image of a peaceful tree-lined neighborhood of traditional "colonial" style houses, spelling "home.")

As for authentic colonial survivals, you may or may not find them at Williamsburg, Virginia, where an 18th-century American town has been reproduced at enormous cost. Some call Williamsburg an elaborate counterfeit (the landscaping, in particular, is a modern improvement, a historical Disneyland). Responding to criticism, Williamsburg recently added a slave quarters where before it had had only spinning wheels and butter churns, sentimental tokens of labor.

In practice, colonial has come to mean a favored stylistic genre for developers capitalizing on nostalgia. Outside of housing tracts, where so-called "Dutch colonial" is a popular sell, pseudo-colonial prototypes and motifs are also common in American theme parks. You may also recall colonial-style A & P supermarkets and Howard Johnson motels with steeples like colonial town halls.

The Colonial Revival in America edited by Alan Axelrod is an excellent collection of articles on the subject. See also William H. Pierson, Jr.'s *American Buildings and Their Architects: The Colonial and Neoclassical Styles. Colonial: Design in the New World* by David Larkin et al. is a picture book of authentic examples with a tenth-grade text.

COMMEDIA DELL'ARTE

On tour with Sergei Diaghilev's Ballets Russes in 1917, the composer Igor Stravinsky and artist (and scene designer) Pablo Picasso encountered a traditional Italian theater

in the streets of Naples. The commedia dell'arte, which goes back to the 16th century, is a form of popular comedy characterized by stock plots, improvised dialogue, and a cast of continuing characters including an ingenue and her handsome but poor lover and a crowd of wily servants engaged in constant intrigue. Chief among the latter are Harlequin in his colorful patchwork costume and the dwarfish Pulcinella, a trickster with a crooked nose.

Picasso's *Three Musicians* (1921), a secular trinity based on Italian street theater *(Museum of Modern Art)*

Picasso, who had already painted Harlequin more than once (in the artist's blue period, as a rather moody figure), now became fascinated with Pulcinella as well. The result was one of the artist's great post-cubist icons, *The Musicians* (1921), a secular trinity of masked tricksters. Picasso and Stravinsky also collaborated on a Pulcinella ballet (1919), a score that launched Stravinsky's neoclassical period. Earlier, in his ballet *Petrouchka* (1911), Stravinsky had drawn on Russian carnival puppets, distant cousins of the Italian comedians. As yet another example of the appeal of these age-old characters, the composer Arnold Schoenberg wrote a 1912 song cycle entitled *Pierrot lunaire*, a French equivalent of Pulcinella. (The English version is, of course, Punch, as in Punch and Judy.)

This instance of the cross-germination of the arts is related by John Russell in *The Meanings of Modern Art*.

COMMUNISM

Preferring to leave the details to be worked out in practice, Karl Marx and Friedrich Engels deliberately wrote little on the revolutionary new society they predicted would succeed capitalism, the classless society in which private property would be abolished. After the failure of the revolutions of 1848, Marx and Engels added to their historical prediction a caveat about "the dictatorship of the proletariat," a tacit admission that the "engine of history" would not suffice to accomplish the overthrow of the bourgeoisie. Lenin later developed his theory of imperialism as the final stage of capitalism, further explaining why the revolution had not occurred spontaneously.

In the end the Marxist revolutions that did occur came "from above," led by small groups of professional conspirators, themselves often bourgeois, and not, as predicted, in the advanced capitalist nations but in impoverished, backward giants—Russia after World War I and China after World War II. We are accustomed to calling these com-

munist rather than Marxist revolutions for the resulting communal or state ownership of property and the means of production. In fact, Marx would have been as appalled as anyone at the enormous discrepancy between the ostensible goal of social justice and the ruthlessness and repression used to achieve it in the Soviet Union, China, and elsewhere, a cautionary tale in applied Marxism. (Socialist writer Michael Harrington believes that when Marx and Engels called for a dictatorship of the proletariat, they really meant some form of democracy.)

In practice, communism means the militant left wing of socialism, featuring the elimination of private property, government ownership of the means of production, and rule by a repressive bureaucracy that takes the surplus created by labor to invest in industrialization. Regardless of its motives or their perversion, economic historian Robert Heilbroner remarks, communism did offer a technique for forcibly building capital and accelerating the rate of industrialization, albeit at the cost of freedom. The ruling elite also tended to invest in itself, creating a vast network of privilege and corruption.

In the United States communism has historically been considered antithetical, even inimical to capitalism. In the 19th century we had a succession of interesting communitarian experiments, like Brook Farm, Oneida, Amana, and the Shakers, some of them quite successful, but somehow they always seemed a threat to American individualism, downright "un-American" in the sense of Senator Joseph McCarthy's 1950s political inquisition. American communists were a motley collection of fellow travelers and true believers mouthing contradictory inanities in their effort to follow the Soviet party line. As a group, the Americans were also given to factionalism, backbiting, recanting, and telling all; one of their chief stooges was the problematic Whittaker Chambers, a one-time *Time* magazine writer who called Alger Hiss a communist spy and in the process launched Richard Nixon into presidential orbit—such is the negative power of the

● ———————————————— ●

Variations on the Communist Theme

BOLSHEVISM: *Bolsheviki* means members of the majority of the Russian Social Democratic Labor Party formed in 1898, but by the time they launched their revolution in 1917, the Bolsheviks were a determined, dedicated minority.

LENINISM: The revolution having failed to occur spontaneously, Lenin advocated seizure of power by a cadre of professional revolutionaries; he also added the theory of imperialism as the final stage of capitalism.

STALINISM: In practice, this means the cult of personality, specifically the ruthless, paranoid personality of a power-mad mass murderer.

TROTSKYISM: One of the chief organizers of the Bolshevik revolution, Leon Trotsky continued to advocate world revolution while his rival Stalin was consolidating power in a single country; exiled and finally assassinated, Trotsky came to symbolize the dissident (also Jewish) intellectual.

MAOISM: The application of communist strategy and tactics (including guerrilla warfare) to a backward peasantry; as the chairman advised in his little red book, maintain your flexibility and take direct action (the Red Guards) to renew revolutionary commitment (the Cultural Revolution).

See also MARXISM, SOCIALISM.

American anti-communist phobia. By 1960 the American communist Party, which in 1945 numbered 45,000 members, had practically self-destructed.

Harcourt, Brace & Co. published a three-volume set on "Communism in American Life," including Theodore Draper's *The Roots of American Communism* and David A. Shannon's *The Decline of American Communism*. Having recently lost their raison d'être, cold war historians (such as Adam Ulam, author of the recent *The Communists: The Story of Power and Lost Illusions, 1948–1991*) are now busy trying to explain what went wrong with both Communism and their own analyses of events.

CONCEPTUALISM

In conceptual or process art, a movement that arose in the 1960s as sort of an antidote or corrective to minimalism, the idea or concept is more important than its realization. Conceptual artists used ephemeral everyday objects (inclining to the animal-vegetable-mineral kingdom) to provoke thought and association. Instead of canvas and marble, their media of choice were cement, newspaper, twigs, occasionally air, hair, ice, wind, and lots of earth and rocks, sometimes just dumped on the gallery floor. Conceptual works by Lawrence Weiner, considered important at the time, consisted of bleach poured on a rug or paint on a floor. Needless to say, you had to be there, because the same effect could never be reproduced elsewhere.

(As art writer Calvin Tomkins explains conceptual art: "If the essence of art was idea, then a way had to be found to convey the idea without the benefit of a 'work.' At that point art disappeared into philosophy, and Americans lost interest.")

One branch of the conceptual movement specialized in what were called "earthworks," site-specific projects such as Robert Smithson's 1970 *Spiral Jetty* in the Great Salt Lake, or Christo's many and continuing "wrapping" projects. Then there was an Italian school called *arte povera*, led by Michelangelo Pistoletto (his 1967 *Venus of the Rags* included a plaster version of the Roman goddess), and a German offshoot under Joseph Beuys, whose favored everyday materials were wax and felt.

-ism = Gr *-ismos*, often via L *-ismus* or F *-isme*— or both; its conn is abstract; in general, it answers to vv in *-ize* and esp to agents in *-ist*, with their adjj in *-istic*. Its principal manifestations are these: whereas, formed from vv, it indicates action, as in *baptism*, OF *baptesme*, LL from Gr *baptismos*, from *baptizein*, to baptize, formed from nn it indicates the manner of action, as in *despotism*, or the conduct to be expected of the person implied, as in *heroism* or *Micawberism*. Very common too is the conn 'state, condition' (or the fact of being such-and-such), as in *hypnotism* or *barbarism*. Flowing from the general 'action' and 'state' connotations is that of 'doctrine' or 'mental or moral practice or habit', as in *materialism*, or 'adherence to' (a doctrine, a theory), as in *Catholicsm*. Hence, 'characteristic, esp a peculiarity', as in *Briticism*. In Med it denotes an abnormal state or condition, consequent upon excess in (the thing denoted by the n implied), as in *alcoholism*.

Artist Joseph Kosuth exhibited this dictionary definition at the Hirshhorn Museum in 1992

Conceptualism even made its influence felt in serious music. La Monte Young wrote a 1960 composition consisting of instructions for building a fire in front of an audience. And the written word has been explored as an artistic concept by Joseph Kosuth, who exhibits (at Washington, D.C.'s Hirshhorn Museum in 1992) blow-ups of dictionary definitions of words like *-ism*.

CONFUCIANISM

Confucius, a Chinese sage who lived in the sixth century B.C., contemporary with Buddha, was only later ennobled, canonized, and worshipped as the founder of China's traditional ethical and philosophical system. It was during the Han period (200 B.C.–A.D. 200) that Confucian ideals of duty and order, moderation and right conduct were generalized into a social ethic that prevailed for 2,000 years. (Like Hinduism, Confucianism is really a Western designation; the Chinese speak rather of the "School of the Literati" and of the five classic texts.)

Coexisting in a sometimes uneasy relation with Taoism and later Buddhism, Confucianism gradually extended its reach into Chinese education and through it into government, the civil service, and the arts. (Confucian education is said to have produced history's largest class of amateur artists, with every scholar acquiring skills in painting and calligraphy—but not sculpture, too plebeian a skill.)

Some consider Confucianism excessively conformist, repressive, and illiberal, a forerunner of the totalitarian mind-set. Using an early Christian analogy, Asian scholar Ernest Fenollosa compared Confucians to "Sadducees and Pharisees who hold with the tenacity of bulldogs to the letter of the law," stifling creativity with excessive formalism. Certainly Confucian control of Chinese education and bureaucracy put an elite in position to oppose if not persecute its competitors. Tensions peaked during the Sung era (A.D. 960–1279), when the Confucians attempted to suppress scientific speculation and dissidence. Under the Mongol (Yüan) dynasty, the Confucians sided with the invaders as a means to maintain their hegemony. In the 18th century they claimed the expulsion of Christians from China as a victory. (Before they left, the Portuguese coined a word that became practically synonymous with Confucian bureaucrat—*mandarin*, from the verb to command, which also became the name of the Chinese dialect spoken by the educated classes.)

Identifying and collaborating with successive reigning dynasties, the Confucians went into decline after the overthrow of the Manchus in 1912. Although officially repudiated by the communist People's Republic of China, the Confucian spirit often seems to be alive and well there. Author Edgar Snow, who found Mao Tse-tung an accomplished scholar of the Chinese classics, believes that the Chinese communist leader owed as much to Confucius as to Marx.

A standard source is H. G. Creel's *Confucius and the Chinese Way*.

CONGREGATIONALISM

The Pilgrims who came to America in 1620 were Congregationalists, members of a separatist movement in England revolting against church-state control and perfunctory piety. Eliminating bishops and presbyteries or councils of elders, they formed themselves into autonomous congregations with control over their own affairs, entering into covenants only with God and with one another in a fellowship of faith. Notably democratic, they elected their own ministers and conducted their affairs like a New England town meeting. In fact, church and meeting house were one, a rather plain lecture hall with a pulpit at the center of the long side rather than the traditional central altar. (Architectural historian William H. Pierson calls this the sole colonial innovation in architecture.) In the 19th century the Congregationalists inclined toward Romanesque-

style churches as more appropriately "early Christian," compared to the Episcopalians who favored Gothic.

As a minority in England, Congregationalists had had to be more flexible. In the American Promised Land they became more doctrinaire, arguing over admission to their little aristocracies of grace. Dissent progressed to charges of heresy, and conviction resulted in banishment. Connecticut, a sanctuary for Congregational dissenters from the Massachusetts Bay Colony, eventually became a new citadel of orthodoxy. As a result, Congregational churches had evolved by 1750 into "dull repositories of the correct faith of the established classes," historian Richard Hofstadter wrote. The largest denomination in the United States in 1776, the Congregationalists lost ground rapidly after the secession of the Unitarians in the early 1800s.

In American history Congregationalists are a distinguished group. Jonathan Edwards, our most original early theologian, has been called the father of Congregationalism. John Adams, our second president, married the daughter of a Congregational parson and remained a pillar of the church. Later in the 19th century, Henry Ward Beecher, the most eminent preacher of his day, was also a Congregationalist. (His son Lyman, another famous preacher, became a Presbyterian.) Well supplied in early years with ministers from Cambridge and Oxford, England, the church was also active in establishing important American centers of higher education, from Harvard in 1636 and Yale in 1701 to Dartmouth, Williams, Amherst, and Oberlin.

Religious historian Sydney Ahlstrom points out that the Congregational Church played a significant role in the movement to American independence from England, helping by its very example to lay the theoretical and institutional groundwork for self-government. Other denominations also followed the Congregational example: the Baptists, the Disciples of Christ, some Lutherans, and other American churches have adopted a Congregationalist structure of church government.

CONSTRUCTIVISM

In the turmoil of the Russian Revolution of 1917, constructivism was a conscious attempt to create an art of the proletariat, socially expedient and of utilitarian significance. In fact it was not meant as a style or even as art per se, according to Aaron Scharf, so much as "a deeply motivated conviction that the artist could contribute to enhance [society's] physical and intellectual needs."

Rejecting representational art as strictly bourgeois, the constructivists took their basic stylistic grammar from cubism and the other abstract and nonobjective currents of the day. They also embraced machine technology and the mass production of socially useful goods like furniture, clothing, and housing. As to actual design, they tended to talk about the purity inherent in elementary geometric forms, about "nude" architecture divested of ornamental excrescences, about tectonic forces and respect for the logic of materials.

So what does this abstract art for the new society, this functional design of the brave new world aborning, look like? The best-known constructivist is probably Alexander Rodchenko, an artist who experimented with graphic and furniture design, photography and film, but is known above all for the black-on-black canvas he painted in response to the suprematism of Kasimir Malevich. Other leaders of the movement were sculptor-designers Vladimir Tatlin, who designed a bicycle-airplane and a spiraling leaning

tower as a monument to the Third International; and El (Eleazar) Lissitzky, who also tended to minimally adorned erector-set-type constructions, the leaning *Lenin Podium* (1924), even buildings entirely detached from the earth. (Never built, these projects have been called rhetorical architecture, the most influential nonexistent buildings of the 20th century.)

The constructivists enjoyed a brief period of official patronage in Soviet Russia. Most of the old cultural elite having fled during the Bolshevik revolution, the Russian avant-garde had a unique opportunity to assume control of important professorships and academies, but they were unfortunately able to accomplish little. (Tatlin's proposed monument alone was estimated to require more steel than was available at the time in the entire USSR.) For the first anniver-

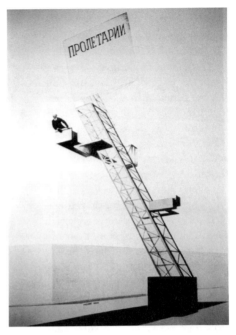

Rhetorical architecture: El Lissitzky's leaning *Lenin Podium* (1921), a drawing/photomontage

sary of the storming of the Winter Palace in 1918, constructivists decorated the city with giant triangles, rectangles, and circles; for May Day that year, Moscow was decked out similarly ("demented squares battled with rhomboids on the peeling facades of colonnaded Empire villas," the Russian writer Ilya Ehrenburg remembered).

In the disruption and schism of the 1920s, with leading dissidents such as Wassily Kandinsky and Marc Chagall leaving the movement and their country as well, most constructivist projects remained on paper only. And by 1930, as abstract art was pronounced a crime against the people, constructivism and other modernist movements were virtually eliminated in the Soviet Union.

The actual accomplishments of constructivism may be meager, but the ideas of the movement had repercussions. In the United States, art deco and precisionism were both strongly influenced by constructivism. And in the 1980s, an avant-garde movement of architects calling itself deconstructivism claimed the constructivists as ancestors.

With the advent of glasnost, Westerners began rummaging in Russia's cultural attics, bringing many early works of the revolutionary period to the light of Western scrutiny for the first time. In 1992 the Guggenheim Museum in New York City mounted an exhibit of Russian modernists called *The Great Utopia*, mixing together the work of constructivists and suprematists who in their own day engaged in heated verbal polemics and even occasional fisticuffs.

The best of accessible sources on the subject is Aaron Scharf's chapter in *Concepts of Modern Art*, edited by Nikos Stangos. See also the catalog of the 1992 Guggenheim exhibit, *The Great Utopia: The Russian and Soviet Avant-Garde.*

COPTIC

Coptic is the Arabic corruption of the Greek word for *Egyptian*. The name goes back to the fifth century A.D., when Egypt was largely Christian. After the Muslim conquest in the seventh century, Coptic came to mean Christian. The group was so heavily taxed that many converted to Islam, leaving a declining, sometimes persecuted Egyptian Christian minority.

The Copts are of particular historical interest for linguistic and cultural reasons. Their language, which by the 16th century was used only in the church (rather like Latin in the Roman church), is the last surviving link to the Egyptian of the pharaohs, although written in Greek characters rather than in hieroglyphics. In religious matters Copts are known for inventing monasticism and for their three- and four-hour services and frequent, extended fasts. (In other respects, such as prayer, ablutions, and diet, they belong in the Islamic rather than the Christian tradition.) Most significant are the manuscripts found in Coptic monasteries, including the oldest dated book in the world (A.D. 411), many clas-

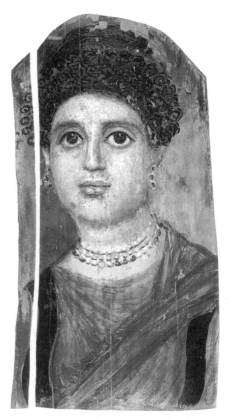

The Coptic "gaze of eternity" as seen in this Fayum portrait of a woman, c. 100 A.D. (*J. Paul Getty Museum*)

sical works preserved only in Syriac and later Arabic translation, and some early writing linked to the Old Testament. In their church music, too, the Copts stand in a direct line from the synagogue of the time of Christ and the Apostles.

Coptic art is largely religious, representing biblical subjects such as Adam and Eve and Jonah and the whale, rarely scenes from the life of Christ (except the Mother and Child). The style is reminiscent of Byzantine and Hellenistic, hieratic and decorative. Most frequently seen in Western museums are Coptic portraits with large, outlined eyes expressing spiritual intensity ("the gaze of eternity," Malraux called it). These are sometimes identified as Fayum portraits for the region west of the Nile where they were unearthed, a rich source of archeological finds (the Fayum has a canal system dating back to 1800 B.C.). Many of these Fayum portraits, however, also show pagan influences. In practice "Coptic" is loosely applied to Egypt between the third and the tenth centuries A.D. or specifically to Egyptian Christians.

Historically the Copts were employed by the Muslims as administrators. They were also known as weavers of fine textiles, many early fragments of which have been preserved by the dry climate. (The Textile Museum in Washington, D.C., has a collection

of these.) In later centuries they became laborers, indistinguishable to the Western eye from Egyptians but for the dark robes and blue turbans they have worn for centuries. They constitute the largest minority in the Arab world today, with six million in Egypt, including the "rubbish barons" who work the public dumps of Cairo. As of 1988, there were 100,000 Coptic immigrants in the United States.

The most prominent Copt in the world today is undoubtedly Boutros Boutros-Ghali, former Egyptian foreign minister, then secretary general of the United Nations.

Barbara Watterson wrote a good short survey, *Coptic Egypt.*

COUNTER-REFORMATION

The Counter-Reformation, or the response of the Roman Catholic Church to the Protestant Reformation, is sometimes considered to have started in 1534. That is when the Society of Jesus or Jesuits was established as a militant right-wing army to carry the faith, "by any means and at any cost, into any land of the globe," as historian C. V. Wedgwood wrote. Meanwhile, the church in Rome also responded to the Protestant challenge by trying to put its own house in order by clamping down on Renaissance humanism, which some blamed for unleashing the forces of dissent. To this end, the Pope activated the Inquisition and called the Council of Trent to deliberate the church's standards of orthodoxy in its traditional role as patron of the arts. Among other measures, the council condemned "superfluous elegance" in places of worship and set rules for religious art (in particular, martyrs and their heavenly rewards were to be emphasized). The cult of saints reached new heights, as did superstition and fear of witchcraft.

The early Counter-Reformation was austere and puritanical when not outright oppressive. As cultural historian Egon Friedell writes, "In art the nude and profane were rejected and persecuted; in poetry, the indecent and the merry; in philosophy, libertinism and skepticism. Michelangelo's figures were given clothing, and Petrarch's sonnets were 'purified.'"

Gradually, however, as the church recovered from what the Germans call the *Glaubenspaltung* (division of faith), it turned to the baroque as a propaganda vehicle with great audience appeal, a means to proclaim its splendor and omnipotence. From puritanism the movement went to the opposite extreme (the painter Caravaggio was now criticized for depicting saints as just plain folks). It was precisely in those areas where the Reformation posed the strongest threat, in the German lands between Protestant northern Europe and Catholic Austria and Italy, that the baroque Counter-Reformation achieved its greatest effulgence, with religious confections that anticipate Hollywood and Disney.

Along with repression, proselytizing, and cultural propaganda, the church took the offensive militarily, sponsoring that most confusing and futile of all conflicts, the Thirty Years War (1618–48). Central Europe became an armed camp, with dynastic and religious factions competing to destroy it. Far from reuniting Christendom, the war resulted in a stalemate.

The literature on the Counter-Reformation, like that on the Reformation, is generally dull reading for the layman. But war being generally a livelier subject than religious dispute, there is an absorbing account of *The Thirty Years War* by C. V. Wedgwood.

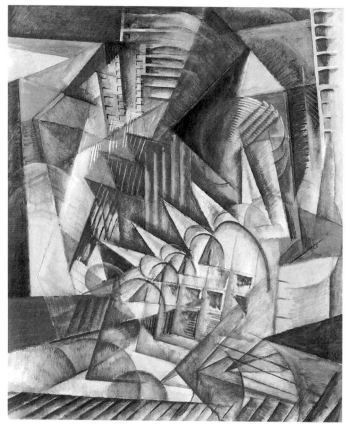

American cubist Max Weber's *Rush Hour, New York* (1915)
(National Gallery of Art)

CUBISM

It was a hostile critic, deriding the early work of French artist Georges Braque ("chopped into little cubes"), who gave this path-breaking early 20th-century style its name. Rejecting classical traditions of representation and perspective, the cubists refracted, distilled, and otherwise dismembered their subjects (mostly still-lifes) into many-faceted, overlapping planes and prisms, creating a rhythmic jumble of lines and thrusting volumes. By these means they found they were able to represent the same subject simultaneously from several points of view, like a two-dimensional form of sculpture. (One typical cubist subject is a head seen frontally and in profile at the same time, or even at different points in time.)

The two great cubists, working together in Paris in a highly symbiotic relationship, were Braque and Pablo Picasso. Only 26 when he painted the first cubist masterpiece, *Les Demoiselles d'Avignon* (1907), the Spanish-born Picasso was emerging from what have been called his "blue" and "rose" periods. Braque, a reserved Frenchman, came out of fauvism. Both were inspired by primitive and archaic art, and above all by the example of Paul Cézanne, whose impressionist canvases also refract light and color

into geometric shapes. (Cézanne had said that everything in nature has correspondences to the sphere, cone, and cylinder, all curved forms; the cubists went further, adding straight lines.)

Braque and Picasso worked in tandem (like Siamese twins, quips art historian Robert Hughes), stimulating and inspiring one another. They often painted the same subjects (guitars, for one), so that it is frequently difficult to tell their work apart. From their early work in the new style, which was monochromatic and austere, they proceeded (in 1912) to invent the collage (a new form of sign language, as someone aptly put it), adding the dimension of texture. Experts divide the cubist movement into analytic and synthetic phases, the first featuring fragmentation, the second reintegration.

Some wonder that the cubists never made the leap to abstraction. In any case, having thoroughly explored its options, cubism went into decline around World War I. Picasso turned to a more "classical" style, but he and others (particularly the German expressionists) continued to use cubist compositional techniques which, in a brighter, looser key, became part of the vocabulary of mainstream art.

Cubism also influenced other media. The spillover to sculpture (Jacques Lipchitz is one example) is perhaps the most predictable, but there was also a cubist school of architecture, with walls sculpted into facets (Czechoslovakia is said to have a number of such buildings). Guillaume Apollinaire, another protean figure in the Paris art world, wrote so-called cubist poetry, distorting and reconstituting his images. The American Gertrude Stein, an expatriate in Paris for her adult life, tried to achieve with words what her friend Picasso did with paint, shifting voices and juxtaposing inner and outer realities. There was even a cubist theater; Wylie Sypher calls Luigi Pirandello's *Six Characters in Search of an Author* (1921) a cubist study in "oscillation of appearances" and "diffractions of reality." Another example is *Parade* (1917), a play on which Picasso collaborated with Sergei Diaghilev, Jean Cocteau, and Erik Satie.

In the United States artist Max Weber was already adapting cubist techniques in 1911. Others who experimented with the style include Marsden Hartley, John Marin, Lyonel Feininger, and Charles Sheeler. With Sheeler, cubism began shading into precisionism, one of several mostly short-lived movements (futurism, synchromism, and constructivism are others) to which cubism gave impetus.

Cubism by Paul Waldo Schwartz is a good, short introduction, with illustrations. Wylie Sypher's *Rococo to Cubism in Art and Literature* contains some provocative ideas.

CYBERPUNK

When panic over the "Michelangelo" virus broke out among computer users in the Western world in spring 1992, life was only imitating art—or to be more specific, science fiction. Cyberpunk, a genre of sci-fi based on outlaw high technology in a world doomed by ecological overload, has been with us for quite a while. (The name derives from cybernetics, or communications and control theory, plus punk, or outrageously anti-social.) An early prototype was John Brunner's 1975 novel *Shockwave Rider*, about a rebel hacker who brings down an authoritarian futurist government by disabling its omnipotent computer. Another cyberpunk classic, *Neuromancer* (1984) by William Gibson, influenced a young German hacker who was found guilty of cracking U.S. defense computer systems and passing information to the Soviets—again, life imitating

art. (The hacker's parents, all the while, had been grateful his computer addiction was keeping him safely off the streets.)

While cyberpunk literature tends to circulate only within its subculture, cyberpunk themes are surfacing in more Hollywood movies. *Blade Runner* (1982) is a classic example, portraying a dangerous future ruled by high-tech amorality. By 1992 we had Robert Redford—a definite sign that cyberpunk had gone mainstream—as a high-tech private investigator saving the world from radical-left computer sabotage in *Sneakers*.

In music, electronic feedback plus industrial noise is typically cyberpunk; in fashion, cyberpunks favor black duds and mirrored sunglasses. The latest cyberpunk development is called "virtual reality," or a heightened, ultra-sophisticated version of reality created by such devices as the data glove, sort of a bionic hand; the eyephone, a stereoscopic vision apparatus, primitive versions of which are already available in video game arcades; and the body glove, fusing man and machine, with unlimited imaginative possibilities.

Former hippie guru Timothy Leary, struggling to come to terms with the computer age, called the personal computer the LSD of the 1990s. And *Time* magazine, describing the popular computer games Super Nintendo and Sega Genesis as "the training wheels of cyberpunk," predicted in 1993 that we will all eventually be cyberpunks.

Cyberpunk: Outlaws and Hackers on the Computer Frontier by Katie Hafner and John Markoff is a nonfiction thriller.

CYCLADIC

The exquisite small marble heads and figurines from these island stepping-stones between Greece and Turkey might easily be mistaken for the quintessentially modern sculpture of Brancusi or Modigliani. Yet Cycladic art is some 3,000 to 5,000 years old—timeless, transcendent, streamlined, and abstracted to the utmost simplicity. The figurines, which were found in graves, are assumed to be divinities, but there are no written records so this is only a guess. Other "grave goods" found include pottery vases and bronze swords and daggers.

All that we know about the people of the Cyclades is that they were famous sailors, fearsome pirates—and skillful sculptors of their local white marble. Curiously, although this was the Bronze Age and they had Bronze Age tools, they fashioned their art using neolithic or stone tools, according to Honour and Fleming.

The premier collection of Cycladic art in the Goulandris Museum in Athens is the subject of Colin Renfrew's *The Cycladic Spirit*.

Cycladic statuette in marble from the ultra-modern Stone Age, c. 2500 B.C. *(Metropolitan Museum of Art)*

Decoration exists to please the eye; its images should not seriously engage the mind or strike deep into the imagination, but should be accepted without question, like an ancient code of behaviour.

Kenneth Clark, The Nude

DADA or DADAISM

The name of this World War I–era anti-art movement is sometimes said to have been pulled at random from a French dictionary. Its meaning may be "hobbyhorse" or "yes, yes," as to life. Or it may have been chosen for sheer nonsense value by a group of anti-war iconoclasts (many of them refugees from cubism who later merged into surrealism) in Switzerland in 1916.

Rejecting inherited assumptions of style, the dadaists sought to provoke, to puncture what they called "hoaxes of reason," by outlandish pranks and deliberate absurdities. The purpose of their improvisations or "manifestations" (grandparent of the "happening") was to challenge the bourgeois values that dadaists held responsible for the war. According to literary scholar Edmund Wilson in *To the Finland Station*, they wanted "to shock a world of which they totally despaired and which they could only desire to insult."

One dada manifestation consisted of reading from a newspaper so fast as to be unintelligible, ringing bells at the same time. Another featured a young girl in a white communion dress reciting obscene poetry. Dadaism even invented its own nonsense movement, "instantism." The dadaists were also interested in exploring the irrational by means of accident and automatism. One prime dada medium was the photomontage, using and scrambling materials from the mass media, which largely eliminated

the need to paint or draw.

According to Maurice Nadeau's *The History of Surrealism*, two currents fed into dadaism: the first, playful and high-spirited, is exemplified by the work of Jean Arp, the Alsatian artist and pacifist; and the second, bellicose and doctrinaire, an offshoot of futurism led by the Romanian-born Tristan Tzara. More concerned with politics than with art, Tzara was the ideologue who coined dada's anti-Cartesian dictum, "Thought is made in the mouth." After dada merged with surrealism in 1924, Tzara broke with that group and went over to Communist party cultural politics.

Dada also had a New York branch, thanks to the fortuitous presence there of Marcel Duchamp and Francis Picabia. Duchamp was the French artist famous for his "ready-mades" or found objects such as the urinal exhibited as art at a 1917 show of independent artists in New York; Picabia was a Cuban-born painter of Rube Goldberg-type devices, who believed an artist should change styles like shirts. The sole important American surrealist was Man Ray, a painter who became better known for his photography and Rayographs, created by placing objects on light-sensitive paper. The U.S. dada movement did not produce much art, according to critic William Agee, but gave rise to an influential "salon" in the home of New York poet and critic Walter Arensberg.

Dada had a somewhat marginal vogue in the United States, being contrary to our practical, literal bent. But something of dada's absurdist spirit survived to resurface later in pop art, which is sometimes even referred to as "neo-dadaism." (Note that both these nonsense names, dada and pop, are forms of father.)

Any history of surrealism begins with an account of dadaism. Man Ray wrote a memoir, *Self-Portrait*, but it is unfortunately rather deprecatory about the dada period. William Agee's essay on "New York Dada" is in *Avant-Garde Art*, edited by Thomas B. Hess and John Ashbery. The Philadelphia Museum of Art claims the premier world collection of work by Marcel Duchamp.

DARK AGES

The concept of a "dark age" is so universal that it can be applied to almost any culture. Ancient Greece, for example, is considered to have had a dark age around 1300 B.C., precipitated by northern invaders and accompanied by a lapse into total illiteracy. Likewise, the McCarthy era in U.S. history has been described as a sort of dark age, according to the title of a contemporary history. In general in Western culture, the Dark Ages is somewhat arbitrarily assigned by historical convention to the half millennium between the collapse of Rome and the beginning of the Middle Ages. This period includes the great migration of peoples in the fifth and sixth centuries, the *Völkerwanderung*, when barbarian tribes from the East poured into Europe, where they settled and were gradually converted to Christianity. (Some have compared the present massive influx of émigrés from behind the former Iron Curtain into prosperous Germany to another *Völkerwanderung*, which will presumably result in conversion to capitalist consumerism.)

The European Dark Ages are now thought not to have been so dark after all. This was the time when the legendary King Arthur is believed to have lived ("through the shadows," writes Michael Wood, "modern historians think they have distinguished a real-life British hero") and Camelot (the invention of a 12th-century French poet) to have reigned. On the continent, the Merovingians (Childeric, Dagobert, Fredigarius)

ruled Gaul with barbarian vitality from 428 to 751; their court has been compared to a brothel, full of luxury and decadence, rivalry and chaos. They were succeeded by the Carolingians, who launched a period of enlightenment followed by yet another period of turmoil. In any case, even the best of ages have their dark periods—the Great Plague during the Middle Ages, the Inquisition during the Renaissance.

Michael Wood's *In Search of the Dark Ages* is based on a BBC-TV series.

DECONSTRUCTION or DECONSTRUCTIVISM

Originally a system of philosophical and linguistic analysis that arose in Paris in the 1970s, deconstruction made a rather sprawling leap into the visual arts in the 1990s. The French gurus of the movement, Jacques Derrida, Jacques Lacan, and Michel Foucault, began in opposition to the structuralist school (hence "deconstruction") of anthropologist Claude Lévi-Strauss. Questioning *meaning*—the structure of meaning, the meaning of structure—the French deconstructivists challenged traditional Hegelian, Kantian, and Cartesian concepts, launching grand philosophical discussions of such arcane topics as chiasmus and catachresis. This was a time when linguistics was chic. (Guerrilla cultural historian Camille Paglia, not a fan, calls deconstruction "the French fog machine.")

After Derrida's 1978 book, *The Truth in Painting* (trans. 1988), artists and architects began to jump on the intellectual bandwagon, finding principles of deconstruction (meaning not dismantling but rather disruption, dislocation, deviation, and distortion) in their work. Adepts talk about "surgically" opening classical and modern to discover suppressed elements, or about suspending the Hegelian dialectic between mind and body, theory and practice, form and content, to explore the in-between areas, the "both" and "neither." They have also created a genealogy for themselves, claiming a direct line of descent from Russian constructivism and suprematism and from such works as Marcel Duchamp's *Bride Stripped Bare by Her Bachelors, Even* (1913–23) and the staircase rid-

Planes out of plumb at the Hysolar Institute (Behnisch & Partners, 1987), Stuttgart University, Germany *(Manfred von Crailsheim)*

dles of 18th-century Italian architect and artist Giovanni Piranesi, which—there is no better word—"deconstruct" perspective.

In 1988, thanks to a symposium at London's Tate Gallery, an entire issue of *Architectural Digest,* and an exhibit at the Museum of Modern Art in New York, deconstruction ("decon" to those in the know) became an overnight media event. The main body of work under discussion and exhibition consisted of strange space-age architectural drawings full of anti-gravitational projections, radical juxtapositions, and spatial discontiguities, resembling fractured flow charts or crazy-quilt circuit boards. Most of the drawings represented unbuilt and indeed possibly unbuildable projects, such as a prize-winning "horizontal skyscraper." There do exist a handful of realized deconstructivist projects (probably strongly compromised by the forces of reality and gravity) in the United States and in Europe. Critics tend to dismiss these as "anti-social architecture," totally indifferent to comfort and convenience, making an aesthetic of bad workmanship (for example, windows and whole planes out of plumb) and bad taste.

As an example of the trickle-down process in popular culture, deconstruction made another great leap, this one into fashion. In presenting their fall 1992 collections, couturiers described unfinished seams facing outside and skirts shredded like car-wash curtains as deconstructivist. (Why not brutalist?)

The source book on the subject is *Deconstruction: Omnibus Volume,* edited by Andreas Papadakis, Catherine Cooke, and Andrew Benjamin.

DEGENERATE ART

Degenerate Art is the title (*Entartete Kunst*) of a 1937 exhibit in Munich, Germany, of all that Hitler considered objectionable in modern art, 600 works by the expressionists Max Beckmann, Wassily Kandinsky, Ernst Ludwig Kirchner, Emil Nolde, and Paul Klee. (Also banned as degenerate were serialist music and what the Nazis called "nigger" jazz.)

We are so accustomed today to the distortions, visual quirks, and glaring palette of German expressionism that it is difficult to imagine what all the fuss was about. Fortunately, a 50th anniversary remounting of the *Degenerate Art* exhibit reveals how shrewdly the Nazis made propaganda of art and how relentlessly they enforced conformity to their own ideals. Individual paintings, not necessarily shocking in themselves (and certainly not to our more sophisticated eyes), were juxtaposed or grouped in a fashion deliberately calculated to provoke. For example, expressionist portraits were hung side by side with pictures by insane asylum inmates, the caption asking "Which was painted by a schizophrenic?" A group of portraits of women, including an expressionist view of a slovenly prostitute, posed the question, "Which is the ideal of our young German womanhood?" (A concurrent exhibit of officially sanctioned art included much classically conceived, heroically overblown nude statuary.)

The 1987 retrospective in Munich included a 1937 letter from a French art collector, inquiring whether the degenerate pictures might be available at, shall we say, an appropriate knock-down. In fact, the Nazis hoped to sell the condemned art abroad for foreign currency, but having created a glut on the market, they got poor prices. Even works by the better-known expressionists realized only a few hundred dollars each. In March 1939 some 5,000 of the less saleable works were burned, and that summer 125

A page from the original 1937 catalog of degenerate art proclaiming "The whore is elevated to a moral ideal!"

of the better known were offered at auction in Switzerland, where many U.S. museums (Cambridge, Massachusetts, Cincinnati, Minneapolis, St. Louis) were able to bid successfully. A surprising number of the condemned canvases remained in Germany, where today they enjoy a certain cachet for having been blacklisted by the Nazis.

When an American version of the *Degenerate Art* retrospective was mounted in 1991 at the Los Angeles County Museum of Art, the focus was rather different. The exhibit aroused indignation about what rotten monsters the Nazis were, with little appreciation of Nazi skill at distorting and manipulating art and life.

The catalog of the exhibit was published as *Degenerate Art: The Fate of the Avant-Garde in Nazi Germany*, Stephanie Barron, ed. The exhibit also gave rise to an excellent documentary film that plays occasionally on public television.

DELFT

In the mid-17th century this riverine city in Holland, a brewery town fallen on hard times because of British competition, became the most important European center of earthenware production. Inspired by Oriental porcelain imported by the Dutch East India Company, the potters of Delft created a distinctive ceramic language which would spread, acquiring slightly different accents, far and wide. In production technique, Delft is a tin-glazed earthenware, similar to Italian majolica and French faïence. The distinctive Dutch contribution is to have adapted the fad for blue and white chinoiserie (in contrast to the brighter colors and busier patterns of majolica and faïence) into highly personal and charming landscapes, flower patterns, and genre scenes. A successful sideline in decorative tiles, frequently seen today lining the kitchens of French châteaux, is also called Delft although the tiles were generally produced elsewhere in Holland.

Delft went into decline as a production center in the 18th century, but generic delftware (that is, tin-glazed earthenware, usually with a blue and white pattern) was produced for another century in England, although never quite as finely shaped or colored as the Dutch prototype.

DEMOCRACY

Again, using the more active suffix *-cracy* (see ARISTOCRACY) from the Greek verb "to be strong," rather than the more passive, conceptual *-ism* form of the noun, we have democracy or the rule of the people. Ancient Greece is considered to have developed the world's first "direct democracy," but the United States ranks as the first major experiment in constitutional or representative democracy. Not only did we overthrow a colonial monarchy, we also eliminated the hereditary ranks and privileges of aristocracy, making in effect a social revolution as well as a political one. Culturally, however—and that is the aspect of democracy at issue here—the United States has been in a continuous process of self-creation.

The American experiment was of particular interest to the French, who under Napoleon had reversed the social component of their 1789 revolution, restoring aristocratic privilege. Visiting the United States in the 1830s, the French nobleman Alexis de Tocqueville affirmed democracy as the great principle of the day but warned against the American tyranny of the majority and contempt for creativity. De Tocqueville concluded that American democracy had a deleterious effect on culture—"the principle of equality," he wrote, "has dried up most of the springs of poetry."

Writing after the Civil War, the American poet Walt Whitman (in an essay called *Democratic Vistas*) also deplored American intellectual superficiality and materialism, but he credited democracy with making possible his own self-discovery and his poetry. Feudalism, Whitman believed, had long restricted advancement and advantages to the privileged, whereas democracy, the most comprehensive political faith, opened the future to all. Openness itself, to oneself and others, Whitman considered a peculiar American virtue. (De Tocqueville had also remarked on this American openness, in striking con-

trast to the English aristocracy, "closed" by constant dread of familiarity with inferiors.)

The general consensus on democracy, as a culture rather than as a political method, is that it replaces the former "high" culture of the aristocracy with the "low" culture of the masses. (Another way of expressing this distinction is between classical and popular—as in popular music, or rock 'n' roll, which to many seems the very antithesis of classical music.)

Examining the relation of democracy and culture in the later 19th century, historian Daniel Boorstin tends to agree with de Tocqueville. Democratization of power in America brought the democratization of cash and of culture as well, Boorstin writes, marshalling all the evidence of American ingenuity and progress—our genius for homogenization, condensation, and mass-production—as death to (high) culture.

See any edition of de Tocqueville's *Democracy in America*, first published in 1835. Boorstin's *The Americans: The Democratic Experience* is one volume of an excellent three-part study of American history.

DE STIJL

An eminently serious and austere post–World War I movement in Holland, De Stijl was based on geometric principles of absolute abstraction. "The square is to us as the cross was to the early Christians," proclaimed Theo van Doesburg, an artist with architectural and design interests who in 1917 founded the journal from which this movement took its name. He and his followers proposed to disengage form from nature, to purify it of all ornamental idiosyncracy.

By way of cultural background, De Stijl (pronounced *dee style*) was influenced by Dutch Calvinist iconoclasm, chiefly the idea that images distract man from God's sanctity, and by the effort of the Dutch to control nature, itself practically rectilinear in the flatlands of northern Europe. The post-war rejection of decadent bourgeois individualism and the search for cultural community also affected these artists. A certain dogmatism is apparent in the name van Doesburg chose— "THE style." The movement had a short and not always harmonious history, coming to grief over what others would consider arcane issues.

To nonspecialists the work most readily identifiable with De Stijl is that of artist Piet Mondrian, whose grid-like compositions have been widely imitated in the United States in everything from linoleum to fashion. (There is even an entire building

The orthogonal versus the diagonal: Piet Mondrian's *Diamond Painting in Red, Yellow, and Blue* (1921–25) (*National Gallery of Art*)

painted Mondrian style on the Sunset Strip in Hollywood.) Mondrian already had an independent reputation and base in Paris when his rather obscure philosophical tract on "Neoplasticism in Painting" was reprinted in the early issues of van Doesburg's magazine. The publisher developed his own ideas (called elementarism), and the two eventually parted company in the mid-1920s when van Doesburg proposed to introduce diagonals into Mondrian's grid format. There would be no compromise between these two austerely dedicated men, each claiming a higher authority: Mondrian was a Theosophist, while van Doesburg subscribed at one time to the ideas of a philosopher who believed in "the cosmic pre-eminence of the orthogonal."

Then the publisher (who in the early 1920s went to Germany and set himself up in direct competition with the like-minded Bauhaus) alienated the architects in his movement over the issue of color, which van Doesburg argued should have primacy over structure. De Stijl collapsed in any case with its founder's death in 1931, leaving to the history of style a few pieces of innovative furniture and a house in Utrecht designed by Gerrit Rietveld.

De Stijl: 1917–1931, Visions of Utopia, edited by Mildred Friedman, is a handsome coffee-table book that tends to take its subject a bit too piously.

DIRECTOIRE

This was a brief but pivotal period in French history, the turbulent post-revolutionary years of 1795–99 when the new republic was ruled by a directory of five men. As a style in the decorative arts, directoire is transitional between Louis XVI and Empire, a further simplification of Bourbon neoclassicism. A movement toward greater austerity had begun even before the revolution, for economic as well as aesthetic reasons. Besides, the post-revolutionary years were too unsettled to encourage creativity.

Directoire furniture is often simply waxed or even painted, in contrast to the elaborate Bourbon confections in marquetry and gilt that it replaced. Republican symbols (including the *fasces*, or sheath of wheat, later to become a fascist emblem) were common on cloth, wallpaper, and ceramics as well as on furniture. There was also a distinct directoire style in dress: the low-neck, high-waisted chemise or classical tunic for women, and tight breeches and wide lapels for men ("a fantasticated version of English country clothes," according to fashion expert James Laver). In art, the austere neoclassicism of Jacques-Louis David, who depicted heroic subjects from antiquity, is sometimes identified as directoire. (David was later commissioned to paint a giant tableau of Napoleon's coronation, which he executed in a slightly more "Byzantine" style.)

Something called directoire fashion enjoyed a revival in 1908. U.S. President Theodore Roosevelt's daughter, Alice, was among those to adopt a "refashioned" sheath dress that year.

DOULTON

In the second generation of this English ceramics dynasty, Sir Henry Doulton ensured the family fortunes and launched the great sanitary revolution of the Victorian age with his glazed stoneware baths and basins. Naturally preferring not to be remembered as the father of the modern WC, Doulton also forged a relationship with the nearby

Lambeth School of Art to produce ceramics in the Arts and Crafts style, giving artists and potters individual responsibility and credit for their production.

The typical 19th-century Doulton product was salt-glazed or matt-glazed stoneware in the traditional styles and shapes (jugs and tankards) of 17th-century England and Germany, with incised or carved decorative patterns. The factory also produced everything from vases and candelabra to brewery and pub fixtures. In fact, Doulton has produced such a variety of wares over time—a line based on the characters of Charles Dickens, a series of "Gibson girls," dogs, hunting scenes, and nursery motifs—that it is impossible to identify a recognizable Doulton style. When in doubt, turn the piece over and look for the mark (since 1902, when they became Royal Doulton) of four interlaced Ds under a coronet and lion. The problem of identifying 19th-century pieces is complicated by the long list of artists who signed their work for Doulton.

DYMAXION

This is not so much a style as a code-word (meaning "optimal rationality" or "energy efficiency") for the many-faceted ideas and inventions of an eccentric American genius. The word Dymaxion was actually coined by a publicist, synthesized from dynamic, maximum, and ion, but it became the personal trademark or design concept of self-taught guru Buckminster Fuller. Descendant of a long line of New England nonconformists, Fuller was sort of a holy fool who believed in using science to meet basic human needs like food and shelter. Among his early inventions were the Dymaxion house (patented 1927) and Dymaxion car (1937), both capable of inexpensive mass production. The house or "living machine" with its mooring mast (to be erected by dirigible, according to the instructions) was a bit ungainly, a high-tech idea way ahead of its time. So was the 12-passenger car: omnidirectional, it could move sideways like a crab or forward (to 120 mph), consuming fuel at the economical rate of 50 mpg. After the prototype was involved in a fatal accident, the car was shelved, to the undoubted relief of Detroit. This would be the fate of most of Fuller's 2,000 patents.

After World War II Fuller seemed to catch a second wind, finally achieving a measure of popular acceptance with his geodesic dome. An elegant structure of honeycombed metal struts, Fuller's dome (first erected in 1959) maximized strength and space enclosed with minimum expenditure of time and materials. (St. Peter's dome in Rome weighs 30,000 tons; a geodesic dome of the same size would only weigh 30 tons.) It became a regular feature at international fairs, the best known probably being the U.S. pavilion at Expo '67 in Montreal. (It was in a Fuller dome at a Moscow trade fair in 1959 that the famous Nixon-Khrushchev "kitchen debate" took place.) The domes have

The prototype Dymaxion House *(Kansas State Historical Society)*

Buckminster Fuller's geodesic dome at Expo '67—the Biosphere *(© 1968 NFB Phototheque ONF)*

mushroomed everywhere over the years, from models built by architecture students on campuses to banks and auditoria (the acoustics are said to be great). When a dome was erected in Afghanistan, the locals were sure it was a modern Mongolian yurt; in the Arctic, the Eskimos recognized it as a relative of their igloo.

Expounding "salvation-through-design at the rate of seven thousand words a minute," Fuller did not find many willing to listen. Architect Louis Kahn came under Fuller's influence for a period, proposing a geodesic skyscraper for Philadelphia's City Hall, but Kahn was a rare case. Near the end of his long career, however, Fuller found a receptive audience in the hippie generation, who welcomed the Harvard College dropout as a counterculture hero, listening raptly to his extraordinary marathon lectures on tuning up Spaceship Earth. (Fuller was definitely entertaining, with his own personalized lyrics to "Home on the Range": "Roam home to a dome, where Georgian and Gothic once stood....") Straight society has always tended to dismiss as benign nonsense Fuller's conviction that "Earthians" are shockingly wasteful and need to learn to do more with less.

The Dymaxion World of Buckminster Fuller by Robert W. Marks is a sympathetic, affectionate account. English architectural critic Reyner Banham was also pro-Fuller, giving him a chapter in *Theory and Design in the First Machine Age*.

All is ephemeral—fame and the famous as well.

Marcus Aurelius

EASTLAKE

Better American furniture of the period after the Civil War is sometimes said to have been "Eastlaked," or improved according to the ideas of English art and architecture expert Charles L. Eastlake. Author of an influential book, *Hints on Household Taste in Furniture, Upholstery and Other Details* (1868), Eastlake (in the same tradition as William Morris and the Arts and Crafts movement) helped put a brake on early Victorian excess, the tendency to clutter and fuss in overstuffed interior decor.

An authority on the Gothic, Eastlake rejected fashionable revival styles of the 19th century in favor of simple, solid medieval forms, angular rather than curved, designed for comfort and convenience. His "austerely picturesque" furniture, ornamented with incised lines, stylized sunflowers, and diagonal paneling, ranked for many as the epitome of high Victorian good taste. Not everyone agreed, however. "Mr. Eastlake has the misfortune," according to an 1877 American design publication, "to have his name associated with more ugly furniture…than the world ever saw before." In any case, there are few if any surviving pieces based on Eastlake's book. His designs were widely influential but rarely copied.

Joseph T. Butler's *Field Guide to American Antique Furniture* has a section on "Eastlake-influenced" furniture, including some pieces produced in Grand Rapids, Michigan.

EDWARDIAN

The Edwardian area is one of those neat little periods, not too long, quite distinct from what came before and after, and very appealing in its own right. It evokes a special quality of nostalgia because it is the watershed of the modern era, the "last golden summer" of the British Empire.

During an exceptionally long immaturity, which lasted until he finally succeeded to the throne in 1901 at age 59, Edward had the reputation of a playboy prince who ruled society while his mother, Queen Victoria, ruled the world. Edward reigned as king for only nine years, but the period named for him is usually extended back in time to enclose the Gay Nineties and forward to 1914, when the curtain came down precipitously on the old order.

Mrs. Edward L. Davis and Her Son (1890), one of John Singer Sargent's portraits of the Edwardian aristocracy *(Los Angeles County Museum of Art)*

Having suffered an archetypal Victorian childhood, Edward tended to the other extreme. Where the Victorian era was prudish and repressed, the Edwardian was pleasure loving, indulgent, lavish in display. And where the Victorian era was typically feminine, the Edwardian was self-consciously masculine, its ideals expressed in the poetry and adventure novels of Rudyard Kipling, full of swagger, jingoism, misogyny. (The king, who had an eye for pretty women, did not share this latter sentiment.) Another prime Edwardian character is Peter Pan, the little boy who prefers the charms of childhood to the dubious advantages of maturity.

Edwardians enjoyed low taxes, large house parties, and armies of servants. (This is the world of "Upstairs, Downstairs," remember.) As if for Edward's personal amusement, the auto, the airplane, and the cinema came along at about this time, coexisting with the horse and carriage, the luxury train, and the music hall (called vaudeville in the United States). Edward was himself a music hall fan and a seasoned traveler, who went regularly for cures at the glittering spas of Europe. A corpulent

voluptuary (in Kipling's words), he accidentally made the discovery that creases in one's trousers had a slimming effect, launching a new fashion. He is also credited with inventing the dinner jacket to replace the traditional swallowtail coat.

In architecture, the new London Ritz, the first major building in the city with a steel frame, became a symbol of Edwardian luxury. (A new London hotel chain now calls itself the Edwardian, obviously hoping to capitalize on the association.) Another Edwardian creation was the *Titanic*, the luxury liner whose sinking in 1912 is such a striking metaphor for the age.

The Edwardian era is singularly English, but there were some prominent American Edwardians—including President Theodore Roosevelt, a leader after the heart of Kipling. In literature and in art, curiously enough, the great Edwardians (after Kipling) were Americans. John Singer Sargent, an American who lived most of his adult life in Europe, gave a new visual meaning to aristocracy with his elegantly elongated portraits of the English elite. (Many of his subjects were in fact American heiresses married to English peers.) At home, the willowy Gibson girls and pigeon-breasted matrons in women's magazine illustrations were distinctly Edwardian. And in literature, America threw up two great Edwardians in Henry James and Edith Wharton, both upper-crust Anglophiles who wrote tales of Old World sophistication versus American naiveté.

Wharton also wrote the last word on Edwardian interior decor, collaborating with Boston architect Ogden Codman on a how-to book, *The Decoration of Houses* (available in a recent paperback reprint). There was no very distinctive Edwardian style in furniture, but this period produced reproductions on a large scale of 18th-century French antiques (to furnish the Ritz and other Edwardian palaces). These are considered good quality copies, and considerably less expensive today than the real thing.

The Edwardian era ended with the First World War, but there were abundant signs of its demise before then. The last years before 1914 were full of confrontations in Britain, with organized labor testing its strength and increasingly militant suffragettes demanding the right to vote. One of their many acts of protest was to vandalize Sargent's portrait of Henry James.

J. B. Priestley's *The Edwardians* is a historian's memoir of his childhood. *The World of Edwardiana* by Philippe Garner is a good and lively survey.

EGYPTIAN

Egypt was the site of the first great civilization of ancient history and one of the longest lasting, bequeathing to us the pyramid, the column, the obelisk, and the very language of stone. Writing, astronomy, geometry, and the invention of glass were other major spin-offs from this new cultural vortex that arose in the Nile valley around 3000 B.C.

Having constructed large-scale waterworks to control the annual run-off from the great Nile River, the ancient Egyptians were skilled engineers. They also had the ability to command vast armies of laborers, who were set to work building the pyramids, tombs and ladders to the sun for the pharaohs, who were venerated as gods. Eventually some 80 tombs, major and minor, would be uncovered by archeologists, many crammed with ritual objects and personal possessions to accompany the mummified deceased into the afterlife.

Like everything else in ancient Egypt, culture was centralized and conventional-

ized, creating a common style that underwent little change for 3,000 years. This is not to say there is no variety; scholars identify 120 different poses in Egyptian art of the Old Kingdom alone, each with its own rules. Seated figures generally have their hands on their knees, and men are typically depicted a few shades darker and a few degrees larger than women. Figures carved in the round are strictly frontal, but bas-relief sculpture and wall painting feature a characteristic "Egyptian pose," the lower body in profile, shoulders and chest facing front, the head in profile but with a full-face eye. Most typically represented were the pharaohs and their retainers, along with the gods Isis, Osiris, and Horus, who appear as frequently in Egyptian art as nativity and crucifixion scenes in Western art.

The Egyptians had a supreme style instinct, investing their sculpture with an elegance and mystique that continue to fascinate. In any of the world's major museums on a Sunday, you will find the greatest crowds grouped around the mummies, sphinxes, and statues of Egyptian rulers. Highly stylized, perfectly dignified, elaborately detailed, down to the plaited hair and square-cut beards—Egyptian sculpture also captures an occasional feeling of tenderness, a moment of intimacy, in stone. Forever elegant (guerrilla cultural historian Camille Paglia calls them the first "beautiful people"), museum Egyptians evoke the power of beauty and mystery.

Scholars divide Egyptian civilization into three periods, the Old Kingdom (2686–2160 B.C.), the Middle Kingdom (2040–1633 B.C.), and the New Kingdom (1558–1069 B.C.), each followed by an intermediate period. Your memory bank probably contains the name Tutankhamen, the boy king whose grave was found in 1922; Nefertiti, whose famous bust (now in Berlin) has become a kitsch icon; or Ramses, familiar from Verdi's *Aïda* (an opera commissioned when the Suez Canal opened in 1869). All three reigned during the New Kingdom. (Nefertiti is not to be confused with Nefertari, wife of Ramses II, who lived a century earlier, but both are New Kingdom.)

After the New Kingdom, Egyptian civilization fell under the influence of the ancient Greeks and Persians. When Alexander the Great conquered the country in 332 B.C., a new dynasty was founded by his general, Ptolemy. (Most famous of the Ptolemies is, of course, Cleopatra, who ranks as one of the most fascinating females in history, immortalized by Shakespeare, George Bernard Shaw, and Cecil B. De Mille.) The ancient Greek historians Herodotus and Plutarch were among the first tourists to visit Egypt and write about it, while the Romans were the first in a long succession of plunderers, scrawling their names on tombs and carrying off whatever antiquities took their fancy—including the world's tallest obelisk, one of the tapered stone monoliths that flank temple entrances.

Some scholars go so far as to call Egypt the cradle of Greco-Roman classicism, but unfortunately, following the decline of pharaonic Egypt, the country somehow got pruned from the family tree of Western culture. The Romans closed the "heathen" temples, thus cutting Egypt off from its past, since the knowledge of hieroglyphics, a priestly monopoly, was lost. In the Bible, Egypt appears from the Hebrew point of view. After the decline of the Roman Empire, Egypt was islamicized, waxing and waning under various Islamic dynasties until it was "rediscovered" by Napoleon's armies in 1798.

The French launched the great age of Egyptian scholarship, tourism, and looting of antiquities. Accompanying the French army were scientists charged with measuring and drawing all monuments. The most important of them was Champollion, whose linguistic studies finally unlocked the secret of the hieroglyphics in 1825. In the looting

department, great hoards of Egyptian antiquities were shipped to London, Paris, Berlin, and Turin, Italy. From the temple at Luxor, France acquired the obelisk that stands today in the Place de la Concorde in Paris. (The twin "Cleopatra's needles," which stand in London and in New York's Central Park, were a gift from a later pasha.)

Napoleon's Nile campaign launched a popular vogue for things Egyptian, a style called *Retour d'Egypte* (return from Egypt) or Egyptian revival in English. Small objets d'art such as clocks were turned out with Egyptian pylons flanking the face, or vases featuring the Egyptian cat goddess. If you were really into it, you could remodel your fireplace after a temple entrance. Experts report that authentic Egyptiana is still plentiful and some of it surprisingly affordable because Egyptian tombs were crammed full of provisions for the afterlife. Good-luck scarabs can be had for $50, with bronze servant figurines starting at $1,200 and stone-carved reliefs at $5,000.

Architecturally, Egyptian revival style seemed to lend itself to funerary monuments and centers for religion and the occult. In the United States, Philadelphia's Cherry Street Synagogue was reconstructed in the 1820s in Egyptian style, as was the city's Debtors' Prison in the 1830s. The Kansas state capitol has Egyptian ceilings, constructed by Egyptian laborers brought in for that purpose. Of a list of 60 Egyptian-style buildings in the United States before the Civil War, most famous was the New York City Hall of Justice built in 1838, a prison popularly called "the Tombs." Best known is certainly the obelisk-shaped Washington Monument on the Mall in Washington, D.C., dedicated in 1885.

Somehow, some Egyptian tombs and

Detail from a tomb mural depicting the supremely elegant Queen Nefertari *(Guillermo Aldana, Getty Conservation Institute)*

treasures managed to survive intact until the early 20th century, when the great American collections were put together. New York's Metropolitan Museum of Art conducted its own excavations in 1907–42 and later acquired an entire Egyptian temple (albeit from the Roman era), moved lock, stock, and barrel from Dendur in the 1970s when it was threatened with flooding by Nile dam construction. Other major American hoards of

Egyptian antiquities were amassed by the Brooklyn Museum and by the Boston Museum of Fine Arts.

In the 20th century, the Egyptian pyramid continues to exert a timeless fascination. Some recent variations on the theme include San Francisco's Transamerica Tower; a rose marble pyramid in California's Sonora Desert, supposedly marking the center of the earth; a high-rise sports and entertainment complex in Memphis, Tennessee (a city named after the capital of the Old Kingdom); and a pyramid (plus sphinx and curse) on the Las Vegas strip.

For Egyptian antiquities you can visit without leaving the United States, see *Ancient Egyptian Art in the Brooklyn Museum* by Richard Fazzini and Howard Hibbard's *The Metropolitan Museum of Art*. Cyril Aldred wrote *Egyptian Art* in the Thames & Hudson series. *The Egyptian Revival* by James Stevens Curl is a scholarly compilation of Egyptiana in the West.

ELIZABETHAN

The Elizabethan period is the English Renaissance, the great age of exploration and the Armada, and the age of Shakespeare, but the dominating feature of the time is the 45-year reign of Queen Elizabeth I (born in 1533, crowned in 1558, died in 1603). If ever there was a "Renaissance woman," it was Elizabeth—audacious, vain, witty, autocratic, proud. Historian Lacey Baldwin Smith describes her as "a brilliant liar, a pinchpenny of great talent, an egoist of royal magnitude." She learned and used Latin, Greek, French, and Italian; rode and danced well; and ruled surely and with relish, despite the fact that she lacked clear title to the throne, had no army standing behind her, and was of course the wrong sex. Last but not least she was a great actress, with a flair for the extravagant pageantry that made her reign so popular. After the masculine Tudor era, the Elizabethan era was feminine, with women looking like "gorgeous wasps" in their high ruffs (as if they were being elegantly strangled to death, as Quentin Bell so aptly wrote), narrow bodices, farthingales, and voluminous skirts, every surface covered with jewels and embroidery.

You have only to read Elizabethan literature to realize that before the curtain of Puritanism fell in the 17th century and was sealed shut by the Victorians, the English were a bold, expressive, and ostentatious lot, pleasure loving and passionate. Picture those grand swashbucklers Walter Raleigh (a poet, adventurer, and entrepreneur) and Francis Drake, out forging the foundations of the British Empire, an enterprise in which the queen took the most avid interest. Considering that England arrived late on the scene—a hundred years after the Spanish, and after the Pope had already divided the Western hemisphere between the Spanish and the Portuguese—and were a much smaller nation, the British Empire in America is the more impressive an achievement.

Culturally England was far from Italy, and its Renaissance remained in many respects nearer to the Middle Ages in spirit. (As historian A. L. Rowse puts it, the Renaissance came late to England, where it took a mannerist form.) In architecture, the extravagant mansions built by the Elizabethans (primarily as showplaces to entertain the queen on her "progresses") were still primarily Gothic, with some Italian Renaissance details. And in poetry and drama, the great Elizabethan arts—as evidenced by the imperishable works of William Shakespeare, Christopher Marlowe, and Edmund Spenser—were only super-

ficially influenced by Renaissance ideals. Shakespeare, in particular, was a determined anticlassicist, ignoring all canons of unity and restraint, mixing the grotesque and the sublime in his inimitable tragedies and comedies.

In music, the Elizabethan era gave us lovely motets and madrigals, the virginal, and the lute. In the visual arts, it is fashionable to deride the Elizabethans for failing to acquire Italian Renaissance skills in perspective and representation, but take another look. After the disestablishment of the church by Henry VIII, it was no longer acceptable to paint religious subjects, so Elizabethan painting is primarily portraiture—and what grand portraits, especially of Elizabeth herself. The flat, frontal style with its somewhat naive quality was copied by early American limners, our first portrait painters, in preference to "correct" Renaissance canons.

Another American inheritance from the Elizabethan era, cultural historian Vernon Parrington points out, is a picturesque, racy style of speech, full of idioms, aphorisms, and practical jokes, that still lingers in our southern backwoods.

The standard work on the era is the two-volume history by A. L. Rowse. *The Horizon Book of the Elizabethan World* by Lacey Baldwin Smith is also highly recommended.

EMPIRE

After the destruction, tumult, and austerity of the Revolution and Directoire, France under Napoleon returned to the unabashed opulence and ostentation cultivated by the ancien régime. The basic neoclassical style, popular since the archeological discoveries at Pompeii and Herculaneum in the last years of Louis XVI, became heavier and more sumptuous with the addition of imperial emblems (giant Ns in laurel wreaths or Napoleon's emblem, the bee) and insignia of conquest (the Egyptian sphinx or lotus). The resulting style, which spread through Europe to Russia in the wake of Napoleon's armies, is known as Empire (pronounced *omm-peer*).

The wealth and furnishings of royalty and nobility having been confiscated and dispersed during the revolution, Napoleon had his role cut out for him as a patron of the decorative arts. The emperor would devote enormous expenditures to refurbishing recently plundered châteaux and public buildings. The chief Empire medium was therefore furniture and interior decor. Distinctively Empire are the console table; the curule, a bench or chair with an X-shaped base; and the "clismos," a chair with flaring sabre legs. Also in vogue were récamiers or Greek couches with scrolled ends, so called for a famous portrait of a Frenchwoman reclining seductively; sleigh beds; and the use of fabric suspended from the ceiling or wall to create a tentlike effect (reminiscent of Napoleon's campaigns?) over the bed.

In architecture, the Arc de Triomphe in Paris is a prime example of Napoleonic style. And in Russia, the eastern terminus of Napoleon's invasions, Leningrad's Admiralty and Stock Exchange were built in the Empire style.

In Germany and Austria, Empire underwent a rather bourgeois metamorphosis into Biedermeier. In the United States, still a cultural borrower rather than an innovator, we designate as Empire the second phase of classicism, running after the Federal period from 1810 or 1820 to 1840. After the British burned the White House in the War of 1812, some of the reconstructed rooms were remodeled in the newly fashionable Empire style.

New York, where many French cabinetmakers had fled the revolution, became a center of fine furniture production, turning out the clismos, curule, and récamier. The most important figure of the period in America, however, was the Scottish-born Duncan Phyfe, whose stylistic signature falls somewhere between English Regency and French Empire. Quite an enterprising businessman, Phyfe provided generations of Americans with furnishings in the finest West Indian mahogany.

The world's largest collection of Empire objects, French and Russian as well as American, is said to be in a New York City antique shop called Malmaison. Dubbed "the art deco of the 19th century" by pop artist Andy Warhol, Empire is now in vogue again.

Empire Style: 1804–1815 by Nietta Aprà is a good introduction.

ENLIGHTENMENT

The Germans, who first gave the Enlightenment its name (*Aufklärung*—the same word for explaining the facts of life), have a branch of spiritual or intellectual history that has no equivalent in English. An offshoot of German idealist philosophy, German intellectual history (*Geistesgeschichte*) focuses on ideas rather than on political, economic, or social forces as the motive power of history. Thus, while a cultural historian might describe the 18th century as baroque, rococo, or neoclassic, and someone with a political or economic specialty would talk about the ancien régime and mercantilism, the Germans characterized the Enlightenment by a common style of thinking.

Historian Arnold Hauser, for one, believes that the Enlightenment and not the Renaissance is the decisive turning point to modern history. The period is generally held to begin with the scientific discoveries of Newton, Galileo, and Descartes in the 17th century. The scientific revolution they launched encouraged European scholars in all fields to seek more rigorous rules or methods—their own laws of gravity, as it were. Replacing faith with reason, these scholars (called *philosophes*) were cosmopolitan, humanist, above all secular. (Newton, an exception, described God as "the Great Mathematician," and fussed with "biblical arithmetic" to date the millennium.)

From unraveling the mysteries of nature, the philosophes turned to the science of man, giving birth to the first classics of the social sciences. In sociology, Montesquieu wrote his path-breaking *The Spirit of Laws* (1748); in psychology, Diderot (better known to us for his encyclopedia, a typical Enlightenment enterprise to spread knowledge) anticipated some of the concepts of Freud; John Locke applied the scientific method to the study of government; and perhaps most important of all, in political economy, Adam Smith opened new worlds of analysis with his *Wealth of Nations* (1776). (The field of history, neither new nor claiming to be a science, also produced new classics, such as Gibbon's *Decline and Fall of the Roman Empire* in 1776–88.)

Just as the scientific revolution launched the Industrial Revolution and the Enlightenment, these forces combined in turn to launch a political revolution. First we see a new variation on an old theme—"enlightened despotism," as in Frederick the Great's Prussia, Catherine the Great's Russia, or Joseph II's Habsburg Empire. (Frederick, write Bronowski and Mazlish in *The Western Intellectual Tradition*, "collected great philosophers in the way his father before him collected outsized soldiers.") It was in the least enlightened of contemporary despotisms, Bourbon France, that the great revolution burst forth in 1789, sweeping away the ancien régime entirely.

The first country to put the Enlightenment into practice was the United States, under the leadership of our own great philosophers, Benjamin Franklin, Thomas Paine, and Thomas Jefferson. "The American nation," writes religious historian Sydney Ahlstrom, "was born in the full illumination of the Enlightenment. And this fact would permanently distinguish it from every other major power in the world." With the American Revolution in 1776, as Peter Gay points out, the United States first became an exporter rather than an importer of ideas, helping prepare the way in turn for the French Revolution.

The leading contemporary work on the period exists fortunately in both short and long forms. Peter Gay's two-volume study, *The Enlightenment: An Interpretation*, also comes in an abbreviated volume published by Time-Life, *Age of Enlightenment*. On the American Enlightenment, see *Cincinnatus: George Washington and the Enlightenment* by Gary Wills.

EPISCOPALIAN

The Protestant Episcopal Church is the name of what was the Anglican or Church of England in the American colonies before the Revolution. This was the colonial church for the socially prominent, especially in the South: George Washington was an Anglican, as were (nominally, at least) Thomas Jefferson and James Madison.

The Anglicans were active in colonial higher education, founding King's College (later Columbia University) in New York in 1754, and aggressive proselytizers through their Society for the Propagation of the Gospel. Some Anglican landmarks in the colonies include Trinity Church in New York and Boston's North Church, whence Paul Revere made his ride. In matters of faith, Anglicans considered the Bible to be the last word. Because of the close ties between mother church and mother England, Anglicans were perceived to be Tories and Loyalists, an identification that would have serious consequences for the church. In fact, an estimated 70,000 Anglicans left America after the Revolution rather than accept independence. In Virginia, where Anglicans had enjoyed special privileges as the established church, fully two-thirds of rectors joined the exodus.

In 1789 the former Anglicans (their ranks further thinned by the defection of the Methodists) reestablished themselves as the Protestant Episcopal Church in the United States. The new church adopted more democratic forms, electing its leaders and strengthening local vestries. Generally known as Episcopalians (meaning church of the bishops, a rather Roman Catholic concept), they continue to rank as "high church" by American standards, with a small (3.3 million in 1974) but select membership. According to a Twentieth Century Fund survey of art museum trustees in 1969, a disproportionate 38 percent identified themselves as Episcopalians.

EXISTENTIALISM

In Paris after World War II, the "in" movement was existentialism, a pessimistic statement about humanity whose leading guru was Jean-Paul Sartre. Drawing on the works of philosophers Soren Kierkegaard and Friedrich Nietzsche and novelists Fyodor Dostoyevsky and Franz Kafka, Sartre formulated a philosophy in *Being and Nothingness* (1943) that turned Cartesian logic upside down. Where René Descartes had said "I think, therefore I am," Sartre put existence first: "I am, therefore I think...and feel...and

despair." Sartre's great originality, leftist philosopher Fredric Jameson points out, is to have made a problem of something we take for granted, our very existence.

Focusing on will rather than on reason, subjective experience rather than "truth," Sartre stressed man's freedom and responsibility, further sources of guilt and despair. Every action precludes other possible actions, its consequences further limiting potentialities, to a point of dizzying absurdity. (Put simply, the odds are against us and the best we can do is to play a losing game well...with style, the French might say.)

Existentialism had great post-war influence in such disparate fields of endeavor as religion and psychology, literature and film. Although Sartre certainly considered God to be dead, existentialist ideas were reflected in the work of Protestant (Paul Tillich and Karl Barth) and Jewish theologians (Martin Buber). Existential psychologists dealt with here-and-now consciousness, man being personally without history according to Sartre, while existential literature—two key works are Sartre's *Nausea* (1938) and *The Stranger* (1942) by Albert Camus—inclined heavily to alienation and dread. The French "New Wave" film classics *Hiroshima Mon Amour* (1959) and *Last Year at Marienbad* (1961), both directed by Alain Resnais, reflected the existentialist position that the past has drastically compromised the future. Existential angst even trickled down into television (remember *Run for Your Life* and *The Fugitive*?). In fact, as a descriptive adjective, *existentialist* became so elastic it could be vaguely applied to just about anybody past (19th-century psychologist William James) or present (beats, hippies).

If you still don't understand what existentialism means, the anthology edited by Walter Kaufmann, *Existentialism from Dostoevsky to Sartre*, may help.

EXPRESSIONISM

The stronger a society's inhibitions, it may be said, the stronger will be the revolt against them. When the wraps came off in Germany, the Western world's capital of duty, order, and conformity, the result was violent, grotesque, alienating. We are talking here about the early 20th century movement called expressionism, of which the leading exponents were all German or Nordic (with the possible exception of the Frenchman Georges Rouault). Their immediate models were Cézanne, Van Gogh, Matisse, fauvism, and cubism, but what they really sought was to go back to the origins of art, back beyond the archaic and primitive to the primeval.

During the 18th and 19th centuries the Germans had followed the lead of the French in the arts, developing their own voice only in music. Only around 1900, a generation after German unity was tardily achieved under Bismarck, did a distinctive German style in painting, named "expressionism" to distinguish it from impressionism, arise. Instead of seeking beauty, truth, or harmony, the expressionists painted violently distorted portraits of people with garish red and purple mask-like faces that were shocking and grotesque. Giving free rein to emotion and carnality rather than intellect and reason, extolling untamed, urgent subjective experience rather than objective reality, they created monuments of angst, alienation, depression. Typical themes were rebellion against authority, redemption via suffering, love and hate, finally love of death.

Expressionism went through several phases (see THE BRIDGE, THE BLUE RIDER, NEW OBJECTIVITY), and its influence seeped from art into various media. In literature, the pre-eminently expressionist novel is Heinrich Mann's *Professor Unrat* (1905), better known

**An 1895 lithograph of the preeminent image of expressionism,
Edvard Munch's *The Scream*, an 1893 oil *(National Gallery of Art)***

to us via the Marlene Dietrich film *The Blue Angel* (1930). In the theater the movement produced stereotyped characters speaking shorthand dialogue against sketchy backgrounds, sort of early Brecht. The German film *The Cabinet of Dr. Caligari* (1920) is an expressionist canvas in celluloid, a crazily tilting nightmare. Expressionism left its imprint on architecture—the Einstein Tower in Potsdam, Germany, and Le Corbusier's mushroom-shaped chapel at Ronchamps, France, both treat concrete as a plastic material to be sculpted into primal forms. In politics expressionism came to mean rejection of bourgeois values in favor of socialism and anarchism.

Thriving on opposition to authority, the expressionist movement matured in Wilhelminian Germany. By the 1920s, when the German empire had been replaced by the short-lived Weimar Republic, expressionism even enjoyed a certain vogue. The movement was of course repressed by Hitler, who considered it degenerate art, burn-

ing and banning its exhibits and even forbidding some artists to paint at all. (In defiance, the Austrian Oskar Kokoschka painted his 1937 *Self-Portrait of the Artist as a Degenerate.*)

Yet as art historian Bernard Myers suggests, expressionism and nazism have more than a little in common. "There is a consistent type of emotional expression in German culture," Myers writes, "which contains varying ingredients of mysticism, hysteria, religiosity, romantic yearning and identification with nature." Mix these ingredients in different proportions, replace rebellion with repression, and you have nazism. Art critic Robert Hughes even finds an uncanny similarity between the rather shapeless, slack-skinned expressionist nudes and the emaciated corpses found at Nazi concentration camps.

Since World War II, expressionism has been recognized as the great modern German art movement, losing most of its shock value in the process. At the 50th anniversary remounting of Hitler's *Degenerate Art* exhibit in 1987, the big surprise was that all those blue and purple people have with time and familiarity lost their capacity to shock.

Although its name was co-opted after World War II into abstract expressionism, expressionism per se was never very influential in the United States. (It played a more important role in the development of modern Mexican art, for example the work of José Orozco.) Parenthetically, the Guggenheim Museum in New York City owned the world's largest collection of works by Wassily Kandinsky, the most abstract of the expressionists, but many of these were sold in order to acquire a collection of minimalism.

From the late 1970s to the mid-1980s some European and American artists (the best known in the United States are probably Julian Schnabel and the late Jean-Michel Basquiat) became known as neo-expressionists for the quality of primal screaming in their work. Abandoning the restraint of minimalism and the coolness of conceptual art, as art lexicographer Robert Atkins puts it in *ArtSpeak*, neo-expressionism (otherwise "neo-ex") resurrected easel painting, eclectic imagery, even social commentary.

The German Expressionists by Bernard S. Myers is a good basic introduction.

Full many a glorious morning have I seen
Flatter the mountain-tops. . . .

William Shakespeare, Sonnet 33

FABERGE

The name Fabergé conjures up fabulous jeweled confections, designed solely for the amusement of idle royalty, millionaires, and maharajahs. The Fabergés, French Huguenots who established a family firm in St. Petersburg in 1842, enjoyed a special acclaim in the last days of imperial Russia as purveyors of exquisite objects to the czar and czarina. Most famous of these were the imperial Easter eggs, made for the Russian tradition of exchanging eggs as symbols of the resurrection. These were not just decorated eggs, mind you, but ornate bejeweled eggs, four to six inches tall, usually containing a surprise inside—a miniature palace, yacht, railroad, or swan, sometimes capable of mechanical tricks. "Civilian" versions were also made, usually larger than the imperial eggs, and they became some of the most highly prized objects in the history of gift giving. Other Fabergé products included jeweled and enameled cigarette cases, precious little picture frames, brooches, a whole Noah's ark of carved stone animals, or, with a more practical application, bell-pulls to summon the servants, personalized handles for a riding crop or parasol, and opera glasses.

The Fabergé style, insofar as there can be said to be one, is an eclectic compound of historicism (particularly its Renaissance and baroque components), art nouveau and traditional Russian motifs, all in a fin-de-siècle package. To cite a more specific influence, the founding father, Carl Fabergé, himself collected Japanese netsuke, which

The Coronation Egg presented by Czar Nicholas II to his wife Alexandra for Easter in 1897 *(Larry Stein, Forbes Magazine Collection)*

undoubtedly influenced his animal figures (which in turn anticipate Walt Disney). Fabergé products are also known for a mixture of various shades and textures of gold, silver, enamel, glass, porcelain, wood, and stones (the latter usually semiprecious, brightly colored, and modest in view of the old Russian penchant for fabulous, costly jewels). The Fabergé hallmark is a quality of preciousness that by definition threatens to shade over into kitsch. As one critic put it, Fabergé is related to great art as *Cats* was to great theater. But if this is kitsch, it is the very best. When Mary McCarthy described Vladimir Nabokov's *Pale Fire* as "a Fabergé gem," she meant a rare kind of delectation, by no means a put-down.

The house of Fabergé, which at its peak in the 1890s had branches in London, Paris, Moscow, St. Petersburg, and Odessa, and employed a staff of 500, was closed by the Bolsheviks in 1918. Shortly after the revolution, it was possible to acquire Fabergé objects from the Soviet office of confiscated national treasures at relatively reasonable prices (which have since multiplied by at least 100). Another cache of Fabergé treasures came on the market in 1954 after the death of King Farouk of Egypt. Most highly prized are the imperial Easter eggs, of which there are said to be 57 in existence, plus civilian versions made for fortune's favorites like American heiress Consuelo Vanderbilt.

A major American collection of Fabergé, including nine imperial eggs and three others, was amassed by late magazine publisher Malcolm Forbes. (Will this collection, too, go the way of the czar's and Farouk's toys?) Lillian T. Pratt left five imperial eggs to the (Richmond) Virginia Museum of Fine Arts, while the Matilda Geddings Gray Foundation collection in the New Orleans Museum has three. The world's largest collection of Fabergé, including a menagerie of 350 animals (out of a total of 450 objects), is owned by the British royal family. And of course the Russians have

some left—there are 10 imperial eggs in the Kremlin Museum.

Originally sold for around $15,000 each, the imperial eggs are considered "priceless" today. In the 1970s one went at auction for $190,000; in 1992 another sold for $3.2 million. Given limited availability and constant demand, there is no shortage of knockoffs and fakes. Superior copies of the eggs are said to be available from Latin America now for $25,000. And glasnost seems to have sparked the market for a whole range of sentimental pseudo-Fabergé. A "Gateway to Freedom Egg" in cranberry crystal, containing a replica of Berlin's Brandenburg Gate, was advertised by a Fabergé descendant for $3,250. For those on a more limited budget, egg replicas can be had for $50, and a collector's plate with a thoroughly kitschy, vaguely old-Russian nativity scene from the "House of Fabergé™" for only $29.50. The Fabergé name is also being used to advertise Detroit automobiles.

So how do you recognize the real McCoy? A beginner should visit the antique shop À la vieille Russie in New York City, the traditional American outlet for authentic Russian treasures. And take a short course in Cyrillic, the alphabet used for the Russian language. (Hint: the Russian *F* in the Fabergé mark looks like a lollypop; the other letters in the name will be recognizable except for the *g*, which looks a bit like an eight-armed x.)

Masterpieces from the House of Fabergé by Alexander von Solodkoff concentrates on the Forbes collection. Solodkoff also collaborated with G. von Habsburg-Lothringen on *Fabergé: Court Jeweler to the Tsars*.

FAIENCE or FAYENCE

In the genealogy and geography of ceramics, faïence is the 16th-century French version of majolica or tin-glazed earthenware, a technique that was originally developed in ancient Babylon and introduced to Europe by the Muslims. The French name is a corruption of the Italian place-name of Faenza, whence majolica was carried to France and the Netherlands by potters of dissident sects such as Anabaptists during the early dislocations of the Reformation.

Although faïence is synonymous with majolica (as is delftware, the English version sired by way of Delft, Holland), the term also refers to the varied products made by the technique since the 17th century. (The great period of majolica production was the 16th century.) The demand for faïence declined when the formula for porcelain was discovered in Europe in the 18th century. Since then majolica has been considered a folk art.

Pot Pourri Vase (c. 1755), faïence produced at the Sceaux Manufactory in France *(J. Paul Getty Museum)*

FASCISM

"Fascist" is one of those powerful epithets, used pejoratively in so many different contexts that its actual meaning has become vague. The Soviets, for example, used to denounce anyone with whom they disagreed as fascists. As recently as the mid-1980s, after a British politician called an opponent a fascist, the word was proscribed (along with guttersnipe, swine, and cad) from parliamentary debate.

To define the phenomenon in its historical context, fascism (from the Latin *fasces*, denoting a token of deference to authority) arose in the aftermath of World War I as a response to defeat, alienation, and the apparent paralysis of individualism. Some welcomed fascism at the time as a third force between liberal democracy and communism, borrowing the latter's methods of organization and control by terror. In the name of law and order, fascist state control would be extended into every aspect of life.

In ideology, fascism is reactionary, harking back to a golden age that is often more mythical than real, and nationalistic, an exaggerated nationalism that in the end would prove destructive to all humankind. The fascist concept of the nation exalts narrow tribal loyalties (*das Volk*) and dark emotions, identifying minority groups as subversive internal enemies—in some cases, most notably that of the Jews, to be exterminated. Another key ingredient of fascism is the apotheosis of the leader as a hero or superman, obedient to the mystique of will rather than the dictates of reason.

Fascism began in Italy but took its most extreme form in German National Socialism or nazism. During the ascendancy of Mussolini and Hitler, fascism seemed to be contagious, prompting widespread imitation of its signs and symbols as well as its doctrines. In Eastern Europe, in particular, fascism became a powerful mass movement during the interwar period. Scholars also identify sub-varieties, such as "Latin fascism," to cover the long regimes of Franco in Spain and Salazar in Portugal. (Others disagree, categorizing those governments instead as traditional authoritarian.) Norway had its own peculiar wartime fascist leader, Vidkun Quisling, expounding a strange hodgepodge of romantic and authoritarian ideas. The United States threw up scattered groups with fascist tendencies during the 1930s (some call Louisiana governor Huey Long, with his 100-percent Americanism, a native American fascist). The last fascist regime to emerge, and the only one after 1945, was that of Juan Perón in Argentina. (One theory is that given basic conditions of depression, fear, and frustration, poorer or underdeveloped nations tend to turn to communism while wealthier countries—Argentineans were the wealthiest Latin Americans—turn to fascism.)

An extremely belligerent form of nationalism, glorifying violence, audacity, adventure, and sacrifice, fascism is inherently aggressive. Fascist ideology also makes use of Social Darwinist notions of a struggle for the survival of the fittest, thus legitimizing aggression and expansion at the expense of weaker neighbors. Not surprisingly, the two main fascist prototypes, Italy and Germany, both went down to defeat and destruction in war.

Culturally, fascism tended to favor classical architecture of the monumental (Roman) variety, befitting its grandiose aspirations and providing a setting for mass political and military displays in mechanical unison. Of the grandiose buildings designed by Hitler's architect Albert Speer, only the Nazi party reviewing stand in Nuremberg survives. Classical idealization of the human form was also favored in art. In general the arts (except perhaps for the graphic arts—the poster would become a prime medium of propaganda) proved resistant to state control.

In *Totalitarian Art*, Igor Golomstock marshalls facts and photographs to show a striking similarity between the art and the architecture of Hitler's Germany and Stalin's Soviet Union.

FAUSTIAN

Scholarly allusions to the Faust legend have always been common. For example, Poggioli writes in his *Theory of the Avant-Garde*, "The experimentalism of such artists is a kind of aesthetic Faustianism, a search for Eldorado and the fountain of youth...." One cannot even read the newspaper any longer without stumbling across the body of this medieval German necromancer. As the *Los Angeles Times* remarked in a piece on Reaganomics, "The Republicans had made a Faustian bargain in the early 1980s—grow now, pay later." Or reviewing a book on body-building, the same newspaper referred to a Faustian bargain with steroids.

The best-known version of this major theme in Western literature is Johann Wolfgang von Goethe's two-part drama (1808, 1832) about an aging scholar who makes a pact with a demonic figure, trading his immortal soul for youth, knowledge, and power. Rejuvenated, Faust seduces a young woman, indulges his thirst for learning, and finally is rescued from his satanic pact by angels as a reward for striving toward truth.

Faust is more than just a theme. In his *Decline of the West* (1922), German philosopher of history Oswald Spengler writes of a Faustian *Weltanschauung* or world view as the primary orientation of Western culture since the Middle Ages. For Spengler as for Goethe, the focus of the Faust myth is Western man's continual striving for knowledge. Spengler even identifies a visual analogue or symbol of Faustian culture, the Gothic cathedral with its arches thrusting upward to encompass infinity.

The Faustian theme (Jung would call it an archetype of the collective unconscious) constantly recurs in Western literature—including American literature, which otherwise shares none of the metaphysical concerns of Goethe or Spengler. A particular province of Faust is the genre we call "Gothic," which arose in the late 18th century, named for its typical setting in medieval ruins or haunted castles. In fact, Horace Walpole, author of the first prototype of the genre, *The Castle of Otranto* (1764), actually built his own neo-Gothic villa. To Walpole as to the romantics who followed his lead (one of the most famous examples being Mary Shelley, who published *Frankenstein* in 1818), Gothic ruins evoked darkness, horror, the grotesque, beauty, and terror, the mystery and attraction of evil as a metaphorical background for the diabolical Faustian pact.

In his outstanding study of American literature, *Love and Death in the American Novel*, Leslie Fiedler finds the Faust theme or protagonist, the ambivalent hero-villain, everywhere: James Fenimore Cooper's Leatherstocking is a Faust in buckskins, Melville's Captain Ahab is a Faustian figure, even Huck Finn is a boy Faust ("All right, then, I'll go to Hell!"). The setting for American Gothic is no longer medieval ruins, but the frontier, the river, or the ocean, symbolizing the last line of defense between civilization and barbarism. The greatest Faustian tale in our literature, according to Fiedler, is Nathaniel Hawthorne's *The Scarlet Letter* (1850), in which American Gothic achieves tragedy. More frequently, Gothic lends itself to melodrama, triviality, and finally cheap sentimentality, as in the paperback romances of Victoria Holt, Mary Stewart, and others, which became hugely popular in the 1960s.

We have strayed somewhat far afield from Faust and his pact with the devil. Thomas

Mann wrote a modern version—*Doctor Faustus* (1947)—featuring a serialist composer as the Faust figure, played out against the horror of World War II and the Holocaust. In Brian de Palma's 1974 movie *The Phantom of the Paradise*, Faust is a solitary pop musician, locked away in a tower creating infernal music on a synthesizer. And as Fiedler points out, Faust is also alive and well in science fiction. Just substitute pseudo physics for black magic, and you get Gothicism of the future, or terror in the atomic age.

FAUVISM

"Like Donatello among the wild beasts [*les fauves*]," a critic remarked of a lone neo-classical sculpture amidst the canvases of Henri Matisse, André Derain, and others at the 1905 Paris salon. Thus another modern movement was baptized in derision, labeled an aberration, "a paint-pot thrown in the public's face," according to the newspaper *Le Figaro* (using virtually the same words with which critic John Ruskin had libeled artist James McNeill Whistler a generation earlier).

The primary characteristic of fauvism is of course the use of color—exhilarating, garish color, an orgy and a riot of color, color as energy and exaltation. "We merely thought their colors were a bit dull," one of the fauves is reported to have said of the reigning impressionists. The fauves did more than just heighten color; they liberated it from its descriptive function to assume a more purely expressive role, giving us green skin tones, red tree trunks, pink mountains. Even shadows were redefined as red, pink, orange, green. New colors were invented, old ones keyed up (as brown to red, or gray to blue), and above all, more colors were used and juxtaposed. Finally, fauve color overflowed its contours, creating a new approach to form (actually to landscape, the primary fauve subject).

Fauvism ranks today as less intellectually exacting than cubism, more lyrical and decorative than expressionism, sharing some qualities (shock value) and leaders (Braque, who began as a fauve, or Rouault, later an expressionist) with both. The fauve movement was amazingly short-lived, quickly burning out after two or three years. Only Matisse continued, imperturbably painting in a modified, more serene fauve style all his long life.

The American illustrator and versifier Gelett Burgess interviewed the fauves in France and wrote an early article about them, undoubtedly prompted by the same serendipity that had caused him to write (10 years earlier) his famous quatrain, "I never saw a purple cow...."

Thames & Hudson published Sarah Whitfield's *Fauvism* in 1990.

FEDERAL STYLE

Alexander Hamilton and his "federalist" argument for a strong central government are probably buried somewhere deep in your memory bank, but the style associated with this period—beginning just before the establishment of the Federal government in 1789 and extending to around 1830—is still very much with us. Federal is more a period than a style, for it encompasses a succession of neoclassical trends, from Georgian to Adam and Empire, in architecture and the decorative arts.

In architecture, we call Federal the Bulfinch design for the original U.S. Capitol

dome, as well as the same architect's Connecticut and Massachusetts statehouses. Federal is not always monumental; eastern seaboard towns from Maine to Virginia (Portsmouth, New Hampshire, is a good example) are full of rows of town houses in the Federal style. These are usually rectangular two- and three-story structures with graceful brick facades and nicely articulated windows and doors, somewhat more austere and delicate than Georgian, often with fan-shaped windows over the front door and grand oval or polygonal rooms—the Adam influence—within.

The Oval Office at the White House is a good example, with its complex curved interior space, understated elegance, and attention to ornamentation. Needless to say, Federal was an expensive style. Butler's *Field Guide to Antique American Furniture* classifies as Federal several newly introduced pieces of furniture that only the affluent would have been expected to possess: various versions of the sideboard, sectional dining tables, dressing tables with combined mirrors. The wood of choice was mahogany, decorated with classical or patriotic motifs such as eagles.

The Federal style even had a musical analogue, according to architectural historian William H. Pierson in his study of American neoclassicism. Pierson describes Haydn's string quartets as "the exact counterpoint in sound to the spatial qualities of the Federal style." (The oldest Haydn Society in the world was founded in Boston, he adds.)

FEUDALISM

Feudalism means the complex of socio-economic and political arrangements that arose in medieval Europe after the collapse of the Carolingian empire. (Actually, the word only came into use in the 18th century, and is often used polemically—by Marx, for example, as a synonym for the precapitalist stage of history.) Depending on their specialty and personal bias, scholars of the period emphasize different aspects of feudal society. An economic historian will explain that the very concept derives from the German word for "cow" (*Vieh*; *fief* in Latin) and generally denotes movable property. Legal experts focus on the feudal system of mutual obligations, which they consider the forerunner of constitutional government. (Remember the Magna Carta, whereby the barons put a brake on absolute monarchy in England?) Literary scholars examine the special qualities of human relations, the feudal ethos as conveyed in the ballads, chronicles, and romances of chivalry. The two great cultural achievements of chivalry, according to Arnold Hauser in *The Social History of Art*, are a new conception of love and the poetry in which it is expressed.

The economy of feudalism, whereby peasants or serfs exchanged their labor for protective services from the (land)lord, is today considered one of the system's least attractive features. (Anthropologist Gordon Childe calls this a step up from slavery, a means of tying seminomads to the soil.) Rather, the adventures of those at the top of this rigidly stratified society, the lords and their knights and ladies, hold more appeal. Since Victorian times the concept of chivalry, a system of ethics that values honor, loyalty, and courtesy, has enthralled most people, causing them to overlook its origin in a class-bound warrior culture. In any case, the feudal concept of courtly love (notice the etymology: court, courtly, courteous), the more romantic in that it was typically extramarital and unrequited, was highly original.

One theory of feudalism attributes its rise to the great expense (assumed by the

**From the charming medieval illuminated manuscript, the *Codex Manessa*
at Heidelberg University, Germany**

lord) of warfare by horse, and its decline to the development of firearms which made
the armored knight obsolete. In a general sense, feudalism represented a decentralized
system of power relations, and thus an obstacle to consolidation of the modern monar-
chy and nation-state. By the 14th century, centralizing monarchies had weakened if not
suppressed feudalism throughout Europe, although vestiges survived—in France until
1789, in Russia until 1917. For our founding fathers in the 18th century, feudalism was
still a very real evil, representing as it did a thoroughly un-American system of inher-
ited inequality.

The classic on the subject, *Feudal Society*, by French economic historian Marc Bloch, is
heavy reading. On the 19th century's romance with feudalism, see Mark Girouard's *The
Return to Camelot: Chivalry and the English Gentleman*.

FIN DE SIECLE

This French expression for "end of century" first became current in the waning years of the 19th century, a "hothouse" period characterized by increasingly rarified and highly aesthetic styles with a strong connotation of decadence, if not perversity.

In a more general sense, fin de siècle draws on the early Christian concept of the millennium, variously defined as the end of the world, the day of judgment, or the second coming of Christ. Historians report that during the last years of the tenth century, the 990s, people lived in imminent expectation of such an event, either withdrawing from the world or indulging in a last orgy of pleasure. In the mass hysteria, debts were forgiven, convicts released, and sins absolved, amid rumors of mass suicide, two-headed calves, and comets' tails.

Something of this same spirit is identifiable at other century endings, particularly the 1890s, a time of economic and spiritual depression (in the United States the end of the materialistic and profligate Gilded Age). There was a sense that not only a century was passing, but an era, a way of life, a world—which came true not long after in the First World War.

In the visual vocabulary of (19th century) fin de siècle, according to a study by Bram Dijkstra, the man with a scythe was replaced as the traditional symbol of death by a succession of female vampires. The 1890s were heavily populated with images of feminine evil: Delilah as dominatrix; Pandora, whose greedy curiosity unleashed the world's ills; or Salomé, portrayed as an eroticized Ophelia with a lust for blood. Dijkstra also lists an impressive number of images of woman in a state of autoerotic trance, thrall, or sacrificial submission. This was the time when the term masochism was coined, inspired by the rather silly novels of the Austrian Leopold von Sacher-Masoch, whose heroes all seemed to take pleasure in humiliation or maltreatment.

One wonders what new *-ism* will emerge from what is shaping up as another major fin de siècle, the 1990s. As the time on our cultural clock seems to be accelerating, typical fin-de-siècle concerns proliferate: global warming, nuclear winter, the greenhouse effect, the ozone hole....

Two absorbing books on the subject are *Century's End* by Hillel Schwartz and Bram Dijkstra's *Idols of Perversity*.

FOLK ART

Before we can begin to define this style—such a catchall that some consider it an attitude rather than a style—we have to decide what to call it. Besides folk art, other common designations are naive art, self-taught, nonacademic, primitive, and outsider art. Primitive can be eliminated for implying either that the art itself is primitive, a pejorative value judgment, or that it is the product of a culture at a lower level of evolution. Self-taught and nonacademic do not seem to say anything essential about the style, so they can be crossed off, too.

Naive is the designation of preference in Europe; the Frenchman Henri Rousseau is always called a *naif*, never a primitive or folk artist. The Europeans have a theory that naive art arises as a response to socioeconomic change, which itself creates the distinction between high art and naive art. The purpose of naive art is therefore to overcome

Watercolor rendering of a weathervane shaped as an Indian archer, typical of folk art (*National Gallery of Art*)

man's growing alienation from himself and from nature, to heal the split in consciousness resulting from modernization. In other words, the psyche finds itself impoverished and goes back to its roots in search of a little magic.

This definition does little to explain American naive art, generally called folk art. Whatever you call it, we have always had a mainstream folk or naive art in the United States, beginning with itinerant limners (possibly a derivation from illuminer, or medieval manuscript painter) who painted early portraits and landscapes. In the 19th century, the Quaker preacher Edward Hicks created innumerable charming variations on the same theme: Isaiah's prophecy of a child leading the wild animals. And in the 20th century, Grandma Moses (Anna Mary Moses) painted landscapes of her simple rural cosmos that became so popular she was invited to appear on the Ed Sullivan Show. Not quite so well known but still very much in demand is the folk art of John Kane, a Scots-born housepainter; Morris Hirschfield, a Polish émigré garment worker; and Horace Pippin, an African American from Pennsylvania. (A Pippin canvas that had sold a few years earlier for $20,000 went for $350,000 in 1989. And one of the many renditions of *Peaceable Kingdom* by Hicks brought $300,000 at auction in 1980, up from $8,500 in 1959.)

The premier American collector of folk art was Abby Aldrich Rockefeller, whose gleanings are now at Colonial Williamsburg. Other fine American collections can be seen at the Museum of American Folk Art in New York and the Museum of International Folk Art in Santa Fe, New Mexico. These include as folk art ship figureheads, weathervanes, cigar store Indians, decoys, samplers, quilts, and toys. The basic common denominator is production by and for the people, sometimes by amateurs for their own gratification, often copying motifs from high art or popular magazines. Characteristically these motifs are simplified, flattened, immobilized within a narrow field of vision, or in primitive perspective. Alice Winchester attributes the authenticity of such work to "the eye of the artist directing the hand of the craftsman."

The British have a naive or folk art tradition of Sunday painters, cultured dilettantes like Winston Churchill. In France, there is the unique Rousseau, who exhibited along with the moderns and enjoyed great success. In recent times we have the Haitians, whose popular naive art ranks as their island's premier cottage industry. In the Old World, the nearest equivalent to the Haitians would be the (pre–civil war) Yugoslavs, who enjoyed a vogue as Europe's primitives.

There are many large-format picture books on folk art. One of the best is *The Flowering of American Folk Art* by Jean Lipman and Alice Winchester. For a broader perspective, see Jane Kallir's *The Folk Art Tradition: Naive Painting in Europe and the United States.*

FREUDIAN

In the late 19th century, when Sigmund Freud's ideas first burst on the world, chang-ing forever man's image of himself, medical science was attributing insanity to brain lesions and seeking antitoxins to cure mental illness. Neurasthenia, then the currently fashionable emotional disorder, was a kind of nervous bankruptcy. The unconscious, that linchpin of Freudian theory, had long since been discovered, and scholars were also investigating dreams and sexuality, but the treatment of psychological ills was no more sophisticated than common sense with a dash of phrenology.

Following in the tradition of the Enlightenment, which adapted the laws of sci-ence to the study of society, Freudians argued that the human mind is governed by laws as binding as those for the planets in space. In fact, many of Freud's concepts, such as the ego-id-superego configuration, resemble 19th-century models in physics and bio-mechanics. Sublimation, for example, defined by Freud as the channeling of sexuality into other forms of energy, is a concept from chemistry meaning to refine, purify, or free from baser qualities. Add some glandular hydraulics—repression, as the cause of neuroses and psychoses—and stages of development—from oral and anal to phallic and genital—and you have a rough schema of the Freudian universe based on sex as the wellspring of all motive and emotion.

Many ideas incorporated by Freud were not new. Rather, he was a great summa-rizer and systematizer, making highly original connections to fill the gaps in his theory. He also made some radical breakthroughs in treatment, in the use of dreams, free asso-ciation, and slips of the tongue as routes to the unconscious and keys to psychological riddles; and in the transition from hypnosis, used for his early patients, to the prover-bial sofa and darkened room where patients undergo a "talking cure." One of Freud's great abilities was as a listener, hearing out his patients for long hours and sometimes years, in a day when many doctors declined to dignify obsessions by listening to them. (Nathan G. Hale recounts the case of an American neurologist who claimed in 1910 to have cured a patient in two sessions simply by having him repeat over and over, "What a damn fool I am.") Freud's prodigious powers of observation and analysis are also appar-ent in his writing, as for example in his brilliant studies of Michelangelo and Leonardo da Vinci (the former suffering from unresolved authority conflicts, the latter a case of latent homosexuality sublimated into art, Freud believed).

Last but not least, Freud functioned as the high priest of a great cult of personal-ity, propounding and proselytizing throughout his life. Americans were first exposed to him in 1909 when he delivered a series of lectures at the newly established Clark University in Worcester, Massachusetts, creating the nucleus of a new American psy-choanalytic movement. In fact, America welcomed Freud more warmly and embraced his ideas with greater enthusiasm than Europe did (although Americans with their proverbial prudery had some difficulty swallowing Freud's insistence on sexuality).

Despite the warmth of Freud's American welcome (he went camping in the Adirondacks, saw his first movie, and visited Niagara Falls and Coney Island), his visit revealed some cultural gaps that would widen with the years. The dignified Old World psychoanalyst was discomfited by American informality, eclecticism, and optimism. Although personally very conservative, Freud was intellectually more radical than his American followers, who despite greater confidence in man and his fundamental insti-tutions, tended to greater caution and conformism.

Another point of difference was that the American movement sought respectability by requiring all psychoanalysts to become physicians first; Freud disagreed, considering lay analysts effective. Even American patients were different, representing a greater variety with different types of problems. Freud's patients in Vienna were mostly hysterics, with repressed energies to be released, while Americans seeking early psychiatric help were predominantly compulsives, according to psychoanalyst Rollo May. There were also basic cultural differences in treatment, American analysts stressing independence from the mother while Europeans were more concerned with independence from the father.

Last but not least, Freud abhorred the American tendency to popularization. Within a few years of his U.S. visit a leading American Freudian published an analysis of Shakespeare's Lady Macbeth as a victim of frustrated maternal instincts; a popular magazine ran a story about a fictional detective using Freudian dream analysis to solve a murder; and the first American psychoanalytical novel appeared, *Mrs. Marden's Ordeal* (1917), about a young society matron struck dumb after the death of a rival for her husband's affections. With the disappearance of taboos, "the repeal of reticence" hastened by World War I, the 1920s saw a veritable epidemic of parlor Freudianism, hailed as the new miracle of healing.

Freudian analysis is somewhat out of fashion now, bedeviled by a poor "cure" rate (about as good as chance) and prohibitive cost. Feminists reject it outright as sexist, and other critics complain that its determinism makes patients creatures of conditioning, helplessly driven by their unconscious; even after years of analysis, the will to change is usually lacking. Nevertheless, Freud's ideas and concepts—from ego and id to complex and repression—are an ineradicable component of our intellectual baggage.

Out of an entire library of Freudiana, I recommend highly Nathan G. Hale's *Freud and the Americans: The Beginnings of Psychoanalysis in the United States, 1876–1917*. For Freud's influence on the arts, see SEZESSION, SURREALISM, SYMBOLISM.

FUNDAMENTALISM

Fundamentalism is one of those loaded concepts that have acquired a heavy freight of assumptions and biases. In the United States, fundamentalism arose around the turn of the 20th century among Protestants reacting against scientific and secular threats to their faith. A 12-volume compendium published in 1910–12 (financed by two California millionaires) called *The Fundamentals* covered the inalienable concepts of faith, from the Virgin birth and the resurrection of Christ to scriptural infallibility.

American fundamentalists have always been particularly vigilant to prevent the teaching in public schools of any challenge to these beliefs. One of their first great campaigns, that against the teaching of evolution, resulted in the 1925 trial of a Tennessee teacher, John Scopes. (You may remember Spencer Tracy as defending counsel Clarence Darrow and Fredric March as fundamentalist politician William Jennings Bryan in the excellent 1960 movie version, *Inherit the Wind*.) In the effort to "save our children for God," the fundamentalists declared themselves willing to throw out all books but the Bible, a stance they have continued to maintain.

Having lost the battle against the teaching of evolution, fundamentalism during the 1930s focused on President Franklin D. Roosevelt as public enemy number one.

(Fundamentalists have traditionally tended to identify people with whom they disagree as enemies of God.) After the Second World War, American Fundamentalism finally settled on a worthy external enemy. Identifying world communism as the new anti-Christ, fundamentalists treated the cold war as if it were a religious crusade. Assuming Americans to be a chosen people, with a political and economic system endorsed by God, they embraced patriotism and anti-communism with religious fervor.

Theirs is a Manichaean view of the world as the arena for conflict between good and evil, with conspiracy to be uncovered everywhere. The United Nations, for example, is considered a front for the Rothschild takeover of the world, or for international miscegenation. Glasnost is just a ruse, with Gorbachev's visible birthmark giving away the game. And sex education was a communist plot to destroy the moral fiber of our children. After prayer and Bible reading in the schools became unconstitutional in 1963, and busing added insult to injury, many fundamentalists started their own (generically called "Christian") schools, as have other religious denominations in the past, to perpetuate their views of the world.

When you consider that other societies also nourish their own fundamentalisms—particularly Islam, for whose true believers the United States is shaping up as the apocalyptic fiend—the fragile nature of world peace becomes apparent.

See Daniel Bell's *The Radical Right* and Richard Hofstadter's *Anti-Intellectualism in American Life*. A popular account of the Fundamentalist campaigns of the 1960s is Gary K. Clabaugh's *Thunder on the Right: The Protestant Fundamentalists*. On the subject of world Fundamentalism, see *The Glory and the Power* by Martin E. Marty and R. Scott Appleby.

FUTURISM

This is way-out stuff, beyond the fringe for most of us. Founded in Italy in 1909, futurism glorified originality and boldness, movement and the machine age, violence and war. A speeding car is more beautiful than the Nike of Samothrace (see HELLENISTIC), according to the most famous pronouncement of the futurists (who considered America "the vortex of modernity"). Among the targets on the futurist hit list were the solemn, the sacred, and the sublime; sickly nostalgic poetry and romantic sentimentalism; marriage and the family; museums, moralism and religion; history and anything designated as passé-ist. These were then attacked with shock tactics, a mixture of deadly earnest and outrageous fun that is a little hard to appreciate today.

The most successful futurist format was probably the manifesto, beginning with the 1909 statement by founder Filippo Marinetti, printed on the front page of a prestigious Parisian newspaper. A skillful propagandist, the self-advertising Marinetti succeeded over the years in gaining a wide press for his "intoxicated rhetoric." (A 1913 manifesto is entitled "Imagination Without Strings".) The futurists were also pioneers of a sort of happening, combining theater, concert, speech, and riot; they utilized what they called synoptic declamation, varying speed, rhythm, and tone of speech, and a "Noise Intoner," an invention to reproduce noise on a range from whispers and whistles to rumbles and roars.

In art, the futurists have been called provincial second-cousins of the cubists, with whom they developed in tandem. Futurist art retains some representational forms, as

Umberto Boccioni's
*Unique Forms of
Continuity in Space*
(1913) bears a fleeting
resemblance to the
Hellenistic Nike of
Samothrace *(Museum
of Modern Art)*

for example dogs or cars blurred by motion and speed. Other devices are radiating lines of force, colliding and interpenetrating objects, and the kaleidoscopic facets of cubism. There was also a futurist architecture, which remained mostly on paper, a cross between science fiction and dramatically stepped art deco skyscrapers. And lastly there were a handful of futurist films (one title is *The Perfidious Enchantment*), black-and-white silent films shot against boldly abstract backgrounds.

The Italian American artist Joseph Stella (*Brooklyn Bridge*) is said to have been influenced by futurism, but this is a connection most artists would prefer to avoid. Futurism got into bad repute as the artistic corollary of fascism thanks to its glorification of violence and war. Marinetti was an early supporter of Mussolini and remained loyal to *il duce* to the end. (Once in power, however, Mussolini favored more "orderly" art, preferably neoclassical, to underscore the Roman continuity.) The futurist movement struggled along until World War II, but many of its leaders and arguably its future were extinguished in World War I. (One of those who fell was Umberto Boccioni, whose 1913 sculpture *Unique Forms of Continuity in Space* resembles, ironically, a cubist Nike of Samothrace.)

In the Thames & Hudson series, see *Futurism* by Caroline Tisdall and Angelo Bozzolla.

Go, and catch a falling star,
Get with child a mandrake root....

John Donne

GEORGIAN

If you remember the Georges at all, it is probably as the German-accented kings of England who were so inept that they lost the American colonies. They also gave their name to the period of the 18th century (by American reckoning, the period ends with the Revolution, although the Georges ruled England until 1830) and to a style of architecture common in the mother country and its colonies. Since this was a period of expansion and construction, the style became widespread, representing a kind of "Englishness" recognizable the world over.

Georgian, or the English version of neoclassicism, is a gradually evolving mixture of Palladian and other styles. More austere than European neoclassicism, Georgian is usually strictly rectilinear and classically balanced. The many houses surviving in the United States from this period, made of brick in the southern colonies and wood frame in the North, have a perfectly centered front door framed by pilasters, topped by a pediment, often with a fanlight; large, evenly spaced sash windows, of uniform size and detailing on each floor; and a central chimney or paired chimneys. The corners of the house may be quoined or marked by engaged pilasters, and the roof may be hipped and have dormer windows. The general impression is one of stability, permanence, understated elegance. Interiors were more elaborate, with Adam, Chippendale, Hepplewhite,

and other contemporary appointments. The fireplace became the new center of the living room.

The first major building in the Georgian style in the United States was the College of William and Mary in Williamsburg, dated 1695. (According to William Randel in his study of American taste, the Georgian style began to take shape in the reconstruction after London's Great Fire of 1666, but did not acquire a name until George I from the House of Hanover ascended the throne in 1714. The earliest American Georgian-type structures thus predate the Georges.) Along the eastern seaboard of the United States, and particularly in seaports whose growth was stunted by the coming of the railroad in the 19th century, you will find neighborhoods of two- and three-story Georgian row-houses and town houses, their narrow front facades to the street, survivals of our colonial history. In the late 19th-century colonial revival, Georgian was a major presence.

A Field Guide to American Houses by Virginia and Lee McAlester has an excellent chapter on all the variations and permutations of American Georgian. In *Georgian Grace: A Social History of Design from 1660–1830,* John Gloag identifies the keynote of the style as "grace," discernible even on pill-box labels.

GESTALT

"I do my thing, and you do yours"—this was the Gestalt prayer, a hackneyed incantation from the 1960s counterculture. One of those weighty German concepts that means form, configuration, pattern, "wholeness" (the derivation of holistic), the Gestalt movement started around the turn of the 20th century as the study of perception. Its basic tenets and theories (such as the phi-phenomenon, that objects shown in rapid succession appear to be moving, or the truism that the whole is greater than the sum of the parts) were then extended to aesthetics, the study of learning and problem solving, economics and political science.

It is as a school of psychotherapy, a trendy quick-fix for the hedonistic me-generation, that Gestalt is best known today. Its chief practitioner was Frederick S. Perls, a bearded, roly-poly guru in a jumpsuit who operated for a time out of the Esalen Institute in Big Sur, California. Perls was a genius at cutting through what he called "Freudian crap," circumventing the wild-goose chase of conventional psychoanalysis and the patient's protective layers to get to the guts of the matter in the here and now. The average person lives at only 5 to 15 percent of his potential, according to Perls, who got people to act out their feelings, complete what he called their unfinished business, and achieve the Gestalt goal of wholeness. However effective Gestalt was as therapy, it was good theater, with Perls (who had studied dramatics as well as medicine) giving some memorable performances. Since his death, the movement has lost its momentum.

One of the basic texts in the field, Wolfgang Koehler's *Gestalt Psychology* is again available in paperback. Also recommended are books by or about Perls: Martin Shepard's biography, *Fritz,* or the guru's *Gestalt Therapy Verbatim,* a transcript of actual Gestalt sessions.

GILDED AGE

It soon becomes apparent why this period in 19th-century American history has spawned at least two recent popular histories. Like the present era, the years between the Civil War and the turn of the last century were dominated by rapacious financiers, speculators, and promoters whose venality spilled into and corrupted politics. Other characteristics of the Gilded Age include the growing disparity between the new rich with their incredibly conspicuous consumption; a wretched working class swelled by immigration; and a rising tide of American imperialism, which, having disposed of the Indians (this was called "Manifest Destiny"), overflowed into the Pacific and the Caribbean. Above all, the common thread between that era and ours is money, and a profligate culture devoted to its pursuit. (The Gilded Age is when the dollar acquired its nickname of "greenback," meaning picked before ripe.)

The era was named for an 1873 novel by Mark Twain and Charles Dudley Warner, drawing in turn on a Shakespearean word-play about gold, waste, and crime. The rapidly advancing Industrial Revolution fueled the American dream of rags to riches, spawning a nouveau riche class eager to flaunt its wealth. Abandoning Puritan austerity and Victorian propriety, robber barons with the "ostentation of upstarts," as Milton Rugoff put it, ransacked all of European history for architectural and decorative styles, copying English castles, Italian palazzos, and French châteaux. The Vanderbilt family alone is said to have built some 17 mansions costing more than $1 million each, including the "châteauesque" Biltmore in Asheville, North Carolina, possibly the largest house ever built. The Vanderbilt Marble House in Newport, Rhode Island, was modeled after the Temple of the Sun at Heliopolis, only it was bigger.

These mansions were furnished with a rich and eclectic mixture of Venetian ceilings, Louis XIII mantels, Chinese vases, Gobelin tapestries, and treasures brought from the ends of the earth. Converting pork into porcelain and new money into Old Masters, the Gilded Age sought legitimacy in culture, endowing in the process mammoth new emporia of the arts, universities, opera houses, and museums to serve as repositories for cultural booty.

A telling caricature of the day showed industrialist Henry Frick sitting on a Renaissance throne reading the *Saturday Evening Post*. Indeed, the Gilded Age was once called *The American Renaissance* (the title of a 1979 exhibit at the Brooklyn Museum), and rapacious robber barons liked to encourage identification with Medici princes. The appropriate analogy is more likely imperial Rome in its gaudy, savage declining days. (One European observer believes that America in the last third of the 19th century jumped from barbarism to decadence without ever achieving civilization.) Great imperial powers have always plundered works of art from their predecessors and neighbors, as the robber barons did. And in sheer architectural scale, Gilded Age America was imperial, with its fabulous mansions and museums, even railroad stations modeled after Roman baths. Roman triumphal arches were erected to celebrate American militarism (Brooklyn's arch was dedicated to Civil War heroes, one arch in New York City to the Spanish American War, and another in that city's Washington Square to the soldiers of the Revolution). And the nation's capital was acquiring a series of temples devoted to our national deities, Washington, Jefferson, and Lincoln. Tending to dwarf existing structures, this American imperial architecture introduced a disproportion, particularly in downtown areas, that persists to this day.

Sean Dennis Cashman's *America in the Gilded Age* and Milton Rugoff's *America's Gilded Age* are two recent efforts. An earlier generation of popular historians saw this rather as *The Age of the Moguls* (Stewart H. Holbrook). Lewis Mumford called these *The Brown Decades*, arguing that the Gilded Age was not bright and gay, the Gay Nineties notwithstanding.

GNOSTICISM

The Gnostics were "knowers" as distinct from "believers," who in the early Christian era tried to reconcile Christianity with Greek and Oriental philosophy. They believed they *knew* God, rather than relying on revelation or faith. In the Gnostic cosmogony, the world was created by Yahweh, the Old Testament god (not the supreme deity) whose son came to earth in the guise of a mortal to overturn false teachings. (Some said it was not Jesus but a ghost-like substitute who was crucified.) The Gnostics believed in successive emanations called "eons," of which Christ was the highest. The sect declined after Christianity was recognized in the Roman Empire. Gnosticism is chiefly relevant today as the root of agnosticism, or denial of knowledge of God. It has also been called a forerunner of existentialism.

Giovanni Filoromo explores an arcane subject in *A History of Gnosticism*.

GOTHIC

The Goths were nomadic barbarians who conquered the Roman Empire, briefly, in the fifth century A.D. (Your memory bank may contain the name of Alaric, who sacked Rome). The Italians, who naturally despised these alien marauders, later gave the name of "Gothic" to the style of European architecture that prevailed from the 12th through the 14th centuries, or the high Middle Ages, a style they considered so barbarian it might have been (but was not) invented by the Goths. In fact, the Gothic style is French in origin, and eminently feminine, in the opinion of historian Henry Adams, compared to the masculine Romanesque that preceded it.

Gothic architecture is characterized by pointed arches, soaring spires, elaborate vaulting, graceful stone tracery, and crenelated parapets. The introduction of the flying buttress, a device rather resembling multiple spider legs, afforded structural support from the outside and made possible large windows of stained glass admitting a variegated profusion of light. The resulting balance of tension, space, and light has been called the classic expression of the Western spirit.

We are talking here, of course, about the cathedral, the crowning achievement of the Gothic—"infinity made imaginable," as the poet Samuel Coleridge put it. The two keynotes of Gothic architecture are height (the pointed arch allowed greater height than the rounded Romanesque arch), and light, in the search for which common sense as well as safety were sometimes sacrificed. The overall effect is one of intense spirituality (undoubtedly furthered by the fact that the workers confessed themselves before setting to work, according to Adams).

The finest examples of Gothic architecture are considered to be Chartres Cathedral in France and Cologne Cathedral in Germany. The style was never so popular, nor did it reach such heights, in Italy or Spain. There are, however, some perfectly beautiful

Gothic cathedrals as far afield as Portugal. European Gothic is sometimes subdivided into phases (high; late) and subgenres, the perpendicular peculiar to England and the French flamboyant manner with intricate window tracery. Finally, there is the late 18th- to early 19th-century Gothic revival, sometimes spelled "Gothick."

The French built primarily cathedrals in the Gothic style, under the patronage of the Roman Catholic Church. The English secularized Gothic, producing the neo-Gothic Houses of Parliament, the campuses at Oxford and Cambridge, and countless country homes, in the style of French cathedrals. This eclecticism spread to the United States, which has the full range from 18th-century Gothick to 19th-century Gothic revival and later pseudo-Gothic.

American Gothic monuments include St. Patrick's Cathedral in New York City, copied from the cathedrals at Cologne and Amiens; the Brooklyn Bridge, which has Gothic arches; even a Gothic skyscraper (or cathedral of commerce), the Woolworth Building in New York City. Then we have pedagogical Gothic, such as the Yale and Princeton libraries, modeled after Oxford and Cambridge. (Yale also has a 10-story Gothic gym and a power plant, cathedrals of steam and sweat.)

In the late 19th century even American Protestants who had previously favored plainer houses of worship turned to Gothic. The world's largest Gothic

Grant Wood's *American Gothic* (1930), practically a national icon *(Art Institute of Chicago)*

cathedral is the Episcopalian St. John the Divine in New York City, begun in 1893 and not yet finished. (In the Middle Ages, too, it often took centuries to complete a cathedral.) The Gothic National Cathedral in Washington, D.C., is also Episcopalian.

American country Gothic residences (designed to convince the owners they are living in ancestral digs) are especially common in New York's Hudson River valley. The largest of these, Lyndhurst, in Tarrytown, is a property of the National Trust for Historic Preservation and may be visited. On a more modest scale, we also have an indigenous style known as "carpenter's Gothic," sometimes spare and somber, sometimes decorated with a profusion of fanciful fretwork. The largest concentration of Gothic cottages in the United States is a former Methodist camp on Martha's Vineyard, Massachusetts. At the other end of the continent, a pristine example of gold rush Gothic (precut and shipped in pieces around the Horn) is the Surgeon's Quarters at The Dalles in Oregon.

Grant Wood's archetypal 1930 painting, *American Gothic*, features in the background a midwestern farmhouse of the more spartan variety, with farmers crafted to match. Gothic architecture also influenced medieval representations of the human body, according to Sir Kenneth Clark in his study, *The Nude*, where he describes the curve of the nude Eve's stomach as ogival, or like the curve of the Gothic arch.

Gothic is also a genre in literature going back to the Gothick novels of Sir Walter Scott, who returned to the Middle Ages as a time of pageantry and color, of heightened spirituality and idealized innocence. In the 20th century we use "Gothic romance" to mean a pseudo-literary genre descended from Scott, with the emphasis on gloom and doom rather than color and chivalry.

On American Gothic architecture, see *The Only Proper Style* by Calder Loth and Julius T. Sadler; *American Gothic* by Wayne Andrews; and William H. Pierson's *American Buildings and Their Architects: Technology and the Picturesque, the Corporate and the Early Gothic Styles. Mont-Saint-Michel and Chartres* by Henry Adams is a classic appreciation of French Gothic by an American scholar. See also MIDDLE AGES, CHRISTIANITY. On Gothic literature, see FAUSTIAN.

GREEK

When the Elgin marbles were first taken from the Parthenon in Athens to England in the 1860s, John Boardman reports, Londoners began to affect what the newspapers of the day called "the Grecian bend," imitating the characteristic angled hip stance made possible by the marvelous pelvic musculature of classical Greek sculpture. So familiar have these statues become that it is hard to imagine the impression they caused, in their own day as well as in 19th-century England. As Sir Kenneth Clark points out in his pathbreaking study of *The Nude*, the Greek cult of (mostly male) classical bodily perfection involved overcoming an almost universal inhibition against nudity, common to all but the most primitive peoples.

Ancient Greek history is usually divided into three periods: the archaic, from 700 to 480 B.C., the classical from 480 to 323 B.C., and the Hellenistic, which will be described separately. Throughout, the human body is the chief object of artistic representation, sculpture the main medium and man the measure of all things, serving as model for the many gods in the Greek pantheon. (By way of comparison, consider the monumental status of gods in the Egyptian and Mesopotamian traditions.) The archaic period is chiefly interesting for its free-standing nude youths called *kouroi* or devotees, characterized by a stalwart, stiff frontal stance and the so-called "archaic smile." (The same smile can be seen on the medieval statues at the main portal of Chartres Cathedral in France, on Leonardo da Vinci's enduring Renaissance enigma, the Mona Lisa, even in Far Eastern art.)

Curiously, more than 100 of the archaic-era *kouroi* are known today, more sculpture than survives from classical Greece. Gradually, almost imperceptibly, there evolved from these *kouroi*, through a softening and relaxing, an exploration of flesh and musculature, the classical ideal—a blend of idealism and realism, a pure, passionless dignity, raising white marble (and bronze) to unequaled heights of sensuous serenity. So perfect are these classical Greek nudes that they seem beyond criticism. (Leftist historian Arnold Hauser in his *Social History of Art* takes exception to the lack of individualism

and liberalism in the culture that created them.)

In architecture, the Greek temple is based on rather simple rectilinear principles, using lintel and post or column and beam structural members, with decorative effects, moldings, and statuary (relief and in-the-round) filling pediments, metopes, and friezes. Greek columns evolved from the unadorned Doric to the voluted Ionic and eventually the Corinthian, its more elaborate capital decorated with acanthus leaves. Classical Greek architecture and statuary are conceived as an organic whole, to the point where columns take on a feminine shape in the caryatids of the Erechtheum on the Athenian Acropolis.

In addition to their temples (a form to be experienced from the outside, as architectural expert Patrick Nuttgens remarks), the Greeks also left us acoustically perfect open-air theaters. Both theaters and temples were usually dramatically sited, as anyone knows who has been to Delphi or seen the Acropolis on a clear day in Athens.

Classical Greek civilization has been called the most extraordinary flowering of culture in history, a period giving rise to great literature and philosophy as well

Victorious Athlete, a classical bronze from the fourth century B.C., illustrating a characteristic stance *(J. Paul Getty Museum)*

as art and architecture. Some more intangible Greek contributions to world civilization include our concepts of politics—democracy, aristocracy, tyranny, and oligarchy—and many of our forms of verbal and literary expression, from logic and polemic to comedy and tragedy.

So compelling is the classical Greek ideal that throughout history man has continued to return to it, most notably in the Renaissance and again in the neoclassic revival of the late 18th and early 19th centuries. Indeed, "classical" has become a category in itself, applicable to the life cycle of any style.

As an example of the depth of Greek roots in Western culture, when the cubists in the early 20th century wanted to repudiate classicism, they had to look in deepest, darkest Africa for forms unaffected by classical ideas; even the Far Eastern Buddha with his archaic smile manifests classical repose. And Greek architectural models, although somewhat limited aesthetically and functionally, have been grafted onto more contemporary structures everywhere, in particular creating the standard for courthouses and countinghouses all over America (see GREEK REVIVAL).

In the course of this book you will find many words noted as being of Greek ori-

gin, particularly in the vocabulary of religion: messiah, evangelist, presbyterian, catholic. Another field in which Greek words are common in English is medicine: for example, *oncology* derives from the Greek for "mass" or "tumor," and *metastasize* from the verb meaning "to change from one place to another."

John Boardman's *Greek Art* is one of the better studies in the Thames & Hudson series.

GREEK REVIVAL

After the American Revolution, the former colonies deliberately turned away from British influence in culture as well as politics. In constructing our new capital in Washington, D.C., for example, the founding fathers consciously rejected the neo-Palladian architectural forms then prevailing in England in favor of a simpler classicism derived directly from Greece and Rome.

In the United States the neoclassical style that prevailed from roughly 1820 to the Civil War is called Greek revival. Historian Roger Kennedy points out that it was probably more Roman than Greek, but Roman was no longer fashionable in the young American republic. There had been a time when letters to the editor were commonly signed "Cincinnatus" or "Brutus," the cultural referent being the Roman republic. Then the French Revolution forged its own stylistic path from neoclassicism to the monumental excesses of the Napoleonic period, recalling the later Roman Empire rather than the republic. (What is Paris's Arc de Triomphe, after all, but a celebration of imperial conquest?) At the same time, Greece was fighting for its independence from the Ottoman Turks (with romantic poet Lord Byron for publicist)—clearly a more sympathetic model.

The Greek revival style was simple, logical, dignified, and identified with the world's oldest democracy, as architectural historian William H. Pierson writes in his volume on American neoclassicism. It was also relatively easy to construct, the lintel and post temple form involving a simple pitched roof. For a house, put the long side to the street; for a church, the short side, usually with a tower on top for good measure.

And thus was born the Greek revival style with its pediments and porticoes, colonnades, domes, and rotundas, which spread from one end of the U.S. to the other. One of the first monuments of the new style was the Branch Bank of Philadelphia (1818), a veritable copy of the Parthenon in Athens (as is the south portico of the Old Patent Office in Washington, D.C.; Nashville, Tennessee, has the world's only full-size replica of the original Parthenon, completed in 1931 and now used as an art gallery). The U.S. Capitol, which went through several architects, has been described as Greek revival with a neo-baroque dome added later. (One distinctly American touch inside the Capitol is the use of corn ears and tobacco leaves instead of the classical acanthus to decorate the capitals of columns.) Another much admired project in the style was the University of Virginia, designed by Thomas Jefferson.

All through the United States the Greek revival idiom was expressed in courthouses, churches, banks, all types of public buildings up to and including the Utica (New York) insane asylum. Private homes were also constructed in the Greek revival style—not only the familiar full-colonnaded mansions of the South, but less pretentious houses in Nantucket (Massachusetts) and Ann Arbor (Michigan) and row houses in Greenwich Village (New York). Even modest homes acquired classical Greek details. To this day, Greek revival is probably most closely identified with the dream of the

South—Tara, the ante-bellum plantation house. Poet Derek Walcott, in his prize-winning modern epic, *Omeros* (1990), reminds us that these plantations were built by slaves with Greek revival names like Hector and Achilles.

Speaking of slavery, the Greek revival style had a sentimental and rather embarrassing spinoff in the field of sculpture. Hiram Powers's *Greek Slave* (1843), a marble statue of a manacled virgin being sold into slavery by the Turks, was so popular that replicas of it cropped up everywhere, Greek revival kitsch. Again mixing the Roman metaphor, George Washington was modeled as a Roman senator by Antonio Canova in 1820, and wearing a toga by Horatio Greenough in 1841. Washington himself was so fond of the Roman statesman Cato that he had Addison's tragedy on the subject performed at Valley Forge and quoted it frequently.

Talbot Hamlin's *Greek Revival Architecture in America* is an old standard. *Greek Revival America* by Roger G. Kennedy is a handsome picture book with a lively text by a former Smithsonian museum director.

GREGORIAN

The voices are usually male, the words Latin and Greek (*kyrie eleison*, with each syllable stretched out over many notes), and the setting a church or monastery, its stone walls solemnly echoing. What we call Gregorian chant or plainsong is melodic and rhythmic chanting, generally unaccompanied (though sometimes with organ), of the words of the Roman Catholic mass, psalms, or hymns. This style of plainsong is both older and younger than the pope for whom it is named, Gregory I (reigned 590–604), who is often depicted with a dove hovering at his ear to symbolize divine musical inspiration. Its origins go back to the Greeks (musical theory) and the Jews (melody), these two strains coming together in Roman

Antiphonal or choir book from late 13th-century Florence (*J. Paul Getty Museum*)

times. And the codification of the large body of plainsong literature that is usually credited to Gregory was actually accomplished later, during the Carolingian era.

Over the centuries the monodic Gregorian chant shared in the general musical drift to polyphony, beginning with two-part harmony and acquiring multiple simultaneous melodic lines. This process was reversed in the late 19th century by a movement led by the Benedictine order to restore plainsong to its original purity. Since traditional plainsong notation had no time values and a staff with only four lines, scholars continue to debate Gregorian tempo and syllabification.

There is also a Gregorian calendar, named after Pope Gregory XIII, in use in western Europe since the 16th century. Russia remained 13 days behind Europe into the 20th century because the czars elected to remain on the old Julian or Roman calendar.

Hope is a thing with feathers.

Emily Dickinson

HABSBURG

The Bourbon kings of France are famous for their absolutism and, in the history of style, for ornate interior decor (see LOUIS); and the Windsors of Great Britain have a chair named after them and a properly knotted tie. What we remember the Habsburgs (sometimes spelled Hapsburg) of Austria for are their prognathous jaws and for a long and troubled experiment in empire-building.

Founded in the 13th century, the dynasty was extended and consolidated by marriage rather than by conquest. When there were no heiresses to be had, the Habsburgs married one another, producing a disproportionate number of idiots and that telltale projecting jaw that you will learn to recognize in museums as far afield as Madrid, Vienna, and New York. At one time or another the Habsburg Empire included Spain, the Low Countries, parts of Italy, and most of Eastern Europe, including such troublesome enclaves as the Banat of Temesvar and Bosnia-Herzegovina. The empire lacked natural boundaries and its national groups spilled over into neighboring states. Elsewhere, historian A. J. P. Taylor wrote of the nationalities problems that would eventually tear the empire asunder: "Dynasties are episodes in the history of a people; in the Habsburg Empire, people were a complication in the history of the dynasty."

The Habsburgs reached their apogee in the 16th and 17th centuries, when they ranked as the strongest power in Europe and the West's primary bulwark against the

Turkish tide. Catholic absolutists, they were pillars of the Counter-Reformation, constructing a grandiose baroque civilization (polyglot but based on German culture) in their capital at Vienna. In the 19th century nationalist movements and irredentism posed a continual threat to the peace of Europe, culminating in the assassination at Sarajevo in 1914 of the Habsburg heir apparent. The monarchy was dissolved in 1918, leaving its unresolved problems to bedevil successor states such as Yugoslavia and Romania.

You may see the name of one of the last of the Habsburgs in art and antiques magazines, offering his services as a peripatetic auctioneer and appraiser of others' treasures.

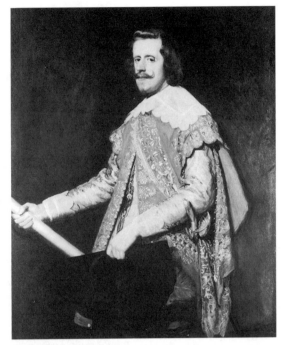

That telltale jaw in New York City: Velázquez's portrait of Philip IV of Spain (1599–1600) (Frick Collection)

Two standards in the field are A. J. P. Taylor's *The Habsburg Monarchy 1809–1918* and *The Dissolution of the Habsburg Monarchy* by Oscar Jászi.

HAN

"Clearly Han!" proclaimed the glossy full-page ad in a recent upscale decorating magazine, showing a carved jade bell described as dating back to this first great Chinese empire. The Han period (200 B.C. to A.D. 200), considered a golden age, produced the first great surge of Chinese cultural consciousness. History, literary criticism, language studies, and philosophy all flourished, while the arts received enormous stimuli from the dissemination of Buddhism in the first century A.D. and the establishment of the first caravan route carrying Chinese silks to Rome.

Tracing the flow of this trade eastward, scholars can identify Mesopotamian and Persian influences on Han China's new ceramic shapes, low cylindrical jars and tall vases with a mottled yellow or dull green glaze. Calligraphy and painting also emerged as major expressive arts in China during this era. Perhaps the most distinctive survivals of the period are the stone carvings in caves—narrative scenes juxtaposing the real and the imaginary—and early monumental Buddhas. These are the result of one of the great religious movements of history, the transmission of Buddhism from India to China—"one of those stupendous revolutions, like the carrying of Christianity to the

Gentiles," writes Oriental expert Mary Tregear.

Like their contemporaries the ancient Romans, the Han Chinese were great engineers, their proudest accomplishment being the construction of the Great Wall. The wall, which eventually spanned some 1,500 miles, is the single most extensive alteration of the earth's surface by man. And like the Roman Empire, the Han Chinese empire eventually disintegrated into feudal states under pressure from "barbarian" Tartars to the north.

Han also refers to the ethnic group of that name, the most numerous in China.

HASIDISM or CHASIDISM

The Hasidim or "pious ones" are Jewish mystics who find in everyday life the immanence of God, honoring him with exuberant prayer, singing, dancing, and storytelling. Followers of a tradition going back to 18th-century Poland, over half of the 250,000 Hasidim in the world today are believed to live in Brooklyn, New York, where they took refuge after World War II.

There are several different Hasidic groups, all named for their place of origin, passing along leadership in dynastic fashion. Most visible of the American groups are the Lubavitcher Hasidim, known for their proselytizing drives ("the Jewish Peace Corps") run from vans on the streets of New York City. But then all Hasidim are highly visible, the men with

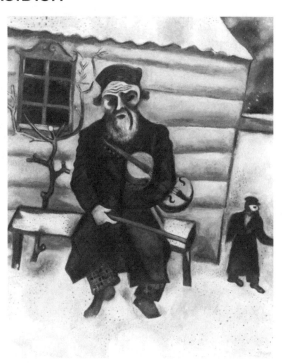

Chagall's *Violinist in the Snow* (c. 1912) enjoys a special freedom of fantasy in the Russian ghetto *(Los Angeles County Museum of Art)*

their long beards and sidelocks, long black coats and fedoras or broad-brimmed fur hats. Hasidic women, segregated from their men in temple and elsewhere, adopt wigs and modest dresses to keep their allures under wraps. Their dress and the myriad dietary, hygiene, and other ritual regulations they zealously follow (the Jewish mitzvoth include 248 positive and 365 negative commandments) preserve a highly traditional way of life and distinguish the Hasidim from other Jews and from gentiles.

Intensely disputatious, some Hasidim support Israel, while others, so traditional that they consider it no accident that it was the "worldly" German Jews who first fell victim to the Holocaust, reject the Zionist state as a usurper of the Messiah. Hasidim

also tend to disavow other Jews who would represent them to the world, such as the Austrian-born philosopher Martin Buber, who wrote a number of interpretive works on them, or the Polish-born novelist and short-story writer Isaac Bashevis Singer, whom they dismiss as "an irreverent teller of secrets." And Marc Chagall, the first major modern Jewish artist, who drew on Hasidic folklore in his paintings of flying lovers and fiddlers on the roof, is of course beyond the pale, a violator of the biblical commandment against graven images.

Anyone interested in contemporary American Hasidim should take the trouble to look up a September 1985 series in *The New Yorker* magazine by Lis Harris.

HEGELIAN

Madame de Staël is credited with the saying that God gave to the French the land, to the English the sea, and to the Germans the air. One of the great spinners of philosophical spider webs in Germany's castles in the air was G. W. F. Hegel, continuing in the German tradition of idealism founded by Kant. Hegel's writings, particularly his *Logic* and his *Phenomenology*, are considered masterpieces of obscurity even by experts.

Addressing the age-old problem of the nature of reality, Hegel chose to focus on relations. He found the most universal relation to be that of contrast or opposition, a continuous process resulting in merger and reconciliation. This is the proverbial dialectical process of thesis-antithesis-synthesis. Making a leap from the nature of reality to the process of history, Hegel also found the same dialectic process of change there.

So far this is all rather nebulous, one might say. Applied to the real world, Hegel's ideas are more provocative. For example, he considered Alexander the Great, Caesar, and Napoleon "world-historical" individuals, war morally superior to peace, the authoritarian state a superior form. He also described the United States as the land of the future, where the world's next great civilization would arise.

The Hegelian philosophy of history enjoyed only a brief vogue and might have been forgotten if it had not been discovered by Karl Marx. Although he considered himself a neo-Hegelian, Marx used the master's dialectic method to come to opposite conclusions, radical rather than conservative. It is only via Marx that Hegel entered the historical stage as a major player.

Parenthetically, we owe to Hegel the very idea of style as the expression of a force larger than the individual—the "will-to-form."

Philosophy majors may be interested in *The American Hegelians: An Intellectual Episode in the History of Western America*, edited by William H. Goetzmann.

HELLENISTIC

It is no coincidence that many of the most familiar classical masterworks—the Venus de Milo and the Winged Victory or Nike of Samothrace, both in the Louvre in Paris, or the Laocoön and the Apollo Belvedere in the Vatican—belong to the late Greek or Hellenistic period. (This is the preferred form of the word; although sometimes intended to mean the same, *Hellenism* actually means "Greekness.") The art produced in this period, which is usually dated from the death of Alexander the Great in 323 B.C., when

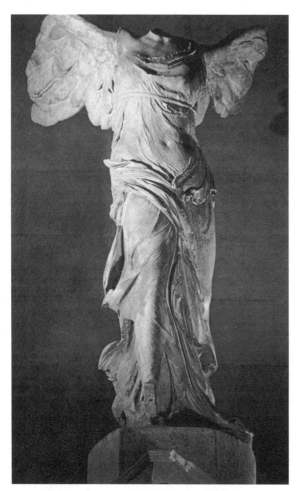

One of the all-time artistic moments: the Nike of Samothrace (c. 200 B.C.) at the top of the stairs in Paris's Louvre

the empire he had conquered broke up into satrapies, was bigger, bolder, more dramatic, classicism past its prime.

As the foci of Greek culture shifted from the mainland city-states to far-flung areas where Greek rulers and colonists were vastly outnumbered by indigenous populations, classical culture became inevitably more diluted and more cosmopolitan. An example of this shift of cultural gravity: the well-known statues of Venus and the Nike were found on islands in the Aegean, halfway to Asia Minor, and the two great libraries of the day (this was a period of collecting, of books as well as art and ideas) were at Pergamum in Turkey and Alexandria in Egypt. Today you have only to go as far as Germany to see the glory that was Pergamum, carried off during the heyday of imperialism and reconstructed in a Berlin museum. While the sculpture of the famous Pergamum altar remains in the classical mode, the figures exhibit more expressiveness, heightened movement, and magnified scale. Consider the writhing bodies of the giants and gods in battle, their anguished expressions—a far cry from classical serenity. Some even call this the mannerism of classicism.

Likewise, the Venus de Milo, with her nude torso draped only around the loins, is a late development; in the classical period, women were almost always chastely clothed. These Hellenistic sculptures also seem to be larger in scale, with more massive musculature, even taking into account the inevitable inflation of the Roman copying process. The two of the seven wonders of the ancient world that date from this period, the Colossus of Rhodes and the Pharos or Lighthouse at Alexandria, were both in scale and conception typically Hellenistic, or gigantic. (In fact, it was Hellenistic man who first identified "wonders," to awe an early generation of tourists.) The period itself has no

definite end; as the Roman Empire consolidated and expanded from the west, it fell heir to the Hellenistic cosmopolitanism of the Greeks.

Guerrilla cultural historian Camille Paglia (in her *Sexual Personae*) argues that the United States is in a Hellenistic period now—presumably meaning late-imperial decline, our original (classical) impulses exhausted, producing bigger and bigger spectacles....

Michael Grant's *From Alexander to Cleopatra: The Hellenistic World* is a good introduction for the lay reader.

HINDUISM

The name by which we refer to the religion of the vast majority of (East) Indians is a Western invention with no precise equivalent in Indian languages. There is no church or hierarchy of Hinduism, only countless sects in more or less common agreement on social and spiritual matters. Taken from *Hindu*, the Persian word for the Indus River, Hinduism has come to mean a body of religious and cultic practices and a philosophy of life. Its chief aspects include reincarnation, with rebirth in a higher form as the reward for virtue; a caste system, headed by the hereditary Brahmin ruling class and supported by the labor of "untouchables"; and a crowded pantheon of gods, subjects of a rich literary and artistic heritage.

The Hindu pantheon is extensive (some count Hindu deities in the millions), and even main characters may be difficult to identify. Each may have numerous avatars or incarnations, sometimes personifying different (this is why they have multiple heads and myriad arms) and occasionally contradictory characteristics. Instead of representing opposites, creation and destruction are part of the same flow in Hinduism (very Hegelian, in the opinion of scholar Heinrich Zimmer). By the same reasoning, the spiritual and the sensual, the ascetic and the erotic are not viewed as opposites either, but as aspects of the same life force.

The chief triad of Hindu gods is headed by Brahma, creator of the universe, an abstract figure who is seldom represented artistically, followed by the more popular Vishnu and Shiva (sometimes Siva). Vishnu is the preserver of the universe, dreamer of the world, also called the "cosmic sleeper"; Shiva, its destroyer, the divine yogi and "cosmic dancer." Shiva is sometimes represented by a lingam or phallus, indicating the life force, or with three heads, symbolizing creator, destroyer, and feminine energy. Then there are the wives—Vishnu's wife, Lakshmi, the lotus goddess, and Shiva's wife, Parvati—and children. In the second generation the most readily identifiable is Ganesha, son of Shiva and Parvati, represented as an elephant and identified with wisdom and learning.

Each of these deities has symbols and attributes (Vishnu is often represented wearing a heavy necklace or with a wheel or shell), and avatars or incarnations. Krishna, the blue shepherd dallying with the *gopis* or milkmaids, is another of Vishnu's many avatars, who also include the historic Buddha and Rama of the "Ramayana." Legions of lesser characters include *yakshis*, wood nymphs or fertility spirits; *nagas* or serpents; *apsaras* or heavenly nymphs. Animals are also frequently and charmingly represented in Hindu art; given the belief in reincarnation in higher and lower forms, there is no great distinction between man and animal.

In the United States, Hindu concepts were first popularized by transcendentalists and theosophists in the 19th century. In more recent times, Hindu-style movements

Vocabulary

ASHRAM: a center for religious study, often a remote hermitage inhabited by an ascetic or teacher and his disciples

DHARMA: duty, virtue

FAKIR: a devotee or naked ascetic

GURU: spiritual leader

KARMA: fate; endless cycle of reincarnation

MANTRA: hymn or magical formula, to be chanted ("Om...")

MANDALA: sacred diagram based on symmetrically arranged concentric circles

NIRVANA: enlightenment

RAGA: classical Indian musical modes

SHASTRA: iconographical system

SUTRA: treatise on various subjects

SWAMI: Hindu religious teacher

YOGA: union; exercise and meditation to achieve union with the universal self

YOGI: practitioner of yoga

Literature of Hinduism

THE VEDAS: oldest scriptures, c. 1500–900 B.C.; books of hymns, instructions, magic formulas

THE UPANISHADS: commentaries on the Vedas, 600–800 B.C.

THE RAMAYANA: epic poem, c. 400 B.C.

THE BHAGAVAD GITA: religious poem, c. 200 B.C.

THE KAMA SUTRA: text on erotica, A.D. 300–600; describing 64 positions of sexual intercourse

THE TANTRA: esoteric ritual to achieve union with the godhead (common to both Hinduism and Buddhism), A.D. 550–600

have been established by charismatic religious leaders, Indians with few ties to India: Paramhansa Yogananda of the Self-Realization Fellowship; Maharishi Mahesh Yogi, founder of Transcendental Meditation; and Maharaj-ji, boy guru of the Divine Light Mission.

Heinrich Zimmer's *Philosophies of India* is a classic.

HIPPIE

From a bohemian subculture with its own sartorial style (headbands, bell-bottoms, and love beads) and lifestyle (early Christian-communal, complete with a chemical sacrament), the hippie movement launched a cultural revolt in 1960s America. There is some disagreement whether their name is derived from "hippy-dippy," or from the beatnik concept of "hip" (the hippies also inherited from the beats some leftover Buddhism and Hinduism). In any case, the starting point is rejection of WASP middle-class values, the nuclear family, and the imperfect affluent society with its assassinations, riots, and wars.

Dropping out, hippies began experimenting with drugs and macrobiotic diets. The hippie pharmacopeia included marijuana, mescaline, and the new consciousness-altering hallucinogens, of which LSD is the best known. These produced effects ranging from euphoria to heightened perception and, occasionally, psychosis. (The term "psychedelic," used to describe various manifestations of hippie style, derives from psycho-delic with the nuthouse association eliminated, according to writer Tom Wolfe.)

Moving beyond euphoria and alienation, the hippie revolution created its own distinctive popular music, the highly amplified "acid rock" pioneered by a group called the Grateful Dead; a popular art of the poster variety, using fluorescent and high-key colors applied in pseudo–art deco swirls and arabesques; and a vocabulary or argot chiefly expressive of drug effects (bummer, freakout, mindblowing) and rejection of mainstream America (hangup, uptight, square). These phenomena all came together in new forms of community and celebration—happenings and be-ins, light and sound shows—which, even when not intensified by drugs, re-created the euphoria and timespace distortions of being "high."

Mandala *(courtesy Lois Mader)*

Meanwhile, back to the real world, where long hair and bell-bottoms enjoyed a general vogue (sometimes called "mod"), where Madison Avenue adopted psychedelic art techniques (Peter Max), and acid rock went mainstream with the Beatles' *Sergeant Pepper's Lonely Hearts' Club Band*. In 1969 the hippie revolution held a last great love fest at Woodstock, New York. Later that year the Manson family murders cast permanent discredit on the hippie injunction to turn on and drop out.

In a prime example of what is called fashion retro, the "hippie look" with its beaded, fringed, thrift-shop costumes turned up in fashion collections in the midst of the fall 1992 election. As one couturier explained, hippie hostess outfits were a good way for his Republican clients to get in the swing.

The Electric Kool-Aid Acid Test by Tom Wolfe is a masterful re-creation of the subjective experience of an era. See also *Psychedelic Art* by Robert E. L. Masters and Jean Houston.

HISPANO-MORESQUE

Shortly before setting sail in 1492, Christopher Columbus saw the flags of Spain flying over the Alhambra in Granada, formerly the citadel of Islamic power in Spain and a

monument to the style we now call Hispano-Moresque. Always extremely race-con-
scious, the Spanish compiled elaborate tables of the racial admixtures or *castas* (sort of
a "pigmentocracy") of their subjects. In the Spanish New World, for example, a *mes-
tizo* (or *mestiza*) was defined as a mixture of Spanish and Indian. During seven centuries
of Islamic domination in Spain similar categories arose to express degrees of racial, reli-
gious, and cultural interpenetration, categories such as *mozarabic* for Christians under
Arabic domination, or *mudéjar*, Muslims under Christian rule after the reconquest. The
Alcazar in Seville, built by Muslim workmen for Christian use, is considered a monu-
ment of mudéjar style. For those who cannot (or prefer not to) keep in mind such reli-
gio-racial distinctions, Hispano-Moresque serves as an umbrella for the various combinations
and permutations of Spanish and Moorish (the Moors being the North Africans of
berber and Arab stock who converted to Islam, conquered Spain, and built, in the
Moorish style, the mosque in Córdoba, Spain).

Over the years the Spanish Christian and Islamic cultures cross-fertilized each
other, the former contributing medieval Romanesque and Gothic forms, the latter, intri-
cate geometric patterns of ornamentation in architectural relief, woodwork, textiles, and
ceramics. This process came to a peak in the 13th and 14th centuries with the Alhambra,
a palace-fortress with myriad sumptuously adorned chambers and deliciously cool tiled
interior courtyards, like a vision out of *A Thousand and One Nights*. This is the archi-
tectural ideal that the conquistadors brought to Mexico, California, and their other New
World colonies, where it would become known simply as Spanish.

HISTORICISM

History was a great preoccupation of the 19th century. Whatever the field of endeavor,
historical precedents and models were sought, studied, and imitated. This was the great
period of the historical novel; philosophers like Karl Marx called on history in predict-
ing the future; and naturalists, who in the 18th century had done the great work of clas-
sifying species, turned in the 19th century to studying their history or "evolution."

Nineteenth-century arts and particularly architecture were given to what the
Germans called *Historismus*, or historicism, meaning the revival of period styles in faith-
ful sequence. Classicism, Gothic, Renaissance, and baroque each underwent a succes-
sive 19th-century revival or wave of infatuation, which varied in length and intensity
by country. Gothic, which seemed to provide a vital link to an idealized past, enjoyed
the longest run in both Germany and England. As cultural historian Wylie Sypher
remarks, "Dreaming of the Middle Ages was one of the shortest ways out of Manchester"—
Manchester symbolizing the new horrors of industrialization.

The result was a carnival of styles, a fancy-dress ball of history. Critics denounced
historicism as a "trance of dead forms," a "vain endeavor to reanimate deceased art…to
reproduce a body without a soul." Even the most ardent historicists deliberately sought
new styles, to break out of the historical cycle. Bavaria's King Ludwig I, for example,
sponsored a competition for a new style, with unknown results; he continued in any
case to build neoclassical monuments, while his grandson Ludwig II progressed to neo-
Gothic at Neuschwanstein. It was only at century's end with the advent of art nouveau,
the first modern style, that the treadmill of historical revival came to a definite halt.

America, in its Gilded Age at the end of the 19th century, also went through most
of the historical cycle in architecture, although not necessarily in proper sequence.

From the western branch of the Hudson River school, Albert Bierstadt's *Yosemite Falls* (1864) *(Timken Museum of Art)*

HUDSON RIVER SCHOOL

To the Pilgrims and other early settlers in North America, nature was a vast untamed wilderness, a chaotic and dangerous place which they set out to tame and conquer. Only in the mid-19th century, as the tide of urbanization and development was threatening to engulf it, did a group of artists emerge to celebrate the beauty of our virgin landscape. Based in New York, these artists began by exploring the wilderness nearest at hand—"the polite wilderness," as historian Serge Kostof called it: the Hudson River valley, from which they took their name, and the Catskills.

The first of the school were the British-born Thomas Cole, whose canvases depict turbulent, primal scenes, and former engraver Asher B. Durand, a specialist in detail. Rejecting the picturesque and highly domesticated scenes favored at the time by European landscape artists, they sought instead a higher moral significance, the imprint of God in the grandeur of nature. (Man, when he appears at all in Hudson River canvases, is only a small figure, dwarfed by the beauty he is contemplating.) In the school's second generation, although still based in the Hudson River valley (where they built rather grand homes), Frederic Church and the German-American Albert Bierstadt ranged farther afield. Church traveled as far as the Amazon and the Arctic (his *Heart of the Andes* has been called the most celebrated American painting of the 19th century), while Bierstadt journeyed overland (still a dangerous trip) to the West Coast to develop his

specialty in mountains (Hood, Shasta, Rainier, Whitney). In these days before photography became widespread, critics thought he was exaggerating the monumental scale of the Sierra and Rocky mountains. In any case, the awe-inspiring, luminous landscapes of Church and Bierstadt enjoyed great popularity among Americans eager to know what their country looked like.

The Hudson River school achieved international recognition at the 1867 Paris Expo, where it was hailed as a unique national style, suggesting new images of the New World. "No one is likely to mistake an American landscape for the landscape of any other country," one European observer remarked, although others thought Bierstadt's Rockies looked suspiciously like the Alps. To most viewers today, spoiled by travel and photography, these canvases have lost their original impact.

There are several coffee-table books on this movement. The best account I found was in young-adult format, Barbara Babcock Lassiter's *American Wilderness: The Hudson River School of Painting*.

HUMANISM

Humanism, the intellectual movement or style of thought underpinning the Renaissance, involved a basic shift in values from medieval religiosity and Scholasticism to a more heroic and secular model of man as a thinker, a learner, a transmitter of culture. Where the Renaissance celebrated the creative genius and the condottiere, humanism went back to the Greeks and the Romans (the word itself is taken from Cicero) to focus on man in general, his perfectibility and his place in the universe.

The humanists (chief among them was Erasmus of Rotterdam) set out deliberately to reconcile antiquity and Christianity, treating every discovery as a rediscovery, every progress as a return to the past. For example, they were instrumental in reviving the classics, which they hailed as the "natural gospel" of antiquity. The revival of the classics was only part of the larger spread of culture to a growing public, one with a new sense of history, hope, and pride in civilization. (It is in this sense that the "humanities" got their name, as a body of knowledge concerning enduring human truths that, unchanging, are continually rediscovered.)

Although the movement was not irreligious, and certainly not "pagan" as is sometimes charged, the humanistic search for the laws of man and nature would eventually lead to the religiously divisive Reformation and the agnostic Enlightenment. (In the short run, humanism was succeeded by mannerism.) In current usage humanism tends to be imprecise and polemical, usually connoting left-wing and anti-church, if not downright subversive and sacrilegious—presumably drawing on the Renaissance fear of humanism as antithetical to religion. For example, American fundamentalists have denounced sex education as a devious attempt "to destroy the traditional moral fiber of America and replace it with a pervasive sickly humanism...." This is a long way from the humanism of Cicero and Erasmus.

Moses Hadas in *Humanism* argues that the Renaissance revived the Greek tradition of assertive individuality, which had been superseded by medieval notions of submission and anonymity and human sinfulness. Alan Bullock's *The Humanist Tradition in the West* is lucid and enlightening.

Sometimes people call me an idealist. Well, that is
the way I know I am an American.

Woodrow Wilson, address at Sioux Falls, Iowa, September 8, 1919

ICONOCLASM

The Old Testament injunction against the worship of graven images—stigmatized as pagan idols, their creation a usurpal of God's authority and their veneration an act of idolatry—was observed by the Jews and absorbed from Judaism into Islam, but fell into the breach of early Christianity. Arnold Hauser points out in his *Social History of Art* that after the western church was recognized by the Roman state, the fear of a lapse back into idolatry eased and the visual arts could be put to restricted church use. It was only in the eastern Roman or Byzantine Empire that the icons (from the Greek *eikon*, or image) became a major issue in the eighth century A.D. There icons were still held to be so powerful, possessing almost magic or supernatural force, that their creation was subjected to strict rules.

The Byzantine sensitivity to icons was compounded by military insecurity and political infrastruggle. During the eighth century when Islamic armies came close to capturing Constantinople—as if to punish idolatry—the Byzantine emperor issued his famous edict ordering the destruction of icons and punishment of idolaters (called *iconodules*, and subject to flogging and mutilation). Part of his motivation may have been to conciliate the eastern Byzantine provinces, those most susceptible spiritually as well as geographically to Islam. The opposition, in any case, was chiefly the monasteries, which favored icons as a source of influence and income, and the church in the West. The result was

a conflict of theology and power that eventually caused a permanent schism between Roman Catholicism and Eastern Orthodoxy.

Iconoclasm remained official policy in Byzantium for about a century, with some fluctuation: icons were permitted again briefly, banned anew after further Islamic victories, then permanently restored in 843. The controversy, playing as it did on deeply held beliefs, superstitions, and fears, seems to have permanently inhibited the impulse to religious representation in the Eastern Orthodox Church, which continues to conform to this day to crabbed Byzantine canons (although infused by the Russians in particular with new vitality). In sculpture only low relief is allowed, sculpture in the round being considered conducive to idolatry.

This struggle over religious imagery was replayed during the Reformation in Europe, with Protestant iconoclasts purifying their places of worship of all visual distraction and the Catholic Church responding with ever greater baroque excesses.

In English usage iconoclasm has become synonymous with irreverence, the puncturing of sacred cows whether religious, political, or other. It may also imply a certain kill-joy philistinism. For example, Eva Weber in her book on art deco compares the destruction of New Deal art after the Depression with the eighth-century Byzantine campaign against icons.

IDEALISM

If you studied philosophy in college, you may know what idealism means; if not, you may only think you know, itself a typical philosophical conundrum. The key concept is *idea*, not ideal as in idealistic or having high principles. Not to get too deeply ensnared in epistemology, suffice it to say that idealism is the German philosophy of the supremacy of the idea—distinct from or somewhere between the British tradition of empiricism and the French of (Cartesian) rationalism.

Immanuel Kant, the fount of German idealism, set out to explain all experience in terms of concepts, categorizing the principles of organization that transform experience into knowledge. The result is his ponderous, 800-page tome, the *Critique of Pure Reason* (1781), followed by his *Critique of Practical Reason*. Kant's categorical imperative, his supreme principle of ethics, is a convoluted way of eliminating the theological trappings from "do unto others," a philosophical version of the Golden Rule, according to historian Peter Gay.

Kantian idealism dominated 19th-century philosophy, penetrating even the intellectual backwoods of America. Our transcendentalism, for example, took from Kant its raison d'être, the concept that ideas are transcendent (although Americans tended to confuse Kant's distinction between pure and practical reason, historian Paul Boller points out). Kant's ethics, Boller adds, were also "tremendously appealing" to transcendentalists "struggling to free themselves from the Puritan tradition without throwing aside its moral impulse."

So what does this all have to do with the real world? A lot, it turns out. Bronowski and Mazlish, in their excellent study on *The Western Intellectual Tradition*, point out that German scholarship has always been characterized by a split between grand idealistic metaphysical mystagogues and pedants specializing in painstaking investigation of minute detail. "The middle level," they continue, "of careful synthesis and the modest testing of hypotheses, tended to drop out entirely." The resulting German failure to do what

we call "reality-testing" has had a major effect on the course of modern history.

Peter Gay cites a German professor who considered democracy a foreign form, "suitable for the materialistic Anglo-Saxons, but incompatible with the idealism of the Germanic race." This is idea-lism. The Nazi leader Adolf Eichmann, captured in South America and brought to trial in Israel, maintained that he was an idealist because he remained true to the idea of the Final Solution.

Never underestimate the power of an idea. Kantian idealism directly influenced Hegel (see HEGELIAN), whose work became a major source of Marxism, which in turn gave rise to communism...which dramatically changed the lives of millions of people and the sweep of history.

IMPERIALISM

Imperialism literally means government by empire, or a state uniting many territories and peoples under an emperor. There have, of course, been empires since the dawn of time, but imperialism, in current usage, is a relatively recent development. We speak for example of the Roman Empire but not so readily (although it is possible) of Roman imperialism. Modern imperialism seems more motivated than the Roman version by gold, glory, and some variation on what Rudyard Kipling called "the white man's burden."

Following on the age of exploration and discovery and the industrial revolution with its constant need for resources and markets, modern imperialism got into full swing in the 19th century. In the last quarter of the century alone a handful of European nations took as colonies 12 million square miles inhabited by 183 million people. These colonies were mostly on what were called "the darker continents." Mapmakers were kept busy changing these areas to new colors denoting European ownership. Some of the new emperors saw themselves as modern Romans—classical became the style of architectural choice to convey imperial authority, historian Mark Girouard remarks in *The Return to Camelot*. Chief among the colonizers was Great Britain, which added 4 million square miles and 88 million inhabitants to its empire, invoking the Christian gentleman's duty to help the less fortunate. As British imperialist Cecil Rhodes put it baldly: "I believe we are the first race in the world, and that the more of the world we inhabit, the better it is for the human race."

Another Englishman, economist J. A. Hobson, was the first to give imperialism the meaning it now carries on the left. Writing in 1902, Hobson characterized imperialism as capitalism trying to rescue itself from its dilemmas by foreign conquest. This is the sense of imperialism subsequently adopted by Lenin, who used it to account for capitalism's failure to destroy itself as Marx had predicted. Imperialism, according to the central tenet of Leninism, was the final stage of capitalism, the new threshold of revolution.

The United States, preoccupied by its own manifest destiny, and having its own dark continent to conquer, arrived late on the world stage of imperialism. Justifying our first overseas conquests, President McKinley said of the Philippines during the Spanish American War, "There was nothing left to do but to take them all...and civilize and Christianize them...." Never mind that the islands, named for the devout Philip II of Spain, had been Catholic for centuries.

In the 20th century the United States emerged as a major imperialist power, often

proceeding aggressively and apologetically at the same time, a "reluctant giant" respond-ing knee-jerk fashion to competitive threats by others. As characterized by economic historian Robert Heilbroner, American imperialism has been "the reaction of a great power placed on the defensive by the thrust of world events and seeking through mil-itary force to maintain friendly governments in power and to thwart unfriendly ones."

IMPRESSIONISM

Sun sparkling on water, shadows dancing on a girl's dress, quivering reflections on a rainy street—this is the world of impressionism, probably the most popular and ulti-mately most accessible style in painting of the last century, commanding peak crowds at exhibits and top prices at auction in recent years.

You may therefore be surprised to learn that in their own day the impressionists were a much maligned and struggling group. Arnold Hauser considers impressionism one of the most daring stylistic leaps in the history of art and reports in his *Social History of Art* that it aroused a great shock in the art public. People found the apparent slop-piness and shapelessness of these pictures to be a mockery, an insolent provocation, a "pancake of visual imbecility." Impressionist painters were at first treated as mad, ridiculed, or simply ignored. The arts in France were then governed autocratically by an acad-emy that strictly controlled access to *the* annual showing of new art, called the "Salon." Their paintings continually rejected by the establishment, the impressionists joined the counter-culture "Salon des Refusés" in 1863, finally beginning to organize their own (initially unsuccessful) exhibits in 1873.

Rejecting the vestiges of neoclassicism, romanticism, and realism that still passed for high style in mid-19th-century France, the impressionists developed a marvelous pictorial shorthand ("They send detail to the dogs," novelist Henry James remarked) out of streaks of pigment, comma-shaped brushstrokes, dots, dashes, smudges, and blotches. Their subject was primarily the landscape in its changing moods, seasons, light. Dispensing with line, outline, and eventually form, they concentrated on the fleet-ing, evanescent effects of light, its reflection and refraction.

First, last, and most perennially popular among the impressionists was Claude Monet, who specialized in serial views of the same subjects—haystacks, poplars, Rouen Cathedral, waterlilies—in different light and mood. Closely associated with Monet (sometimes they even painted the same subjects together) was Pierre-Auguste Renoir, whose picnics, boating parties, and dancing couples exude great joie de vivre. Others among the giants of impressionism include Camille Pissarro, a rather retiring elder statesman, and Paul Cézanne, whose provincial landscapes would provide the bridge to cubism. Somewhat apart by virtue of temperament and style, inclining more to tradi-tional realism, were Edgar Degas and Edouard Manet. This was the core group fea-tured at eight exhibits of impressionist painting beginning in 1874 and ending in 1886, by which time they were beginning to enjoy modest sales.

The year 1886 also saw the first exhibit of impressionist paintings in the United States. Impressionism never really caught on in Great Britain or Germany, both resis-tant to French cultural domination, but America was more receptive. One of the first impressionist paintings ever sold, in the 1870s, was acquired by Luisine Elder (later Havemeyer), who took the advice of her friend Mary Cassatt, an expatriate artist who lived in Paris, to buy a pastel of a dancer by Degas, with whom Cassatt was studying.

The best known of the American impressionists, Mary Cassatt specialized in such intimate moments as *The Bath* (1891–92) *(Art Institute of Chicago)*

The greatest American impressionist, Cassatt specialized in nonsentimental portraits of mothers and children, their flat contours betraying the influence of Japanese prints.

Impressionism also inspired imitators in the United States, chief among them Childe Hassam. Some of the American impressionists were such true believers that they traveled to Giverny, France, to paint at the feet of Monet, who seems to have been remarkably hospitable and tolerant when the Americans copied his haystacks, his rows of poplars, his garden. (One of the American painters even married Monet's step-daughter.) With the exception of Cassatt, the American impressionists were second-rate at best, proficient at the stylistic tricks but reluctant to abandon their hard-won academic (usually realist) techniques.

Prominent American artists such as the expatriate John Singer Sargent (a friend of Monet's) painted for a time in a modified impressionist style. There was also a domes-

tic branch of impressionism called luminism for its landscapes bathed in crystalline light, sharper-edged than impressionistic. (The best-known luminist was FitzHugh Lane.) Our greatest artists of the last third of the 19th century—Thomas Eakins, Winslow Homer, Albert Pinkham Ryder—favored "the dull side of the palette, a world of slates and muds," in the words of historian Lewis Mumford whose study of these post–Civil War years is called *The Brown Decades*. In the early 20th century the Ashcan school used impressionist techniques in a predominantly realist style. Impressionism had by this time become part of the basic vocabulary of art.

In 1894 impressionism was still so far out of favor in France that the government rejected outright one-third (including eight Monets) of the paintings in this style included in a bequest to the state. Only the advent of cubism after the turn of the century made the impressionists seem respectable, safe, familiar—and an increasingly lucrative investment. (According to a mid-1980s *Connoisseur* magazine article, American impressionist paintings have become an even better relative investment value than French, at least in part because they are in much shorter supply.)

The themes and methods of impressionism spilled over into music and to a lesser extent into literature. The music of Claude Debussy, with its tendency to break up and reprise melody and chords in new contexts, has been called impressionistic. In literature, the influence of impressionism is somewhat harder to pinpoint (Hauser calls the Russian author Anton Chekhov the purest impressionist writer) and to distinguish from the symbolist movement. You may also hear tell of the "impressionist sociology" of Georg Simmel.

The great mother lode of impressionist art is to be seen in the Musée d'Orsay in Paris, with another dazzling collection at the Hermitage in St. Petersburg. American museums also have significant holdings, bequeathed by the robber barons who collected them so avidly. Every Rockefeller and Vanderbilt had to have at least one, and the Whitneys cornered a good bit of the market. Another American collector, Albert C. Barnes, a physician who became rich thanks to an improved antiseptic, acquired 200 canvases by Renoir alone! (Fortunately, the impressionists were prolific.) There are important American collections of the French impressionists at the Metropolitan Museum of Art in New York, which inherited the Havemeyer holdings; at the National Gallery in Washington, D.C., thanks to benefactions of the Mellon family and Chester Dale; and at the Art Institute of Chicago, owner of Monet's waterlilies.

John Rewald's *The History of Impressionism* is detailed and quite rewarding, with well-chosen illustrations. For the American angle, see *American Impressionism* by William H. Gerdts. On U.S. collectors, see *The Havemeyers: Impressionism Comes to America* by Frances Weitzenhoffer. You will be hearing a lot about the Barnes collection, subject of a traveling exhibit in 1993–94 and companion volume, *Great French Paintings from the Barnes Foundation* (Richard J. Wattenmaker, et al.).

INCA

The Inca were relative latecomers on the Meso-American scene, occupying their Andean empire for barely a century before they were defeated by the conquistador Francisco Pizarro in 1532. (The last Inca emperor, Atahualpa, lost his life after failing to fill a room with gold.) The environment was harsh, steep narrow mountain corridors that

the Inca tamed by means of engineering, terracing, and irrigation. They domesticated the llama and alpaca, became accomplished metallurgists, and constructed an elaborate system of highways and bridges connecting their great megalithic mountain cities.

The Inca had no written language, although Quechua or Quichua, which they spoke, is still spoken by millions of South American Indians. We know their history from Spanish accounts and from the evidence of archeology.

In the decorative arts, the Inca were skilled textile weavers (far ahead of the rest of the world in their day, according to art historians Honour and Fleming) and made conventional pottery with geometric designs. They also did extensive mining of copper, tin, silver, and the gold that would prove their downfall, and they were knowledgeable about smelting and alloying. They are most celebrated for the architecture of their terraced towns, featuring massive, superbly fitted stone masonry, strongly symmetrical in plan and construction. The most famous of these is Machu Picchu, one of the great sights of the world. The Inca heritage also includes the white potato, varieties of Indian corn, quinine, and cocaine.

A benevolent despotism, the Inca government assumed responsibility for public welfare. The people were impressed into military and labor service and absorbed into an all-embracing cycle of agricultural ceremonies and religious duties. These centered on worship of the sun, divination, feasting, and fasting, with occasional human sacrifice. The Inca Empire was defeated by Pizarro with his band of only 200 Spanish soldiers, and cities such as Machu Picchu were abandoned, but the Quichua Indians of South America, with their communal forms of life and worship, survive. Textiles from the area of the old Inca Empire, chiefly Nazca and Aymara, are highly prized by collectors.

The mutual fascination of Pizarro and Atahualpa was the theme of a popular 1964 play, Peter Shaffer's *The Royal Hunt of the Sun*. *Lost City of the Incas* by Hiram Bingham is the story of the rediscovery of Machu Picchu in the early 20th century.

(EAST) INDIAN

Indian historical periods are somewhat difficult for the uninitiated to follow. A Bronze Age civilization in the Indus River valley, sometimes referred to as Mohenjo-Daro for one of its urban sites, was unearthed by archeologists only in the 1920s. The art of this civilization, estimated to have lasted from 3000 B.C. to 1500 B.C., reveals Mesopotamian influences as well as some sinuous forms that in retrospect look typically Indian. Little is known of the next thousand years of Indian history after the decline of Mohenjo-Daro, often called the Vedic period after the ancient scriptures that constitute the basis of Hinduism. With the invasion of Alexander the Great shortly before his death in 323 B.C., India reenters the stage of world history. Under the Maurya dynasty (322–185 B.C.), India converted to Buddhism and erected towering "edict pillars," in a style indicating Persian and Hellenistic influences, to commemorate the as yet only symbolically represented Buddha.

The second to fifth centuries A.D. in India are called the Kushan period, which gave rise to two distinct styles. Decorating magazines often feature examples of them because they are just esoteric enough to be popular with modern collectors: Gandhara in the North (now Pakistan) produced the first human images of the Buddha, strongly influenced by Hellenistic canons, while Mathura (south of Delhi) is known for a more

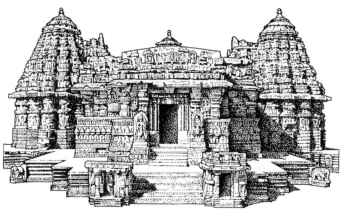

A richly carved, almost baroque, 13th-century temple at Somnathpur and a movie palace (M. I. Diggs, 1928) in Oakland, California *(C. Dunlap)*

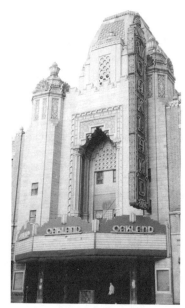

sensual, naturalistic style of representation. Next comes the great "classical" age of Indian art, the Gupta period (A.D. 300–600), when a more spiritual representation of the Buddha became conventional. The 10th to 13th centuries A.D., when Hinduism was gaining the ascendancy over Buddhism, are called—in India as in Europe—the Middle Ages, followed by the Mughal invasion in the 16th century and British imperialism in the 18th century.

Having reduced 4,000 years of Indian history into compartments, it is important now to emphasize the cultural continuity despite great political and religious upheaval. The best evidence of this is the difficulty in differentiating Hindu, Buddhist, and Jain art, all the arts of India being primarily religious, evolving at a relatively slow pace, and featuring many of the same historical and mythological characters. For a more detailed description of this Indian pantheon, see HINDUISM, which established the artistic canons and cast of characters adopted by the others. The Hindu god Vishnu, for example, often looks very like the Buddha, obeying the same myriad stylistic conventions such as the symbolic hand positions (*mudras*) and postures, while the Hindu *yakshis* or wood nymphs would be reincarnated as bodhisattvas or Buddhist saints.

The most important Indian art is unquestionably sculpture. In fact, some consider Indian architecture, with its temples hewn out of rock and deities stacked up like "mountains of writhing forms," to be an extended form of sculpture. It is this "writhing" of sinuous, pneumatic, fleshy, almost boneless forms of full-breasted women and their oversized, many-armed consorts, that to the Westerner is most characteristic of Indian art.

For a good short survey, read Roy C. Craven's *Indian Art* in the Thames & Hudson series. Those with the inclination and the time should seek out the works of Heinrich Zimmer: *Myths and Symbols in Indian Art and Civilization* and *The Art of Indian Asia*.

THE INQUISITION

In Western history the Inquisition has always loomed larger than life, symbolizing religious tyranny, cruelty, torture, and man's inhumanity to man. The reality is somewhat less dramatic, according to a recent reassessment by Edward Peters. The period of the Inquisition runs from the 13th to the 16th centuries, but in fact there was no one Inquisition, no single all-powerful court; rather, there were national and local religious courts of inquiry, with great differences between them, some dragging on into the 19th century. (The Vatican's Index of Prohibited Books, a creation of the Roman Inquisition, remained in effect until 1966.) It was a local French court of inquiry that condemned Joan of Arc to be burned at the stake in 1431 as an unrepentant heretic.

The Inquisition was an effort by the Roman Catholic Church, using old Roman law, to stamp out heresy (minutely defined), to preserve orthodoxy, and to maintain internal discipline. It was in 15th-century Spain that the Inquisition acquired its most lurid reputation. Allying with the monarchy after the reconquest from Islam, the Spanish Inquisition gradually enlarged its jurisdiction from baptized Christians to become a vehicle of anti-Semitism, persecuting Jews who refused to convert. The Spanish court insinuated itself into every aspect of life, prosecuting bigamy and censoring books, but ironically it was rather sparing with respect to torture and the death penalty. (The Spanish punishment of choice was the *auto-da-fé*, a penitential procession and declaration of faith.)

Next most infamous was the Roman Inquisition, which put the astronomer Galileo under house arrest for accepting the Copernican theory of the solar system. The Roman group was also active in censoring the arts, challenging, for example, Veronese's inclusion of jesters and a dog in his depiction of the *Last Supper* (the artist's response was to rename the canvas *Feast of the House of Levi*). Particularly vigorous in prosecuting Protestants during the Reformation, the Roman court bequeathed to history the stereotype of the persecuted Protestant martyr. (For their part, Protestants also proved themselves capable of inquisitorial methods; Luther favored the death penalty for Anabaptists, and Calvin burned a leading Unitarian at the stake. As intellectual historians Bronowski and Mazlish point out, Galileo might have fared worse in Calvin's Geneva than under the Roman inquisition.)

In Western iconography and literary symbolism, the Inquisition plays a large role, practically constituting an archetype of the collective unconscious. It figures prominently in Gothic novels full of what the Germans call the "romanticism of terror," with a sub-genre devoted to the erotic Inquisitor as sexual slavemaster. As examples of the Inquisition in better literature, we have Schiller's *Don Carlos* (1785), which became the basis of Verdi's grand opera, and Dostoyevsky's *The Brothers Karamazov* (1879) with its Grand Inquisitor, a powerful ruthless figure, symbolic of man's need for authority and mystery. In American literature, the Inquisition plays a role in Edgar Allan Poe's *Pit and the Pendulum* (1843).

Due to its Protestant origin, the United States inherited the stereotype of the Inquisition persecuting Protestant martyrs. American Puritans were not the most tol-

erant of people, either, conducting their own witch-hunts. And in the not very remote past, America had its own homegrown political inquisition, the McCarthy era, not to mention the FBI as a self-constituted inquisitorial body under the leadership of J. Edgar Hoover.

Inquisition by Edward Peters is a good recent reevaluation of the subject, with particular attention to the mythology of inquisition. Another recent study for generalists is Edward Burman's *The Inquisition: Hammer of Heresy.*

INTERNATIONAL STYLE

Either you like it, or you don't. The partisanship surrounding this 20th-century movement in architecture is heated. Self-designated as the first great universal style since the Renaissance, the International Style grew out of the austerely functional worker housing and factories designed by Walter Gropius and his Bauhaus colleagues around World War I. The designation itself, taken from the title of a book by Gropius, first gained currency in the United States via a 1932 Museum of Modern Art exhibit on the new architecture, organized by a young man who would become its chief American acolyte, Philip Johnson. Soon after the MOMA exhibit, the architects themselves arrived, refugees from Hitler's Europe, to take charge of America's architectural schools and eventually (with time out for the Depression and the Second World War) to realize in the New World their ideas, which had remained largely on paper in the Old.

Some early American monuments to the International Style are New York City's Lever House (1951–52) and Chicago's Lake Shore Apartments (1950–52), concrete and steel high-rises sheathed in glass, their undifferentiated faces absolutely devoid of ornamentation and of historical references. Some consider them austerely elegant; others, enormous cages to stifle the human spirit, hives of nothingness. Either way, these skyscrapers became the standard for American corporate architecture of the post-war era.

The very fact that a style originally conceived for worker housing, bare and functional, austere out of aesthetic conviction as well as economic necessity, should now house 98 percent of America's malefactors of great wealth, is itself a source of malicious pleasure to critic Tom Wolfe. Perhaps Wolfe's most telling indictment of the International Style is the undeniable fact that corporate tenants go to great and expensive lengths to transform their slab-grid offices into period parlors and Restoration town houses.

There are of course regional variations in International Style design, and other types of buildings besides skyscrapers. Southern California in particular has some interesting and rather idiosyncratic International Style houses dating back to the 1920s and 1930s.

For Wolfe's send-up, see his *From Bauhaus to Our House.* The opposite position, that of uncritical acceptance, is taken in the majority of architectural texts—perhaps a reflection of the extent to which the proponents of the International Style captured the architectural establishment. In *Postmodernism* leftist philosopher Fredric Jameson dismisses Wolfe's stand as Babbitry, a philistine reaction against modernity.

IROQUOIS

The Iroquois confederation of Indian tribes or nations, historically based in the New York State area, was an important military and political factor in early American history. Originally formed in the 16th century by the Mohawks, Oneidas, Onondagas, Cayugas, and Senecas, and later joined by the Tuscaroras, the Iroquois played a pivotal role between the British colonists and the French to their north in Canada, using statecraft and diplomacy to maintain their neutrality. They also waged energetic wars against their enemies, the Hurons, the Eries, the Conestogas, and the French, in the 17th century. A vigorous agricultural people, they lived together in extended families in bark longhouses, governing themselves by elections in which women participated.

The Iroquois had no written language (until Anglican missionaries devised a system for writing Mohawk, into which they translated Iroquois religious literature). Traditionally, they created bands of shell and later beadwork arranged in representational and geometrical designs with conventional meanings, mnemonic devices recalling important historical and ceremonial occasions. Called "wampum belts" by

A "False Face" mask (c. 1900), believed to have therapeutic powers, from the Onondaga tribe *(St. Louis Art Museum)*

the Yankees, who encouraged them as a medium of exchange (one purple bead equaled two white ones), these are now highly prized by museums and collectors.

Another characteristic Iroquois art is the carved wooden mask, often grotesquely expressive, worn by members of "False Face Societies" in ceremonies to exorcise various ills. One variant of the mask is made out of corn husks, with trailing streamers. Even modern Iroquois attribute psychotherapeutic powers to the mask ceremonies. Some of the masks represent people seen in dreams, while others are clever caricatures of neighbors.

Most Iroquois remained loyal to the British during the American Revolution and shared the British defeat. American independence meant the end of their power; they were dispersed (north to Canada, west to Wisconsin and Oklahoma) and confined on reservations, where they were condemned to a gradual process of decline. In recent years, in an ironic commentary on lost Indian martial pride, the "Mohawk" haircut has enjoyed a vogue among inner-city youth.

See Barbara Graymont's *The Iroquois*.

ISLAM

Islam burst on the world with a tremendous force in the seventh and eighth centuries A.D. Within 200 years of the death of the Prophet Muhammad in 632, his followers had stormed out of Arabia to conquer Syria, Iraq, Egypt, Morocco, Spain, Turkey, Persia, and later Central Asia, encircling the Mediterranean on three sides; only Byzantium eluded capture (until 1453), and Charlemagne held the line at the Pyrenees. The unprecedented speed and order of the Muslim expansion has been attributed to the exaltation of the new faith, aided by the excitement of sheer momentum. Cultural historian Adda Bozeman called the Muslim conquest "the greatest of all caravans," an "empire in motion" with no geographic limits.

The chief tenets of Islam are that there is but one God, Allah, to whom unquestioning obedience is required, and one prophet, Muhammad; and that God's word as revealed to Muhammad in the Koran or Islamic bible is the final word on all questions of faith. The Koran is a retelling of the Old and New Testaments from the Arab point of view: Jesus is downgraded to a minor prophet; the virgin birth and crucifixion are dismissed as "Jewish fable"; the archangel Gabriel serves as Allah's chief courier. Other objects of Muslim belief and practice include retribution, or "an eye for an eye"; mutual help as a sacred duty; and guaranteed entry to heaven to all who die fighting a holy war, or Islamic *jihad*.

Islam has no priesthood per se, and the Koran contains no political organizing principles. Because Allah alone legislates, governmental power is unrestrained by any practically applicable principles of law or human rights, encouraging, in effect, despotism. Poorly defined geographically, the Islamic empire was too vast in any case to be held together by one central government. Once its initial momentum was exhausted, it began to decline almost immediately. By the 11th century A.D., there were eight different potentates calling themselves caliph, or "successor" to Muhammad (see below).

Muslim conquerors did not require conversion to their faith, but offered it, easily,

● ——————— ●

Familiar Islamic or Arabic Words and Concepts in English

CALIPH: Muhammad's successors as temporal and spiritual leaders

EFFENDI: from the Turkish for *man of property, authority*

HAJJ: pilgrimage to Mecca, a religious duty

HAKIM: doctor, wise man

HAREM: from the Arabic for *protected and forbidden*; usually designates the place where women are sequestered, but also applies to sacred areas

ISLAM: literally means *surrender*

JIHAD: holy war or crusade

MADRASSA: school

MAHDI: savior or the *guided one*

MIHRAB: niche or focal point of the mosque

MOSQUE: place of prostration, for public worship

MUFTI: advisory judge or jurist; also, civilian dress

PASHA: from the Turkish for *man of high rank*

RAMADAN: the ninth month of the Islamic calendar, when fasting from dawn to sunset is a sacred duty

SHAIKH, SHEIKH, or SHEIK: an Arab chief

A spiraling minaret from the 9th-
century mosque at Samarra, Iraq, and
an ornately carved wood panel from
11th-century Fatimid Egypt
(Metropolitan Museum of Art)

to all observing the minimum duties: submission, prayer, ablutions, fasting, and pil-
grimage. Islam, therefore, embraced large subject populations, becoming a cosmopoli-
tan community linked by faith and by the Arabic language.

The Muslim conquest of the Mediterranean coincided with the Dark Ages in Europe.
But in Islamic territories it was a time of economic prosperity and great cultural stimu-
lus. In art, because of Koranic restrictions on the use of living figures—as a guard against
idolatry—Islam developed no tradition of large sculpture or painting. Instead, the empha-
sis was on smaller, portable objects, often functional as well as aesthetic—ceramics, ivory,
precious metals, leather, textiles, illuminated manuscripts, and, of course, rugs. Whatever
the medium, surfaces tended to be richly decorated, even transformed, by ornamentation
of all kinds—engraved, chiseled, carved, encrusted, embroidered, woven, in floral, geo-
metric, and calligraphic forms. The arabesque, a repeating pattern using largely geomet-
ric motifs, of Hellenistic origin, became the ultimate and ubiquitous expression of
nonfigurative Islamic art. Another important Islamic decorative element is calligraphy or
inscriptions in Arabic script. (The ceremonial script developed mainly for the Koran is
called *Kufic*.) Finally, mention should be made of illuminated manuscripts, in which script
and painting flourished on a small scale. (The Persians, who excelled at illuminated man-
uscripts, were the most liberal interpreters of Koranic restrictions.)

In architecture, the chief Islamic contributions are the mosque, the *madrassa* or
school, and the mausoleum honoring the eminent dead. Originally the mosque was an
unpretentious structure modeled after Muhammad's home, a courtyard enclosing a large
inner space to hold the congregation, always facing Mecca; the madrassa, similarly, was
a courtyard lined with cells for the students and lecture halls. In the 13th century the
mosque's open courtyard was first enclosed under great domes, sometimes tiled, reach-
ing their epitome of grandeur under the Ottomans. In the far West, the mosque at
Córdoba, Spain, is a fantastic structure, even containing within its acres of columns a

Principle Islamic Caliphates and Successor Empires

UMAYYAD (661–750): The powerful Arabian warrior clan that carried Islam all the way to the Atlantic; based in Damascus, created the first Islamic monuments drawing on Byzantine, Hellenistic, and Persian models; defeated by the Abbasids in alliance with the schismatic Shi'ites, the Umayyads survived in Spain until 1009.

ABBASID (750–1258): The "classical age" of Islamic culture under the caliph Harun al-Rashid (of *A Thousand and One Nights*), based in Baghdad; lavish expenditures on mosques and palaces with multiple vaults and cupolas, ornamental brickwork and stucco paneling; interdiction on representation of living beings leads to abstract and geometric decorative arts; gradual loss of control over great territorial conquests.

FATIMID (10th–12th centuries): Based in Cairo, achieved dominion over North Africa and parts of the Middle East; defeated by the crusaders, who copied their defensive structures and their pointed arch; decorative arts characterized by abstract motifs, arabesques, calligraphy; important textile industry.

SELJUK (10th–12th centuries): Former nomadic Turkoman tribesmen who dominated the Middle East; famed for caravansaries or inns, patterned brick mosques, mosaic tiles, and early knotted carpets with geometric patterns; partial victory over the Byzantines in 1071, later defeated by the Mongols.

MAMELUKE (1250–1517): Successors to the Fatimids in Egypt; built great Islamic monuments of Cairo, typically with asymmetrical towers and pointed arches; distinctive red and blue carpets; defeated by the Ottomans in 1517, survived as a landlord class in Egypt to serve Napoleon as mercenaries.

SAFAVID (1502–1722): Great Persian cultural renaissance under Shi'a Islam, based in Isfahan; richly ornate tiled mosques, highly developed decorative arts, vividly painted miniatures, and the first great flowering of the Persian carpet under official patronage; great luxury and extravagance: our word "paradise" derives from the hunting grounds of the shahs, or Persian leaders.

MUGHAL (1526–1858): A powerful centralized state that ruled in India.

OTTOMAN (15th–20th centuries): Last dynamic Islamic successor empire and fierce warriors of Turkoman origin; conquered Byzantium in 1453; great domed mosques inspired by the Christian Hagia Sophia; the great age of Turkish carpet weaving.

Calligraphic emblem of Sulaiman the Magnificent, Ottoman sultan of Turkey *(Metropolitan Museum of Art)*

See also SHI'ISM, SUFISM.

Gothic cathedral! Outside the mosque, minarets or towers from which the faithful are called to prayer exhibit regional variation—square in Syria, polygonal in Egypt, pencil-thin cylinders in Turkey. Domestic architecture is distinguished chiefly by the need to keep women secluded, as required by the Koran.

During the "dark" and Middle Ages in the West, Arab developments in the fields of science, medicine, and philosophy reached Europe through Spain. The first European paper factories were established by the Muslims in Spain and Sicily, using Chinese know-how, and Europe acquired a more efficient system of decimal numeration from the Arabic. (What we call Arabic numerals, however, are characterized by the number of digits attributed to the powers of ten; our numbers themselves are only remotely similar to Arabic.) The single best-known Islamic (actually, Turkish and Persian) creation to reach the West is, of course, the rug. Other products, the names of which are Arabic in origin, include apricots, artichokes, tulips, lilacs, and a variety of textiles such as damask from Damascus and muslin from Mosul. (Gauze, cotton, and taffeta are also Arabic words.)

Islam continued to grow as a religious and cultural community all the while it was ebbing and flowing politically. Eventually it would embrace one-seventh of the world's population, including a greater racial variety than any other religion. Orthodoxy has been challenged by dissidents and mystics since the beginning, with splinter groups (see also SUFISM, SHI'ISM) breaking away from the main body of the faithful, the Sunni (*Sunnah*, meaning custom or usage) majority. Spain was lost in the 15th century. The last and most powerful of the Muslim dynasties, the Ottomans, would succeed in conquering Byzantium in 1453 and threatening Vienna, the back door of Europe, only to decline in the late 19th century and collapse in 1918.

Turkey became a modern secular state, but elsewhere in the Middle East since World War I, Islamic religious cosmopolitanism and political nationalism have kept an uneasy balance. Some areas like Saudi Arabia remain under traditional religious caliphates, kingdoms, and sultanates, jealous of their sovereignty, while Shi'ite Iran alone calls for a universal Islamic state. But despite political divisions, Islam continues to survive as a community, as a cultural and value system, and as a memory of great past glory.

The 1991 *World Almanac* estimates that Islam has six million followers in the United States. A good percentage of these are members of the Black Muslim movement, which draws on the African American historical experience as well as the Koran in its basic teachings. Religious historian Sydney Ahlstrom traces the origin of the sect to Marcus Garvey's "Back to Africa" movement before World War II. The Temples of Islam founded in Detroit and Chicago in the 1930s under the leadership of Elijah Muhammad claimed about 100,000 members before the advent of the Black Power movement. Succeeding Elijah Muhammad in leadership was the controversial radical activist Malcolm X (like Elijah Muhammad, also the son of a Baptist preacher). Before his assassination in 1965, Malcolm X was influenced by a visit to Mecca to found a separatist, presumably more authentic, Muslim group.

David Rice's *Islamic Art* is a good survey. *The Art of Islam* by Nurhan Atasoy is a handsome picture book organized around visual motifs such as domes and minarets, by geography and dynasty. *The World of Islam*, edited by Bernard Lewis for Thames & Hudson, is outstanding. For general cultural influence on the West, see *The Legacy of Islam*, edited by Thomas Arnold.

Beware the Jabberwock, my son!
The jaws that bite, the claws that catch!

Lewis Carroll, "The Jabberwocky"

JACOBEAN

The reign of James I (1603–25), who succeeded Queen Elizabeth on the throne of England, is called the Jacobean period (from the Latin *Jacobus*, from which the name James is derived). This was a prosperous time, with widespread construction in a transitional style between Elizabethan and Renaissance, mixing Gothic elements in a fanciful vernacular with columns, pilasters, parapet roofs, and round arcades. Some famous examples of Jacobean architecture include Knole House in Kent, England, ancestral home of writer Vita Sackville-West, and Bacon's Castle in Surry County, Virginia (c. 1655), a rare example of the style in the colonies. (Dunnellen Hall in Greenwich, Connecticut, owned by hoteliers Harry and Leona Helmsley, is a neo-Jacobean estate.)

The late plays of Shakespeare are also typically Jacobean. The most enduring monument of the period is the King James Bible (1611), which for beauty of language is often ranked with Shakespeare.

JACOBIN

Theirs was the most feared faction in the French Revolution, so-called for the Jacobin (Dominican) monastery in Paris where they had their headquarters. Initially a group of professionals and well-off bourgeois, the Jacobins became more and more radical in

response to chaos and the pressure of the Paris mob for blood. It was the Jacobins who instituted the Reign of Terror, executing counter-revolutionaries and former allies as well by guillotine and mass drowning.

During scarcely more than a year in power (1793–94) the Jacobins adopted the official revolutionary style of neoclassicism, staging festivals as antique rituals. Personally, however, they favored natural hair and loose trousers, abandoning the powdered wigs and tight-fitting, knee-length trousers of the ancien régime. With the fall of Robespierre in July 1794 the Jacobins came to an end, but their name lived on as a synonym for radical dress and manner as well as politics.

In the politics of the new American republic at the turn of the 19th century, "Jacobin" became a term of opprobrium as heinous as fascist or communist in the 20th century. Although they wore their hair naturally, many of our founding fathers clung to their ancien régime knee-breeches rather than adopt the radical Jacobin trousers. So great in fact was the conservative horror of Jacobin excesses, according to cultural historian Vernon Parrington, that many Americans also closed their minds to the positive contributions of French liberal idealism.

Historically, scholar Isaac Deutscher points out, revolutionaries have always been haunted by the ghosts and terrors of revolutions past. To 19th-and 20th-century radicals, the Jacobins represented a cautionary example of revolution consuming its own adherents, then self-destructing. According to Deutscher, Soviet dictator Josef Stalin was trying to avoid a Jacobin solution by sending his archrival Leon Trotsky into exile in 1929. But within a few years Stalin was exceeding Jacobin excesses; where Jacobin victims went proudly and defiantly to the guillotine, Stalin subjected his rivals to humiliating show trials before executing them or sending them to a living death in Siberia. (Trotsky himself was finally assassinated in exile.)

JAINISM

Jainism, an ancient East Indian religion of asceticism and nonviolence (*ahimsa*), preaches release from the endless cycle of rebirth by purification of mind and body. Jains are strict vegetarians and ascetics with an extreme regard for animal life; they believe the universe is made of particles that all possess soul. The devout may become wandering mendicants, wearing gauze masks to keep from harming the invisible animalcules in the air and carrying brooms while walking to sweep them away. They may even go naked, rejecting any artificial barrier between themselves and the elements.

Severely persecuted during the

Delicately carved marble in the 10th–11th-century Dilwara Temple, Mount Abu, India

Mughal era, Jainism numbers two to four million adherents in India today, typically wealthy urban merchants. There are several beautiful surviving Jain temples, notably one at Mount Abu in Rajasthan with a shimmering filigree of marble carving. Except for the exceptionally high polish of its stonework, Jain sculpture tends to be difficult to distinguish from Hindu and Buddhist as they all share stylistic features and even some of the same subjects (where the Hindus call them "gods," the Jain refer to "great teachers"). Scholar Hugo Munsterberg points out in *Der indische Raum* that the Jain male figure is usually represented nude with his organ visible, whereas Buddha is typically draped in a robe.

Jain palm leaf painting, in a flat decorative style similar to Indian miniature painting, is immediately recognizable by the second eye of the figures in profile, an eccentricity that would be adopted by cubism.

JAPANESE

Modern Japanese culture is considered to date back only to the sixth century A.D. when Buddhism was introduced from China, followed by the adaptation of Chinese-style writing. Historically regarded as the source of all civilization, China would generate successive waves of influence which the Japanese always managed to absorb and infuse with their own distinctive spirit.

Art historian Joan Stanley-Baker offers an instructive example of this Japanese style already perceptible a thousand years ago. Japan's Shosoin Museum, repository of the personal belongings of an early emperor, contains objects of central Asian, East Indian, Persian, and above all Chinese provenance or influence. But a T'ang-style pot with an uneven mottled glaze must be Japanese in origin, Stanley-Baker argues; the Chinese would have rejected the glaze as unacceptable, whereas the Japanese have always made a virtue out of accident, whimsy, and naturalness. Even Buddhism took a different course in Japan than elsewhere, with the emphasis on individual spirituality and harmony with nature. (Yet another example of selective Japanese adaptation is dietary. Japanese cuisine differs from Chinese in its exquisite presentation and its emphasis on quality rather than quantity, Stanley-Baker points out.)

Japanese historical periods may be difficult to follow because they are sometimes designated by ruling family names (Fujiwara, Minamoto, Ashikaga) and sometimes by their capital cities. The Heian (Kyoto) period, for example, is roughly coterminous with Fujiwara control and the Edo (Tokyo) with Tokugawa (see p. 144). Suffice it to say that Japan's imperial family went into permanent decline in the ninth century, its power usurped by various feudal overlords and shoguns (meaning "barbarian-subduing supreme general"). European missionaries and traders arrived in the 16th century, but were rigidly excluded by law until the Meiji restoration in 1868, which was followed by rapid industrialization and Westernization.

Culturally, Japan from the sixth to eighth centuries was dominated by T'ang-era influences from China, chiefly Buddhism which merged with and partly superseded the earlier native Shintoism. During the extended feudal era, Chinese influence in Japan waxed and waned depending on regional balances of power. The Fujiwara period (898–1185) of ultra-refined aristocratic idealism gave way in the 13th and 14th centuries to the great domestic flowering of Zen Buddhism. The 15th century saw the development in Japan of the celebrated tea ceremony, an aesthetic and contemplative

experience uniting art and metaphysics. The Tokugawa period (1600–1868) has been called a time of cultural and physical isolation, dominated by exaggerated feudal codes of honor and loyalty and outdated Chinese Ming canons of beauty.

The Tokugawa period and Japanese isolation came to an end with the arrival of Commodore Perry in 1854 and the Meiji Restoration 14 years later, followed by the adoption of a Western-style constitution. Opening to the West, Japan turned its back temporarily on its own culture. With the abolition of feudalism, some of the great lordly art collections were dispersed to retainers, an opportunity for foreign collectors to make major acquisitions. It was at this time that the magnificent Freer and Fenollosa collections, now in Washington, D.C., and Boston, were amassed.

The most typical Japanese medium is painting on silk or soft paper with ink and watercolor—Chinese in origin, but again with distinctive adaptations. Japanese execution is often more vigorous, dramatic, and economical, tending to asymmetry and giving greater prominence to the human figure rather than to nature as in China. The Japanese were particularly gifted at painting continuous narratives in scroll form, vivid pictorial diaries of events which constitute in effect "moving pictures." Another format for Japanese painting skills was the screen, especially favored for the interior decor of 17th-century feudal castles. And in the 18th and 19th centuries, Japanese artists turned to wood-block scenes from everyday life, called *ukiyo-e*, or "pictures from the passing world," printed in single sheets and illustrated books. (Among the best known examples of *ukiyo-e* in the United States, practically claiming the status of icons, are Hokusai's volcano and his waves.)

Suit of armor (1578) made of lacquered iron braided together with silk threads from the Momoyama period *(San Diego Museum of Art)*

Japanese public architecture follows the Chinese style of tiled roofs with upturned eaves and red lacquered pillars. Domestic architecture on the other hand tends to be plain, pristine, and rustic, with natural pillars and thatched roofs. Great attention is always paid to the landscape, and gardening enjoys the status of a religious art. Calculated

to induce contemplation and calm, the Japanese garden features rocks, water, and green plants but rarely flowers, except flowering trees (like the famous cherry trees in Washington, D.C., a gift from Japan).

With industrialization and Westernization, the traditional fine arts of Japan went into temporary eclipse, displaced by fads for Western-style oil painting and classical music. The applied arts remained traditional, particularly textiles (finely printed silks and cottons, embroidered, brocaded, and appliquéd) and ceramics. Porcelain such as the glossy, deeply colored Imari ware (named for the port of embarkation) was made for export to Europe, but its very lustre was considered a distraction from the seriousness of the tea ceremony; the domestic preference continued to be for natural, minimally adorned, sometimes imperfect, and occasionally whimsical pottery.

At the same time that Japan was absorbed in Westernization, in the late 19th century, the West was also discovering Japan. A mania for things Japanese was launched by the 1885 Gilbert and Sullivan musical, *The Mikado*. An 1890s novel was made into one of the great tragic operas, *Madame Butterfly* (1904), about the seduction of a Japanese girl by an American sailor. Japanese art, meanwhile, with its two-dimensional stylization, its economy and purity of line, influenced every major late-19th-century movement in the West, from impressionism to art nouveau. For example, the American expatriate artist James McNeill Whistler painted canvases and screens in a distinctly

● ———————— ●

Japanese Periods

JOMON (until c. 200 B.C.): The Japanese Neolithic period; pottery is made without a wheel.

ASUKA (A.D. 552–710): Buddhism is introduced and Chinese styles copied.

NARA (710–794): The first permanent Japanese capital, imitating the capital of T'ang China. The oldest Buddhist temple in Japan and the Shosoin Museum are in the city of Nara.

HEIAN (794–1185): Named for the capital city of Kyoto, the cultural heart of Japan, this period was that of the Fujiwaras and was characterized by courtliness and luxury. Flourishing of rich art traditions including garden cultivation and temple building.

KAMAKURA (1185–1392): Under the Minamoto shogunate, the capital moves to Kamakura, a religious center with 80 shrines and temples and monumental Buddhist sculpture.

MUROMACHI (1392–1568): Ashikaga shoguns rule from the city of the same name (Muromachi is the name of a palace), famous for textiles and its library.

MOMOYAMA (1568–1615): A period dominated by contending warlords, whose fortified castles featured wall murals and painted screens, usually with a gold background to reflect light. Rise of the tea ceremony.

EDO (1615–1868): Tokugawa shoguns rule from Tokyo. Rise of the merchant class.

MEIJI (1868–1912): With the end of feudalism, modernization and Westernization begin to influence Japan.

Japanese style. (In a later generation, the abstract artist Mark Tobey studied Japanese calligraphy and Zen, formative influences on his work.) More recently, there has been something of a fad for collecting netsuke (pronounced *net'skee*), mini carved figurines formerly worn tied to the sash.

In architecture, the California bungalow (despite its Indian name) is considered to derive from rustic Japanese housing. California also has some ultra-ornate Japanese productions, such as the "Tokugawa-style" Yamashiro mansion in Hollywood. But the most significant Japanese architectural influence has been on the International Style. From the horizontally slung Japanese bungalow the corporate high-rise took its flat planes, weightlessness, and flexibility in the partition of inner space.

Japanese literature (the 10th-century romance, *The Tale of Genji*, or haiku, 17-syllable verse) and theater (Nōh, or formal, and Kabuki, or popular, theater) do not translate very well, but are at least vaguely familiar to most Americans. These as well as other familiar Japanese words—*kimono* and *geisha* come to mind—all evoke the essence of Japanese style, featuring gracious and decorative ceremony.

See *Japanese Art* by Joan Stanley-Baker in the Thames & Hudson series. *Japanese Style* by Suzanne Slesin et al. is oriented toward design. Clay Lancaster examines *The Japanese Influence in America*. An authority on *ukiyo-e*, the novelist James Michener wrote two books on the subject: *The Floating World* and *Japanese Prints from the Early Masters to the Modern*. The Freer Gallery of Art in Washington, D.C., has an important Japanese collection, while Boston's Museum of Fine Arts claims the best collection of *ukiyo-e* outside Japan, and the Los Angeles County Museum of Art devotes an entire gallery to Japanese art of the Edo period.

JAZZ

America's outstanding native musical idiom, jazz stands somewhat outside the mainstream of music history, a unique and rapidly evolving amalgam of influences and trends. It first began to take shape in the late 19th century, drawing on the African American vocal tradition of spirituals, work songs, and the blues. As developed in New Orleans around the turn of the century, jazz came to be defined as melodic variations on a theme against a background of rhythmic syncopation, emotional in content and improvisational in exposition.

New Orleans jazz was played outdoors, with trumpets leading an integrated ensemble, clarinets embellishing the melody, and trombones providing a bass line. It was only in the second generation, the heyday of trumpeter Louis Armstrong, that virtuoso soloists began to emerge from the jazz band. Also about this time, around the First World War, jazz began to migrate north up the Mississippi via the riverboats to Kansas City and Chicago, then New York and Los Angeles. Some consider the 1920s, when pianist-composer-conductor Duke Ellington arrived in New York, the great age of jazz. In this period jazz was tied socially and economically to prohibition, which was responsible for creating the intimate, slightly illicit environment of the speakeasy. At the same time, jazz was associated with popular dances such as the shimmy, the Boston, the Charleston, and with the great blues singers Bessie Smith and Billie Holiday.

In the 1930s, with the arrival of the touring "Big Bands," jazz gradually acquired greater respectability. "Swing"-style orchestration began to replace improvisation as

Duke Ellington
jamming in Jamaica
in the late 1960s
(*Tony Russell*)

bands under celebrity leaders vied for popularity and loyalty like football teams today. The most celebrated were Ellington, considered a master of orchestration, and Count Basie, another pianist leading a classic Big Band. The first generation of white jazz band-leaders also came of age: clarinetist Benny Goodman (the "king of swing"), trombonist Tommy Dorsey, and Glenn Miller. Miller, in particular, signaled the watering down of the jazz concept for white consumption.

The Big Band era ended with World War II. In the post-war era, jazz entered yet another phase as virtuosi like saxophonist Charlie Parker and trumpeters Dizzy Gillespie and Miles Davis broke away from old harmonic conventions to expand the jazz vocabulary enormously. Their "progressive" or "cool" jazz (sometimes called bop, bebop, then neo-bop and hard-bop) had a more esoteric appeal, attracting fewer but more knowledgeable fans.

For Europeans, jazz has always exercised the fascination of the exotic. At home, however, jazz has gradually entered the mainstream, influencing and enriching the whole spectrum of American music from serious (Aaron Copland wrote a jazz piano concerto in 1927) to film music and pop. American composer Gunther Schuller goes so far as to suggest a "third stream" fusion of jazz and conventional classical techniques.

The "jazz age" is sometimes used to mean the "roaring twenties," when "flappers" dancing the Charleston in speakeasies seemed to epitomize a new freedom. F. Scott Fitzgerald's *Tales from the Jazz Age* (1922) refers to this experience of jazz.

Gunther Schuller, who considers jazz a democratic, communal form, as distinct from Old World art music for aristocratic consumption, has completed the first two-thirds of a monumental three-volume history of jazz: *Early Jazz* and *The Swing Era*. Distinguished British historian Eric Hobsbawm, a jazz buff, wrote *The Jazz Scene*.

JESUIT

Founded in 1540 by St. Ignatius of Loyola, the Society of Jesus or Jesuits was from the beginning a disciplined and aggressive missionizing force—"militant shock troops of the Church," they have been called. Loyola, who is described as having "the cunning of a soldier and the tact of a courtier," conceived of his followers as knights of God and latter-day crusaders. Like other orders of the Roman Catholic Church, Jesuits take vows of poverty, chastity, and obedience. Where they differ is in being more worldly than monastic, and in their extensive training, which may last 15 years or more. The end product is a highly sophisticated group with a command of diplomacy and casuistry that some consider positively Machiavellian; as "teachers of the wealthy and confessors to the powerful," the Jesuits historically became practically synonymous with intrigue.

At home in Europe, the Jesuits were a major force behind the Counter-Reformation. Their new churches were among the first to reflect the dramatic new baroque canons of architecture—indeed, baroque was initially called "the Jesuit style." They also became active as missionaries to the far corners of the earth. In Paraguay, the Jesuits are credited with helping reconcile Indian and European cultures, while in China they were sophisticated enough to seek common ground with folk traditions which the Franciscans and Dominicans rejected outright as "wicked."

In their peregrinations, some intrepid Jesuit missionaries met martyrdom; others by their very success aroused envy, opposition, and eventual suppression. For a time the Jesuits were the only Catholic order allowed in England's American colonies. In the Catholic colony of Maryland a scenario played out that would later be repeated worldwide. Jesuit energy and success, according to religious historian Sydney Ahlstrom, antagonized the majority Protestants; alarmed by a perceived political threat, the colonial proprietors, the Calverts, moved in the 1640s to curtail Jesuit activity in Maryland.

For much the same reasons, the Jesuits were expelled from Portugal in 1759, banned in France in 1764, in Spain and its American colonies in 1768, and ultimately dissolved by Pope Clement XIV (a Franciscan) in 1773. The order managed to survive and maintain its identity until it achieved recognition again in 1814.

In the settlement of North America, the Jesuits were particularly active in the Northeast and French Canada, among the Huron and Iroquois Indians there, and in Oregon Territory among the Flathead Indians. In the Southwest, they founded the Mission San Xavier del Bac near Tucson. Always keenly interested in education, they created Georgetown University in Washington, D.C., Fordham University in New York City, and St. Louis University in St. Louis, Missouri, among others.

See *The Jesuits: A History* by Christopher Hollis.

JUDAISM

The oldest continuously practiced religion in the Western world, Judaism differs from other great religions in that it is tied historically to a specific "chosen" people or ethnic group, the Jews. Evolving in the Middle East in the first 500 years before Christ (himself a Jew), Judaism was, above all, monotheistic, proclaiming a single Lord of the universe, an object of both love and fear; and a religion of the book, the Torah or Pentateuch (the five books of Moses: Genesis, Exodus, Leviticus, Numbers, and

Deuteronomy) and the Talmud or oral (later written) law governing diet, hygiene, and ritual. Judaism is strongly ethical and historical, recalling in its ceremonies and holidays the great events of Jewish history—the diaspora, persecution, and the hope for national restoration in a "promised land."

The foundations of Judaism in America go back to 1492; the year Columbus sailed the ocean blue (with two Jews among his crew, it is said) was also the year the Jews were expelled from Spain, where they had enjoyed a relatively privileged position under Islamic rule. Expelled from Portugal as well a few years later, these Sephardic (named for the biblical land where the Jews wandered after the Babylonian exile) or Iberian Jews were condemned again to wander in search of a haven. Many went to South America, but only isolated Jews resided in North America until the arrival of what writer Stephen Birmingham facetiously calls the "Jewish Mayflower" in 1654: During yet another deportation, this time from Brazil back to Holland, 23 Jews on this ship were detoured by pirates and sidetracked to New York City. Reluctantly allowed to stay there, they became the nucleus of a very old and proud Jewish community.

In the 19th century, large numbers of German Jews or Ashkenazim (so-called for another biblical kingdom that was identified in medieval rabbinical literature with Germany) immigrated to the United States, and in the last two decades of the century there came a great flood of Jews from the ghettos of eastern Europe and Russia, prompted

●────────────────●

Key Jewish Concepts and Expressions in English

BAR MITZVAH: puberty rite or initiation of boys into the religious community at age 13; marked by the initiate's first reading in the synagogue and a major social ceremony; modern adaptation for girls called a bat or bas mitzvah

CHUTZPAH: Hebrew for *insolence, audacity, brazen presumption*; taken as the title of a recent memoir by a particularly audacious lawyer

DIASPORA: from the Greek for *dispersion*, or the scattering of the Jews outside Palestine

GOYIM: plural of *goy*, or not Jewish

HANUKKAH: a minor holiday that has gained increasing importance because of its proximity to Christmas

KABBALAH (also CABALA): mystical wisdom, esoteric or occult

KADDISH: a prayer in praise of God; often a prayer for the dead

KOSHER: fit, proper, in accordance with religious law; applied to diet, only fish with fins and scales and only cud-chewing cloven-hoofed animals, ritually slaughtered and certified by religious experts, permitted, and no milk with meat

MENORAH: a candelabrum with seven or nine arms

MESHUGGE: Hebrew for *crazy*

A uniquely American Hanukkah menorah, cast by artist Manfred Anson (*Lelo Carter, Hebrew Union College Skirball Museum*)

by pogroms and poverty. Unlike the Sephardim, who had been prominent and prosperous in their native land, or the German Ashkenazim, mainly merchants and traders with a secular German cultural inheritance, the east European Jews (also referred to as Ashkenazim because they spoke Yiddish, a German-based language written in Hebrew letters) were working class and considerably more devout in religious observance. (Even the atheists among them were great believers, channeling their ardor into socialism, Marxism, and Zionism.) By 1920 when mass immigration came to an end, the east Europeans constituted 80 percent of the 4.2 million American Jews, and the center of gravity of world Jewish civilization began to shift to America. By the late 20th century, the six million American Jews (three percent of the U.S. population) constituted the largest Jewish community in the world.

American Jews belong to three main groups. Largest is the Orthodox Jews, mainly east European in origin, who observe the traditional regulations (including a prohibition on intermarriage) which are the law of the land in Israel. Nearly equal in strength are the Reform Jews, who emphasize moral precepts and may ignore dietary laws and other practices they consider superstitious. The smallest group, ranking as moderate midway between Orthodox and Reform, is the Conservative Jews, who honor tradition but recognize the need for change.

American Jews of all groups participate in numerous overlapping social and phil-

● ———————————— ●

MEZUZAH: Hebrew for *doorpost*; a small case, placed on the doorframe of a dwelling, that contains a scroll on which passages from the Bible are written; also an amulet or lucky charm

MITZVAH: Hebrew for *commandment*, a virtuous, meritorious deed, or a ritual observation

PASSOVER: one of the most important Jewish holidays, lasting a week in the spring, commemorating deliverance from Egypt (the date of the Christian Easter is calculated from Passover)

ROSH HASHANA: the Jewish New Year or beginning of the year; usually in September or October

SABBATH: Hebrew for *cessation of labor*, in observation of the commandment to rest on the seventh day; from Friday sundown to nightfall Saturday, the devout do not even answer the telephone

SCHLEMIEL: a foolish person or born loser

SCHMENDRICK: a kind of schlemiel

SEDER: ceremonial evening meal during Passover

SHOLOM (or SHALOM) ALEICHEM: the Yiddish greeting *Peace be upon you!* Also taken as a name by the Ukrainian-born Yiddish language author whose stories were adapted as *Fiddler on the Roof*

YESHIVA: rabbinical college or seminary

YOM KIPPUR: the most sacred holy day, of "atonement," when Jews fast and pray for forgiveness of sins; falls in late September or October

anthropic activities, and they contribute more per capita to charity than any other American group, according to author Will Herberg. They have also been involved in a continuous process of redefinition, moving toward a religious culture based on values and customs rather than faith. In mid-20th-century America, with success and affluence erasing distinctions among Jews and between them and the general populace, the most serious concern has been assimilation and loss of identity. The 1967 Arab-Israeli war, in the opinion of writer Nathan Glazer, marked a turning point. Aroused by the threat to Israel, and by what Glazer calls a delayed emotional response to the Holocaust, more and more Jews began redefining themselves in traditional ways.

Historically a closed religious culture, bound to the authority of the Scriptures, discouraged from questioning values and from artistic expression, Judaism has experienced a cultural explosion in the United States. The first important medium was the Yiddish theater, which around the turn of the 20th century attracted two million spectators yearly. The theater in turn spawned an identifiable Jewish humor, which from the Marx Brothers to Woody Allen has enjoyed great popularity. One of the main themes of this humor, according to literary critic Leslie Fiedler, is "the hero as schlemiel."

American Jews have also created a significant body of imaginative literature, often concerned with problems of Jewish identity in America. Some key figures in this literature are the so-called Jewish princess, exemplified by Herman Wouk's *Marjorie Morningstar* (1955), and the Jewish prince, of whom Philip Roth created an amusing prototype in *Portnoy's Complaint* (1969). On the theme of the schlemiel, Nobel-prize winning writer Saul Bellow created some memorable characters.

In classical music, the American Jewish community has produced a disproportionate number of top instrumentalists, particularly violinists. And finally in the visual arts, traditionally inhibited among Jews by the second commandment against graven images, important Jewish American artists began to emerge in the mid-20th century (for example, abstract expressionists Mark Rothko and Barnett Newman).

Nathan Glazer's *American Judaism* is a good short introduction to history and issues. On the longer side, there is Howard M. Sachar's *A History of the Jews in America*. On the popular side, Stephen Birmingham wrote two entertaining studies of the Sephardic and German Ashkenazic sub-cultures: *The Grandees* and *Our Crowd*. Leo Rosten's *The Joys of Yiddish* is amusing and informative, while Sharon Keller's *The Jews: A Treasury of Art and Literature* is handsomely illustrated. (See also HASIDISM, ZIONISM.)

JUGENDSTIL

This is the German name for art nouveau, taken from the main German forum for the style, the journal *Jugend*, which was founded in Munich in 1896. *Jugend* means of course youth, or the new as opposed to the prevailing old styles (in Germany at the end of the 19th century, chiefly historicism).

A recent German book on Jugendstil covers the usual European and American manifestations of art nouveau, mentioning Tiffany in the introduction and devoting a chapter to Louis Sullivan, Frank Lloyd Wright, and the Chicago school of architecture. The German (mainly south German) variant of the style mixes folkloric and sublime-mythic motifs with art nouveau's usual abstract curvilinearity.

An 1897 Jugendstil exhibit featured painting and sculpture as well as applied arts,

German art nouveau architecture: an apartment house in Ansbach, Germany, c. 1900
(C. Dunlap)

but the medium in which the style found its most characteristic expression was graphics. Jugendstil architecture is attractive, and many examples survive at artist colonies in Darmstadt and Worpswede, Germany. It has even been argued that the poetry of Rainer Maria Rilke describes what Jugendstil artists were painting—naive yet voluptuous maidens, swans, water lilies, and the glistening reflection of the moon on the lake.

Jugendstil had a brief but intense life, no longer than the decade 1894–1904, during which it functioned with all the attributes of a cult including prophets and high priests. Later generations would look back on it as a decadent, bourgeois style, chiefly important as a source of German expressionism.

The Philadelphia Museum of Art mounted a 1988 exhibit on Jugendstil with a catalog entitled *Art Nouveau in Munich* edited by Kathryn Hiesinger.

JUNGIAN

Like Freud, his Swiss associate (and eventual defector from the Freudian camp) Carl Gustav Jung endeavored to define the architecture of the human personality. Sharing the same compulsion to arrange things in neat categories, both Freud and Jung examined the structure and function of ego, libido, intellect, subconscious, instinct, and so on. Where Freudian analysis gives primacy to what are called the lower instincts, chiefly sex, Jungian psychology is concerned with the more mystical, higher functions of psyche, soul, and spirit.

Jung's chief contribution to the literature of analysis is his concept of archetypes

of the collective unconscious. These are images and symbols—typically revealed in dreams and in mythology—which mediate between the conscious and unconscious. Jung defined his archetypes as species-wide, common to all cultures and times. "Just as the human body shows a common anatomy, over and above all racial differences," Jung wrote, "so, too, the psyche possesses a common substratum transcending all differences in culture." He searched through art, religion, mythology, alchemy, and the literature on dreams and psychoses for examples of his archetypes, which usually relate to what Jung called transformation experiences: death and rebirth, initiation, expiation, and redemption.

An individual's failure in this process of mediation between the conscious and the unconscious, Jung believed, results in disequilibrium or neurosis. He classified Americans in general as extremely neurotic—particularly American men for spending so much libido on their work and so little on their wives—as well as extremely prudish.

Jungian psychology has always enjoyed a certain vogue in leftish American artistic circles. One of the better-known Americans to undergo Jungian analysis was the abstract expressionist Jackson Pollock, who paid his therapist with stream-of-consciousness canvases.

A member of the Mellon family who admired Jung established the Bollingen Foundation to publish his collected works (some 18 volumes) and similar studies. For an introductory selection of Jung's ideas, try his *Psyche and Symbol*.

Knowledge comes, but wisdom lingers.

Alfred, Lord Tennyson

KEYNESIAN

One of the rare economic philosophies to make the leap from academic theory to implementation, enter the popular consciousness, and earn a certain opprobrium in the process, Keynesian economics is the brain-child of British economist John Maynard Keynes. Writing during the Great Depression, Keynes tackled the question of capitalism's boom and bust cycles, the paradox of simultaneous unemployment and declining production. The problem, he concluded, lay in the seesaw of savings and investment: as income contracted during an economic slump, savings were squeezed out and investment declined, further squeezing production and employment.

To break out of this vicious circle, Keynes advocated what has come to be called "priming the pump"—government planning and investment to stimulate the economy. This became the keystone of U.S. President Franklin Roosevelt's program for economic recovery, the basis of modern macro-economics, and a significant departure from free market economic theory. Those who disagree with Keynes's theories—and there are many conservatives who rank the economist, and FDR as well, as public enemies—blame him for abandoning laissez faire, destroying the gold standard, and starting the nation's long slide into mega-debt. Whatever your personal opinion of him, Keynes had the greatest impact of any economist since Marx.

L. R. Klein wrote *The Keynesian Revolution*.

KITSCH

This German word originally meant *trash*, but its meaning has expanded to include a genre of trivial sentimentality that is universal but for which the Germans have a particular penchant and a name. Designed to appeal to the emotions, kitsch is anything trashy, treacly, or phony. Little and cute are kitsch attributes, as are sweetness, goodness, and sadness.

With their customary earnestness, the Germans are also given to comparative analyses of the phenomenology of kitsch, breaking it down into sub-species. Traditional kitsch includes such objects as the plastic garden gnome (as in Snow White and the Seven Dwarfs), of which Germany has an astonishingly large population, or cute greeting cards featuring Hummel-type figures and heartwarming homilies.

Another category consists of souvenirs, curios, replicas, and imitations. This includes plastic Eiffel Towers, commemorative coffee mugs featuring Charles and Diana, and snow globes. Masterpieces such as the Mona Lisa, Venus de Milo, and Rodin's *The Thinker* are frequently subject to mass replication as kitsch, for sentimental or merely pecuniary (i.e., advertising) purposes. Death and departure have a special affinity for kitsch; funeral trappings such as plastic flowers are invariably kitschy. Aldous Huxley's *The Loved One* is a satire on California-style kitsch mortuary practices; even kitschier is the local pet cemetery. And dead heroes, from George Washington to John Kennedy and Elvis Presley, are subject to eternal kitschification.

Most kitsch is all very harmless, although it may lend itself to political purposes; the fascists were particularly skillful at using kitsch for propaganda. The American variety seems relatively harmless, favoring mass replication of such icons as the American eagle and Mount Rushmore. One of the writer's favorite examples (cited by writer Curtis Brown) is a masterpiece of politico-culinary kitsch from a colonial-theme restaurant— "Tuna Ticonderoga," a creamed casserole served in a stockade made of potato sticks. Jane and Michael Stern, in their *Encyclopedia of Bad Taste*, include tuna casserole on their list of kitsch Americana along with Twinkies, Wonder Bread, aerosol cheese, astroturf, Barbie dolls, bell-bottoms, Frederick's of Hollywood couture, and muzak. One never knows, however, when harmless nonsense will run amok. There was a time, after all, when the swastika was nothing but a Sanskrit symbol of good luck and well-being.

Star-Spangled Kitsch by Curtis F. Brown is a picture book covering the American variety. *Kitsch; The World of Bad Taste* by Gillo Dorfles is a more philosophical, comparative analysis.

The lunatic, the lover, and the poet,
Are of imagination all compact. . . .

William Shakespeare, Midsummer-Night's Dream

LAISSEZ FAIRE

As an economic doctrine, laissez faire ("leave us alone") arose around 1700 in reaction against the suffocating mercantilism of Bourbon France, with its government monopolies, high taxes, and paternalistic regulations. The same doctrine became synonymous in the English-speaking world with opposition to political interference of any kind. In *The Wealth of Nations* (1776), considered the classic exposition of laissez-faire capitalism, Adam Smith argued that competition acts as an "invisible hand," rationalizing selfish instincts into social virtues. If you let the market alone, Smith said, it will reach its point of highest return and all will benefit. This same line of reasoning was extended by Utilitarian philosopher Jeremy Bentham to individualism and personal liberty.

Laissez-faire capitalism reached its apogee in the United States in the 1870s (only after massive government expenditures on infrastructure had created conditions favorable to large corporations, political sociologist S. M. Lipset points out). By the end of the century it had become apparent that unrestrained competition led in practice to what used to be called "combinations in restraint of trade," or monopolies, prompting state intervention to restore competition. But despite a somewhat checkered history, laissez faire continues to be evoked to this day by conservative American opponents of government interference, as sort of a divine right of capitalist individualism.

John Maynard Keynes, who had as much to do as anyone with burying this philosophy, wrote a 1926 book, *The End of Laissez-Faire*; long out of print, it is included in the economist's collected works, published by Cambridge University Press.

LALIQUE

Beginning as a designer of jewelry, René Lalique founded a family business in France to produce the art glass for which he is best known. Lalique's jewelry took art nouveau forms: sinuous, asymmetrical nymphs and femmes fatales, dragonflies with enameled wings, and gleaming lizards, with semi-precious stones for color only, not as centerpieces. Many Lalique pieces of jewelry are considered works of art today and exhibited in museums.

In 1902 Lalique began producing glassware and crystal, often decorated in high relief, sometimes alternating frosted and clear surfaces. Versatile and enterprising, the family firm produced a wide variety of items, from perfume bottles for the great

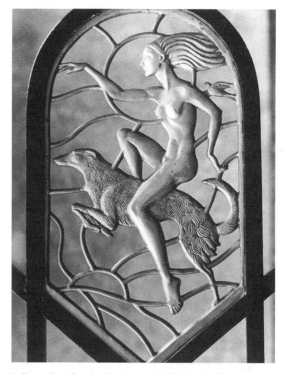

Lalique detailing in the Oviatt Building (Walker & Eisen, 1927–28), Los Angeles *(Tony Russell)*

French parfumiers to lighting and other fixtures for luxury trains and ships. In the 1920s Lalique even produced some glass furniture. The Oviatt Building in Los Angeles (1928) has distinctively Lalique wrought-iron grillework, illuminated glass ceilings, elevator doors, and even a designer mailbox. The old Coty building on Fifth Avenue in New York City (now Henri Bendel's) also has a glass facade by Lalique.

In 1921 Lalique founded a factory in Alsace-Lorraine to mass-produce crystal. The firm had its own pavilion at the 1925 art deco exhibit in Paris, and won worldwide recognition in the period between the two world wars. It continues to do big business into the 1990s—Lalique ads often appear in the daily newspapers, touting wares available at better department stores. But Lalique lost its stylistic cachet with World War II, and collectors tend to concentrate on pre-1945 pieces signed by the founder. Under third-generation leadership, Lalique now produces novelty items such as hand-enameled butterflies, vases lined with painted zebras, and a sea lion named "Ooglit." The granddaughter of the founder often visits American stores and will autograph purchases.

For a recent appreciation of the subject, see *Lalique Glass* by Nicholas M. Dawes

LIBERALISM

Tolerance, optimism, compassion, and generosity; social justice; freedom from political and economic as well as religious tyranny; compromise, consensus, and reform—this is the general intellectual baggage of liberalism that the Puritans brought with them from England in the 17th century. At different times and places the mixture has varied: the Puritans were rather more intolerant of differences than we are today. In the 19th century, liberalism (with the emphasis on individualism and freedom) became the political analogue of American capitalism, producing a whole range of socio-economic abuses that a quite different 20th century liberalism (stressing social justice and compassion) would seek to redress.

Considering the heavy freight it carries, it is no wonder that in the late 20th century American liberalism appears politically and intellectually bankrupt, a relic from a kinder, more optimistic and idealistic era. (In Great Britain, the historic Liberal Party, having launched the so-called welfare state over conservative Tory opposition, has been practically defunct since the 1930s, superseded by the more narrowly defined Labor Party.)

LIMOGES

Located in southwestern France near that country's main source of kaolin, a vital ingredient in the making of porcelain, Limoges became an important center of production under royal patronage in the 18th century. At one time, this provincial operation was intended in the Bourbon scheme of royal manufactories to produce plain white wares for embellishment at Sèvres. As a result, Limoges porcelain tends in shape (rococo to classical) as well as decoration (medallions set in deep blue or, more typically, rose backgrounds) to resemble the distinctive style developed at Sèvres.

After the French Revolution, Limoges replaced Sèvres as the main center of French porcelain production. Its many different factories (now private enterprises) included Haviland et Cie, established in 1842 by New York retailer David Haviland to produce porcelain for export to the United States. Notably, Haviland created two dinner services for the White House in 19th-century historicist styles.

Contemporary Limoges doesn't have much cachet, but the Metropolitan Museum of Art in New York sells copies of an 18th-century Limoges dinner service made for the czarina of Russia.

LOUIS

During the 17th and 18th centuries, France was the dictator of style in the Western world. The styles named for the last three kings of the French ancien régime are to the modern eye all very sumptuous and ornate, a Hollywood extravaganza on divine right to elegance in interior decor. Yet each of these kings produced his movie in a slightly different focus, which the initiated learn to recognize.

Louis XIV, who began the transformation of an old hunting lodge into the famous palace of Versailles (actually, the French call it a château, or castle), was an absolute monarch in full-blown baroque style. His long reign (1643–1715) saw the establishment of royal manufactories of furniture, tapestries (Gobelin and Aubusson), glass (especially

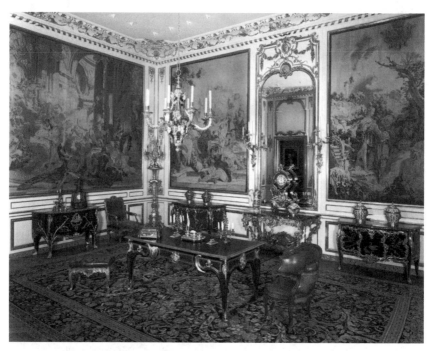

The ultimate in interior decor: paneled room from the Hôtel Cressart (1725–26), Paris, containing objects dated from 1660 to 1740 (*J. Paul Getty Museum*)

mirror glass), silk, and other luxuries—all to furnish Versailles. Every detail was carefully coordinated, from the furniture to the carpets and from the paintings to the panelling, achieving heights in the decorative arts that have never been surpassed.

Historian Lewis Mumford (in *The City in History*) calls Versailles a stage set for megalomania, "a spoiled child's gigantic toy." Even the gardens, rigidly formal in the French style, represent autocracy exercised over nature. The French Bourbons believed that after warfare, which they unfortunately played with live rather than toy soldiers, nothing would impress posterity with their greatness more than style.

You are most likely to encounter this style in furniture. Louis XIV's craftsmen made great advances over the blocky cubes in use since the Middle Ages, paring down and crafting elegant new forms to fit kingly needs. Whole new genres of tables (for coffee, for work, for beside the bed, for writing, or playing backgammon) and chairs (the bergère, the duchesse, and the chaise lounge) came into being, all beautified with gilt, lacquer, silver, marquetry, and velvet, brocade, or embroidery.

The Louis XV style, named for the great-grandson who succeeded Louis XIV in 1723 and who reigned for over 50 years, is considered French rococo, more delicate and graceful than baroque. Some of the vast rooms at Versailles were partitioned to create a more intimate atmosphere, and these were furnished with charming small tables and comfortable chairs. This was the era of the boudoir (from the verb *to pout* or *sulk*), inhabited by those royal favorites, Mesdames de Pompadour and du Barry, who introduced a feminine touch to Versailles.

Louis XV was followed by his grandson, Louis XVI, and rococo by neoclassicism.

This vogue, inspired by contemporary archeological discoveries in Italy, replaced rococo curves with classical straight lines and symmetry, gilt and lacquer with mahogany. Never before or since, according to Honour and Fleming in their survey of *The Visual Arts*, has so much money been spent on furniture. Come the revolution, however, it was all sold (the sale lasted a year) and dispersed. As a result, there are a good number of authentic Louis XIV, XV, and XVI pieces scattered all over the world.

So how does a collector judge authenticity? Thanks to French bureaucratic zeal, there is an inventory and description of every elaborate object acquired by the French royal family. These are outnumbered by the copies in existence, some of them also very fine indeed. To sort things out, Sotheby's makes the following distinctions: a "mid-18th century piece" means authentic; a "Louis Quinze piece," no date, means significantly altered; while a "Louis Quinze–style piece" means a copy.

To this day, if a truly sumptuous decor is desired, the designer will undoubtedly draw on 17th- and 18th-century French furniture styles. (In the decorating trade, "FFF" is shorthand for fine French furniture.) Unfortunately, one usually sees only single pieces, often chairs, totally out of their intended context—the supremely coordinated environment of elegance. Only in museums (the Metropolitan Museum in New York or the J. Paul Getty Museum in Malibu, California) does one get the whole, grand effect.

A note for name droppers: it is considered chic in some American circles to render the royal Roman ordinals in French, to say Louis Quatorze, Louis Quinze, and Louis Seize (when in doubt, Louis quelquechose; or if you wish to make sophisticated fun of an American imitation, Louis-le-Grand-Rapids). The French do not use these appellations; rather, they give the date and provenance, so far as is known, of the piece in question.

For Louis-style copies in the United States, there is the Kentucky governor's mansion, modelled after the Petit Trianon at Versailles, and a Louis XVI parlor in the unlikely venue of Billings, Montana, created for the mansion of a millionaire named Moss. However, Louis was within the reach of everybody thanks to Sears, which featured in its catalogs for years Louis XV-style chairs in the $300 range.

Nancy Mitford's *The Sun King* is a gossipy good introduction to the era, generously illustrated. On interior decor specifically, *The Louis Styles* by Nietta Aprà provides a short introduction.

LUTHERAN

In a pioneering work of what is called psycho-history or psycho-biography, Erik Erikson describes how the German monk Martin Luther's resolution of his personal identity crisis and conflict with authority changed the course of history, launching the Protestant Reformation. Luther's key contribution was to personalize and internalize Christianity, based on justification by faith (rather than by penance or good works) and on scriptural (rather than papal) infallibility. Lutherans reject priestly celibacy, the worship of saints, and elaborate hierarchy, favoring direct communication with God. They also made changes in the service, eliminating most of the Roman Catholic sacraments (extreme unction was dropped, ordination and confirmation demoted to rites and marriage to civil status). But Lutherans differ from other Protestants in retaining belief in the eucharist as the corporeal presence of Christ.

Lutheranism developed in the United States through individual immigration, often in response to economic pressure or the dislocations of war, rather than the transplantation of whole religious communities like the Puritans fleeing persecution. For example, Louis XIV's incursions into the Rhineland in the 17th century (when the Heidelberg Castle and many others were destroyed by French armies) prompted those who would become the first American Lutherans to respond to William Penn's promotional offer of land in Pennsylvania. Thanks to such patterns of settlement, the Lutherans in America tended to remain isolated from one another or to splinter into myriad groups based on geography and even dialect.

The first German Lutheran Church in America was established in 1703. In 1792 the Lutheran synod in New York took a significant step toward Americanization by adopting more democratic procedures of church government. Thanks to massive immigration, Lutheran church membership in the United States quadrupled during the 19th century. By 1910 the Lutherans were the third largest Protestant group in America, after the Methodists and Baptists, a position which they retained in 1960 with eight million members.

Modern American Lutheranism is Congregational in church organization, compared to European Lutherans who favor an Episcopal system.

Erikson's *Young Man Luther* is highly recommended. See also REFORMATION. Contributors to *The Lutherans in North America*, edited by E. Clifford Nelson, were chosen for their representation of different Lutheran groups as well as their scholarship.

Memory is the diary that we all carry about with us.

Oscar Wilde

MACHIAVELLIAN

As an adjective, Machiavellian evokes a picture of devious, shifty, self-aggrandizing politicians, typically continental or Old World. Niccolò Machiavelli, the founding philosopher of power politics, was an admitted admirer of Cesare Borgia, to whom he addressed his treatise which we call *The Prince*. Wordsmith Hugh Rawson suggests that Machiavellian first acquired its negative connotation from the Roman Catholic Church for its concern with man's will rather than God's, and because the church saw its power diminished as Machiavelli's princes consolidated theirs. So what, you ask, does this have to do with upstanding, democratic American politics?

A princeling of the species Machiavelli instructed: Verrocchio's *Giuliano de'Medici* (c. 1475–78) *(National Gallery of Art)*

With our naive faith in human nature, Americans have trouble with concepts like Machiavelli's that portray man as selfish, cow-

ardly, greedy, and duplicitous, always bad unless constrained by necessity to be other-wise. This betrays a failure of imagination on our part, verging on denial of reality. Shakespeare's plays present a gallery of Machiavellian characters: amoral tyrants, ruth-less traitors, and devious intriguers. A whole European school of political sociology fol-lowed Machiavelli's lead in examining the role of force and fraud in government. And such skills are not confined to the Old World. Franklin D. Roosevelt, for one, was a Machiavellian adept. (The title of the FDR biography by James MacGregor Burns, *The Lion and the Fox*, refers to a Machiavellian parable.)

Machiavelli's *The Prince* (originally published in 1532) is short, pithy, and guaranteed to hold your interest.

MAGIC REALISM

This designation has been applied to diverse groups (mostly art but also literature) in different periods, from pre-Columbian sculpture to German expressionism, American precisionism, and the new novel in Latin America. The common denominator seems to be ultra-sharp-focus realism that reveals the magic quality in everyday objects by ren-dering them in exquisite detail. According to Seymour Menton, who has pieced together the various incarnations of the style, the late German expressionist movement called New Objectivity was almost named magic realism instead for its hard-edged realism. In content, however, New Objectivity is distinctly expressionist, emotional, even bitter and corrosive, in contrast to the more typical magic realist attitude of naiveté, as epit-omized in the works of the great French naive painter Henri Rousseau.

Christina's World (1948) by Andrew Wyeth conveying the mystery and magic of realism *(Museum of Modern Art)*

Menton also places the American sharp-focus realists of the 19th century in the mainstream of magic realism, from Edward Hopper with his lonely streets and alienated people to Andrew Wyeth, whose *Christina's World* (1948) is the best-known example of the style. Also included are Ben Shahn, whose realism expresses sympathy with the poor and downtrodden, and the precisionist Charles Sheeler with his meticulous rendering of cities and factories. Grant Wood, although usually classed with the midwestern regionalists, shares qualities of both precisionism and magic realism, according to Menton.

In Latin American literature of the 1950s and 1960s, the short stories of Jorge Luis Borges and the novels of Gabriel García Márquez (chiefly *One Hundred Years of Solitude*, 1967) give realistic expression to the fantastic. Combining history with myth and fantasy, García Márquez in particular invests the social and political with a fantastic dimension. This fix on reality is also apparent in the paintings of the Colombian-born Fernando Botero, who specializes in fat generals, bishops, and whores with a comical toy-like quality.

Although it neglects literature in favor of art, Menton's *Magic Realism Rediscovered, 1918–1981* helps make sense of this style.

MAJOLICA or MAIOLICA

The generic name for tin-glazed earthenware, whether Italian, Dutch, Mexican, or even American in origin, majolica is an Italian corruption of the name of the Spanish island, Majorca, whence these wares came to Italy in the 15th century. The technique of producing majolica, which the Muslims brought to Spain, goes back to ancient Babylon. (In fact, archeologists have identified 11th- and 12th-century finds in the western Mediterranean, surely souvenirs brought home by the crusaders.) However, it was the Italians of the Renaissance, with their broader palette (Middle Eastern majolica is predominantly blue) and their new artistic skills,

Polychromed dish with gold lustre
(Los Angeles County Museum of Art)

who made of majolica the grandest of all painted pottery. The Della Robbia family in particular gave the medium a new sculptural expression, reproducing portraits and old master paintings in majolica. Italian majolica is so various that experts differentiate subgenres—*la famiglia verde*, "severe style," Gothic-floral, *stile bello*.

From Italy the art of majolica spread in the 16th century to France (where it became known by the French corruption of an Italian place-name, Faenza—faïence). Superseded by porcelain in the 18th century, majolica has survived to this day chiefly as a folk craft for collectors, identifiable by its iridescent metallic luster and naive decoration. American majolica often has raised designs in warm, earthy colors.

When an important collection of majolica was auctioned by Christie's in 1993, individual plates went for $50,000–$60,000.

Ceramic buffs may want to consult *World Ceramics: An Illustrated History* (Robert J. Charleston, ed.). *Majolica* by Nicholas M. Dawes concentrates on British and American earthenware.

MANICHAEAN

This was a religion which arose in third century A.D. Persia preaching a pervasive dualism between good and evil, light and dark, spirit and matter. The Manichaeans incorporated Zoroaster, Buddha, and Christ as divine messengers, and they believed in heaven and hell, a last judgment, and everlasting life. Their faith spread from Persia to the West, where it was considered heretical and banned but some groups held on tenaciously in obscure backwaters: the Bogomils in the Balkans and the Albigensians in southern France. To the East, Manichaean teachings spread at least as far as Chinese Turkistan, according to evidence found in the 20th century in a ruined monastery.

Manichaeans were strict ascetics who renounced this world as wholly evil, to the extent of advocating celibacy rather than perpetuate human misery. Somehow they perpetuated themselves in France until the 13th century, when the Albigensian faith was suppressed only by a combined effort of the king, the Pope, and the Inquisition.

One never knows when this knowledge will come in handy. Reading the local Sunday paper recently, the writer came across the following in an article on Indira Gandhi: "...the ever-widening streak of gray in her hair [was] a sign of the Manichaean duality of her character...." Some experts trace radical Islamic fundamentalism in Iran to a heritage of Manichaeanism.

MANNERISM

This is a transition period between Renaissance and baroque, the last 70 to 80 years of the 16th century when the canons of classical harmony were beginning to erode. Michelangelo's late work, including *The Last Judgment* on the ceiling of the Sistine Chapel, is considered the beginning of mannerism, the point when expressiveness begins to overrun formal structure. Other 16th-century artists whose work has been classified as mannerist include El Greco, whose figures appear contorted by mystical and religious strivings, and Pieter Bruegel, a naturalistic observer of human foibles. (Jan Bruegel, one of Pieter's sons, was also an artist, but his work is more conventional.)

Mannerism means a grand manner or style, also stylishness—self-conscious, exaggerated, posed, and prearranged, with a tendency to the precious, ultimately to decadence. "The goddess of mannerism is the eternal feminine of the fashion plate," writes art historian Sir Kenneth Clark in *The Nude*, with "feet and hands too fine for honest work, bodies too thin for childbearing and heads too small to contain a single thought." Mannerist art, as Arnold Hauser put it, is always "a piece of bravura, a triumphant conjuring trick, a firework display." A social historian of art, Hauser considers mannerism emblematic of the age when the innocent certainties and absolute confidence of the Renaissance were collapsing. Introducing conflict, alienation, and doubt, the Reformation (the early years of which are coincident with mannerism) would also create the conditions for modernity.

In architecture, the elaborate fountain and the grand staircase are mannerist art forms par excellence. In literature, Shakespeare and Cervantes are the primary exam-

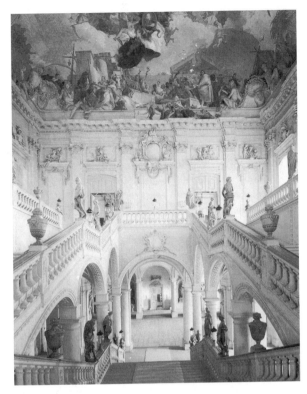

A staircase in the grandest manner: The Residenz in Würzburg, Germany, with ceiling fresco by Tiepolo (1752–53)

ples, creating in Hamlet and Don Quixote the first modern characters, men with whom 20th-century readers can identify. Like Bruegel, Shakespeare exhibits the mannerist tendency to play with conceits and contrivances, mixing gravity and frivolity, asceticism and eroticism, tragedy and comedy. In music, the great mannerist form is the madrigal. One might even say that Machiavellianism is mannerism in politics.

Mannerism is also used generically to indicate what Camille Paglia (in *Sexual Personae*) calls late-phase or decadent art of any period or style. Hellenistic, for example, has been called the mannerism of classicism, sharing the so-called theatrical perversity of the end of an age. The late 19th-century decadents (Charles-Pierre Baudelaire, Oscar Wilde, and Aubrey Beardsley) constitute a mannerist convolution of romanticism. This is actually where the concept of mannerism proves most useful, to designate the end of a period. (One need only read Heinrich Wölfflin's *Renaissance and Baroque*, written in 1888 before the term mannerism came into scholarly currency, to realize what a problem it solves: is this transitional phase the end of one style or the beginning of the next?)

There is surprisingly little mannerist art in American collections (except for the work of El Greco, who enjoyed a 19th-century rediscovery), suggesting Yankee discomfort with overblown manners.

John Shearman's *Mannerism* is a good basic introduction, but Arnold Hauser's *Mannerism* is an intellectual tour de force, illuminating a difficult period in all its richness and complexity.

MARXISM

An economic interpretation of history, Marxism is an ideology—a religion, some argue—that, whatever one's personal opinion of it, has had an enormous impact on world thought and history. Where other philosophers contented themselves with spinning theoretical webs, Karl Marx and his collaborator Friedrich Engels openly proclaimed their goal of changing the world; and change it they did, although not as they had anticipated.

If Marxism could be reduced to a formula, it would read as follows. Take the Hegelian dialectic of change, shift it from nature to history and project it into the future; then take the notions that ideas are determined by material conditions, that production is the basis of the social order, and that class struggle is the engine of history; add class conflict between the bourgeoisie and the proletariat, and the result is the forcible over-throw of capitalism in favor of a classless society, the abolition of private property, and the withering away of the state. Extrapolating from theory to history, Marxism ends up in the realm of pure ideological fantasy.

Living and working in the "epoch of the bourgeoisie," as he called it, the world of Queen Victoria and Charles Dickens, of top hats and horse-drawn carriages, Marx cannot be entirely faulted for the failure of his central prediction: that capitalism was doomed and that the revolution would take place in the advanced capitalist countries that had run the dialectic cycle to its conclusion. In his own lifetime there was little revolutionary activity, and over time many of his predictions—for example, about business cycles—did come true. But capitalism did not die, and the revolutions that finally occurred, out of the ashes of two 20th-century world wars, were in those backward giants, Russia and China, and their client states. These found in Marxism a ready replacement for traditional Oriental despotisms, an engine for the industrialization they lacked, and a substitute for the Protestant ethic. This is the realm of communism or applied Marxism. Man can make history if he understands its laws, Marx had said—he may still make history even if he misunderstood. (When the iron curtain unraveled in the early 1990s, a bitter cartoon made the rounds in eastern Europe. "Sorry, guys," Marx was depicted as saying. "It was just an idea.")

Throughout the long and repressive reign of communism, Marxism survived as a new secular form of Scholasticism, a mental straight-jacket for generations of intellectuals trying to force theory and practice into the mold of *Das Kapital*, Marx's 2,500-page magnum opus (wittily dubbed "the Doomsday Book of capitalism" by economic historian Robert Heilbroner). The book is stultifying—there can be few deadlier subjects than Marx's labor theory of value.

In the capitalist West, Marxism as a framework for understanding social processes has been applied with some ingenuity to art and literary criticism. Hungarian-born literary historian George Lukacs used Marxism as a tool to penetrate the so-called hidden social coordinates of the historical novel, to identify class interests being served. Writing on James Fenimore Cooper's *The Leatherstocking Tales*, for example, Lukacs called the tragedy of the American Indian "the necessary fate of every primitive culture with which capitalism comes into contact."

This may not seem terribly enlightening, but in the field of history, where Marxism got its start, no scholar anywhere proceeds today without giving consideration to economic forces.

The literature on Marxism, pro, contra, polemical, and analytical, is endless. Edmund Wilson's classic, *To the Finland Station: A Study in the Writing and Acting of History*, presents an informed American viewpoint.

MAYA

The Maya have been called the Greeks of pre-Columbian America for their great intellectual and architectural achievements. An agricultural people living under a priestly theocracy in settlements from Mexico's Yucatán Peninsula south to Honduras, they reached their cultural apogee in a classical period (so-called by analogy with the Greeks) between A.D. 300 and 900. Theirs was the only form of writing developed in the New World, a phonetic system using about 800 glyphs, and they knew the mathematical concept of zero, unknown to the ancient Greeks and Romans. The Maya were also keen astronomers and devised a calendar which permits exact dating over seven centuries.

The Mayan accomplishment commanding the greatest admiration today is monumental stone architecture, using cement and carved stone, with corbelled (stepped rather than curved) arches. The oldest major site is at Tikal (c. A.D. 300–900) in Guatemala, featuring great steep, stepped pyramids topped by what are called roof combs. (As someone has pointed out, the ornamental appendage at the top of New York's Chrysler Building, an art deco skyscraper, bears a generic relation to the Mayan roof comb.) The next oldest Mayan city, dating back to the fifth to eighth centuries A.D., is at Copán, Honduras. Here are found elaborately carved stone memorial tablets, called *stelae*, commemorating historical events and personages with strikingly Oriental features. At Copán and other sites are ritual ball-courts constructed for a game that was common to almost

Mayan ruin in the Puuc classical style at Chichén Itzá, Yucatán, Mexico (*C. Dunlap*)

all pre-Columbian civilizations (interpreted by scholar George Kubler as a "symbolic enactment of the diurnal passage of the sun").

Last and greatest of the Mayan ruins are in the Yucatán, constructed in a late classical style sometimes also called Puuc. At Uxmal and to a lesser extent at Chichén Itzá were built long, low palaces, their upper facades decorated with intricate stucco and stone-carved patterns such as rain-god masks and latticework. These palaces, which contrast beautifully with stepped and chambered pyramids and other neighboring structures, exerted a significant influence on Frank Lloyd Wright and other modern architects. (As the inhabitant of one of Wright's modified Mayan temples remarked, "I am moved to feel an abiding and unspoken link to the great civilizations of Meso-America while I brush my teeth.")

Their architecture is so exquisite that many consider the Maya more civilized, somehow more humane, than such neighboring tribes as the Aztec with their human sacrifice rituals. This assumption is reflected in various theories of Mayan origins—that they are survivors from the lost continent of Atlantis, descendants of the ten tribes of Israel, or were fathered by aliens from outer space. (This last theory was accepted by New Age seekers of the "harmonic convergence.") The current work of epigraphers at cracking the Maya inscriptions, which has only in the last decade really gathered momentum, suggests a different picture. Mayanists now estimate that they can read 30 to 40 percent of the glyphs carved in stone and painted in the few illustrated Mayan manuscripts that survived the Spanish Inquisition. According to the new translations, the Maya were apparently just as warlike and given to ritual bloodletting as their neighbors.

In 1992, the 500th anniversary of the arrival of Columbus, a Mayan woman from Guatemala—one of two million surviving Maya-language people—won the Nobel Peace Prize for championing the rights of indigenous peoples.

See Kubler's *The Art and Architecture of Ancient America*. For modern-day examples of the Mayan influence on art and architecture, see Marjorie Ingle's *Mayan Revival Style*.

MEISSEN

Chinese porcelain exercised such a fascination in Europe at the turn of the 18th century, such a mystique compounded of luxury and alchemy, that Augustus the Strong, Elector of Saxony and King of Poland, is said to have traded a whole regiment of dragoons for six vases. This same king also dragooned the chemists who succeeded in creating the first European hard-paste white porcelain in 1708. For the next 50 years, the Royal Saxon Porcelain Manufacture at Meissen enjoyed a gradually dissipating monopoly on the young applied art of European porcelain, a new status symbol of wealth and power.

During its period of hegemony, the Meissen factory perfected the enameling process and greatly extended the range of colors. In the second generation of operations, modellers assumed primacy over painters, but high standards of production were maintained. What was particularly distinctive about Meissen was a look of crisp fragility in tableware, vases, and figurines such as harlequins, shepherdesses, and lovers (often called Dresden china for the factory's proximity to that city) which rank today as the epitome and perfect expression of rococo. Enjoying great prestige and popularity, Meissen ware was widely copied, even by the Chinese.

1724
onwards

Meissen

Marcolini period
1774-1814

N-346
W

Inventory mark of
the Johanneum
Collection

Monogram of Augustus the
Strong and of Augustus III

'Dot' period
1763-74

On defective specimens
sold to decorators

Some of the many marks that grace authentic Meissen ware

The great age of Meissen china ended in 1756 when Frederick the Great occupied Saxony. In the last years of the ancien régime, the Meissen factory made a not entirely successful comeback attempt by copying the French Sèvres style. The firm survived the Napoleonic era with difficulty, only to revive its once successful rococo style in the mid-19th century. At the end of that century, Meissen, along with other European porcelain manufacturers, tried out art nouveau styles.

Meissen survived two world wars to become a state socialist enterprise in communist East Germany. Ironically, the firm continued to use Augustus's famous crossed swords, possibly the world's most copied porcelain mark. (Some antique Meissen is marked *AR*, possibly denoting pieces made for the king, Augustus Rex.) Also ironic in view of its royal origins and socialist management, the Meissen firm's best-known modern product was a supremely bourgeois pattern, the blue and white *Zwiebelmuster* (onion pattern, believed to be copied from a Chinese peach) that evokes instant nostalgia at the German breakfast table. Because East German production could never keep up with demand, West German firms such as Tirschenreuth and Hutschenreuther did a booming business in *Zwiebelmuster* copies. In the United States, a slightly different (usually Japanese-made) version of *Zwiebelmuster* is called "Blue Danube."

MENNONITE

Menno Simons was a Dutch Anabaptist, a leader of those rejecting infant baptism, whose belief in full obedience to Christ ruled out taking oaths, bearing arms, or holding office. His followers sought to maintain biblical piety by rejecting all worldly temptation, sequestering themselves in the simple lifestyle of rural 16th-century Europe, which they carried with them in their extensive emigrations to Russia, Canada, Mexico, and South America as well as the American colonies.

The first Mennonites arrived in Pennsylvania from Germany in 1683, followed by a group of Swiss Mennonites who settled in Lancaster County around 1710. Among the last to arrive, in 1870, were some German Mennonites who had settled first in Russia. In their new American isolation, the Mennonites continued to cultivate a somewhat medieval view of the world. The Mennonite book of martyrs (*Der blutige Schauplatz*, 1748) has been described as the largest and most disagreeable book published in the colonies before the Revolution.

Mennonites have no churches or priests; services are held in the home, and leaders chosen by lot. Even into the late 20th century, some Mennonites continue to reject all modern conveniences. Inevitably, there has been dissension (over such issues as washing the feet of fellow believers), and a falling away from the straight and narrow, but the Mennonites still constitute the largest surviving group of American Anabaptists.

Similar to but even stricter than the Mennonites are the Amish, followers of a Swiss Mennonite preacher named Jacob Ammann, who shun excommunicated members and insist on educating their children at home. (See also AMISH.)

MESOPOTAMIAN

From the Sumerians in 3000 B.C. and the Babylonians of Hammurabi's day (1700 B.C.) to the Assyrians and Chaldeans (sixth century B.C.) is a long stretch, but these cultures of the Middle Eastern fertile crescent exhibit a certain stylistic continuity which may be expressed as Mesopotamian. Of their monumental architecture, intended to glorify gods and rulers, unfortunately little remains today, the chief building materials having been clay and brick which crumbled with the centuries. Nevertheless, the Bible, other sources, and the evidence of archeology have revealed the existence of the Mesopotamian ziggurats, or terraced temple complexes, of which the legendary Tower of Babel and the hanging gardens of Babylon may be examples.

A winged genie in stone-carved relief from Nimrud, ninth century B.C. (*Metropolitan Museum of Art*)

Of Mesopotamia's huge, labyrinthine brick palaces such as Nimrud and Ninevah, each containing hundreds of rooms, there survive only foundations. Their ornate entry gates, lined by fabulous winged beasts and hybrid monsters, and their dramatic narrative relief carvings, chiefly devoted to martial and hunting themes, have mostly been carried off to the museums of Paris, London, and Berlin. (The winged beasts, by the way, are considered by scholar Heinrich Zimmer in *Myths and Symbols* the precursors of the Greek victory goddess and of Christian angels.)

Sumeria, the first great world civilization, is said to owe its greatness to three factors: the fertility of the soil, which created agricultural surpluses; an early monopoly on iron weapons, which guaranteed its hegemony over Bronze Age neighbors; and the development of a system of writing called cuneiform, the ancestor of Phoenician script, which aided the spread of Sumerian influence.

To the Babylonians we owe Hammurabi's code of laws, the oldest surviving in the

From that modern-day Babylon, Los Angeles, window detail of the former Samson Tyre and Rubber Company (Morgan, Walls & Clements, 1929) *(C. Dunlap)*

world; a legend of beautiful hanging gardens; and the *Gilgamesh*, an epic poem containing the first historical account of the flood. The Babylonian empire is also familiar to us for its association with biblical events and monuments, such as the legendary Tower of Babel, a ziggurat erected after the flood in the hope of reaching heaven. (To frustrate this presumption, Jehovah "confounded" the people so they could no longer communicate; hence *babel* became synonymous with *hubub*.)

Thanks to perpetual warfare, the Assyrians created an empire covering most of the Middle East. Their martial exploits are depicted in great chronicles of carnage carved in relief, now in the British Museum. By this time, Mesopotamian wealth was based on loot, no longer on the produce of its fertile soil. Most famous of the Chaldeans, who established the last ancient Mesopotamian empire, was Nebuchadnezzar, known for the Babylonian captivity of the Jews. According to historical convention, Mesopotamian civilization is considered to have survived until Alexander the Great, dying as it had lived—by the sword.

Babylon went into permanent eclipse in the third century B.C. The nearby city of Baghdad rose to great glory in the first centuries of Islam, but the entire area was devastated by the Mongols in the 13th century and regained importance only in modern times thanks to the discovery of oil.

The Mesopotamian ziggurat and style of relief carving enjoyed a vogue in the United States during the art deco era.

Two pieces of the Mesopotamian puzzle are provided by C. Leonard Woolley's *The Sumerians* and *Babylonian Life and History* by E. A. Wallis Budge, both old standards available in recent paperback reprints.

METHODISM

In 1791 the Wesleyan Methodist Church broke away from the Episcopalian (former Anglican) Church of the United States to become within 50 years one of the largest American denominations. They called themselves Methodists because of the emphasis on "rule and method" in their search for Christian perfection, and Wesleyan after the Wesley brothers who started the movement at Oxford University in 1729.

John Wesley, considered one of the great modern Protestant preachers, and his brother, Charles, who wrote or translated thousands of hymns, both traveled to the American colonies in 1735 but did not stay long. (A plaque on Boston's Old North Church recalls that John Wesley preached there.) Ranking private morality above pub-

lic ethics, John Wesley opposed American independence and called his preachers back to England. They were supplanted by native lay preachers, fervent evangelists who took a personal, emotional approach to religion, emphasizing the conversion experience. Following the frontier to spread the gospel, Methodist preachers perfected the business of "circuit-riding." (According to an old folk saying, in bad weather nobody goes out but crows and Methodist preachers.) In camp meetings lasting from a few days to weeks, they built up a tremendous momentum to conversion by means of powerful sermons and such demonstrations of grace as speaking in tongues and faith healing. In the South, annual camp meetings held after the harvest were the social event of the season.

There are many varieties of American Methodists: Congregational and Episcopal Methodists, African American Methodists, and Wesleyan Methodists. Taken together they constituted one of the most significant American denominations until they split over the issue of slavery in 1845, reuniting only in the 20th century as the United Methodist Church, which claimed nine million members in 1991. They would number even more but for large-scale defections to the Pentecostal movement in this century, prompted by "holiness revivals."

MIDDLE AGES

This long period, somewhat arbitrarily second-classed as the thousand years between the fall of the Roman Empire and the renewal of classical ideals in the Renaissance, has only come into its own in recent times. Certainly for the men of the Renaissance who first named it, the Middle Ages were synonymous with "dark ages." In the 18th century, the philosophers of the Enlightenment considered "medieval" (the adjectival form of Middle Ages) a term of derision, signifying rule by blind faith instead of reason.

For the romantics, however, the Middle Ages replaced the classical period as a sort of lost paradise, a time of innocence, idealism, heroism, and spirituality ("in contrast with the chill of the Enlightenment and the terror of the Industrial Revolution," Norman Cantor adds). And for 20th-century man, not otherwise very romantically inclined, medieval still evokes visions of Camelot and the Knights of the Round Table, when men were noble and maidens fair. As fashions in history go, the Middle Ages have enjoyed rather a long vogue.

One of the difficulties in dealing objectively with the Middle Ages is its extent. In French and German, the name of the period is singular—*le Moyen Age, das Mittelalter*—but in English one speaks of "ages," a construction that lends itself to further division into smaller, more coherent units (included elsewhere in this book): the Dark Ages of the fifth through eighth centuries: the Carolingian renaissance, the Ottonian and Merovingian eras, with the Byzantine running parallel throughout. The remaining high Middle Ages, therefore, run from the 11th to 13th centuries, when the Renaissance (trecento) begins.

What then can be said about the high Middle Ages? The chief factor of historical and political importance was the church—the Roman Catholic Church in the West, which inherited the mantle of the Roman Empire and carried it through the Dark Ages until new political pretenders to the secular throne arose. At first these latter, in their jostling for power, tended to self-destruct, resulting in a political hodge-podge, leaving authority splintered into feudal principalities at the bottom with the church as the sole unifying force.

The major event of the Middle Ages was the Crusades, eight wars of religious imperialism over a 200-year period. Instigated by the Papacy for the ostensible purpose of recovering the Holy Land from the Muslim infidel, the Crusades had the effect of displacing petty power conflicts onto a larger but more remote stage, as European princelings jostled for power and spoils from Constantinople to Jerusalem. It was the Crusades, or the idea of "holy war," that provided a proving ground for later idealization of the Middle Ages, the arena where the romance of chivalry played itself out. Chivalry itself became almost a rival ethical system, with its own laws of war and its own new secular literary form, the *chanson de geste* with its concept of unrequited love.

In the visual arts, the role of the church was paramount. The crowning achievement of the Middle Ages was the cathedral (whether Romanesque, Gothic, or a mixture of both). This was a time of feverish church construction: in France alone, 80 cathedrals, 500 large churches, and innumerable smaller ones were constructed between 1050 and 1350. (As capital investment, this is unequaled by any single economic undertaking in history except war.) Within these sacred structures, religion became visible, palpable, intelligible even to the illiterate, thanks to the development of a conventional symbolic language readable in stained glass and stone. The church did not start here from naught:

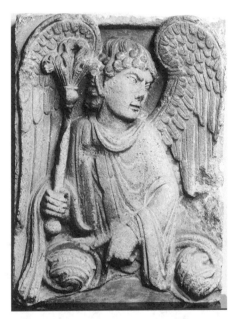

A 12th-century relief sculpture from France
(Nelson-Atkins Museum of Art)

the inherited body of classical motifs was co-opted and adapted to Christian purposes, with, for example, the figure of Hercules becoming Christ. Medieval artists added a few twists of their own: the new cult figure of the compassionate virgin, largely a French creation; that of the infant Jesus, who begins to be portrayed (as a mini-adult) in the 11th century; and the Crucifixion, which develops in the hands of the Germans from a formal subject into a personally painful, tortured event. (In art in general, medieval representation is stiff and two-dimensional, with a special quality of innocence and intimacy.)

We tend to think of the Middle Ages as a vast, static era, secure and changeless. In fact, it was a time of innovation and discovery. A new school of thought holds this to be the most dynamically progressive period in European history, with the development of towns and cities, trial by jury, universities, banks and capitalism, and the middle class.

Medieval survivals in America include the Cloisters, a Spanish monastery transferred lock, stock, and barrel by the Rockefellers to New York. To cite only a few recent examples of the popularity of things medieval in the United States, historian Barbara Tuchman managed to write an unlikely nonfiction bestseller about the 14th century, *A*

Distant Mirror (1980), while Umberto Eco's *The Name of the Rose* (1983), a medieval detective story, became a popular novel and film. J. R. R. Tolkien, with his make-believe medieval universe of hobbits, continues to enthrall generations of young people, and Lancelot, Galahad, and Guinevere, the whole cast and characters of Camelot, remain perennially popular projections of our wish fulfillment.

The literature on the Middle Ages is vast. The writer particularly recommends a new study by Norman Cantor, *Inventing the Middle Ages*, which provides a valuable perspective on all the great medievalists: the American Henry Adams, with his "artificial neo-romanticism"; the Frenchman Emile Mâle and his "glorious vulgarization"; Johan Huizinga of Holland, cultural sociologist; the French Marxist economic historian Marc Bloch; and the German medievalists, fascinated with the concept of kingship. See also CHRISTIANITY, GOTHIC.

MILLE-FLEURS

Meaning *thousand flowers*, this is a generic style of late Gothic or early Renaissance tapestry with elegant figures set against an exquisite background of flowering plants and scampering animals. The most celebrated examples of mille-fleurs all feature the theme of the unicorn, the mythical one-horned animal considered to symbolize purity and

love. Most famous is the series of unicorn tapestries symbolizing man's senses and desires in the Cluny Museum in Paris. These have a predominantly red background, whereas a second series, called The Hunt of the Unicorn, is predominantly blue-green. Purchased in 1923 by John D. Rockefeller, Jr., and exhibited since 1938 in the Cloisters branch of New York's Metropolitan Museum, this second series of

The Unicorn in Captivity, one of the series of French or Flemish unicorn tapestries from the late 15th century, charming but labor-intensive wall coverings that use abundant nature symbolism to convey moral precepts (Metropolitan Museum of Art, Cloisters Collection)

seven tapestries depicts the hunt, capture, and taming of the unicorn by a gentle maiden. Both the Paris and New York unicorn tapestries are dated (chiefly by dress styles depicted) around 1500. They were long believed to have been produced in France's Loire region, where most of them survived in châteaux, but are now suspected to be Flemish in manufacture.

These tapestries on chivalric themes were the most costly artistic creations of their day, according to Honour and Fleming in their survey of *The Visual Arts*, who suggest that Botticelli's *Primavera*—which also features a flower-strewn background—may have been intended as a more inexpensive method, inch for inch, of wall covering.

Another gem of 16th-century Flemish tapestry, similar to mille-fleurs but with large, luxuriant leaves, is called *feuilles de choux* or cabbage leaf tapestry.

Margaret Freeman's book on *The Unicorn Tapestries* for the Metropolitan Museum of Art is as charming as it is beautiful. Freeman describes the symbolic and other qualities of the various flowers, trees, and plants shown in the Hunt tapestries, from roses and lilies to hawthorn, thistle, and pomegranate, 85 of which have been identified by modern botanists.

MING

The name of this Chinese dynasty (1368–1644) means "brilliant," signaling the Ming intention to recapture the glory of T'ang China. In keeping with such aspirations, the Mings laid the foundations of most of the surviving historical architecture of China, such as the Imperial Palace and Temple of Heaven in Peking, which rank as the Chinese equivalent of France's Versailles. Thirty miles from Peking, vast underground palaces were built as tombs for the Ming emperors, their approach flanked by life-size camels, elephants, and monsters.

The Ming era was also characterized by the triumph of conservative Confucianism with its literary and religious pedantry ("an almost Victorian fussiness," according to Honour and Fleming in their *Dictionary of the Decorative Arts*). The great Chinese art of landscape painting became increasingly weak and pretty, narrative and decorative, featuring tired platitudes from China's traditional nature worship. Figures, when present, in the words of Asian expert Ernest Fenollosa, resemble dolls "with empty idiotic faces."

A celadon vase from the Ming period, porcelain with the color of jade and the texture of an old master *(San Diego Museum of Art)*

On the more positive side, cloisonné enamel introduced from the West was developed to new heights in Ming China, as was red and black lacquer work, often stunningly incised. The Chinese novel and drama also developed during this period. In porcelain, the Ming era saw the transition from traditional blue and white to multichrome decoration. Much admired in Europe for the dazzling delicacy of its small paintings, Ming china can be found in important museum collections. (A few years ago a news bulletin announcing the theft from an Ohio museum of a Ming bowl described

it as looking like a cereal bowl—but worth $250,000.) For identification purposes, Ming ceramics are often inscribed with reign titles, of which there are 16 to remember.

Ming culture is considered to have waned in 16th-century China but to have persisted some centuries longer in Tokugawa Japan.

MINIMALISM

As an adjective, minimalist has long been used to mean austere or pared down; the French composer Claude Debussy, for example, considered compatriot Erik Satie's music minimalist. Minimalism as a style per se—that is, making a virtue and an end in itself out of simplification, reductionism, and exclusion—arose in the 1960s as a pendulum-swing response to the waning style of abstract expressionism and to the easy access of contemporaneous pop art.

In the process of eliminating what they considered nonessential, minimalist artists also set out to squelch expressiveness or human feeling in general, plus color, decoration, and any rhetorical aids or cues to understanding. They also renounced the concept of workmanship, favoring minimal modification of raw materials. As a result, minimalist art often consists of found objects, sometimes very large. A sub-genre is called "scatter art," its various components ordered only by gravity.

Art on the border of non-art, minimalism has always emphasized its austerity, barrenness, and boringness. An apologist of the movement argues that boredom is an intentional effect, a means of generating awareness. It is considered a measure of success when observers ask, "Is this really art?" But the response is not always what minimalists might like. (A minimalist sculpture called *Cedar Piece* was inadvertently burned as firewood by someone who was not hip.)

Boring, drab, self-referential—the final irony is that minimalism proved during the 1970s to be "the sculptural style of choice for corporate collections." As art writer Calvin Tomkins put it, apparently modern art can help sell stock or insurance just as medieval art sold Christianity. Its low profile a perfect complement to the International Style architecture favored by many corporations, minimalist art has been called "visual muzak" by one critic. He and others welcomed it as a victory when in 1989 Richard Serra's *Tilted Arc* (sometimes called post-minimalist) was removed from the Federal Building Plaza in lower Manhattan after years of public protest.

Outside of sculpture, minimalism has made its greatest splash in the marathon multi-media collaborations of Robert Wilson with Philip Glass. Their best-known work, *Einstein on the Beach* (1976), is at five hours in length longer than a grand opera. Wilson has been described as an original, but an original "what" is hard to say; perhaps the French *metteur-en-scène* expresses it best, for he certainly does nothing so mundane as playwriting. A kind of performance art mounted in major production, Wilson's work calls to mind the fable of the emperor's new clothes—is he wearing any at all, or is this a very long and boring put-on?

Philip Glass, who deals in notes and sound, is more readily identifiable as a composer, whatever you may think of his limited harmonics and incessant repetition. Minimalist music is usually tonal (compared to the atonality of serialism) and tends to reject classical notions of development in favor of endless repetition. Some cite the influence of Indian ragas, which may go on for hours without any perceptible beginning or end, producing a hypnotic effect. Satie once wrote a series of chords to be repeated 840

times, so he may in fact be the godfather of Philip Glass. The artist Andy Warhol's multiple soup cans and coke bottles have been called a visual analogue to minimalist music, and in fact it is said that the term *minimalism* first came into modern usage with reference to pop art.

Minimalist aesthetics have also influenced writers and designers by the trickle-down process, according to Kenneth Baker. In one so-called minimalist novel, the author describes a lunch break in excruciating detail. But it is in commercial design that minimalism probably had its greatest influence, making other styles seem by comparison cluttered, overburdened, or noisy. Inevitably, then, the pendulum swings back again, and one longs for color, ornamentation, and excitement. That moment seems to have come. According to a recent popular magazine, "Move over minimalism….Exit the antiseptic spirit of the white room."

Kenneth Baker, author of *Minimalism: Art of Circumstance*, is an aficionado of the movement. New York's Guggenheim Museum recently acquired a major collection of minimalist art in exchange for some (old hat) paintings by Kandinsky, Modigliani, and Chagall.

MINOAN

Most familiar to us from Minoan civilization is the legend of the minotaur, a monster with a bull's head on a human body who inhabited a labyrinth under the palace at Knossos, Crete, and required human sacrifices for appeasement. The palace at Knossos still stands, heavily reconstructed in the 19th century by British archeologist Sir Arthur Evans, but contemporary guides downplay the minotaur legend and the only suggestion of a labyrinth is the moderately complicated floor plan of the palace. Evans himself attributed the minotaur legend to the rumbling of earthquakes, one of which destroyed the palace around 1400 B.C., and scholars point out that the classical Greek myth of the Minotaur is a millennium younger than the palace.

Beginning about 1,000 years before the destruction of the palace, the Minoans (so-called by Evans after the legendary King Minos

A modern copy of Minoan sculpture revealing a gentle quality of grace *(courtesy Toni Olivera)*

who ruled there according to Greek mythology) evolved one of the great Bronze Age civilizations, a seafaring island culture—and the last major Western society to worship female powers, according to guerrilla cultural historian Camille Paglia in *Sexual Personae*. The archeological evidence of frescoes, terra cotta, bronze figurines, pottery, and seals suggests that Minoan culture was unusually gracious, happy, and pacific for its day, the minotaur legend notwithstanding. Social historian of art Arnold Hauser points out that the Minoans were unique in the vast stretch of time between the Paleolithic and clas-

sical Greece to prefer naturalism to an abstract geometric style, a freedom of invention Hauser considers European rather than Oriental.

The most famous Minoan figurine (besides the bull) is a "snake goddess," bare-breasted, wearing a long, full skirt, and holding a snake in either upraised hand. Other figurines of bare-breasted women have hands raised as if in homage, or one hand to the brow, or a final variation, one arm crossing the chest and curving around the waist in a graceful gesture of modesty. These naturalistic Minoan forms have entered the vocabulary of modern art; the French sculptor Auguste Rodin even copied the roughly textured Minoan bronze technique.

Until its pictographic script was finally deciphered in 1952, Minoan civilization was thought to be more Oriental than Occidental, closer to Egyptian than to Greek. The discovery that the script is an early form of Greek enabled scholars to trace links between Crete and the Greek mainland, particularly the Mycenaean kingdom which is now understood to have had a Minoan or early Greek ("Helladic" is the current designation of preference) civilization. It is surmised that Minoan culture was transmitted to Mycenae by intermarriage.

In Mycenae, however, this civilization took a more martial form, dominated by a semi-barbarian military caste who invested surplus wealth won in battle in megalithic construction and conspicuous consumption. The so-called Tomb of Agamemnon, one of several beehive-shaped chambers at Mycenae, ranks technically as the largest unsupported space constructed before the Roman Pantheon 1,500 years later.

There is an excellent chapter on Minoan culture in Anne Baring and Jules Cashford's *The Myth of the Goddess*; and in the Thames & Hudson series, see *Minoan and Mycenaean Art* by Reynold Higgins.

MIXTEC

In the crowded, confusing history of Mexico's central highland cultures, the Mixtec are distinctive chiefly for their painted manuscripts. Scribes and compilers of books, they compiled pictorial genealogies covering centuries of dynastic history. These colorful manuscripts, called Mixtec codices, are now held by museums and libraries in London, Oxford, Vienna, and Rome.

At Mitla, near Oaxaca, where the Mixtec began displacing the Zapotec around A.D. 900, there are relief carvings of seated couples (called "marriage reliefs") which bear a family resemblance to the Mixtec manuscript style. Traces of Mixtec style are also apparent in wall paintings at Tulum in the Yucatán, quite a distance away.

The Mixtec were also master gold- and metalworkers, fashioning pendants, rings, bells, and other items, all with complicated symbolic and decorative motifs. Some samples of these, as well as polychrome painted ceramics, were found in tombs at Monte Albán, the great ceremonial city of rough-hewn stone outside Oaxaca. (Comparing Mitla and Monte Albán, the former, although on a significantly smaller scale, appears several leaps ahead in conception and design.)

At the end of the pre-Columbian era, the Mixtec were still engaged in a bitter struggle with their old enemies, the Zapotec. They were finally subjugated by Cortés's armies in the 16th century. Mexico today counts some 300,000 Mixtec-speaking inhabitants.

MONASTICISM

There have probably always been holy men, hermits seeking spiritual perfection in solitude. The word *monk* derives from the Greek word for *alone*. Christian monasticism, which arose in Europe after the disintegration of the Roman Empire, constituted a system of "parallel aloneness," in Erik Erikson's words, based on removal from the world and ritual observances of varying degrees of severity and austerity.

The early Christians had accepted penance and persecution as a means to expiate sin. When Christianity became the Roman state religion and the masses entered the church, monasticism arose as a means to recapture the purity of the original religion. The history of monasticism is marked by periodic waves of revision and reform, peaking during the Middle Ages when monasteries served as important centers of stability and scholarship in Europe, and declining steadily since the Reformation.

The earliest of the Western monastic orders was founded in Monte Cassino, Italy, around A.D. 529, by an Italian monk named Benedict, who had already tried living as a hermit. Benedictine rule, based on eight hours of devotions daily and chanting of the entire psalter weekly, was relatively mild. Around 1100 there arose in France two much more ascetic orders, the Carthusians with their charterhouses designed for seclusion, and the Cistercians, called "white monks" for the color of their robes. The latter built remote, strictly functional monastic communities; they forbade decor even in their churches, where style became a function of ascetic ideals. Design expert Adrian Forty believes the Cistercians used the Romanesque and Gothic styles to create a visible identity, "a focus of loyalty and cohesion," comparable to a corporate logo today.

Dedicated to poverty, the Cistercians were unable to sustain their intention; they were so diligent that they invariably prospered. This was also the experience of other monastic communities, which were efficient economic units, enjoying relative economies of scale. "Western Europe first learned to work methodically from the monks," writes social historian of art Arnold Hauser, citing the important monastic contribution to the development of crafts. The monasteries also accumulated wealth in the form of bequests, and served as inns during the Middle Ages, offering hospitality to pilgrims and travelers. Over time, thousands of European towns (including Munich, Germany, the name of which derives from the German for monk) grew up around them.

In the 13th century there arose two important new orders seeking a more demonstrative spirituality and at least a partial return to the world (strictly speaking, they are not considered monastic; sometimes one hears them called mendicant orders). Evolving from Benedictine rule, the Franciscans, founded by St. Francis of Assisi in Italy in 1209, and the Dominicans, established in 1215 in Spain, were both preaching orders, primarily urban, dedicated to labor in the lay world and to poverty, humility, and simplicity. Nikolaus Pevsner points out in his *Outline of European Architecture* that the churches of these orders were designed with acoustics in mind, to provide a forum for rousing sermons.

The Franciscans or "gray friars" (gray for their cloaks, and as friars lower in status than monks) were great preachers and great travelers. The recent film, *The Name of the Rose* (based on the novel of the same name), depicts Sean Connery as a gray-cloaked wanderer arriving in the relatively comfortable sanctuary of a Dominican monastery, inhabited by more worldly and somehow corrupt brothers in black robes. The Dominicans, for their part, were active in education and showed a strong interest

in the extirpation of heresy. (Savonarola, the "ayatollah" of 15th-century Florence who presided over "bonfires of the vanities" until he was himself burned at the stake, was a Dominican.)

With the Protestant Reformation, some of the old Catholic orders went into decline, and some new ones were founded. The most important of the latter, the more worldly (hence, again, not monastic) Order of Jesus or Jesuits, will be considered separately. Other new orders included the Capuchins, from the Italian for "hooded ones," an ultra-devout branch of the Franciscans. From the Cistercians in 1660 there developed an even more austere offshoot, the Trappists, practicing strict seclusion.

These are all Catholic orders; Protestantism never went in for monasticism. In fact, the Reformation marked the beginning of the end for Western monasticism. When Henry VIII broke with the Pope and established a separate Church of England, he also dispossessed the (mostly Benedictine) monasteries. (Parenthetically, the plundered wealth of the British monasteries is considered to have significantly fueled the Industrial Revolution.) In France, monasticism survived until the Revolution of 1789, when the orders were dispersed and their wealth seized, a scenario which repeated itself wherever Napoleon's armies penetrated in Europe.

In the Western hemisphere, contemplative monasticism per se never really caught on, but the more energetic of the European orders, particularly the Franciscans and the Jesuits, played a significant role as missionaries in early exploration and exploitation. When the Spaniards first arrived in Mexico, they were accompanied by Franciscans, Dominicans, and Augustinians who traveled in groups of 12, like the apostles, seeking new souls for the Catholic Church. Later, the Jesuits were especially active in Mexico, Brazil, and Paraguay.

Missionaries from the monastic orders did not play such an important role in the colonization of the United States, except in Spanish California, but their names crop up repeatedly in early historical records. When Coronado left Mexico in 1540, traveling as far as Kansas in search of the fabled "Seven Cities of Cíbola," he was accompanied by three Franciscans, for example, and in 1549, some Dominicans met a martyr's death at the hands of Florida's Indians. There are even some early American convents: in 1727 the Ursulines, a teaching order of nuns closely related to the Jesuits, established one in New Orleans; and in 1790 the oldest convent on the eastern seaboard was founded by the Carmelites, a contemplative order with a mystical bent, near Port Tobacco, Maryland.

In the New World as in the Old, the Catholic orders were subject to political vicissitudes. When the Jesuits were banned in the 17th century, they were replaced in the American colonies by Franciscans. After Mexico's successful war of independence against Spain, the Franciscans were themselves expelled (from the American Southwest as well) and their churches and missions secularized. Theirs was an ambivalent legacy of construction (witness the chain of missions along the California coast, still standing, built by Franciscan Father Junípero Serra) and destruction of the Indian way of life and culture. (Most of Mayan literature was burned by the friars as superstitious work of the devil.)

In American history, monastic communities wherever they were established became subject to particularly American pressures and influences. During nativist demonstrations against Catholics in 1834, an Ursuline convent near Boston was burned. Then there were the Benedictines from Bavaria who established St. Vincent's Abbey in

Pennsylvania in 1846, complete with a brewery that became a target of the temperance debate. An offshoot of St. Vincent's, St. John's Abbey in Minnesota, became the center of the post–World War II American Benedictine movement for liturgical reform. The order now has in Collegeville, Minnesota, an ultra-modern church designed by Bauhaus architect Marcel Breuer.

To this day, the American landscape features here and there relics from monastic history, like great religious dinosaurs: a Carthusian charterhouse in Arlington, Vermont; a Capuchin monastery in Yonkers, New York, of all the improbable places; and various Trappist abbeys, including Gethsemani in Bardstown, Kentucky, where mystic Thomas Merton and generations of Catholic dignitaries have sought solace in silence.

MONGOL

Genghis Khan—the name alone arouses fear, evoking the Asian hordes who swept from Mongolia south into China and west all the way to Europe in the 13th century. In China, the great Khan's grandson Kublai Khan established the Yüan dynasty (1279–1368), which adopted Chinese customs as well as the Buddhist religion. (The western Mongols became Muslims, and some distant relatives later established themselves as the Mughals in India.) In the brief century they ruled China, the Mongols served as something of a cultural transmission belt to the Middle East, purveying Chinese silks to the Islamic market and bringing back such innovations as cobalt blue ceramics. The most famous traveler on this "silk road" was the Italian Marco Polo, who returned to describe Kublai Khan's magnificent capital, presumably Peking. Unfortunately, the Khan's stately pleasure domes no longer exist outside of the memorable poem by Samuel Taylor Coleridge. After being expelled from China in the 14th century, the eastern Mongols lapsed into relative obscurity, divided in modern times between Soviet and Chinese "people's republics."

MORMON

One of the most controversial and dynamic of American religious sects, the Mormons (or Latter-day Saints, as they prefer to be called) trace their church back to a series of revelations in the 1820s received by a simple New York State farmer named Joseph Smith. Guided by an angel, Smith claimed to have found a set of gold plates containing the history of a lost tribe that made its way from the Middle East to the New World in 600 B.C. ("Mormon" is the name of the angel's father, co-author of the plates.) Translated from "Reformed Egyptian" with the aid of a magical "seer stone," the history was published in 1829 as the *Book of Mormon*, the keystone of a major new religion.

From the beginning, the Mormons cast themselves as a chosen biblical people, suffering persecution and martyrdom. After Smith's assassination in 1844 by "Gentiles," the Mormons followed their new Moses, Brigham Young, on a 1,000-mile exodus to a new Zion in the wilderness of Utah. There they created a unique community of saints ruled by prophets and apostles, with the aid of revelations on diet (no alcohol, tobacco, or coffee) and conduct (polygamy, modesty), which served to separate them from the American mainstream. Or perhaps they are archetypically American, comparable to the Puritans for their closed religious community with its sense of mission and social discipline.

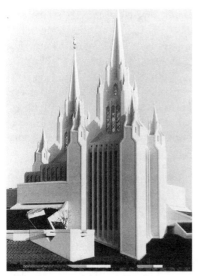

The new Mormon Temple (Dennis and Shelly Hyndman, 1992) in San Diego, a vision of Flash Gordon Gothic *(Tony Russell)*

Thanks to strong central leadership, great diligence, and an admirable ethic of community solidarity and aid—in striking contrast to the wild-western norm of unbridled individualism and maverick disorder—the Mormons survived and prospered in Utah. Pushing back the wilderness, they pioneered in techniques of dry-land farming and cooperative ventures, seeking self-sufficiency and independence from the hostile world. But as western settlements advanced to their once remote desert empire, they again became objects of fear, hatred, and envy. Their communal economy prompted claims of unfair competition, their numbers aroused fear of bloc voting, and such practices as polygamy and baptism of the dead provoked lurid speculation and popular outrage.

Bowing to the inevitable, the Church of Jesus Christ of Latter-day Saints was by 1890 advising its members against plural marriage. In negotiations for Utah statehood culminating in 1896, the church also agreed to abandon some of its cooperative business enterprises and properties.

The Mormons have made a negligible contribution to religious thought, in the opinion of historian Henry Steele Commager. (Literary critic Leslie Fiedler calls the Mormon Bible an unwitting parody of the Christian book.) However, theirs has been an innovative socio-economic experiment. Thanks at least in part to such beliefs as "celestial marriage," or a "sealing" together for eternity, they have created strong families and prosperous communities that are exceptions to the current American norm. They also maintain an active missionizing program, particularly in Latin America, in which young people do service to their faith. Compiled pursuant to the Mormon practice of baptizing the dead, church records constitute the world's premier genealogical archive.

Traditionally, the Mormons built their temples on hilltops for the visual edification of the community. In the late 20th century, with 4.5 million members throughout the United States, the most visible place seems to be next to heavily traveled highways. The Gothic spires of the Mormon Temple in the suburbs of Washington, D.C., are familiar to all who travel the Capital Beltway. One of the latest of the church's 45 monumental American temples is in San Diego, California, a blindingly white Gothic-towered confection with a touch of Flash Gordon. The temple is situated so close to the San Diego Freeway, a local wag remarked, as to arouse speculation on the separation of church and interstate.

Practicing Mormons Leonard J. Arrington and Davis Bitton, authors of *The Mormon Experience: A History of the Latter-Day Saints*, have written a reasoned and epic American story.

MUGHAL

Mughal, Moghol, Mogul—these names are all corruptions of the word *Mongol*, from which group these Islamic emperors of India were remotely descended. Islam had been expanding into India since around A.D. 1200, but the first dynasty capable of uniting Islamic India was the Mughal, beginning with the conquest of Delhi by Babur (a descendant of Genghis Khan and Tamerlane) in 1526. The Mughals reached their peak under Babur's grandson Akbar, a cosmopolite who ruled northern India from his red sandstone palace-fort in Agra. Akbar's grandson, Shah Jahan, built another red sandstone palace-fort in Delhi, but is proba-

bly best known for the monument to his wife, the Taj Mahal. (The Mughals built rather more elaborate tombs and memorials than Muhammad would have favored. The prophet might also have frowned upon the munificent Mughal gesture of the annual weighing of the prince, who then donated his weight in valuables to the poor.) Their decline in the 18th century was accelerated by the arrival of the British East India Company.

The Mughals introduced the dome (a very bulbous one), arch, and minaret to India. Known for extravagant elegance, they created a synthesis of Islamic (chiefly Persian) and indigenous Indian culture. Drawing on Persian models, the Mughals became expert carpet weavers and manuscript illuminators. Where Persian

Four portraits of Mughal courtiers (c. 1605–28) in jewel-like colors, from the Kevorkian Album *(Metropolitan Museum of Art)*

manuscripts are rather formal and sybaritic, the Mughal versions are bold and energetic, their colors still fresh and bright as if they were painted yesterday. (The Mughal style of manuscript painting also spread to some Hindu or *rajput* courts.) In rugs, the predominantly floral Mughal is considered technically superlative, commanding the very highest prices in today's auction market.

G. H. R. Tillotson's *Mughal India* is available in the Architectural Guides for Travelers series.

Naming is the crucial activity of the poet.

Anonymous

NATIONALISM

In the realm of ideas having a major impact on modern history, none ranks higher than nationalism, the religion of the nation-state. As a subject of study, nationalism has been quite popular with political scientists, perhaps for its susceptibility to continuing refinements of definition if not for amenability to prediction. The origins of nationalism are usually traced to the Enlightenment and the French Revolution, when monarchy was replaced by the new nation as the focus of authority, legitimacy, and identity. It is only coincidental, however, that nationalism arose in conjunction with the idea of popular sovereignty; modern history is full of examples of authoritarian and totalitarian nationalisms.

An often dangerous force, nationalism unfortunately lends itself (by analogy with personal development, ego writ large) to feelings of superiority and the pursuit of national self-interest. The danger is compounded by practical difficulties in defining nations. Common history, language, culture, religion, and race are possible but not necessary or sufficient components. And where "nations" are geographically and ethnically mixed up with one another, as they often are historically, the tendency to glorify a master race or nationality—the German "folk," for example, a compound of ancient tribal loyalties and dark emotions forged in primeval forests—typically leads to fascism and aggression, particularly on the part of nations (again, extending the personal analogy) with insecure national identities or egos.

In recent Western history, World War I was precipitated by subjugated national groups seeking independence. World War II, unleashed by the nationalistic hubris of the Nazis, was followed by totalitarian suppression of many of the same national groups that won their independence in World War I. Today, after a generation and more of "multi-nationalism" or internationalism enforced by communist power, the world is now witnessing with surprise and horror the breakup of the former Soviet empire into its smallest national denominators, miniature nations defining themselves too often by aggression against their neighbors.

Culturally, the great 19th-century surge of nationalism is coincident with that of romanticism. Conquered national groups such as the Poles, Czechs, and Slovaks awoke at that time to their identity and roots, enjoying something of a cultural rebirth. This romantic nationalism also entailed a narrowing of horizons, a rejection of the wider European culture unfortunately associated with political repression. As historian Germain Bazin points out, the Renaissance and baroque were truly cosmopolitan eras, with artists like Peter Paul Rubens active all over Europe. In the era of nationalism, each group would exalt its own culture, culminating in rejection and suppression of competitive or alternative cultures and ultimately of the groups themselves. The German Nazis, who began by burning books and suppressing expressionists and other modern artists they considered degenerate, ended by burning people.

NATURALISM

It is the theory of literary historian Edmund Wilson (in *Axel's Castle*) that just as romanticism was a reaction against the mechanistic impact of science, naturalism represents the swing of the pendulum back again to science—specifically, to the kind of deterministic Darwinian biology in vogue during the last years of the 19th century. Where the romantics had elevated man to the status of hero, naturalism reduced him again to a helpless animal, a product of his environment; and where romanticism turned man inward, to the contemplation of his own individual soul, naturalism pointed the way back out, to social action.

The great French naturalistic writer, Emile Zola, whose novels had sold over two million copies by 1900, once said that preparing a novel was like doing a lab experiment: just supply the active agents, environment and heredity, and watch the reaction. Zola's novels tended to depict in unsparing detail the seamy, sordid side of life, with man as a helpless victim of social and economic forces. As for woman, we have Gustave Flaubert's naturalistic classic, *Madame Bovary* (1856), about a provincial housewife who falls victim to her own romantic delusions.

Naturalism has a long tradition in American literature, going back to the novels of Frank Norris. His *Octopus* (1901), recounting the brutal struggle between farmers and the railroad in California's central valley, became a muckraking classic, while *McTeague*, a depressing 1899 novel about a dentist with a lust for gold, was made into an extraordinary marathon film and most recently, an opera. But the great American classic of naturalism is probably Theodore Dreiser's *American Tragedy* (1925), an anti–Horatio Alger story of a young man trapped by his ambitions. In a later generation, Ernest Hemingway with his flat, affectless prose, recording rather than evaluating or evoking, is sometimes classed as a naturalist, as is William Faulkner with his florid, seamy stories of Southern life.

The American artists Grant Wood and Thomas Hart Benton, usually classified as regionalists, are also in the naturalistic tradition.

NAVAJO

The largest surviving tribe in the United States today, with a population of 200,000, the Navajo have proven adaptable to new conditions and challenges. They were late-comers in the American Southwest, arriving just before the Spaniards. Like the Apaches, with whom they share a language of the Athapascan family, which is tonal like many Oriental tongues, the Navajo probably migrated from the Pacific Northwest. From the Spanish the Navajo got sheep and horses, becoming famous sheepherders and raiders. They were finally subdued only by Kit Carson, no less, during the Civil War, after which they were released to occupy reservations in northeast Arizona, northwest New Mexico, and southeast Utah, now totaling some 15 million acres.

A Navajo child's blanket collected by William Randolph Hearst *(Natural History Museum of Los Angeles County)*

From the Pueblo Indians the Navajo took over a lifestyle and cultural forms which they infused with their own spirit. Sand-painting, using colored sands and vegetable pigments, is part of a "curing" ceremony to restore the individual's harmony with the universe, sort of a "powerful magic prayer." These traditional creations, made on the floor of the *hogan* (a circular, slightly domed log and earth house unique to the Navajo) used to be destroyed immediately after use, but in recent years sand paintings on boards have been made for sale to tourists.

Weaving is another skill the Navajo acquired from the Pueblo, surpassing their teachers to become the outstanding weavers of North America. Navajo rugs or blankets (made mostly by women on upright looms built to the size of each weaving) have become collector's items. Tony Berlant, one of the great collectors, divides Navajo blankets into three basic styles: the striped, which the Navajo copied from the Pueblo, the chief's blanket, and the serape. Taking pride of place is the chief's blanket design, not

just for chiefs but so expensive that ownership was associated with high status. (Many examples in museum collections today were owned by Plains Indian chiefs.) The only Navajo weaving in which the warp runs the width rather than the length, the chief's blanket features horizontal stripes in red, white, and blue-black, sometimes with rectangular blocks within the stripes or diamond motifs. The serape, based on Spanish and Mexican precedents, also includes stripes and diamonds but has a central medallion with an opening for the neck.

Another type of Navajo blanket is the Ganado, named after one of the trading posts that are important in Navajo life. The Ganado is predominantly a deep red, with bold designs such as diamonds, triangles, zigzags, and chevrons. Yet another distinctive type is the Eyedazzler, composed of myriad small, stepped diamonds woven in the brightly colored, commercially dyed yarns which became available to the Navajo in the late 19th century. (Saxony and Germantown blankets are named after commercial yarns from Germany and Pennsylvania. Germantown blankets were mostly made for trade.) Finally, a small but distinct sub-genre of Navajo weaving (this predominantly by men) features the stick-like "Yeh" figures from the sand paintings.

(Incidentally, Navajo blankets were initially made for wear. It was only during their internment in the Civil War era that the Navajo adopted from Yankee settlers a "prairie" style of dress featuring calico, gingham, and velvet.)

Last of the great Navajo arts, learned from the Mexicans in the late 19th century, is silversmithing. Navajo silver differs from that of the neighboring Pueblo Indians in that shapes are bolder and more massive, often featuring large pieces of turquoise in their natural, irregular form. Typical Navajo jewelry in silver and turquoise includes the squash blossom necklace, possibly copied from a Mexican bridle ornament, and the concha belt of silver disks connected by leather. *Concha* is Spanish for shell, but some believe the Navajo copied the shape from the Plains Indians who acquired it from the French. Such are the complicated lines of cultural inheritance which have made Navajo crafts (which from the beginning served as a form of currency, savings, or investment) highly prized throughout the world.

There is some dispute over the origin of the word *Navajo*. Two possible sources are the Tewa Indian word for "cultivated fields," and the Spanish expression for "thief." Either way, the name was imposed by outsiders. The Navajo call themselves *Dineh*, or the "people."

There are lots of picture books, at varying levels of sophistication and quality, about the Navajo and their arts. The writer's favorite is *Walk in Beauty: The Navajo and Their Blankets*, by Anthony Berlant and Mary Hunt Kahlenberg.

NEO-GEO

A fad rather than a style, neo-geo provides an instructive example of the politics of style, the sniping and posturing that occur at the leading edge of the avant-garde. Short for neo-geometric conceptualism, neo-geo was a mid-1980s American reprise of surrealism's "readymades," factory- or mass-produced forms. A row of "Star Wars" dolls or other kitsch consumer fetishes (never mind that these are seldom geometric) became "sculptural material" in the hands of this group, which challenged minimalism for stylistic hegemony.

Proponents of neo-geo describe it as cool, unemotional, fresh, and cheerful, but all agree that its self-marketing was aggressive. Kenneth Baker, theorist and apologist of minimalism, is scathing in his criticism of the new movement encroaching on his territory. According to Baker, neo-geo "discredit[s] all acts of observation except those that issue in a knowing smirk," appropriating objects as accessories to a private "agenda of profit or social control."

In any case, a 1987 exhibit of neo-geo in London was a flop, apparently burying the movement even though the artists associated with it (Peter Halley, Meyer Vaisman, and Jeff Koons are most frequently mentioned) remained active.

Another sector of the populace knows neo-geo as the name of a computer game, widely available in convenience stores.

NEOLITHIC

The key factor differentiating the Neolithic or New Stone Age from its predecessor, the Paleolithic or Old Stone Age, is the use of polished rather than chipped stone implements. But Neolithic also signifies a whole cluster of more advanced socio-economic characteristics. These include the transition from hunting and gathering to agriculture and animal husbandry, and the settlement of villages where such crafts as pottery and weaving are developed. Religion also begins to evolve; the Neolithic practice of burying the dead with objects for use indicates belief in an afterlife. Above all, as archeologist Gordon Childe points out, the Neolithic signals a new aggressiveness toward the environment, man as an actor in nature rather than a parasite on it.

The Neolithic occurred at different times in different places, beginning at the end of the last ice age (possibly hastened by climatic change) in southwest Asia between 8000 and 6000 B.C. It reached its peak in Mesopotamia and Egypt between 6000 and 2000 B.C., giving way in some places by 3500 B.C. to its successor, the Bronze Age, which is characterized by the development of urban centers, writing, and metal tools.

Elsewhere, Neolithic cultures survived into the modern era. North American Indians were considered typically Neolithic at the time the conquistadors arrived to speed up and in some ways distort their further development. To the south, although the Maya and the Aztec had some form of writing and urban centers, they are generally considered Neolithic because their great monuments were constructed by Stone Age methods, without the use of metal tools or the wheel. (Sometimes scholars describe the Aztec as economically Neolithic but politically Bronze Age.) Inca culture, on the other hand, ranks as Bronze Age, thanks to more advanced metal-working techniques.

There are surviving Neolithic cultures even today, in such remote corners of the earth as Polynesia and the Arctic. The Eskimos, for one, devised an interesting Neolithic adaption to extreme cold, burning blubber as fuel. Although these cultures have been more or less contaminated by contact with modern technology, they point the way back to a more harmonious relationship with the environment. Another way of looking at it would be that the Neolithic, when man first began to clear the forests and take control of the earth, was the beginning of the end for the ecology of our world.

Carleton S. Coon's *The Story of Man* is dated but still readable. Another old classic is V. Gordon Childe's *What Happened in History*.

NEW AGE

Psychoanalysis is out. The Reverend Moon was removed to prison for tax evasion, and the Maharishi (founder of the once popular TM movement) was forced into exile. Est-style encounter groups have gone with the wind, and one doesn't hear much any longer about rolfing, or spiritual massage. But the dead are alive and talking, thanks to a new vogue for channeling and past-life regression, and there is keen interest in new forms of energy and extrasensory perception.

It's called New Age, and it has evolved by a process of recombination out of the 1960s counterculture, the "Age of Aquarius" and the Human Potential Movement. New Age includes a great cultural grab bag of ingredients, some old (Nostradamus, Edgar Cayce, fire walking), some new (aromatherapy, whole-brain thinking, rebirthing, mystical baseball, alternative orthodontics). What Dale Carnegie used to call positive thinking now goes under the name of neuro-linguistic programming. Borrowing is frequent—from Eastern religions and occultism, for example—and indiscriminate, with the result that non-Buddhists practice Zen meditation and non-Hindus talk about clearing their *chakras*. New Age common denominators are optimism, heightened consciousness, wholeness within and without, and energy, some varieties of which are odic force, orgone energy, and astral projection (the latter a borrowing from Theosophy).

Libraries and bookstores carry an amazing range of titles in the New Age section: *Spiritual Parenting in the New Age*; *The Tao of Selling*; *A Traveler's Guide to Mystical Landmarks*; *The Art of the Intuitive Lifestyle*. Esotericists Gurdjieff, Ouspensky, and Velikovsky are enjoying a new run, as are Carlos Castaneda with his Latin American sorcery and Linda Goodman with her sun signs. Actress Shirley MacLaine is well-represented with a four-volume boxed set of tell-all memoirs on her spiritual strivings and extramarital affairs. Books on numerology, graphology, telepathy, psychokinesis, vibrational medicine, and crystal healing are gathered under the New Age umbrella. There is also a New Age music, something of a cross between bluegrass and jazz improvisation, and a New Age lecture circuit and TV programming, both prominently featuring the Shirley MacLaine school of metaphysics.

Two key New Age books are *The Aquarian Conspiracy* (1980) by Marilyn Ferguson, and *The Mayan Factor* (1987) by José Arguelles. Ferguson is of interest because of her skill at recombining past and current events in New Age jargon and format. Arguelles's book was the source of the "Harmonic Convergence," a sort of watershed New Age be-in in 1987. Arguing that the Maya were extraterrestrials who abandoned the earth because humanity was doomed, Arguelles urged "sun-dancers" to gather at the world's "geocosmic nodes" (which include Niagara Falls and Chaco Canyon in New Mexico) to welcome a new age. Arguelles predicted among other things a rain of UFOs, but it turned out to be a happening at which nothing much happened. (Skeptic Garry Trudeau dubbed it the "moronic convergence.")

New Age differentiates itself from the 1960s counterculture by eschewing drugs for a healthy lifestyle. Holistic medicine is a New Age rage (actually holistic everything—there is holistic accounting, even holistic health for pets), and "toxicity" a major concern, with remedies such as herbal enemas doing a big business. (What used to be called "high colonics" is back, now known as colon hydrotherapy.) On the downside, New Age optimists have fallen victim to a good number of snake oil salesmen and scams, such as a 1987 pyramid scheme called "The Airplane Game."

Some consider New Age a millenarian response to fin-de-siècle fears of death, aging, and apocalypse. Less sympathetic critics call the movement an intellectually insidious mixture of science and fiction. Writer Christopher Lasch places New Age in the mainstream of cultural narcissism, or living for oneself and the moment. Since people seem to be powerless to affect important issues like war, pollution, or crime, Lasch says, they have turned instead to psychic phenomena and self-improvement. Certainly New Age is profoundly ahistorical and decidedly apolitical. Why bother to vote or to march, Robert Basil remarks in *Not Necessarily the New Age*, if all suffering is an illusion and one is going to be reincarnated anyway, or rescued by extraterrestrials?

The library periodicals index lists under New Age a large number of negative articles generated by two surprising sectors, mainstream religion and the publishing industry. On second thought, the threat to religion is obvious: New Age with its spiritual pretensions may be the biggest challenge to organized religion since the Reformation and the Enlightenment. And the publishing industry is concerned, naturally, because many of those titles in the bookstore are do-it-yourself or desk-top publishing ventures that have paid off handsomely.

The curious who would like to know more should see the above books by Arguelles and Ferguson. *Not Necessarily the New Age: Critical Essays* (Robert Basil, ed.) takes a sympathetic but skeptical view of the subject, as does Michael D'Antonio's *Heaven on Earth: Dispatches from America's Spiritual Frontier*.

NEW OBJECTIVITY

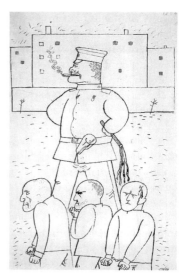

In this last phase of German expressionism, called *Neue Sachlichkeit* or New Objectivity, the deep scars on the human psyche caused by the nightmare and chaos of World War I were graphically portrayed. Like expressionism in general, New Objectivity relied on shock techniques, rendered in a more muted palette with greater detail. Despite the name, it was not more objective, merely more realistic (in the sense of verist, surreal, or even magic realism) or representational, a highly concentrated version of reality with a cynical, vitriolic twist. Typical New Objectivity subjects were whores, cripples, criminals, and beggars, portrayed in full physical disability and moral and emotional lassitude.

The leading artists of the New Objectivity were Otto Dix and George Grosz, who created savage caricatures of profiteers and plutocrats, lecherous officers and mutilated soldiers—so

George Grosz's *L'Etat C'est Moi: Die Vollendete Demokratie* (1919) *(Los Angeles County Museum of Art)*

shocking that both were legally tried for offending German morality and modesty (Dix was acquitted, Grosz fined). The final stage of New Objectivity was dominated by Max Beckmann, whose neoclassical and religious portraits and triptychs are crowded with powerful raw forms and enigmatic symbols.

NORMAN

Medieval historian Henry Adams called them the 12th-century masters of the world, these Viking adventurers who settled in Normandy in 911 and a mere 150 years later conquered the far larger and richer kingdom of England. In Normandy they converted to Christianity and established scores of monasteries (the most famous is at Mont Saint-Michel) which became progressive centers of education, welfare, and agriculture. Within a generation in England the invaders had "normanized" the Anglo-Saxons, according to R. Allen Brown, transplanting the romantic feudal values of their warrior aristocracy. Builders and patrons of the arts, they introduced the castle into England (the most efficient way to dominate a given area with a minimum of manpower) and built and rebuilt churches in the northern Romanesque style we call Norman, massive, serious, and simple, its characteristic round arches double- and triple-molded with chevron bands and scalloping. The Norman cathedral at Durham, England, which is considered one of the great architectural experi-

Portal of Issley Church (c. 1120), Oxfordshire, England

ences of the world, is a key transition to the Gothic. For a more accessible example of Norman architecture at its simple best, visit the Tower of London, a rectangular keep containing a perfectly beautiful chapel.

Even before their conquest of England in 1066, the Norman spirit of wanderlust, daring, and land hunger had driven them south to Italy and Sicily, where they established fiefdoms, castles, and churches displaying Byzantine, Islamic, and Romanesque influences. Here they were well positioned for their last great adventure, the Crusades, in which they played a leading role. As political scientist Ernest Barker puts it in *The Legacy of Islam* (Thomas Arnold, ed.), the Crusades offered a solution to the problem of feudal overpopulation. At least six of the 12 sons of a petty Norman knight named Tancred de Hauteville had already left Normandy to seek their fortunes in Italy when they and their offspring became leaders of the Crusades. En route from Europe to liberate the Holy Land, Normans established another principality at Antioch, and a string of their castellated castles, parts of which survive to this day.

The American version of Norman architecture is found in affluent suburbs, such as the Newbold Estate (1924–25) outside Philadelphia, modeled after a farm complex in Normandy.

R. Allen Brown's *The Normans* is a good introduction, nicely illustrated with photos and scenes from the Bayeux Tapestry.

. . .obedience, bane of all genius. . . .

P. B. Shelley

OLMEC

Anthropologist and artist Miguel Covarrubias calls them Mexico's "mother culture," reaching as far back as 1600 B.C. Their name means "dwellers in the land of rubber," the rain forests and tropical lowlands of Mexico's Gulf Coast, where they developed an agrarian society with sophisticated drainage systems.

The Olmec were great sculptors, best known for their colossal heads carved in basalt that weigh up to 25 tons each. Eighteen of these have been discovered so far (and there may be more lurking in the dense tropical jungle), all men with Mongoloid features wearing helmets on their great square heads. The Olmec also carved altar stones or *stelae* in relief, again like the Maya, and small-scale statuettes in jade and clay, including types called "tiger-face" and "baby face." Miniature replicas of these are common tourist

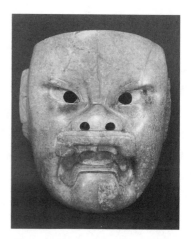

Jadite mask (1200-300 B.C.) showing the animal-like features typical of much Olmec work *(Dumbarton Oaks, Trustees of Harvard University)*

items and enjoyed a vogue during the hippie era, ironically playing a pivotal role in Patty Hearst's conviction for bank robbery. The jury did not believe Hearst's claim that she kept the gift of an Olmec head from one of her kidnappers for artistic rather than sentimental reasons.

Covarrubias calls the Olmec "highly intellectual sorcerers," obsessed with feline spirits. Another of their favorite motifs was the jaguar, anthropomorphically represented. The five dots and a dash of their numerical system are even said to be patterned after the jaguar's paw.

The Eagle, the Jaguar, and the Serpent by Miguel Covarrubias is a seminal work. See also Roman Pina-Chan's *The Olmec: Mother Culture of Mesoamerica*.

OP ART

Vibrating colors and pulsating patterns, forms and images which seem to expand and contract, appear and disappear—this is op art, a short-lived movement in the 1960s. Popularly supposed to have been an outgrowth of pop art, which it succeeded and with which it shared enamel-smooth surfaces and precise forms, op art actually goes back to impressionism and postimpressionism, particularly to the pioneering work of Georges Seurat who let the eye fuse the colors rather than mixing them himself on the palette. (Experts also see traces of constructivism, transmitted via Bauhaus, and so on.)

In theory, op art explores the discrepancy between physical fact and psychic effect. Its practitioners (Josef Albers, Victor Vasarely, Ad Reinhardt, Richard Anuszkiewicz; Frank Stella is also sometimes included) tend to talk about stripping art of all but perceptual associations. But precisely because one's perceptual response was involuntary, many were left with the suspicion that this was all a big trick. Wags even suggested a warning label: this art may cause dizziness, headache; or the hangover is merely an after-image. *Op art* became a household word in America, enshrined in the popular media, but lapsed into artistic oblivion shortly after peaking in a 1965 Museum of Modern Art exhibit. (Op art techniques, however, continued in the psychedelic poster art of the hippie era.)

The catalog of the MOMA exhibit, *The Responsive Eye* by William Seitz, is recommended.

ORREFORS

This Swedish glass factory, established in 1898, began by producing ink and milk bottles, and window panes. Only after 1915 did Orrefors attempt art glass, first using a so-called "Graal technique" of superimposing colored layers, then etching or carving in relief on classically shaped forms. In the 1920s the Swedish glass house specialized in working embedded air bubbles into modernist designs, and after World War II it offered heavy "Ravenna" glass with inlaid nonfigurative patterns.

Orrefors is known today for bold thick vases in what Americans call "Scandinavian modern" style. These are available (according to the manufacturer's ads in glitzy design magazines) only at the better retail stores, coming in at about $140 for an eight-inch vase.

Periods rub off on the men who pass through them.

Honoré de Balzac

PALEOLITHIC

As late as the 19th century, when universal history was first broken down into ancient, medieval, and modern, with everything before designated as "pre-history," scholars were at a loss to explain the crude stone implements turned up every so often by farmers ploughing their fields or hikers exploring caves. Some even called these stones "thunderbolts," or "fairy arrows," left by such mythical ancestors as the Druids at some time before biblical creation (then reckoned at 4004 B.C.).

Gradually, as the tools of geology and archeology were refined, and particularly thanks to radiocarbon dating (an offshoot of World War II atomic physics), historians came to a better understanding of the great eons of time involved. By 1900, prehistory and ancient history were further divided into Stone Age and Bronze Age, each with its own periods and epochs.

The Paleolithic or Old Stone Age is reckoned to have begun anywhere from several hundred thousand to millions of years ago. During this extensive period man evolved from an apelike creature to *Australopithecus*, Neanderthal, and finally *homo sapiens*, a hunter using stone tools chipped to create a cutting edge.

The vast Paleolithic period is divided by specialists into lower, middle, and upper phases (generally, lower was pre-clan society, while upper was matriarchal) and into cultures such as the Aurignacian, Périgordian, and Magdalenian. It was in the upper

Magdalenian era that Paleolithic culture reached its greatest expression in the naturalistic cave drawings and carvings of southwestern Europe. To date, about 200 of these caves have been found, beginning in 1880 at Altamira, Spain, with another major find occurring in 1940 at Lascaux, France.

Depicting primarily hunting scenes—a whole prehistoric carnival of the animals—Paleolithic cave drawings have been variously interpreted as "sympathetic hunting magic," or religion to aid early man in catching his supper; also as interior decor, totemism, even art for art's sake. The problem is that we have little but bones and tools to go on. Correlating tools with lifestyle, Paleolithic society is considered savage, based on hunting, fishing, and gathering, with (barbarian) agriculture developing only in the Neolithic or New Stone Age and literacy in the Bronze Age. Paleolithic art, however, reached a peak that would not be surpassed for thousands of years.

The Mesolithic or Middle Stone Age that followed the Paleolithic, running from about 10,000 to 3000 B.C., is little more than a transition, distinguished chiefly by kitchen middens and the use of bows and arrows. Because of melting of the glaciers, this was a time of famine and population decline.

Radical anthropologist Marvin Harris (writing in *Cannibals and Kings*) believes that Paleolithic man was not so badly off, comparatively speaking, needing only a few hours a day to meet his food and shelter requirements. He therefore enjoyed greater leisure and freedom than more "civilized" descendants, particularly the wage slaves of the Industrial Revolution. Social historian of art Arnold Hauser relates Paleolithic naturalism to individualism and a certain social anarchy, while correlating Neolithic geometrism with a tendency to conformity.

The Idea of Prehistory by Glyn Daniel and Colin Renfrew is an interesting short review of changing fads and fashions in the study of early man. On Paleolithic art, see Ann Sieveking's *The Cave Artists*.

PALLADIAN

Andrea Palladio, one of a few architects whose name has come down in history to epitomize a style, specialized in grafting classical temple forms onto private homes and small churches. These were also designed with an eye to the landscape, meaning the area around Vicenza, Italy (south of Venice), where Palladio created elegant villas for the titled country gentlemen of his day. Palladian is rather chaste and economical compared to mannerist and baroque styles prevailing in architecture in the 16th and 17th centuries. That those styles were primarily Roman Catholic may have something to do with Palladio's popularity (as an alternative) in Protestant countries—England, Holland, and the new American colonies. Most frequently imitated were Palladio's "three-part plan," consisting of a tall colonnaded entrance flanked by two lower wings, and his "five-part plan," the same with blocks of intermediate height on the ends. Also, to this day a three-part window with an arched central pane—common in the United States to Queen Anne, Greek revival, and other styles—is called a Palladian window.

Palladio's fame spread thanks to his writings on architecture, which went through numerous editions to become one of the most important works in architectural history, an indispensable part of any gentleman's library. Two American gentlemen whose libraries included Palladio's works were George Washington and Thomas Jefferson. In fact, when

Jefferson remodeled Monticello (originally begun in the 1770s in a Georgian style) at the turn of the century, he borrowed Palladio's rotunda and one of his nine models of a double portico. Jefferson had great difficulty, however, reproducing Doric columns, since Virginia lacked stone as well as stonemasons; the final columns were jury-rigged by an indentured servant out of brick stuccoed to look like stone, but nobody seemed to notice. Monticello is often compared to a Palladian villa near Vicenza, La Rotunda, itself inspired by the Roman Pantheon; La Rotunda also served as the model for Chiswick House outside London, Marly in France, and many more buildings. (Inside, however, Jefferson decorated his home in traditional English country style, presumably cozier than living in the average classical temple.)

For Jefferson, Palladio seemed to offer the simplest available path through the baroque, which he hated, back to the classical. Later, after visiting Nîmes, France, Jefferson was inspired by the beautifully preserved Roman temple there to go straight back to the original classical models, instead of detouring via Palladio, for his Virginia state capitol. Perhaps he also intuited that the Palladian style, in Virginia as well as Italy, was associated with a privileged *latifundia* or plantation society which would soon become obsolete.

The most famous Palladian survival in the United States is the north portico of the White House. The serious student of Palladio must travel to northern Italy, where several of the master's villas were made more accessible to the public for the 400th anniversary of his death.

Desmond Guinness and Julius Trousdale Sadler wrote *Palladio: A Western Progress*. See also Jack McLaughlin's *Jefferson and Monticello*, the biography of an American Palladian building.

PENTECOSTALISM

On December 31, 1900, the Holy Spirit descended upon a small Bible college in Topeka, Kansas, where founder Charles F. Parham was trying to educate missionaries able to communicate in foreign languages. As if in answer to his prayers, students burst forth on this last night of the old century in a great variety of languages, somehow identified as Bulgarian, Norwegian, and Chinese dialects. Many account this as the beginning of the modern American Pentecostal movement (Pentecost or Whitsunday commemorates the event seven weeks after Easter when Christ's disciples began to speak in tongues), itself an outgrowth of American Revivalism, fundamentalism, and general fin-de-siècle millenarianism.

Pentecostals share with fundamentalists their belief in scriptural infallibility, the virgin birth, and the impending second coming, as well as a certain scorn for scholarship and intellect. Like Revivalists, they practice a religion of exaltation, praying with their arms uplifted, shouting, dancing, and giving testimony in a relatively unstructured, informal, spontaneous service. But Pentecostals put greater emphasis on healing, and on speaking in tongues as evidence of baptism in the Holy Spirit. Also known as glossolalia, speaking in tongues is defined as strings of syllables unmatched with a semantic system, or as a meditative, nonrational form of prayer ("strangely akin to the new jazz scat-singing," writer Hillel Schwartz remarks in *Century's End* of the languages spoken by Parham's students in Kansas). In any case, this is definitely "low church"; such

"holy rolling" is considered undignified if not hysterical by more upscale denominations, which tend to forbid such thrills.

Pentecostalism has from the beginning provided a forum for enterprising charismatic preachers. (In fact, the same groups are sometimes called charismatics.) In the first generation these included William Seymour of the Azusa Street Mission in Los Angeles, and Aimee Semple McPherson, who founded her own Church of the Foursquare Gospel, also in Los Angeles. Some more recent leaders of the movement were Kathryn Kuhlman with her healing sessions in Los Angeles's Shrine Auditorium, Oral Roberts, who founded his own university in Tulsa and converted to Methodism for greater mainline appeal, the Reverend Ike with his gospel of prosperity, gospel recording star Jimmy Swaggart from Louisiana, and Jim Bakker of PTL infamy.

By 1949 the Pentecostal movement was claiming a million followers in the United States, scattered among various denominations. (Some call the movement trans-denominational; there are even Catholic Pentecostals.) The three main groups are the Church of God and the Pentecostal Holiness Church, both of which grew out of Methodist roots, and the Assemblies of God, of Baptist and Presbyterian provenance. Pentecostal groups differ somewhat in beliefs and observances: the Church of God, for example, practices footwashing; the Pentecostal Holiness Church offers baptism by immersion (as distinct from or opposed to baptism in spirit); and the United Pentecostal Church is Unitarian in dogma.

The fastest growing Christian movement in the world after 1945, the American Pentecostal movement became increasingly fashionable in the 1970s—and profitable, with the establishment of great empires of televangelism. These all seem to have come to grief simultaneously in the late 1980s, bedeviled and discredited by sex scandals and financial improprieties. The great new frontier for Pentecostalism is now considered to be Mexico and Latin America.

There are at least two serious studies of American Pentecostalism at its apogee: *All Things Are Possible* by David Edwin Harrell and *The New Charismatics* by Richard Quebedeaux.

PERFORMANCE ART

Remember the topless cellist? Or perhaps you heard about the California student who shut himself in a locker for five days in partial fulfillment of his master's degree in art? Then there is "Guadalcanal Requiem," to be performed atop a tank in the Solomon Islands.

This is the realm of performance art, a medium (actually mixed-media) rather than a style, quite frequently a challenge to style. It is also called body art, theater of life, interactive art, "nonmatrixed representation," or self-experience. At its most basic, the artist exhibits her or himself, becoming both the subject and object of the work—which is usually but not always a one-time, ephemeral happening, like an accident, designed to get art out of the museums, to set ideas in action.

Performance artists cite as their forerunners Leonardo da Vinci with his Renaissance pageants and Bernini's baroque extravaganzas; dada and futurist happenings; Gertrude Stein and the literature of free association in the 1920s; Allen Ginsberg disrobing to declaim his own poetry during the beat generation; John Cage's aleatory music. For

contemporary performance artists, the 1970s (which really began in 1968) were their golden age. Typical of this early period was Vito Acconci, who in 1969 began a series of "Followings," randomly picking out total strangers to follow in the street, FBI-style. Then Acconci graduated to "Conversions," or sex-change exercises in which he burnt his chest hair and hid his penis between his legs—the epitome of "body art," which often involved pain, danger, nudity, sex, and masochism.

By the mid-1970s performance art was becoming more sophisticated, more reliant on electronics, more inclined to seek substantiality and permanence in more conventional venues. Some performance artists even made the crossover into high or popular culture: Robert Wilson and Philip Glass's minimalist *Einstein on the Beach* was performed at the Metropolitan Opera in 1975 (with unusually sophisticated stage settings), to the incomprehension if not indignation of many operagoers, and Laurie Anderson, after a song of hers hit the charts in 1981, was signed to a Warner Brothers recording contract. There was also a movement in the opposite direction, with more established artists such as Yoko Ono and William Burroughs crossing over into performance art.

The Art of Performance: A Critical Anthology (Gregory Battcock and Robert Nickas, eds.) is a crazy salad, containing much food for thought.

PERSIAN RUGS

Unlike Turkish rugs with their rectilinear designs, Persian rugs are characterized by another manner of weaving, an asymmetrical knot (called *sehna*) permitting more curvilinear and naturalistic designs including flowers and animals. The distinctive knot, and a greater number of knots per square inch, combine to produce greater subtlety and delicacy of detail, which along with the soft, rich colors constitute the hallmarks of the Persian rug.

The most "primitive" Persian rugs are made by nomadic tribesmen, while the most sophisticated are produced in commercial workshops. Among the first group is the Bakhtiari, named for a tribe making an arduous seasonal migration. There are numerous basic Bakhtiari designs, including mosaic patterns and panels of different colored scenes, with red, blue, green, and ivory as the predominant colors.

The Shiraz is another Persian rug made by tribes in the region of the old and historic Persian town of that name. (Famous for its gardens, wines, and rugs, Shiraz was immortalized by the poet Omar Khayyam.) Because of the complex tribal composition of the area, there are a wide variety of rug motifs in use. One common Shiraz design is a pole medallion with flowers and birds scattered in a dark red center field. Also typical are rosette patterns, vases and pears, often with a unique checkerboard design at the ends of the rug.

The Bijar is a Persian carpet made with a Turkish knot, for the weavers are Kurds and Afshars working in the same tradition as their kin to the west in Turkey. Historically stateless, the Kurds use a variety of Turkish and Persian design motifs, even an occasional rose copied from a French tapestry. (Typical of such cottage industry products, curvilinear forms such as flowers tend to angular stylization.) Bijar rugs are known for being very thick and tightly woven (they are knotted when wet), so durable that many older ones survive—fortunately, since war, famine, and natural disaster continue to beset this group of weavers.

Baluchis are named after and also made by a large nomadic and widely dispersed tribe that ranges from the historic area around Mashad as far as Afghanistan. Traditional Baluchis live in black tents and use a primitive horizontal loom, producing mainly small and prayer-type rugs in simple rectilinear designs. The predominant color is a dark purplish red, and the ends of the rug may be Kilim-style or pileless. Never very popular in the United States because of their dark color, Baluchis tend to be relatively inexpensive, a best buy per expert Carolyn Bosly.

Of the more sophisticated Persian rugs produced in workshops, the Feraghan with a center medallion or overall pattern of flowers and trees has become a collector's item, no longer made since around 1900. Other famous antique rugs come from Kashan, an old Persian city on the caravan route to India (whence the Three Magi left for Bethlehem, according to legend). Kashan rug production died out at the end of the 18th century

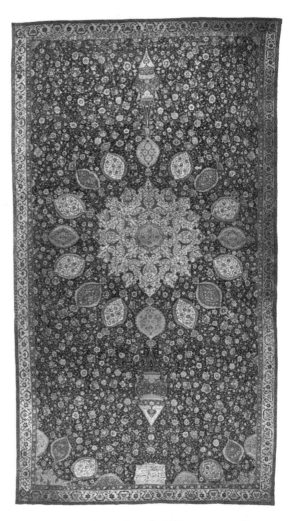

From the Safavid period, an Ardebil carpet, an object lesson in the difficulty of identifying Persian rugs
(Los Angeles County Museum of Art)

but was revived with modern marketing techniques and imported merino wool in the 19th century. Kashans are known for their handsome proportions, rich colors (chiefly red and blue), and high quality. Designs include all-over floral, with elegant leaf and spray patterns in the corners, or center medallions.

Kirman is another historic Persian carpet-making center where production died out but was resumed in the 19th century. The classic Kirman has a center medallion and corner fields, although all typical Persian motifs are used. After World War II local production adapted for export, turning out lighter pastels and an especially thick pile for the American market. Another Persian rug specially adapted for American consumption was the Sarouk, once popular thanks to special promotional sales by New York and

Chicago department stores. Sears, Roebuck and Company even produced its own "American Sarouk," with runners priced at $10.99 per foot in the last Sears catalog.

In his excellent study on Oriental carpets, P. R. J. Ford includes a photo of a mosque in Isfahan, the splendid blue-and-gold tiles of which bear a family resemblance to the rugs from this central Persian city. Very finely woven, synonymous with nobility and prestige, many antique Isfahans are found today in museum and royal collections. Most typical is a floral medallion, but vase, animal, and hunting motifs are also used, as well as a palmetto design named for the famous 16th-century rug patron Shah Abbas.

Another commercial weaving center in northwest Persia is Tabriz, strategically located on the crossroads to Turkey and the Caucasus. Local weavers, who work with a special hook for making knots in the Turkish fashion, are considered among the most skilled in Iran. Large numbers of Tabriz carpets have generally been available in the West, barring war and other dislocations, at relatively high prices because of their durability. (Cheaper copies of Tabriz designs are also made in Romania and Bulgaria.) In recent years, unfortunately, Tabriz has become sort of a knock-off center for rugs of all types, including kitsch creations featuring portraits of celebrities like John F. Kennedy.

The difficulty of distinguishing among the various Persian styles and production centers is exemplified by the case of the famous Ardebil carpets, masterpieces of the elaborate floral type. One Ardebil carpet is now in London's Victoria and Albert Museum, the other in the Los Angeles County Museum of Art. Originally produced for a shrine at Ardebil (hence the name), the rug is identified by Los Angeles curators as a Tabriz (despite its Persian knot) and by their English counterparts as a Kashan, based on a woven inscription. Or could it be an Isfahan? Ford advises that an Isfahan can be distinguished from a Tabriz by its Persian knot and from a Kashan by pattern (the symmetrical Isfahan medallion has up to 16 facets and may be surrounded by palmetto motifs) and color (bright; usually with a blue border). Then you have to factor in historical issues, such as strife disrupting Tabriz rug production at the time the rug was presumably woven.

A current international favorite among rug buffs is the Heriz from northwestern Persia, featuring unusually angular (for Persia) designs with a center medallion. These predominantly brownish-red, blue, and ivory rugs used to be made in special large sizes and durable grades for American hotel lobbies; after World War II, the style became so popular among German collectors that they reimported old American hotel castoffs. As a measure of current growing demand, India and Romania are now producing copies of the Heriz. A variant of the Heriz is the Serapi, featuring a petal-formed medallion with different colored spandrels. According to the posh rug magazine *Hali*, shock-rock singer Madonna recently bought three Serapis for $750,000.

There is no better book on this rich subject than P. R. J. Ford's *Oriental Carpet Design*. For backup, see also Erwin Gans-Ruedin's *Modern Oriental Carpets* and *The Persian Carpet* by A. Cecil Edwards.

PLATERESQUE

This term, meaning *silversmith-like*, applies to the elaborate Spanish Renaissance system of architectural ornamentation, plaster or wood molded in strips like silver and applied to otherwise bare walls. (Wrought-iron work is also sometimes said to be in this

style.) Scholars find Islamic and Hispano-Moresque influences in these sculptural arabesques and garlands, "opulent foliations" which typically appear on altars, portals, and window frames.

Plateresque came to the New World with the conquistadors and was an important design influence in the Spanish colonies. The cathedrals of Mexico City and Guadalajara, Lima, Cuzco, and Bogotá all show Plateresque elements. In North America, because of a longer time-lag in cultural transmission, it is often difficult to distinguish Plateresque from its later baroque incarnation called Churrigueresque. Thus while the mission churches of San José in San Antonio, Texas, and of San Xavier del Bac south of Tucson belong date-wise (early 18th century) to the baroque, their sculptural ornamentation—sometimes called naive Churrigueresque—might also be considered delayed Plateresque.

There is also a Portuguese Plateresque style called "Manueline" after King Manuel I who reigned from 1495 to 1521, the great age of Portuguese navigation and exploration. The Manueline style, featuring emblems and a cornucopia of twisted vegetable forms, was carried to Portugal's colonies in East India and the Americas.

PLATONIC or PLATONISM

In common parlance, "platonic" means a relationship between men and women in which sex is excluded—a definition related in only a roundabout way to the philosophic meaning of platonism. Plato is of course the Greek philosopher who wrote down the dialogues of Socrates and gave us in his *Republic* a whole cornucopia of ideas, from philosopher-king to truth and beauty, might and right, communism, feminism, eugenics, vegetarianism, even free love. The common denominator here is *idea*, defined by Plato as an eternal, innate truth after which all things are fashioned. In philosophy, platonism is the knowledge of ideas, achieved by reasoning rather than by experience or observation (as shown by Plato's parable of the prisoners in the dark cave who see only their own shadows, until one escapes into the [sun]light of truth).

Plato wrote so beautifully that his works have remained classics of world literature. In a narrower sense, his theory of ideas (which was opposed by his student Aristotle, the first materialist) was revived as neo-platonism in the 17th century. But to return to the question of platonic—could it be derived from the perfect idea of a spiritual love? In fact, scholars say that the common usage of the word is based on a misunderstanding of Plato's *Symposium*, where the subject is really the love of Socrates, not exactly pure and disinterested, for young men.

PLEISTOCENE

Geologists divide time into eras (Precambrian, Paleozoic, Mesozoic, and Cenozoic), then into periods (the Jurassic, as in Michael Crichton's recent novel about dinosaur culture, is the middle period of the Mesozoic era, named for Europe's Jura Mountains) and epochs. Of all these divisions, the most dramatic and significant to us is the Pleistocene (meaning *most recent*) or great ice age, when huge sheets of ice and glaciers covered a good part of the earth's surface. Apparently there was not one single ice age but four or five, with warmer "interglacial" periods in between. The penultimate epoch of the Cenozoic era, dating from millions of years ago to 10,000 B.C., the Pleistocene was when modern man first appeared, presumably stimulated by changing climatic condi-

tions to make important adaptions. (The Paleolithic or Old Stone Age, which overlaps with the Pleistocene, is an anthropological rather than a geological construct.)

Of Pleistocene skeletal remains, most are Neanderthal men. None has been found in North America to date. But this was certainly a very exciting time here, if anyone was around to witness it. The great ice sheets extended over Greenland and Canada to a line running roughly between Cape Cod, Massachusetts, and Washington State, with a separate glacier in the Rocky Mountains. Among the great spectacles that early Americans might have witnessed were the formation of the Grand Canyon, the creation of the Great Lakes by melting at the edge of the ice sheet, and the flooding of the Atlantic seaboard when depressed below sea level by the weight of the ice.

The American landscape may seem tame to you now, but just wait. Some geologists surmise that we are presently in another interglacial period, and that the great ice sheets may return.

John McPhee, a layman fascinated with geology, has written several books relating the science to the American landscape. See, for example, his *Basin and Range*.

POINTILLISM

Sometimes classified as "scientific" impressionism, neo-impressionism, postimpressionism, or divisionism, pointillism replaced the untidiness and haphazardry of the mother style with meticulously executed dots. The leader of the movement, Georges Seurat, drew on optical scholarship, spectral analysis, chemistry, and molecular physics in formulating his rather exacting procedures. Where formerly painters had mixed their colors on the palette, Seurat determined to let the eye do its own mixing. Of chief importance in his system was his law of simultaneous contrast, describing the influence of adjacent colors in making lights lighter, for example, or darks darker. Seurat also compiled a table of "complementaries," leaving nothing to chance or improvisation.

In practice, Seurat did preparatory studies using more expeditious (i.e., sloppy) impressionist-style brushstrokes, then a final canvas painstakingly compiled of his colored dots. His most famous painting, *A Sunday Afternoon on the Island of La Grande Jatte* (1885), a large tableau now in the Art Institute of Chicago, took over a year to complete. (This painting has recently been re-created even more painstakingly in topiary form in a public park in Columbus, Ohio.)

Seurat's main follower was Paul Signac, who specialized in brilliant juxtapositions and works named for musical compositions (*Adagio, Scherzo*), reflecting his belief that the laws of color harmony could be learned like musical harmony. The older impressionist Camille Pissarro tried Seurat's system for a few years but found all those dots a nervous strain, inhibiting to life and movement. After the premature death of Seurat and Signac's progression to more decorative techniques, pointillism became yet another, supplementary tool, used for example by the postimpressionist Edouard Vuillard for texture.

Media guru Marshall McLuhan noted that pointillist works bear a family resemblance to the modern wire-photo.

See John Rewald's encyclopedic studies of impressionism and postimpressionism.

POP ART

Around 1960, in reaction against the existential anxiety and high seriousness of abstract expressionism, a new "popular" style burst upon the art world, a distinctly American phenomenon completely outside the European fine arts tradition (unless dadaism, which was not primarily an art movement, is included). Drawing on our everyday inheritance from Madison Avenue, Hollywood, Detroit, and the dimestore, our billboards and comic strips, commercials and celebrities, pop art made icons out of the ordinary, a virtue out of slick commercial techniques of representation, a style out of banality.

Museum-quality cartoonery: Roy Lichtenstein's *Drowning Girl* (1963) *(Museum of Modern Art)*

"Cool, dead-pan, outrageous," pop art won instant recognition, overnight success, and a financial windfall for its acolytes. These include Jasper Johns with his paintings of American flags and archery targets; Andy Warhol, former commercial artist whose mass-produced silkscreen images of Marilyn and Chairman Mao, Campbell's Soup cans and Brillo boxes made him the "high priest of Pop"; Roy Lichtenstein with his giant dotted comic-strip panels; Claes Oldenburg, whose oeuvre includes monumental pneumatic hamburgers and giant phallic lipsticks; James Rosenquist, former billboard artist specializing in Bunyanesque-size canvases; and standing somewhat apart, sculptor George Segal who turned the human body, plaster-cast and engaged in everyday activities, into a found object.

Pop art's very ease of access has lent itself to somewhat facile theorizing. It has been called a flight from self-expression, a celebration of materialism, a visual play on themes of originality, authenticity, and replication. Warhol's multiple images, for example, are said to force viewers to delve into memory and fantasy for a unique personal meaning. Marco Livingstone writes of over-exposure to commercial imagery divesting it of emotion and giving it iconic power. Contemporary historian Tom Wolfe (in *The Painted Word*) philosophizes about signs and sign systems, camp and kitsch. Whatever the explanation, pop art ranks as the most popular and financially remunerative modern art movement of the 20th century, and a distinctively American one. British and German branches of the movement have a distinctly European accent, betraying ambivalence about this celebration of Americana.

Marco Livingstone's *Pop Art: A Continuing History* is handsomely illustrated and nicely written. The most comprehensive museum devoted to a single artist in the United States, the Andy Warhol Museum in Pittsburgh will feature the work of that artist who convinced the world that art could be easy, dumb, and effortless.

POPULISM

This is an American political concept whose time came and went a century ago, but seems to be enjoying a comeback. The problem is, in the meanwhile, we have apparently forgotten the meaning and context of populism—specifically, whether it was a movement of the left or right. You hear today of the right-wing populism of radio guru Rush Limbaugh with his diatribes against liberals and leftists. You may also come across references to Ronald Reagan's "pseudo-populism," or to the populist crusading of Jerry Brown, the former California governor and radical gadfly, clearly at the opposite end of the political spectrum from Reagan and Limbaugh.

The *Oxford English Dictionary* defines populism as the political doctrine of the populists or People's party. This was a movement of hard-pressed American farmers who organized in the 1890s to fight the so-called octopus of entrenched business and political interests. Of their demands—for railroad regulation and an income tax, against protective tariffs—the one that became the party's watchword and downfall was "free silver," or its unlimited coinage, as a panacea to agrarian problems. The populist movement captured the Democratic party in 1896 with the nomination for president of William Jennings Bryan, best remembered for his "cross of gold" speech. Bryan, who called the gold standard "a crown of thorns on the brow of labor," exemplified the complexity of populism: fundamentalism and demagoguery as vehicles for protest and reform.

Populism went down to defeat with Bryan in 1896, although many of its demands would be realized after the turn of the century by the progressive movement. The Depression and subsequent points of social and economic stress also spawned more so-called populists—with an increasing tendency to illiberalism, nativist demagoguery, jingoism and a conspiracy theory of history—all somehow harking back to the people as the source of legitimacy.

The U.S. press sometimes refers to Russian leader Boris Yeltsin as a populist, presumably for his demagogic skills as well as his successful resort to popular referendum— the "voice of the people."

The classic on the subject of American populism is Richard Hofstadter's *The Age of Reform: From Bryan to F. D. R.*

POSITIVISM

The French positivist philosopher Auguste Comte was an incurable Aristotelian who classified all the sciences in a comprehensive ascending scheme, from lesser to greater complexity. At the top of this scheme he placed the new science of man, which he named sociology. Comte also proposed a new religion of humanity, complete with sacraments and a calendar celebrating paragons of human progress (one was Benjamin Franklin, idolized by Comte as a modern Socrates) rather than pagan deities or medieval saints.

In a larger sense, positivism means respect for positives. In general usage, it may be synonymous with knowledge gained by experiment and observation rather than metaphysical speculation, and with responsibility for the general welfare.

Van Gogh's *Irises* (1889), which strongly resembles a Japanese screen motif

POSTIMPRESSIONISM

This is a grab bag for the painters who came of age around the time of the last impressionist exhibit in 1886, the men whose struggles (Van Gogh's with insanity, Gauguin's with poverty) dominate the history of art for the next 20 years. In general, postimpressionist art is in a higher color key, more intense and urgent in execution than impressionism. Where the impressionists had used the diffusion of light and hasty brushstrokes to deliberately break down if not deform objects represented, the postimpressionists restored some representational solidity by means of color, line, and texture. (The postimpressionist pointillists, who atomized color into myriad dots, would be an exception here.) Yet another successor group, the postpostimpressionists, including Pierre Bonnard and Edouard Vuillard (sometimes called the Nabis, from the Hebrew for *prophet*), hewed more narrowly to impressionist canons.

Picasso, Braque, and Matisse are also sometimes considered postimpressionists, thus rendering meaningless any sense of a common postimpressionist style. Only one thing is certain: from Van Gogh to Picasso, it is the postimpressionists who now command the all-time high prices at auction, arousing a positive feeding frenzy among bidders. As early as 1970, *Auction* magazine issued an LP recording of the bidding (which closed at $1.3 million) on Van Gogh's *Cypresses and the Flowering Tree*. More recently, one of two portraits of Dr. Gachet painted by this artist who scarcely earned a sou in his lifetime, dying totally unrecognized, sold in the $80 millions.

Van Gogh is particularly popular with Japanese buyers, who may see in his work the influence of their own *ukiyo-e* tradition rather than allegories of alienation. (Van Gogh's irises, also, bear a striking resemblance to a 17th-century Japanese motif.) A recent film by the great Japanese director Akiro Kurosawa even features a Van Gogh vignette of a farmer plowing a postimpressionist field.

John Rewald's two-volume history of postimpressionism is the standard work in the field.

POSTMODERNISM

In the yin-yang, push and pull currents of contemporary style and its wars of succession, postmodernism stands not (as one might assume) for the continuation of modernism but for reaction against it. We are talking here chiefly about architecture (in which modernism would be the International Style), although the arts and even literature are sometimes also included. If the International Style arose as a sort of architectural Reformation to correct historicist indulgences, postmodernism would be the Counter-Reformation. The debate in any case tends to arouse a certain extra-artistic fervor: those who are pro-"po-mo" talk about transcendence, while antis warn of retrogression, banality, and kitsch.

In practice, postmodern architecture is modern with random historical references or decoration (a term of contempt for generations) attached to formerly bare, pristine surfaces. Postmodernists insist that it is the manner of attachment that is important—the playful or witty, nontraditional or unexpected gesture. The most visible monument of the movement is the high-rise AT&T headquarters in New York, designed by Philip Johnson who, as a young man during the 1930s, was the chief American apologist for Bauhaus. A normally sleek skyscraper except for the surprising broken pediment on top, the AT&T building (finally finished in 1983) has been likened to a vertically elongated grandfather clock or a Chippendale highboy. Aha!, one is supposed to say, and the formerly alienating effect of skyscraper modern is presumably overcome. In his buildings and in his book *Learning from Las Vegas*, architect Robert Venturi goes even further, incorporating honky-tonk as a sophisticated statement, making a virtue out of what Venturi calls U & O—the ugly and the ordinary. If Johnson's motivation was to turn architecture into art, Venturi (whose designs include the Baghdad, Iraq, state mosque) reduced it instead to camp.

Postmodernism in art is characterized by classical realism with ironic, disjunctive contemporary references added. Some artists whose work seems to fit into this vein include Balthus, Alex Katz, and Richard Estes, plus sculptor Robert Graham. In literature, John Barth and Umberto Eco (author of *The Name of the Rose*, in a traditional format with modern effects) have both entered the debate on behalf of postmodernism.

So far, the antis seem to have the upper hand. Architectural historian Ada Louise Huxtable writes about "zoot-suit architecture" and architectural malapropisms, while Stephen Bayley wittily dismisses the style as "history deregulated." In a heavy tome on the subject, leftist philosopher Fredric Jameson tries to put postmodernism in Marxist historical perspective, calling it a stage of multinational capitalism characterized by the commodification of culture and a shift in cultural pathology from Freudian hysteria and neurosis to burnout and self-destruction.

Charles Jencks has written several books on the subject, including *What is Post-Modernism?*, a good short introduction, and *Post-Modernism: The New Classicism in Art and Architecture*, a large-format coffee-table version. For Jameson's thoughts, his book is entitled *Postmodernism, or The Cultural Logic of Late Capitalism*.

PRAGMATISM

The first American philosophy to gain world recognition, pragmatism was formulated by Harvard University psychologist William James, brother of the novelist Henry. William James is also the author of two other American classics, his pathbreaking *Principles of Psychology* (1890) and *The Varieties of Religious Experience* (1902). Among other concepts produced by his fertile mind ("my fevered states...when ideas are shooting together") is "stream of consciousness," and a distinction between tough-minded and tender that Carl Jung would later elaborate into extroversion and introversion.

First expounded in an 1898 lecture at the University of California at Berkeley and published as a book in 1907, James's theory of pragmatism was an effort to reconcile the prevailing Darwinian materialism with some form of ethical idealism. Starting from the problem of how man can know truth, or the meaning of an idea, James hit upon the concept that the meaning of an idea is its consequences in action. (*Pragma* is Greek for "a thing done.") James even wrote of the "cash-value" of ideas as determined in the observable marketplace. This metaphor, which seemed particularly appropriate for our nation of hucksters, the know-how can-do society, provided an easy target for criticism (above all, for expediency) and vulgarization.

Pragmatism is nonetheless typically American ("the American lust for movement and acquisition fills the sails of his thought," Will Durant wrote of James in *The Story of Philosophy*), an American reaction against the sophistries of European metaphysics. In a recent assessment, pragmatism was adjudged "the most sophisticated attempt to reconcile science and religion in the wake of Darwinism."

Pragmatism was applied to the fields of education and politics by the American John Dewey.

A Stroll with William James is a recent effort by scholar Jacques Barzun to come to terms with this American genius.

PRAIRIE SCHOOL

Although the name evokes the great rolling grasslands of middle America, most of the houses designed in this style in the first two decades of the 20th century were in cities or woodsy suburbs like Chicago's Oak Park. As expressed by architect Frank Lloyd Wright, the concept of this first modern house was a horizontally oriented structure with a long, low roof and wide, extended eaves. Within, Wright tried to eliminate strict divisions, letting his rooms flow from one into another, with the hearth occupying pride of place. The fireplace was key, evoking, in the words of biographer Brendan Gill, "the primordial consolations of firelight and tribal gatherings," and "some essential goodness in family life that could be imagined as existing (or as having once existed) on the American prairie." (Gill points out that Wright's European admirers typically assumed Prairie-style houses were in the wide open spaces once roamed by Buffalo Bill and

Sitting Bull, not in the heart of Chicago.)

As first described by Wright in February 1901 in the *Ladies Home Journal*, "A Home in a Prairie Town" was a composite of influences from traditional Japanese architecture, the Arts and Crafts movement, the Vienna Sezession, and the Swiss chalet. It also reflected Wright's rather grandiose Wagnerian idea of *Gesamtkunstwerk*, meaning the architect extended his control over the details of interior design as well, from furnishings and carpets down to fixtures. This alone assured that construction costs would far exceed the modest $7,000 claimed in the *Journal* article. In fact, most of Wright's clients were wealthy, if not always tolerant of the maestro's chronic cost overruns, or the fact that there might not be a direct connection between the kitchen and dining room, or that the roof leaked chronically. A Wright house generally turns out to be a good investment: a six-bedroom model in Santa Barbara, California, recently came on the market for $1.5 million.

Wright's Prairie period is considered to have run from 1900 to 1911, by which time he was at work on his Maya temples in California, based on an entirely different philosophical concept. But Wright's followers continued to execute commissions in this style for some years. In the opinion of architectural critic H. Allen Brooks, the ranch-style house which became so popular during the 1950s was but a West Coast bowdlerization of the Prairie house.

Brendan Gill's *Many Masks: A Life of Frank Lloyd Wright* is highly recommended. See also *Frank Lloyd Wright and the Prairie School* by H. Allen Brooks.

PRECISIONISM

Clean sharp lines, meticulous clarity and containment, colors in crisp contrast—these were the hallmarks of a modern American movement that came to be known as precisionism. Its two primary exponents, Charles Demuth and Charles Sheeler, also sometimes called "new classicists" or "immaculates," took cubist geometry but eliminated cubist planar fragmentation and spatial ambiguity. Their great subject was the city, its industry, machine technology, and architecture, which they portrayed with an almost photographic realism.

Sheeler also painted some rural themes, and a third American artist who is often grouped with them, the now popular Georgia O'Keeffe, gave precisionism a feminine and southwestern slant. O'Keeffe favored organic over rectilinear subjects, and also did some nonobjective painting, but shared the crisp precisionist style, eschewing texture and detail.

Georgia O'Keeffe's *Brooklyn Bridge* (1948), with its Gothic arches (*Brooklyn Museum*)

Contemporary estimations of precisionism seem to reflect prior, extra-art convictions. In his history of American art, Abraham Davidson calls the precisionist world view naive, "gross materialism wrapped about by a transcendental purity of innocence."

Radical art critic Barbara Rose, on the other hand, gives the precisionists credit for celebrating "what was best about indigenous American forms—their cleanness, integrity, efficiency, and simplicity." Seymour Menton includes Sheeler in his study of magic realism for the special luminous quality of his work.

Most of the literature on precisionism centers on Sheeler. The New York Graphic Society published a two-volume edition of his works in 1987, edited by Carol Troyen.

PRE-COLUMBIAN

One of the great debates in world history concerns the origin and development of American Indian civilizations. According to the "isolationist" school of thought, the Americas were first settled by migration from Asia 20,000 to 40,000 years ago, were subsequently cut off by geologic shifts at the Bering Strait, then developed in complete independence. The "diffusionist" school, seeking to explain the high level of culture attained in pre-Columbian (i.e., before Christopher Columbus) America, holds that there must have been continuing contact with and influence from the Old World. A third opinion is that resemblances between Old and New World forms—such as corbelled vaults, typical of Maya as well as Mycenaean (see MINOAN) architecture, or the Atlantean figures found in ancient Mexico and the ancient Mediterranean—are purely adventitious, or accidentally convergent.

Archeologists have found so many Mediterranean affinities in pre-Columbian America that they use a descriptive vocabulary derived from Egyptian and Greek studies for the stepped "pyramids" of the Maya, or their *stelae*, votive slabs carved in relief. The peak of Maya civilization is even designated as a so-called classical era (A.D. 300–900), with pre-classic and post-classic (to 1492) periods by reference to which other great Meso-American cultures are dated. (Historians given to analogizing also like to point out that the Mexicans had their Genghis Khans and Kublai Khans, that the Toltec Quetzalcoatl bears a family resemblance to a Chinese emperor, that Monte Albán is a Mount Olympus, and so on.)

Whatever your opinion, you have to revise your cultural horizons significantly after seeing the splendid ceremonial cities of the Maya—all the greater an achievement considering they were constructed by Stone Age methods. The Maya had no wheeled vehicles until after their classic era, and their masonry techniques remained largely unaffected by the introduction of metals around A.D. 1000.

In some respects, the New World was more advanced than the Old. The Maya had an accurate calendar more than a thousand years before the adoption of the Gregorian calendar, and they were familiar with the mathematical concept of zero a thousand years before the East Indians. It is in their social organization that the pre-Columbian societies are considered "primitive," for they had no notion of private property or individualism, and they found competitiveness and aggressiveness positively offensive. In short, they had no Protestant ethic to help them extend their domination over nature, with which they lived on terms of awe and reverence, practicing propitiatory human sacrifice. In the end, their great civilizations, the Aztec in Mexico and the Inca in Peru, were overturned in very short order by small bands of Spanish buccaneers.

Roughly half the estimated 20 million population of the Americas in 1492 lived between the tropics of Cancer and Capricorn, with the rest widely scattered in aborig-

inal isolation. Relatively speaking, North American Indians rank as poor stepchildren of the pre-Columbian era, despite what archeologists have identified as the Anasazi culture of southwestern cliff-dwellers, or the Hopewell culture which left sculptured earthworks ("land art") in the Ohio valley between 100 B.C. and A.D. 200.

It is a measure of the cultural egotism of the Old World that pre-Columbian civilizations were not really "discovered" until early in this century, 400 years after the voyages of Columbus. Cultural borrowings from them, such as Paul Klee's use of ancient Peruvian textile patterns, or the influence of Mexican sculpture on Pablo Picasso and Henry Moore, or Maya architecture on Frank Lloyd Wright, will undoubtedly increase with time.

On the more mundane level of diet, almost half the food crops grown in the world today, including corn, potatoes, pumpkins, tomatoes, and many beans were acquired from pre-Columbian Indians. Never underestimate the cultural importance of agriculture. In the opinion of historian Fernand Braudel, it was corn that made possible the great pre-Columbian achievements. Because corn virtually produces itself, requiring cultivation only one day a week, the peasants were otherwise free for gigantic public works projects.

Kubler's *The Art and Architecture of Ancient America* is readable as well as scholarly. Also enjoyable is *The Eagle, the Jaguar, and the Serpent: Indian Art of the Americas* by Mexican anthropologist and illustrator Miguel Covarrubias, who tends to analogize. For more historical background, see Alvin M. Josephy's *The Indian Heritage of America*. In the Thames & Hudson series, Mary Ellen Miller wrote *The Art of Mesoamerica from Olmec to Aztec.*

PREPPIE or PREPPY

This is a lifestyle, encompassing everything from haberdashery to leisure activities, which has proved amazingly persistent over the decades. Named for the prep school, that most important institution of socialization of upwardly mobile WASPs, it undoubtedly drew strength from the adolescent terror of being different and the resulting tyranny of conformity. Although it was basically an adolescent affectation, preppies locked themselves into a uniform—khakis, button-down madras and oxford-cloth shirts, and sockless topsiders, for both sexes—which they continued to wear through college (Ivy League, of course) into the country club and the junior league, with blue-chip law firms remaining important bastions of preppie taste. More than just dress, preppiness carries over to all facets of life, from sports (by preference, tennis, squash, and crew) to the very naming of one's children. (Preppie names run to the childish: Buffy and Muffy, Skip and Chip, now Tipper.)

Since preppie is an adolescent and androgenous style, not at all flattering to at least half the population, its survival since the 1950s and its widespread imitation by less privileged Americans are all the more surprising. In the late 1980s preppie even spread to Europe, where boating shoes became *de rigueur* for totally landlocked teens. Then, too, add a generous dollop of narcissism and a penchant for conspicuous consumption, and preppie segues neatly into yuppie.

The Official Preppy Handbook (Lisa Birnbach, ed.) is amusing and informative.

PRE-RAPHAELITE

The Pre-Raphaelite Brotherhood ("PRB") was a group of self-conscious young English aesthetes, an occult fraternity (sort of a dead poets and artists society) who in the revolutionary fervor of 1848 proclaimed their independence from the art establishment. Rejecting the artistic canons of the High Renaissance as epitomized by Raphael, canons they considered pompous and insincere, they drew instead on the Middle Ages for inspiration, on the Bible and early Christian and Arthurian romance, and on the poetry of

In *Beata Beatrix* (1863), Dante Gabriel Rossetti used his ethereal wife, Elizabeth, as model *(Art Institute of Chicago)*

Keats, Tennyson, and Shakespeare. Popular pre-Raphaelite subjects include Ophelia, Galahad, Guinevere, and the Lady of Shalott. Paintings were executed in a very bright key (the colors enhanced by a white underground), realistic in detail although romantic in spirit. They were narrative in concept, sometimes depicting only part of a sequence of events, and often bore ponderous titles. (*A Converted British Family Sheltering a Christian Missionary from the Persecution of the Druids* is one.)

In their painting as well as the poetry some of them wrote (best known in that department are Dante Gabriel Rossetti and his sister Christina), the emphasis is on deep feeling and high-minded love, a combination of solemnity and sensuality. In reality, the leading pre-Raphaelites—Rossetti, John Everett Millais, William Holman Hunt, and Ford Madox Brown, as well as critic John Ruskin and designer William Morris—were typically repressed Victorians with an unfortunate tendency to fall desperately in love with one another's wives, whom they all used as models. These sylph-like women with their hooded eyelids, chiseled features and gauzy curly hair—a style of beauty still called pre-Raphaelite—are an interesting study in their own right. (In *Sexual Personae*, guerrilla culture historian Camille Paglia calls them androgenous.)

Foremost among the second generation of pre-Raphaelite painters working in the 1870s was Edward Burne-Jones, who specialized in mythological subjects and heavily populated canvases with lots of clinging drapery. (He drew heavily on the work of Michelangelo, which makes him technically a post-Raphaelite; actually, his work verges on art nouveau.) But whether first or second generation, pre-Raphaelite paintings rate today as little more than camp classics, curiosities ("self-conscious sentimental medievalism") with no lasting influence. (William Morris, on the other hand, became very influential through his Arts and Crafts movement.) Several of the pre-Raphaelites became rich and famous in their lifetimes and were satirized in Gilbert and Sullivan's *Patience* as "arty," but the revolution in art that they so earnestly sought was soon carried out by another group, the impressionists.

There is an American group of pre-Raphaelites, but this is something of a misnomer. They called their group (formed in 1863) the "Association for the Advancement of Truth in Art," but because they were devotees of Ruskin they acquired by osmosis the name of the PRB with which he was identified. The Americans specialized in any case in watercolor landscapes rendered in minutely accurate detail, somewhere between the Hudson River school and luminism. An exhibition of their work was held at the Brooklyn Museum in 1985.

Timothy Hilton's *The Pre-Raphaelites* is a standard introduction. Gay Daly's *Pre-Raphaelites in Love* is first-class soap opera. *The New Path: Ruskin and the American Pre-Raphaelites* by Linda S. Ferber and William H. Gerdts is the catalog of the 1985 Brooklyn Museum exhibit. The Delaware Museum of Art in Wilmington is said to have an outstanding collection in this style.

PRESBYTERIAN

Taking shape in 16th-century Scotland, where it became the established church, Presbyterianism came to the New World with the earliest Scotch-Irish settlers. They stood in the right wing of the Puritan movement, with a hierarchy of authority similar to that in John Calvin's Geneva, a pyramidal structure with the congregation at the bot-

tom, then the presbytery (Greek for "hierarchy of elders"), synod, and general assembly. Within the individual church, truth, error, and access to communion were determined by an "aristocracy of grace."

The Presbyterians ranked among the elite in Massachusetts Bay Colony, nurturing a sense of divine right to dominate society. Along with their conservative orientation to social control, they also clung to the strictest Calvinist dogma, such as the belief in infant damnation or predestination, into the present century.

In 1776 Presbyterians constituted the second largest American denomination, after Congregationalists, but with the great American religious revivals of the 19th century they began to lose ground, preferring to remain conservative than follow "the vagaries of the illuminated spirit."

Always active in education, the church established Princeton University (once described as the theological center of Presbyterian life) in 1746. Princeton's Theological Seminary takes pride in having produced conservative leaders of all denominations. With the Congregationalists, with whom they have enjoyed close ties, Presbyterians joined in founding Knox (1837), Grinnell (1847), Ripon (1851), and the forerunner of the University of California at Berkeley (1855), among other distinguished institutions of higher learning in the United States.

In everyday social intercourse, American Presbyterians have long been stereotyped as dour and doctrinaire. One good example is Woodrow Wilson, the educator who became U.S. president in 1912. "The peculiar rigidity of his mind and his lack of bonhomie," writes historian Richard Hofstadter in *Anti-Intellectualism in American Life*, "seem to be more the result of his Presbyterianism than his scholarly vocation." Another American president, Benjamin Harrison (elected in 1888), is described succinctly by historian Sean Dennis Cashman as "a frigid Presbyterian deacon." Two prominent American cold warriors were both sons of Presbyterian ministers: publisher Henry R. Luce and Secretary of State John Foster Dulles.

The Disciples of Christ, a group of conservative Presbyterian dissidents who broke from the church in the 19th century, produced two recent U.S. presidents, Lyndon Johnson and Ronald Reagan (the latter, who attended a church college, turned in his mature years to more upscale Presbyterian congregations).

PUEBLO INDIAN

The Spanish called them Pueblo Indians because they lived in villages, many of them high on *mesas* or table mountains, in what is now known as the Four Corners area of the American Southwest. At the time of the Spanish Conquest, the Pueblo (who actually include various linguistic groups as well as tribes with their own distinctive identity, such as the Hopi and Zuni) numbered around 16,000 in 80 autonomous settlements. They were considered to enjoy the highest level of civilization north of the Aztec, tracing their ancestry back to the Anasazi or cliff-dwellers of Mesa Verde, Colorado, and elsewhere.

The Spanish converted the Pueblo Indians to Christianity, at least nominally, and used their indigenous architecture—adobe walls with rough surfaces, rounded corners, and roofs laid across projecting beams—in constructing the first American churches. The Church of San Francisco de Asís at Ranchos de Taos, and the Church of San Esteban in Acoma, both in New Mexico, remain to this day monuments of simple dig-

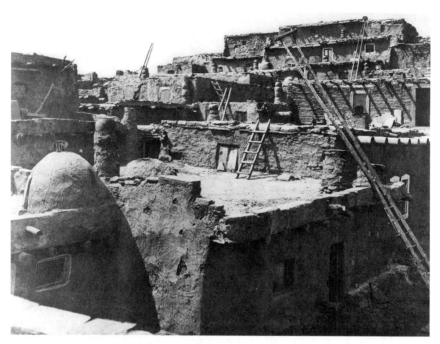

Pueblo translates as village, as in this multilevel prototype photographed early in the 20th century by Edward Curtis *(Princeton University Library)*

nity in a "Pueblo style" which is enjoying a mid-20th-century revival. (Regrettably, the use to which this style is most commonly put is the shopping center and the upscale condominium community, both multi-unit.)

Architectural historian William H. Pierson makes an analogy between Pueblo architecture and pottery—what is an adobe building but a huge, hand-molded container for living? Pueblo pottery and baskets are still made (by women) in styles that have varied little in 1,500 years. Pueblo rug weaving, in a striped style that has also changed little, is the work of men.

Pueblo Indians are intensive cultivators of corn, and avid traders as well. One of the primary articles of modern trade in the Southwest, the *kachina* doll, reveals the superficiality of Spanish missionary efforts. Made by the Hopi and other Pueblo Indians, kachinas, variously described as wooden effigies and educational toys, are carved figurines that are painted, dressed, and creatively decked out, representing a pantheon of characters who number in the hundreds. Some are spirits of life and growth, while others are ogres, performing an admonitory function in the complicated Pueblo rituals and dances. These dances may take place outside, or in the *kiva*, a circular, usually subterranean Pueblo ceremonial chamber. (Kachinas, by the way, are expensive, separating collectors from souvenir hunters.)

Another popular item of Pueblo commerce is turquoise and silver jewelry. Most easily identifiable, by its mosaic technique and delicate inlay work, is the work of the Zuni, who also make distinctive "fetish" necklaces and maintain an active tribal ceremonial life.

Santa Fe Style by Christine Mather and Sharon Woods is an attractive picture book tracing Southwest Indian influence on modern style. Also amusing is Carla Breeze's *Pueblo Deco*, which identifies Native American motifs such as the Thunderbird in the art deco movement.

PURITANISM

"The New Puritanism," ran the headlines when the National Endowment for the Arts launched its recent campaign against obscenity, which not even the U.S. Supreme Court has succeeded in defining. In current usage, puritanism is synonymous with prudery, sanctimony, repressive inhibition, and prohibition, particularly concerning sexuality. Historically, puritanism also implies conformity to the purity of some original ideal. Here the image comes to mind of a dark-suited pilgrim with a white collar and steeple hat over his cropped hair, eking out a grim, kill-joy existence in Old New England.

Puritanism is common to all religious movements; Islam, for example, also has "puritans." American Puritanism arose in England in the 16th century as a grass-roots reform movement, seeking to purge papist survivals from the Church of England and to bring about a renewal of spirituality. When Henry VIII broke with the Roman Catholic Church in 1533, his motivation was political rather than spiritual, leaving the content of English religious life largely untouched. The Puritans were thus in the mainstream of the European Reformation, along with the Lutherans in Germany and the Calvinists in Geneva (with whom they also shared an unfortunate tendency to legalism and intolerance), in seeking religious reform. Going back to the Old Testament, they saw themselves as militant servants of the Lord. Their zeal brought them to power in England under Oliver Cromwell, but after the Restoration they sought refuge from persecution in the New Israel, the Promised Land of New England, where puritanism would achieve its fullest flower.

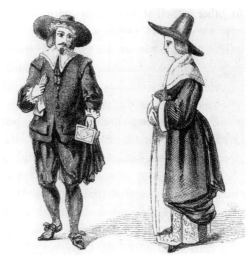

Puritanism as a fashion statement
(Library of Congress)

Generally speaking, America's Puritans believed in a covenant of grace with God, and in a specific experience of conversion which separated them from the naturally depraved body of mankind into an elect body of saints, an ethical aristocracy. In practice, they were not a single group but included a range of denominations from Anglicans (later Episcopalians) and Presbyterians on the right, Congregationalists in the center, and Baptists and Quakers on the left, each group differing in its approach to church organization, membership, and creed.

New England's Puritans tried at first to establish a theocracy, their civil state act-

ing as the police department of the church. In a climate of extreme hardship, aggravated by dread of the devil, they tried to legislate sin out of existence with thoroughgoing prohibitions. It was considered a sin to play, dance, drink, or go to the theater; on Sundays it was a sin to do practically anything except worship the Lord; and in the domain of sexuality, masturbation was a capital crime, bestiality a hanging offense, and adultery punishable by public ostracism. (The Puritans were not simply prudes; as a "chosen people" they naturally had a vital interest in procreation, producing the largest families in the New World.)

In literature, the great American classic of puritanism is Nathaniel Hawthorne's *The Scarlet Letter* (1850), a tale of sin, crime, and guilt. Besides the scarlet *A* for adultery, David Fischer points out, the Puritans had "an entire alphabet of humiliation," including *B* for blasphemy and *I* for incest.

Inevitably, the Puritan dictatorship of saints came into conflict with democratic pluralism and republican ideals. Historian Alan Simpson describes theirs as a "losing struggle...to preserve the intensity of the experience of the saint and his authority over society." Then too, the supply of saints seemed to dwindle, leaving only zealous conformists. Finally the Puritans with their harsh, often painful religion were outnumbered, outvoted, and ultimately transformed by the American experience, not least of all by the material prosperity resulting from their Protestant ethic of work for its own sake.

In *Anti-Intellectualism in American Life* historian Richard Hofstadter calls puritanism "the ideal philosophy for the pioneer, [one] whose contemptuous view of human nature simultaneously released the acquisitive side of men and inhibited their aesthetic impulses." Every so often, as during the recent NEA effort to dictate artistic standards, or the banning of harmless fairy tales by the public schools, Americans come up against subterranean survivals, usually activated by fear, of their Puritan heritage.

The standard work on the American Puritan heritage is Perry Miller's two-volume *The New England Mind*. A good short survey is provided by Alan Simpson in *Puritanism in Old and New England*. *Albion's Seed* by David H. Fischer is excellent.

The Queen of hearts
She made some tarts
All on a summer's day

Nursery rhyme

QUAKER

Founded in 1652 in England by George Fox, the Religious Society of Friends, or "Quakers," as they were derisively called, were on the left wing of the Puritan movement. Plain in speech, dress, behavior, even diet, they eliminated all formal rites for communion with God, including the sacraments and the intermediary of an ordained ministry. They believed in an "inner light" passing directly from Jesus to every soul. Their religious service consisted rather of a meeting or group sitting in silent worship, punctuated by praise, prayer, and exhortation, possibly quaking, according to individual spiritual impulse. Meeting houses were plain and bare but suffused with light entering via the many windows and reflecting off whitened walls.

In America as in England, the Quakers met with incomprehension and persecution. Massachusetts Bay Colony even hung four Quakers in 1659–61. But apparently it was safe enough by 1672 for Fox, the founder, to visit New England; it is also recorded that he spent a month in North Carolina, where he healed the wife of a former governor. American Quaker life changed significantly with the establishment of Pennsylvania as a Quaker colony in 1681 and passage of the Toleration Act in 1689. However, the Quakers continued to have problems with authority even when they themselves constituted the authority, as in Pennsylvania, chiefly due to their refusal to swear oaths or bear arms.

Radically egalitarian, Quakers refused on principle to take off their hats before supposed superiors, addressing all alike with the familiar "thee." Because of their discipline they prospered in the New World, but were among the few to question the American dream, warning against the temptations of prosperity. The issue causing the Quakers to abandon their leadership role in Pennsylvania was pacifism, a difficult position to maintain during the violent upheavals that led to American independence, first the French and Indian War, then the Revolution itself.

Gradually withdrawing from political participation and turning inward, the Quakers remained active as missionaries and in matters of conscience. Distinguished Quakers who took leading roles urging abolition of slavery in the 19th century include poet John Greenleaf Whittier and Lucretia Mott, later a feminist activist.

Of some 200,000 Friends in the world today, about half live in the United States, playing a role disproportionate to their numbers as humanitarian social witness. In recognition of this, a Nobel Peace Prize was awarded after the Second World War to the American Friends Service Committee.

Novelist Jessamyn West drew on her Quaker background in writing *The Friendly Persuasion*, source of one of the better American films, starring Gary Cooper. In *Albion's Seed*, David Fischer lists American heroes with a Quaker background: presidents Abraham Lincoln, Grover Cleveland, Herbert Hoover, and Richard Nixon, whose home town of Whittier, California, is the only Quaker town west of the Mississippi.

QUEEN ANNE

This is the eclectic high Victorian style of architecture favored by Britain's progressive aesthetes between 1860 and 1900. Named for no very good reason after the queen who reigned from 1702–14, the style is characterized by historian Mark Girouard as "an architectural cocktail, with a little genuine Queen Anne in it, a little Dutch, a little Flemish, a squeeze of Robert Adam, a generous dash of Wren, and a touch of François Ier." Others less favorably inclined call it a "pastiche look composed of decorative clichés," "a calculated chaos" that at best avoids monotony, or "the tubercular style" for all its eruptions.

Queen Anne buildings typically have lots of gables and turrets, steeply pitched roofs, and large bay and oriel windows, all asymmetrically and picturesquely arranged—anything to avoid a smooth wall, it was said. Arising in reaction against Victorian Gothic heaviness, the style was better suited to brick construction than Gothic was, and afforded more light thanks to its many windows. The overall effect is one of quaintness and prettiness. That in its day it was also considered progressive and aesthetic is somewhat harder to fathom, but in fact the arty leaders of late Victorian society (including American expatriates Whistler and Sargent) all lived in Queen Anne homes.

Queen Anne furniture, on the other hand, means early 18th-century English: upholstered love seats, whatnots, highboys, and chairs with graceful curvilinear back splats, cabriole legs, and claw-and-ball feet. In the field of book illustration (again, fast-forward to the 19th century), Kate Greenaway's children's books are considered quintessentially Queen Anne.

In the colonial revival following the 1876 centennial celebrations, Queen Anne style also caught on in the United States, with some minor variations. American Queen

The Hotel del Coronado in San Diego (J. W. & W, Reid, 1886–88), a beloved sample of American Queen Anne *(Tony Russell)*

Anne architecture was usually timber frame rather than brick construction, allowing much more malleability and fancy in its effects, including a great deal of spindlework detailing. The style also underwent adaptation to a different climate and more open social structure: wide porches and verandas were added, a friendly touch. Whereas English Queen Anne was primarily an urban style, not quite grand enough for country houses, Americans found the style suitable for mansions in Newport and for such resort hotels as the beloved Del Coronado near San Diego.

Mark Girouard's *Sweetness and Light: The Queen Anne Movement 1860–1900* is very readable.

Revolutions are not made; they come. A revolution is as natural a growth as an oak. It comes out of the past. Its foundations are laid far back.

Wendell Phillips, in a speech, January 8, 1852

REALISM

Generally considered an offshoot of romanticism, or a correction of its more grandiose tendencies, realism became the dominant trend in European literature and art in the 1840–80 period and in America somewhat later. The movement achieved its highest expression in France, chiefly through the novels of Honoré de Balzac, Gustave Flaubert, and Emile Zola, and the paintings of Gustave Courbet. The latter is reported to have said, "I cannot paint an angel because I have never seen one." Instead, he and other French realists introduced a new, sub-heroic cast of characters to literature and art, ordinary people such as laundresses, beggars, workers, and a succession of prostitutes or demi-mondaines running from Camille to Nana. (Although Edgar Degas is generally considered an impressionist rather than a realist, his dancers and laundresses are in the latter vein.)

With a more democratic cast of characters, realism set out to describe ordinary reality rather than the ideal or sublime, in an objective rather than subjective fashion. Instead of heroic events, a realist novel may recount drab everyday commonplaces, set in the here and now, rendered with circumstantial accuracy and impartiality. In art, Linda Nochlin points out, portraits in the realistic mode tend to be penetrating rather than flattering, and include seemingly random, fortuitous details for verisimilitude.

In the United States realism, which was always a strong component of native roman-

ticism, began to supplant the latter movement around the 1870s, somewhat later in fiction than in art. Early realist writers, virtually no longer read, are William Dean Howells and Sarah Orne Jewett. Later exponents, following Zola from realism into naturalism, include Frank Norris with his *McTeague* (1899) and *The Octopus* (1901) and Theodore Dreiser, author of *Sister Carrie* (1900) and *An American Tragedy* (1925).

Among American realist artists, pride of place is usually awarded to Thomas Eakins, who frequently painted from photographs and insisted on teaching with real nude models, which brought his dismissal from the Pennsylvania Academy of the Fine Arts in 1886. A later recruit to the style was George Bellows, whose paintings of prize fights ("so realistic you can see the sweat flying") are American classics. Actually, realist canons, with a varying admixture of naturalism, dominate American art from its pre-revolutionary beginnings under John Singleton Copley and Benjamin West to the mid-19th-century Hudson River school and the turn-of-the-century Ashcan school. Such 20th-century American movements as precisionism, regionalism, even pop art, and postmodernism, are basically realist or representational. (Another way of putting it might be that we are a very literal people, even in our visual arts.)

Although she concentrates on Europe rather than America, and on art rather than literature, Linda Nochlin provides a good general introduction to the subject in *Realism*. Erich Auerbach's *Mimesis: The Representation of Reality in Western Literature* is excellent. See also SURREALISM, SOCIALIST REALISM, and MAGIC REALISM.

REFORMATION

The concept of religious reformation, or returning to the purity of an original religious idea, may pertain to any church (one can speak of an Islamic reformation, for example), but as a period it is specific to each. In European history, the Protestant Reformation began in 1517 when German monk Martin Luther launched his protest against the selling of indulgences to pay for the construction of St. Peter's in Rome, a sort of spiritual high finance. (According to a popular English ditty of the day, "Place your money in the drum/The pearly gates open and in walks mum.")

Beginning with the issue of corruption in the Roman Catholic Church, the Protestant Reformation proceeded quickly to doctrinal issues. Taking leadership of this great Christian spiritual revival, Luther argued for justification (or salvation) by faith alone, not by indulgences, penance, or even good works. He went on to proclaim the church a priesthood of all believers in direct communion with God, not requiring the mediation of an imperfect (or celibate) priesthood or the worship of saints. For papal infallibility Luther substituted the authority of scripture, which he then personally translated into German (his New Testament appeared in 1522, followed by the Old in 1530). Thanks to the Gutenberg revolution in printing, every German thus became his own interpreter of the Bible.

The Reformation spread through Europe like wildfire, taking a slightly different national accent in each country, affecting every aspect of life. In Germany that accent was paternalistic, as Luther sided with the princes in suppressing the great and bloody peasant revolt (with over 100,000 fatalities) which his challenge to religious authority had coincidentally helped unleash. The picture in Germany was complicated by the survival of dozens of petty duchies and principalities, some of which remained Catholic

while others reformed, all within a nominal "Holy Roman Empire" in which the Pope played a pivotal role. German Lutheranism became a popular movement thanks in part to the support of princes seeking freedom from the interference of a foreign pope. (In fact, the word *Protestant* relates not to Luther but to the protest of the Lutheran-professing princes against a 1529 German diet ruling on religious toleration.)

In France, the Catholic Church managed to maintain its hegemony by persecuting and eventually (in 1572) slaughtering French Protestants (called Huguenots), an event known to every Frenchman as the Night of Saint Bartholomew. In Holland, the characteristic political expression of the Reformation was republicanism. In Calvin's Switzerland, Protestantism took on a totalitarian character, with the persecution and even burning of non-conformists. (As the humanist Erasmus remarked, tolerance no longer moves man when opposing tolerances compete.) In England the Reformation ran a somewhat different course: Henry VIII's independent break with Rome in the 1520s was political rather than religious in motivation, and the resulting Church of England chiefly differed in that it was a national church. Henry also authorized the translation of the Bible into English, which helped prepare the way for later internal "reformation" by the Puritans.

A likeness of reformer Martin Luther by Lucas Cranach, one of the great German Protestant portraitists *(Library of Congress)*

The reform in Christian religious observance had repercussions at all levels of cultural and social endeavor. The Gutenberg revolution in printing, already mentioned, helped transform what Sir Kenneth Clark has called (in his *Civilisation*) the Renaissance civilization of the image into the Reformation culture of the word. In the visual arts, which had been a branch of the church since the Middle Ages, a new spirit arose, individualistic rather than institutional, literal rather than symbolic. This spirit is evident in the intense personal piety of Rembrandt's portraits, in the first Dutch landscape and genre paintings, and in the work of the great German Protestant artists, Albrecht Dürer, Lucas Cranach, and Hans Holbein, with their portraits of prosperous merchants. (The great German sculptor and woodcarver Tilman Riemenschneider, whose subjects were more narrowly religious, had a hand chopped off for taking the wrong side in the peasant wars.) In the field of music, Luther even wrote his own hymns, some of which were incorporated into the great Bach oratorios.

In architecture, the reformers set out to purify their churches of all idolatrous decor, sometimes even changing the shape of their houses of worship (see CONGREGATIONAL-ISM). The wealth formerly devoted to church and cathedral-building was now channeled into personal adornment and enterprise, launching a new economic era. The

Catholic Church had generally opposed trade, so it is no accident that merchants as a class favored Protestantism. (This and other religio-economic connections were first made by the German sociologist Max Weber in 1904 in his *Protestant Ethic and the Spirit of Capitalism*.) Poverty, which for the early Christians had been a sign of grace, became for the Protestants a misfortune if not a sin.

As a period, the Protestant Reformation is considered to end in 1648, with the close of the Thirty Years War of religion it unleashed.

There is no single, accessible work for lay readers on the Reformation; most histories generally make soporific reading. See also COUNTER-REFORMATION and LUTHERAN. For other Protestant denominations see BAPTIST, CONGREGATIONALISM, EPISCOPALIAN, METHODIST, and PRESBYTERIAN.

REGENCY

Strictly speaking, Regency means the period from 1811, when George III was declared insane, to the English king's death in 1820. But like most periods it tends to swell at either end: add to the far end the decade-long reign of the son and former regent as George IV, and to the front end the general neoclassical trend of the late 18th century. During this period of some 40 years, English style in furniture and art was characterized by eclectic ornamentation (Greek, Roman, Egyptian, Oriental) on neoclassical forms or a fusion of classical and picturesque. The French influence was also strong; the Prince Regent himself was a collector of French furniture and porcelain, then widely available thanks to the turmoil in revolutionary France.

Thomas Sheraton's *Cabinet Directory* (1803), which introduced to England the Greek couch with scrolled ends, has been called the beginning of Regency style, launching a rage for massive furniture ornamented with archeological themes. Regency is sometimes described as similar to Directoire or Empire but simpler and more elegant, without the Napoleonic accent. This argument is belied, however, by the premier piece of the period, the "Trafalgar chair" (so-called after Nelson's 1805 victory) with its sabre legs and ostentatious marine emblems inlaid in brass. Also typical of Regency are grand staircases and convex mirrors with bright gilt frames topped by eagles, not one of your more modest birds. (Design maven Stephen Calloway characterizes Regency opulence as "a Byronic love of the exotic and dramatic.")

In other media, such as silver, and in architecture and landscaping, Regency tends to be rather less flamboyant. Regent's Park in London is strictly geometrical, in the style of a French rather than an English garden. Regent Street, however, connecting the Regent's residence to his park, is lined with purveyors of extravagant products. The period in general was considered flamboyant, even morally lax, perhaps even prompting the backlash of Victorianism.

An amusing Regency anecdote is that the francophile Prince Regent had Napoleon's home in exile on the British island of Saint Helena fitted out in the decorative splendor—Regency, or the British equivalent of Empire—to which the defeated French emperor had become accustomed. (English Regency should not be confused with French Régence, which is transitional—1715–30—between heavy baroque and lighter rococo.)

Steven Parissien's *Regency Style* is handsomely illustrated.

REGIONALISM

It is difficult today to imagine what all the fuss was about, but in their day—the Depression—the regionalist or "American scene" artists were lambasted as cracker-barrel demagogues, cultural isolationists, parochial reactionaries, even crypto-fascists ("nourished by the same ills that produced nazism"). We are talking about Grant Wood, whose *American Gothic* is practically a national icon (see GOTHIC); Thomas Hart Benton, with his huge murals full of gnarly hayseeds and nubile maidens; and the lesser-known John Steuart Curry, a remote acquaintance painting in the same midwestern vernacular.

Long out of fashion, the gnarled mannerism of Thomas Hart Benton: *July Hay* (1943) *(Metropolitan Museum of Art)*

Certainly the regionalists turned their backs on modernism, tracing their descent directly from the Renaissance and (in Benton's case) mannerism. Having rejected modernism, they aren't even mentioned in books on "modern" (i.e., 20th century) art, and they do very little better in general surveys of American art. Their great sin seems to have been their rejection of urban cosmopolitanism in favor of populist realism. Parochial by choice, they painted in farmers' overalls and sought inspiration and sustenance from a rural America that was vanishing as they worked to capture it. (In literature, John Steinbeck with his 1939 classic *Grapes of Wrath*, and composer Aaron Copland, who tried to write serious music that would be recognizably American, are also considered to have mined the same vein.)

Much of the controversy surrounding regionalism was generated by Benton, the son of a Missouri congressman and nephew and namesake of a senator. Benton studied in Europe (as did Wood), settling afterward in New York City for two decades. An extremely pugnacious man of small stature, he slammed the door resoundingly shut in 1934 on what he considered the effete eastern intellectual establishment. Returning to Missouri, he soon fell out with the local "highbrows" as well, earning dismissal from the Kansas City Art Institute for his remarks on the sexual preferences of museum curators. It was Benton with his provocative, sometimes injudicious statements (he once claimed that "a windmill, a junk heap, and a Rotarian have more meaning to me than

Notre Dame or the Parthenon") that earned regionalism its bad odor. He wrote an autobiography in 1937, *An Artist in America*, reprinted in 1983.

A shy and retiring man who lived most of his life in Iowa, Grant Wood also aroused controversy and misunderstanding—even among his subjects, who were never quite sure whether they were being set up or not. Wood's *Daughters of Revolution* (1932), to cite one case, depicting owl-eyed dowager guardians of propriety, measuring out approval in genteel tea-cups, is probably satirical in intent. But what about *American Gothic* (1930), itself the most parodied American painting in history? At the very least, Wood was somewhat ambivalent in his dedication to the common man.

In any case, the eastern intellectual establishment had its revenge, consigning the regionalists to the artistic attic. For 40 years after Wood's death in 1942, there was no major show of regionalist work, and when the Whitney Museum of American Art in New York City moved in the 1950s, it could find no room to carry along a Benton mural. When in 1983 the Whitney mounted a Wood retrospective, critics admitted the paintings had a certain "freshness" (the majority had never been seen), but dismissed Wood's better work as a magnificent fluke, in the artistic tradition of Norman Rockwell and Walt Disney.

In Benton's line of artistic descent, ironically, one must place abstract expressionist Jackson Pollock, who studied under Benton in New York and enjoyed a close personal relationship with him. According to Benton's biographer Henry Adams, Pollock inherited his teacher's macho posturing and chauvinistic Americanism as well as a certain rhythm of composition, although Pollock chose to paint in an abstract rather than a representational mode.

Henry Adams's *Thomas Hart Benton: An American Original* is a nicely illustrated, impartial, and reasoned account. Wanda M. Corn's book, *Grant Wood: The Regionalist Vision*, was prepared to accompany the Whitney exhibit. William Gerdts's three-volume compendium, *Art Across America: Two Centuries of Regional Painting*, is not about regionalism as described here; Gerdts focuses rather on unsung artists, or the better-known only insofar as they mined some local vein. (Rockwell Kent spent a year in Alaska, for example, while Georgia O'Keeffe worked as a young woman in rural Texas.)

RENAISSANCE

It really should be called the *renascità*, for it was thoroughly Italian in origin and inspiration. But the French who took over in the 16th century as Europe's tastemakers succeeded in imprinting their stamp on the Renaissance, a concept first mentioned by French novelist Honoré de Balzac in the 19th century, and first developed in 1855 by the French historian Jules Michelet. Nevertheless, it was in Italy that, after the "long sleep" of the Middle Ages, the classics of antiquity were rediscovered and studied, a body of knowledge and experience that the Italians considered their own particular heritage. After the angular and mannered Gothic, scorned by Italians as *una maniera tedesca* (a German manner), the Renaissance sought to restore the harmony, symmetry, and elegance of the classics, defining beauty as the perfect balance of all parts.

The Italian Renaissance covers such an extended period and range of styles, from the still rather Gothic Giotto in the late 13th century to the early mannerist Michelangelo in the 16th, that scholars customarily divide it into more coherent subdivisions. The

first of these is the trecento (short for mil trecento, or 1300, the 14th century), the infancy of the Renaissance, dominated by Giotto and the poet Petrarch. Then comes the quattrocento (mil quattrocento, or 1400, the 15th century), the adolescence of the Renaissance, characterized by naiveté of artistic expression as compared to the High Renaissance or cinquecento (16th century) when many of the great masterpieces in the history of art were created.

Between the three periods, there was a gradual transition, with much overlap, from medieval or Gothic sensibilities to those of the Renaissance; from a religious to a more secularized society; from the medieval emphasis on spirituality to the Renaissance pleasure in physical beauty; from imitation and conformity to innovation, individualism, and genius. A mortal sin in medieval times, individualism became a virtue in the Renaissance, possibly its fatal flaw.

Humanism, the great philosophical movement of the Renaissance, also shifts focus from God to man—thereby inviting attack as godlessness. But although the Renaissance was not irreligious and certainly not agnostic, it was definitely worldly. As an example of the new man-centered spirit in art—the premier Renaissance medium, that in which its most profound thought was invested—people had their portraits painted as their name saints, complete with emblems. The great Renaissance achievement in art was to effect a transition from medieval religious symbolism to naturalistic representation, from flat, silhouetted figures to the search for perfectly harmonious proportions and the illusion of depth created by a new system of visual organization called perspective. Themes remained largely Christian, if sometimes expressed in classical (pagan) forms. The preeminent Renaissance male figure is David (sometimes resembling Apollo); the female, the Virgin Mary. Christ is now represented as a serene, confident king, no longer the suffering medieval martyr. Nudity, which in earlier eras had been associated with shamelessness or poverty, became synonymous during the Renaissance with naturalism, simplicity, and honesty. Unwritten rules restricting the use of nudity in Christian subjects were cast aside in depictions of classical mythology. Finally, art became more dramatic and emphatic as extraneous characters and secondary incidents were pruned out, the better to focus on the heroic and sublime.

There are many great names associated with the Renaissance. In the trecento, Giotto's work in retrospect seems like a missing link between Byzantine iconography and High Renaissance classicism. The most important personality of the quattrocento, which was based in Florence, was the sculptor Donatello. A comparison of his and Michelangelo's statues of David provides another object lesson in the development of the Renaissance: Donatello's *David* is immature, a lovely boy in bronze, while Michelangelo's later cinquecento model is massive, tense, and self-consciously sexual. Another important artist of the quattrocento period was Botticelli with his slender, feminine figures, still virginal compared to High Renaissance worldliness. Quattrocento portraits are realistic and descriptive, with simple homely touches and a childlike freshness. Finally, in the High or Late Renaissance, we have the great geniuses, multitalented ("Renaissance") men who cultivated learning and the social graces and themselves aroused a cult of personality: the towering figures of Raphael, Michelangelo, and Leonardo da Vinci. Leonardo, especially, has come to epitomize the "Renaissance man" for his eclectic interest in everything from anatomy to botany, geology, and aeronautics. Ironically, he was the least productive artistically and probably the most frustrated of the great geniuses of the era. His Last Supper is still considered the height of classical clarity, lucidity, and

Leonardo da Vinci's famous canon of classical proportions
(Galleria dell'Accademia, Venice)

perfection, while his Mona Lisa seems to embody the riddle of the eternal feminine.

In addition to subdividing the Renaissance by centuries, experts further identify regional variations. Artists in Tuscany are said to have specialized in "painted drawings," highly linear, while the Venetians favored rich colors and chiaroscuro or *sfumato*, meaning a gradual shading of light and dark, and the Sienese were famous for richly decorated, somewhat Gothic art.

In the field of architecture, the Renaissance has left us hundreds of churches and palaces in the main Italian cities, plus the Palladian villas in the countryside, the first non-fortified country residences for nobility. The keystone of these various buildings was symmetry around a central point. Each floor level of an Italian Renaissance facade repeats some geometric motif, such as a Greek column (used purely as decoration) or style of window, varying by floor. The scale is smaller than Romanesque or Gothic, possibly more "human," and aesthetic qualities are optimized. (Many Italian Renaissance architects, like Michelangelo, were also artists, with an artist's sensibility.)

Politically, Renaissance Italy was a collection of rival city-states ruled by a fascinat-

ing collection of enlightened princes, tyrants, and usurpers, many of them patrons of the arts. This was the era of Machiavelli and the Borgias, when unbridled ambition, avarice, and sensuality reigned. In 1494 when the French invaded, Italy was easily defeated, its professional soldiers unaccustomed, it was said, to fighting battles in which people actually died. For the next 50 years Italy would be a battlefield, chiefly between France and Spain. By the time peace returned, Italy's political power was broken, although its cultural supremacy remained. For centuries, the themes of Italian Renaissance art would be copied and recopied, a new standard of excellence replacing that of classical antiquity.

By the 16th century the humanistic ideals of the Renaissance had spread all over Europe, taking root and flowering somewhat differently according to national soil and climate. Generations of scholars and artists traveled to Italy as to the fountain of creativity, and a taste for Renaissance luxuries was also carried home by the armies that fought there. François Ier of France collected Renaissance art and even invited Leonardo da Vinci to one of his castles on the Loire, where the great artist died. These castles, by the way, are in French Renaissance style, more ornate and varied than the strictly symmetrical Italian palazzo.

In France and Italy the Renaissance was an elite affair of king and nobility, but in Germany and Holland it was adopted by the bourgeoisie. As a result, what is called Renaissance architecture in these countries, chiefly town houses of prosperous burghers, bears little resemblance to Italian models. In their Renaissance art, too, the northern Europeans retained many more late Gothic elements. Of several great German Renaissance artists, only Albrecht Dürer achieved Italian standards of perspective (he also painted his self-portrait as Christ) but was never at ease painting nudes.

American architecture of the late 19th century contains a strain called the "palazzo style," which was considered appropriately magnificent for the homes and clubs (for example, New York's University Club) of the wealthy and powerful. This style copied from 15th-century Florentine palaces also trickled down to some of the city's new cast-iron commercial buildings. And in San Francisco and other cities, one variant of Victorian is known as Italianate, a reference to the Italian Renaissance.

Heinrich Wölfflin's *The Art of the Italian Renaissance* is devoted to the distinctions between quattrocento and cinquecento, with Wölfflin favoring the former. See *The Art of the Renaissance* by Peter and Linda Murray in the Thames & Hudson series. Jacob Burckhardt's 1860 classic *The Civilization of the Renaissance in Italy* is not very rewarding for anyone unfamiliar with the political history of the period. The American art critic Bernard Berenson set the standards of legitimacy for the first great generation of American collectors with his lists of the authentic *Italian Pictures of the Renaissance*, first published in 1897. For the Renaissance in England, see ELIZABETHAN; in Spain, PLATERESQUE.

RESTORATION

The restoration of the British monarchy in 1660, after the death of Oliver Cromwell whose Puritan Commonwealth had executed the previous king, was accompanied by a marked change in style. After a dozen years of Puritan sobriety—years which the Stuart pretender had spent in Louis XIV's France—England rediscovered a taste for luxury. The Restoration in England is coterminous with baroque, and architecturally there is

rather a lot of it, at least in the capital, thanks to reconstruction after the Great Fire of London in 1666. But "Restoration" is usually associated with interior decor, with the grand staircases, handsome fireplaces, and rich marquetry with which the new baroque town houses were filled. A prime piece of Restoration furniture is the new "cabinet" or sideboard, produced by a new generation of fine carpenters called "cabinetmakers."

Generally considered to have lasted until 1700, the Restoration in England is probably best known as a period in literature. Samuel Pepys's diaries, the poetry of John Dryden, and above all the satires and licentious comedies of manners of the newly reopened theater, are archetypically Restoration.

The French, who also executed a king (Louis XVI in 1791), also have a period they call *Restauration*, beginning in 1815 after the fall of Napoleon. There is no very marked shift in stylistic gears from the foregoing Empire style to the French Restoration, which only lasted until 1830.

ROCK 'N' ROLL

To anyone who was not alive (or otherwise unconscious of the popular music scene) in the mid-1950s, it is difficult to convey the sense of shock and outrage, excitement and liberation first aroused by rock 'n' roll. An outgrowth of the black rhythm and blues genre, rock (for short) hit the white mainstream like a cyclone. A similar type of rhythmic stimulation is seen in epileptics, doctors cautioned. Vance Packard, author of *The Hidden Persuaders*, warned that rock music "stirs the animal instinct in modern teenagers." Ministers inveighed against satanic influences, while angry parents, fearful of juvenile delinquency and promiscuity, burned Elvis in effigy. Speaking for the conventional popular music establishment, obviously threatened by the new music, Frank Sinatra described rock as "the most brutal, ugly, desperate, vicious form of expression it has ever been my misfortune to hear."

The incomparable Elvis Presley (*Academy of Motion Picture Arts and Sciences*)

Writing in appreciation of rock, Mablen Jones compares it to primitive religion. Dressed as cultural icons or mythic archetypes (Little Richard as the trickster; the early Beatles as magical children; Madonna as bad-girl sex kitten), rock stars function as sacred public magicians, releasing repressed desires and arousing ardor, hysteria, even trance.

Although it seems to be in a continual process of evolution, merging and re-inventing itself every few years, rock can be defined as follows. First, the music features a relatively simple vocal line and lyrics about dating, cars, and other adolescent concerns, against a heavily amplified instrumental background of guitars and drums, the latter beating a quick and

Rock 'n' Roll Substyles

ROCKABILLY: A mixture of hillbilly and gospel was carried out of the Deep South in the mid-1950s by poor whites like Elvis Presley and Jerry Lee Lewis. From a shocking rebel gyrating to the dance called the twist, Elvis metamorphosed during a long career into a glitzy Las Vegas entertainer.

AMERICAN BANDSTAND: In 1957 Rock went mainstream under TV disc jockey Dick Clark, marketing clean-cut respectability and reassurance, the latest dances as well as music by an Elvis clone called Fabian.

MOTOWN: A Detroit recording label was established in 1959 prominently featuring black girl groups such as the Supremes, plus the (male) Temptations and Four Tops. Motown packaged black music for mass consumption.

PHIL SPECTOR'S "WALL OF SOUND": In the early 1960s, Spector promoted girl groups like the Crystals and the Ronettes against Wagnerian instrumental background.

SURF ROCK: In 1961 the Beach Boys celebrated the California lifestyle with bright, bouncy, bland, almost preppy music.

THE BEATLES: The "Fab Four" evolved from a clean Peter Pan-ish style in the early 1960s to acid rock later in that decade, arousing mass adulation called Beatlemania. Arguably the great lyrical musicians of rock, the Beatles influenced fashion from "mod" to "hip."

FOLK ROCK: It began with Bob Dylan, Joan Baez, Simon & Garfunkel, and the anti-war movement in the 1960s and turned into electrified social protest.

insistent rhythm. Rock comes wrapped in a performance package, with dance, dress, and behavior spinoffs, which have been heavily marketed, constituting a major world industry. At each stage, rock has evolved in tandem with changes in consumer electronics, from the TV to transistor radios, walkman radios, boom-boxes, and now to MTV.

The successive rock substyles and periods are so various that there is nothing to do but list them. If you can't keep up with the changes, you're not the only one. In the 1990s a growing percentage of rock radio stations is taking refuge in an "all-oldies" format, with the emphasis on the early years. (There are also some Christian stations out there, such as KLORD in southern California, broadcasting in a rock format; only the lyrics are different.)

In a world where American power and influence seem definitely on the decline, the one American art form imitated everywhere is rock music.

The literature on rock 'n' roll is about as a-literate as some of the music itself. For a historical survey, David P. Szatmary's *Rockin' in Time: A Social History of Rock-and-Roll* is

ACID ROCK: In the late 1960s, rock groups such as the Grateful Dead and Jefferson Airplane experimented with long solo improvisations, increasing complexity, amplification, and distortion to accompany the psychedelic hippie scene.

HEAVY METAL: High-voltage electric blues and macho stage performance characterize this sound, led by groups such as Led Zeppelin, formed in 1968. The name "heavy metal" derives from a William Burroughs novel, *Naked Lunch*.

DISCO: Dancing revived in the mid-1970s with an insistent thumping beat, set in a club environment. Natty dress style and narcissism were captured on celluloid in *Saturday Night Fever* (1977) starring John Travolta.

PUNK ROCK: A cousin of heavy metal, punk rock broke on the scene in the mid-1970s, featuring exaggerated nazi chic and mortification of the flesh: British star Johnny Rotten had himself photographed nailed to a cross. Style includes distinctive coiffure, fluorescent and spiky; leather and chains; the safety pin as fashion statement.

MTV: In the 1980s, this new TV format—sometimes called "shock rock"—replaced radio, delivering rock to the TV generation; music takes second place to fast-paced, disconnected visuals; MTV became the vehicle to fame and fortune for a new generation of big stars, Michael Jackson and Madonna.

RAP: Black radio DJs engaged in call and response, mixing and altering recordings to create polyrhythmic forms and a street-smart style in the 1980s; baseball caps and tennis shoes, breakdancing and subway spray art are rap statements.

recommended. Other witnesses to the age are fashion expert Mablen Jones, author of *Getting It On: The Clothing of Rock 'n' Roll*, and photographer Annie Leibovitz, who has published several collections of rock portraits.

ROCOCO

Rococo is not a new movement but a continuation or consummation, the last elaborate gasp, of the baroque. But whereas baroque was an Italian invention, closely allied with the church in the Counter-Reformation, rococo was French, secular in origin, a product of the Enlightenment; where baroque was ceremonious if not monumental, rococo was smaller in scale, more intimate and elegant; and where baroque was symmetrical, rococo sought rhythm and balance in asymmetry, like the shell motif or *rocaille* (a completely original form, architectural historian Nikolaus Pevsner points out in *An Outline of European Architecture*) for which the style is named.

Rococo arose in 18th-century France, its graceful elegance epitomized by artists Antoine Watteau and François Boucher. "The distinctive quality of rococo," writes his-

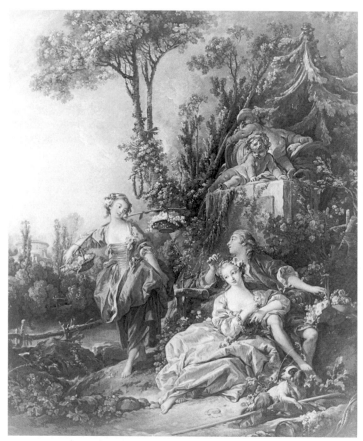

Boucher epitomized the frivolous and fanciful rococo in
Lovers in the Park (1758) *(Timken Museum of Art)*

torian Wylie Sypher, "is taste, that indefinable but very responsive faculty referred to by the French as 'je ne sais quoi.'" Sypher calls rococo a system of decoration, rather than a style of architecture; he also cites as eminently rococo the plays of Racine delineating the geometry of passion. It was in south Germany that the style reached its greatest expression, in princely residences, gorgeous theaters, and incredibly elaborate churches. If this seems unlikely, considering the staid German temperament, it has been suggested that Germany as the cradle of the Reformation had the greatest need of baroque and rococo to draw the masses back into the political and religious fold. In any case, south German rococo architecture is a symphony (the style seems to lend itself to musical analogy) of curves and counter-curves, gilt, marble and stucco modeling, painted figures whirling on trompe l'oeil ceilings—a veritable cornucopia of shapes, colors, and textures.

There is a tendency to consider rococo decadent, not least because it is identified with the ancien régime which was swept away in the French Revolution. Certainly, too, rococo features naked women prominently everywhere—in paintings, tapestry, and porcelain. These are not the mature nudes of the baroque but young girls, erotic objects to arouse

the most blasé taste. Even the rococo style of grooming—the powdered skin and the peri-wig—lends itself to interpretation as "the tragic mask of the age," the old and decrepit trying desperately to hang on to youth, as cultural historian Egon Friedell put it.

Sypher calls the poetry of Alexander Pope typical of English rococo. But rococo was just too continental, frankly, to enjoy much of a vogue in England (historian Sir Kenneth Clark wrote in his *Civilisation* that "the native good sense of a fox-hunting society prevented its more extravagant flights"). The United States experienced rococo as a system of decoration in the last quarter century before the Revolution. A recent exhibit at New York's Metropolitan Museum of Art featured American Chippendale furniture, porcelain and silver, bookplates and calling cards, all with the undulating lines and sinuous curves characteristic of rococo elsewhere in the world. The American taste for rococo (which was not a style lending itself to easy or economical imitation) seemed to dry up with independence, replaced by more "republican" standards.

One of the standard authorities on rococo is an American, Fiske Kimball, who wrote *The Creation of the Rococo Decorative Style*. See also Wylie Sypher's *Rococo to Cubism in Art and Literature*. The Metropolitan Museum of Art exhibit produced a handsome catalog, *American Rococo* by curators Morrison H. Heckscher and Leslie G. Bowman.

ROMAN

Roman history, generally dated from the establishment of the Republic in 509 B.C. to the capture of Rome by Alaric in A.D. 412, covers a lot of time and territory. So what was unique about it and is still relevant today? The Roman genius was a practical one, taking, adapting, improving, and finally colossalizing. The Romans built the first modern roads, for example, drawing on an Etruscan model which they extended into a vast network, the basis of a great empire stretching from Turkey to Scotland at its peak. (Roman roads were not surpassed until the 19th century, according to anthropologist Gordon Childe.)

Making an art out of engineering, the Romans took Greek columns, but instead of topping them with the usual lintel or pediment, capped them with arches. Picture the great arched Roman aqueducts, carrying a lavish supply of fresh water—three million gallons daily to Rome alone, which may have enjoyed the highest per capita consumption of water until 20th-century America. From the arch it was but a step to the vault and then the dome, made possible by the discovery of cement (prompted by experience with the southern Italian volcanoes). With the dome the Romans created the first great secular architecture.

Picture, too, their huge bathhouses—Caracalla in Rome, Cluny in Paris—and the basilicas or courthouses which became the model for early Christian churches. (As architectural historian Nikolaus Pevsner points out, the Romans turned the Greek temple inside out, putting the exterior columns inside to delineate a nave and aisles.) The Roman Pantheon, the largest dome built until modern times, has been called the most influential building in architectural history, inspiring the Vatican and the U.S. Capitol, among others. The Romans also took the semicircular Greek theater, formerly built into a hillside, and made of it the free-standing elliptical amphitheater called the Colosseum, also much imitated (a container, according to Lewis Mumford in *The City in History*, for the "more brutalized forms of sport").

Other characteristic Roman contributions to the idiom of architecture include the atrium (originally, or literally, a "blackened hole" to ventilate cooking smoke and admit rainwater), and the triumphal arch, which marks the transition in Roman inventiveness from the functional to the merely ostentatious. As a recurring architectural style in European history, Roman would become synonymous with imperialism, gigantism, and ultimately fascism, as dictators from Napoleon to Hitler and Mussolini drew on Roman models to meet their needs and pretensions.

In the arts, the Romans fell heir to Hellenistic cosmopolitanism, borrowing from the Greeks with a complete lack of cultural shame. Roman copies of classical Greek statues are considered to be inferior, bloated, but sometimes they are all that remains. Original Roman works of sculpture tend to have a more political and propagandistic slant, becoming in the process more realistic. Instead of idealizing as the Greeks did, the Romans learned to portray character with great subtlety and skill. In the applied arts, one of their proudest achievements was the mosaic pavement.

Other Roman survivals in everyday American usage include a style of lettering based on ancient Roman inscriptions. For numbering, we use "arabic" numerals for everyday, reserving Roman for grander occasions. Then there are whole sections of vocabulary in English derived from the language of the Romans, Latin. Such words as *salary, fiscal, municipal, forum, civil,* and *magnanimity* point to areas of Roman specialty. (On the down side, we also say "bread and circuses" as shorthand for imperial Roman decadence.)

One domain in which the Roman contribution was indisputably original and superior is law. Acknowledging the individual as the chief legal entity, separate from the group, Roman law created the prerequisites for "inalienable human rights." It also gave substance to the Stoic premise of equality, eliminating arbitrary distinctions among

American Roman: Horatio Greenough's portrayal of the father of our country as a Roman senator *(Smithsonian Institution)* and the Triumphal Arch in New York's Washington Square (Stanford White, architect, 1892) *(New York Public Library)*

classes of people. Finally, the Romans explored notions of agreement, leading to the modern concept of contract by good faith, applied by extension to international affairs.

In the early years of American independence, it was fashionable to portray the country's leaders as noble Romans. George Washington, for example, was sculpted by Houdon as the Cincinnatus of the West and by Greenough as a senator in a toga. Then in the early 19th century, as the Roman ideal was discredited by the imperial pretensions of Napoleon, it was replaced by the more democratic Greek revival. By the end of the 19th century as the United States was becoming an imperialist power in its own right, Roman came back into style, particularly the triumphal arch, of which there are a good number in our cities (see GILDED AGE).

In the Thames & Hudson series, there is Mortimer Wheeler's *Roman Art and Architecture*. *The Legacy of Rome: An Appraisal*, edited by Richard Jenkyns, is one of the best books in another series. For a short standard history, see M. Rostovtzeff's *Rome*.

ROMAN CATHOLICISM

The word *Catholic*, from the Greek for *universal*, was first used in the first century A.D. to encompass all Christians (dead as well as living!). Gradually, with the splitting off of the Eastern Roman Empire and its church, which became known as the Eastern Orthodox Church, Catholic came to mean Roman Catholic, or those Christians in communion with the Pope in Rome. Then with the Reformation, *Catholic* again became the operative word, as distinct from Protestant Christians, with Roman remaining as a sometimes pejorative qualifier.

Catholics share many doctrines in common with other Christians: belief in the objective existence of God, the historicity and divinity of God, immortality of the soul, resurrection of the dead, and heaven and hell. Where they depart is in acknowledging the Pope as the vicar of Christ, infallible arbiter of church issues. For non-Catholic Christians, in contrast, the Pope has come since the Middle Ages to be identified with a mixture of superstition and despotism, arousing fear of "popery."

Founded as they were in opposition to establishment religion (or to the Anglican Church in England, itself founded in opposition to Roman Catholicism), the American colonies were generally inhospitable to Catholics. Only in Maryland (founded as a Catholic colony) and Pennsylvania were Catholics allowed freedom of worship in the colonial era.

Thanks to the great waves of immigrants to the United States in the 19th century—first from Ireland and Germany, later from southern Europe—the Roman Catholic Church became the largest American denomination by 1850. The sudden surge of Catholic immigrants, most of them poor and working class, was perceived as a dire threat to WASP hegemony, arousing prejudice, discrimination, and periodic nativist binges of violence. Even as respected a mainstream preacher as Lyman Beecher, a Presbyterian and probably the most widely known American cleric of his day, warned (in 1834) that the Pope (who "holds now in darkness and bondage nearly half the civilized world") would try to take over the Mississippi valley.

The waves of immigration also posed a great strain on American Catholic church organization. The French clerics who had dominated the church in colonial days found themselves replaced by the Irish whose dominance (which continues to this day) was

opposed in turn by German Catholics. By 1886 the majority of American bishops were Irish, numbering more than twice as many as the next largest group, the Germans.

Under Irish domination, according to the Jesuit historian James Hennesey, American Catholicism "tended to be narrow, moralistic and bland." Efforts to establish a more American identity, more consonant with American traditions of democracy and individual initiative, prompted the Pope in 1899 to warn against American demands for relaxation of doctrine and authority. "Something of a deep freeze set in," Hennesey writes, with the American Catholic Church slipping into "theological hibernation."

The Catholic Church in Europe has traditionally been a powerful and very rich patron of the arts, or those arts deemed acceptable to the church. (In the Vatican Museum, all the painting is religious in subject, although sculpture may be broadly mythological.) In the United States, however, Catholicism has been more geared to social assimilation than to creativity. Only in literature is there an American Catholic voice, such as that of James T. Farrell in his novels on the immigrant experience in south Chicago. (Jazz Age novelist F. Scott Fitzgerald ranks as "lace-curtain" or upper-class Irish Catholic).

In the 20th century, American Catholicism has moved from the city slums into the socio-economic and cultural mainstream. The last great outburst of nativism in the 1920s, fueled by the Ku Klux Klan, resulted in the defeat of presidential candidate Al Smith, a Democrat who happened to be Catholic, in 1928. In the 1930s, the Catholics produced radio priest Father Coughlin, a leading right-wing demagogue, and in the 1950s, Joseph McCarthy, who only happened to be Catholic but who enjoyed strong support in the Catholic community. (The Roman Catholic Church, not surprisingly, has been militantly anti-communist since the Bolshevik revolution, a popular stance in the United States. As Cardinal Spellman once put it succinctly, "Communism is un-American.")

The movement of American Catholics into the mainstream was accelerated in the 1960s by the election of the first Catholic president, John F. Kennedy, by the reign (1958–63) of the liberal Pope John, and by such leveling measures as the introduction of the English-language mass and the elimination of the required fish for Friday dinner. (Some Catholics, including writer Camille Paglia, regret the pomp and ceremony lost to these reforms.) By the end of the decade, there were even some radical Catholic priests, the Berrigan brothers, active in opposition to the Vietnam War.

In the 20th century, Roman Catholics constituted half of all Christians and the world's largest (and probably most powerful) church.

American Catholics by James Hennesey is long on detail and short on interpretation.

ROMANESQUE

It was only in the 19th century that the concept of Romanesque was elaborated to describe the style based on ancient Roman forms—chiefly the rounded arch and the barrel vault, plus columns and arcades—which was widespread throughout Europe in the 10th and 11th centuries A.D. This was the era of feudalism, when the Christian church was extending its influence and the monastic orders ranked as major centers of culture. Churches and monasteries (the Cistercians and Cluniacs were particularly avid builders) of massive stone—"fortresses of God"—became the chief Romanesque architectural forms.

American Romanesque: H. H. Richardson's Marshall Field Warehouse (1885–87, demolished 1930), Chicago *(Chicago Historical Society)*

Since the great European cathedrals were typically built over centuries, and because the Romanesque style was only gradually superseded by the Gothic in the course of the 12th century, it is common to find the two styles mixed. It is therefore in thousands of medium-sized and smaller European churches, built sturdily for the ages (often with the more durable flat, timber ceilings), that Romanesque achieved its purest expression. Their scale is very human, their massive stone walls affording a great sense of peace, security, and also excellent acoustics for the appropriate Gregorian chant. Romanesque church decoration is very plain, consisting principally of stone-carved portals and capitals. These usually depict biblical scenes, sometimes fantastic or apocalyptic, particularly in the French churches. (Historian Oswald Spengler, who didn't like Romanesque decor, described it in *The Decline of the West* as "fear turned into stone.") Portals may feature long columnar figures, strictly frontal. The most common theme of these portals is the last judgment—"a product of the millennarian psychosis," social art historian Arnold Hauser points out, and "at the same time the strongest expression of the authority of the church."

Romanesque was one of the first "international" styles, spreading throughout Europe chiefly via the church. Regional variations which might be mentioned are the single campanile of Italian churches, the double-towered Norman facade and the double Ottonian apse. Among 10,000 Romanesque structures surviving in Europe today, the best known to Americans is probably the Leaning Tower of Pisa.

In post–Civil War America, Romanesque enjoyed a revival thanks to the work of

a single architect, H. H. Richardson, who was impressed by its simplicity, spaciousness, and dignity. Some of Richardson's chief efforts, all in heavy stone and highly rusticated, include Boston's Trinity Church (its tower copied from a Spanish cathedral), the Hay-Adams House in Washington, D.C., and the Marshall Field Building in Chicago—all built for the ages with "ostentatious durability." In the words of the architect's biographer, he used "glacial boulders with titanic boldness, almost as if he commanded the forces of nature." It was the age of industrial feudalism, points out Henry Steele Commager in *The American Mind*, and Richardson considered Romanesque symbolic of power and permanence in America just as it had been in medieval Europe.

An excellent introduction is *Romanesque Architecture* by Hans Erich Kubach. For American Romanesque, see Henry-Russell Hitchcock's biography, *The Architecture of Henry H. Richardson and His Times*.

ROMANTICISM

At once a chronological period, a critical and stylistic approach, and a personal credo, romanticism is one of the more difficult period-styles to define. The word itself derives from romance, meaning the love and adventure stories in vernacular romance languages (as distinct from Latin) which became popular in the late Middle Ages. By definition remote in time and place, unreal or exotic, but affording an intense empathic experience, the romance enjoyed a new popularity in the late 18th century.

The philosophy of romanticism, as first expressed then in the works of Jean-Jacques Rousseau and Johann Wolfgang von Goethe, focused on the individual in revolt against the shackles of convention, whether social, political, or artistic. Rejecting the prevailing neoclassical style, the romantics went so far as to deny the validity of all objective rules and absolute values, demanding free rein for imagination, emotion, and subjectivity. Anti-intellectual, rejecting harmony and proportion in favor of inspiration and chaos, many romantics would find there was only a thin line between imagination and insanity. The romantics invented the identity crisis, Camille Paglia points out in *Sexual Personae*. They also created Frankenstein, a study in aberrant personality.

The early classics of European romantic literature are autobiographical, confessional, introspective if not self-indulgent: Rousseau's *Confessions* (1781-88) and Goethe's *Sorrows of Young Werther* (1774). In the field of poetry, the English romantics around the turn of the 19th century excelled in using nature as an instrument to express their feelings—Byron, Wordsworth, Shelley, and Keats. Then there were romantics who took refuge in the past, such as popular novelist Sir Walter Scott, author of *Ivanhoe* (1820). Around this time, the era of industrialization begins and romanticism seems to offer escape from grim reality. French romanticism in the 19th century (sometimes called "black romanticism," as distinct from the "white romanticism" of the English poets) developed a particular affinity for decadence, and German romanticism a fascination with the demonic.

In painting, romanticism is characterized by the abolition of rules and boundaries, by the weakening of line to liberate color, and by a new fascination with the forces of nature. These traits appear in landscapes by the Englishman J. M. W. Turner, volcanoes of color, imminent with catastrophe; the larger-than-life scenes of incredible carnage and ferocity painted by the Frenchman Eugène Delacroix; or the Spaniard Goya's obsession

with the horrors released by the new irrationality. Romantic artists began by asserting the supremacy of landscape, then discovered that nature was not always benevolent and beautiful. (There is a whole romantic subgenre of disaster pictures, especially shipwrecks.)

Perhaps the preeminent romantic art is music, evoking as it does moods of longing, suffering, fear, and sublimity. Still working within classical symphonic and sonata forms, Beethoven infused them with the new romantic dynamism and tension. Other great romantic composers—Chopin, Liszt—moved from classical into freer forms such as the rhapsody and fantasy, which they invested with great passion and bravura. Liszt was also an accomplished performer, the inventor of the solo concert (considered by some a great conceit) and the object of mass hero worship; women even followed him on the streets, like groupies pursuing rock stars.

As historian Jacques Barzun remarks, romanticism came to be considered an aberration, a term of ridicule and reprobation, even a form of insanity. This conservative backlash was partly political in motivation, based on the coincidence or confluence of political and artistic romanticism. One of the great romantic archetypes was Napoleon, whose particular genius and path to individual self-realization would plunge Europe into war and chaos. Early romantics such as Goethe and Beethoven who first welcomed Napoleon as a liberating hero would later revise their opinion. And just as the French emperor's search for personal and collective identity ended in imperialism, German romanticism with its worship of nature, the past, and the irrational, would eventually feed into fascism.

American romanticism is a special case, considering that our entire national epic was based on revolt against Old World conformity and convention. In literature, there was James Fenimore Cooper, who like Scott and the Germans romanticized the past, and Nathaniel Hawthorne who insisted that his *House of the Seven Gables* was romantic because it was set in past time. In poetry, Whittier, Longfellow, and Whitman were provincial versions of Wordsworth, Byron, and Shelley. In philosophy we have transcendentalism and in art, the Hudson River school, worshippers of nature. The great American historians Prescott, Motley, and Parkman are considered to have made historiography a branch of romantic literature.

Any discussion of American romanticism, particularly in art and literature, usually spills over into realism, a movement which overlapped with and extended romanticism. The problem may be that historical American reality was, in effect, a form of high romance—the romance of the frontier. Cultural historian Vernon Parrington even considers economics the great American romance, or perhaps romantic obsession.

The literature on romanticism is extensive. Hugh Honour's *Romanticism* is a good introduction, particularly with respect to the visual arts. For a more general cultural history, see the third volume of Arnold Hauser's *The Social History of Art* and Jacques Barzun's *Classic, Romantic and Modern*. The second volume of Parrington's *Main Currents in American Thought* is subtitled "The Romantic Revolution." In the Thames & Hudson series, William Vaughan wrote *Romantic Art*.

RUSSIAN

Icons, incense, and onion-domed churches; snow, samovars, and redemption through suffering; furs, jewels, embroidery, and enamels; sumptuous coziness, legendary hospi-

Our Lady of Jerusalem, **icon of the Moscow school, 17th century** *(Timken Museum of Art)*

tality, and the lavish romantic gesture—this is the world of old Russia, which since the collapse of communism seems to be reasserting its magic.

The Russian style was cobbled together over the centuries from diverse influences. The first and most significant is that of Orthodox Christianity, a rite inherited (along with the Cyrillic alphabet) from the Byzantines in the 10th century. In Russian history, the Russian Orthodox Church goes back further than the state, assuming particular importance as a focus of national life during two centuries of Mongol domination.

With its rich Slavic liturgy and pageantry, the Russian church is said to have influenced every aspect of daily life. Of particular interest here, the church gave rise to the single most distinctively Russian art form, the icon, a religious figure or scene painted

on wood. Statues being forbidden as graven imagery, Russian churches are decorated with icons—a whole wall of them, called the *iconostasis*, separating the congregation from the sanctuary. Russians also kept icons at home, so they were always in plentiful supply; travelers reported seeing "mountains" of icons in the marketplaces.

The icon tradition derives from Byzantium, but Russian work is said to be recognizably different. Where figures in Byzantine icons are austere and dignified, those in the Russian are more "human," more compassionate, gentler, and more emotional. Experts have various ways of classifying icons: by subject matter (historical, for example, or biographical); plain or *oklady*, meaning encased in special gold or silver frames leaving only the face and hands visible; and by geographic provenance. The city of Novgorod, powerful in the 13th and 14th centuries, was especially highly esteemed for its icons, which feature lively scenes and a glowing flame-red color. Another style was named for the Stroganovs, the family of merchant-princes who established their own icon-painting workshop in the late 16th and 17th centuries. (Stroganov style, considered the last flowering of icon art, is elegant, with fine detailing.)

The church completely dominated Russian art from the 10th to the 17th centuries when, over church opposition, secular influences began to make themselves felt. Early Russian portraiture, interestingly enough, is in an icon style. With the reign of Peter the Great, a deliberate attempt was made to secularize and westernize Russia, especially its arts and architecture. Traditional Russian architecture having been in wood and notoriously susceptible to fire, very little survives from before the 17th century. Peter was the first to build for the centuries, inspired by his travels in Europe, in a style which the Russians call "Peter's baroque." The czar's new capital in the marshy north, St. Petersburg, was inspired by the Dutch canal towns he had visited; he also went to Versailles, the influence of which is discernable in the grand palace complexes that Peter and his successors built—palaces with immense frontages, horizontally oriented with uniformly elaborate window treatments on each floor, and generously provided with the columns for which the Russians have a special affection. Within, Russian palaces somehow manage to combine the most extreme luxury—halls of mirrors, for one—with proverbial Russian coziness. Peter's daughter Elizabeth continued to build in the latest European styles, bringing rococo to Russia.

Russian art, literature, and music also underwent deliberate Westernization in the 19th century. Russian easel painting seems rather a pale imitation of European, down to the end of the 19th century, but Russian music and literature, channeled into conventional novel and symphonic forms, remain unmistakably Russian. Pushkin's poetry (a more traditional medium) loses its special magic in translation, but the novels of Tolstoy and Dostoyevsky, great in any language, seem to embody the strivings of the Russian soul, so given to mystical absolutes. The musical compositions of Glinka and Rimsky-Korsakov, Tchaikovsky and Mussorgsky also seem archetypically Russian, classical and intensely, emotionally romantic at the same time.

In the last half of the 19th century a conscious effort was made to identify a purely Russian style, peeling away Western influences to find essential Russian characteristics and traditions. Most of the surviving grand architecture in Russia (except churches) is not only Western in style, but was even designed by Western Europeans, a long succession of Italian, German, British, and French architects and artisans. Yet it is often said that these foreigners never created anything so beautiful in their native countries, that their work in Russia was somehow mystically infused with the Russian spirit. (Put

the other way around, the Kremlin in Moscow, although designed by expatriates, is considered the most Russian of monuments.)

The great Russian medium, in which storytelling, art, and music come together with epic sweep, is the ballet. In the late 19th century the Imperial Ballet School was producing the world's finest dancers, and a succession of the world's great ballet classics, Tchaikovsky's *Sleeping Beauty*, *The Nutcracker*, and *Swan Lake*. Thanks to Diaghilev's touring Ballets Russe, all of Europe was treated to the magical spectacle of Russian ballet, with fabulous stage decor by Léon Bakst, in the last years of the czarist regime. After the Bolshevik revolution, the Kirov ballet (named for a party boss) preserved this tradition, frozen in its pre-revolutionary splendor.

"A culture of beauty, generosity, grace and exuberance," as Suzanne Massie writes of old Russia—little of this seemed apparent during the 70-odd-year period of Russian communism. What has survived besides nostalgia, and a ballet tradition living on the past? The composers Prokofiev and Shostakovich managed to struggle toward modernism in music, but in literature and the visual arts all creativity was stifled or forced to express itself in code for three generations. Since glasnost, regrettably, the cultural energies of the Russian people seem to be wholly absorbed in capitalist gangsterism and frustrated consumerism.

Suzanne Massie's *Land of the Firebird: The Beauty of Old Russia* is highly recommended. A good, shorter introduction in the old Praeger World of Art series is by Tamara Talbot Rice, *A Concise History of Russian Art*. Laura Cerwinske's *Russian Imperial Style* is evidence of a revival of interest in the subject, at least in the West. In the Pelican History of Art series, see George H. Hamilton's *The Art and Architecture of Russia*.

Seize the day.

Horace

SAVONNERIE

This is the first original knotted-pile carpet of European design and manufacture, named for the old soap factory outside Paris where Louis XIII set up court workshops in 1626. The king also prohibited the import of Oriental carpets, to protect the new French carpet industry. But the French proved no match for Turkish and Persian carpet weavers, achieving at best only one-tenth the output per worker. The result was one of the most expensive carpets ever made, if one had been able to buy them, which in general one could not. Most of the limited Savonnerie production was monopolized by the monarchy, which took 90 large carpets for the Louvre Palace alone. Some of these carpets can still be seen in the Louvre Museum in their gorgeous original baroque and rococo period settings, coordinated with the furniture, the wall colors, even the ceiling moldings.

Savonnerie rugs feature elaborate floral designs with medallions, garlands, scrolls, and ribbons. Colors are soft pastel and, instead of being outlined as in Persian carpets, shade away naturally. The rug has a heavy pile of excellent wool, and is usually quite large, having been made for use by kings and courtiers. Authentic Savonneries are available only from estates, not having been woven or imported into the United States since the 1930s. (In the 19th century, Savonnerie production was transferred to the Gobelins factory in Paris, which still produces token rugs for official government gifts.) Excellent modern copies are made in Japan and India, at a fraction of the price of an antique.

The pastel prettiness of one of the most expensive carpets ever made, the Savonnerie
(Metropolitan Museum of Art)

(Baby-powder heiress Barbara Johnson sold a Savonnerie dated c. 1670 at auction in May 1992 for $1.2 million, the second highest price on record for a rug.)

SCHOLASTICISM

During the Middle Ages a new method of biblical disputation arose among the "school-men," clerics who were the repositories of all learning, in the endeavor to turn Christianity into a philosophy as well as a religion. The method was to debate, question, postulate, and re-examine endlessly—for example, the matter of how many angels fit on the head of a pin. (It was William of Occam, a 14th-century English Franciscan, who evoked the needless multiplication of entities such as angels in his argument against Scholasticism.)

Scholasticism unleashed wars of logic that raged for decades, arousing bitter and lasting enmities between "nominalists" and "realists" over the question of whether universals came before particulars (terms set 1500 years earlier by Aristotle). Since the philosophy of Christianity had in any case to be compatible with Christian doctrine, originality was precluded and the process of debate tended to turn dogma into dogmatism. Medieval truth was not what could be proved, but rather what conformed to prior revelation, according to architectural historian Nikolaus Pevsner. In *An Outline of*

European Architecture, Pevsner compares Scholasticism to the lofty, intricate flights of the Gothic style.

Scholasticism was a European-wide movement: there was Peter Abelard in France, John Duns Scotus in Scotland, and Meister Eckhart in Germany. The great Scholastics also include Anselm, Archbishop of Canterbury, author of an ontological proof of God's existence, and the Italian St. Thomas Aquinas who, with five proofs of the same, ranks as the official theologian of Roman Catholicism.

Needless to say, Scholasticism today is synonymous with pedantry.

SERIALISM

In the evolution of musical style, the single most revolutionary development is probably the elimination of tonality in favor of a system in which all 12 tones of the scale carry equal weight. Atonality or unresolved dissonance had been common since the late romantic period, with the German opera composer Richard Wagner exploring chromatic harmony and the French "tone poet" Claude Debussy making harmony non-functional. But it took Viennese composer Arnold Schoenberg, whose early works were in a dissonant romantic vein (which musical scholars compare to the then prevailing artistic style, expressionism), to abandon tonality altogether after World War I.

Seeking a new organizing principle to emancipate dissonance, Schoenberg devised the serial or 12-tone row and its variations (forwards, backwards, even upside-down). The resulting odd progressions and wild leaps were highly cerebral and esoteric, leaving audiences puzzled and unresponsive. During the 1920s and 1930s, which were dominated musically by the neoclassicism of the émigré Russian composer Igor Stravinsky, Schoenberg and his pupils continued to work in isolation, cultivating an intensely devotional atmosphere. It was only in the 1950s that a new generation of European composers (the Frenchman Pierre Boulez and the German Karl-Heinz Stockhausen) began to incorporate serialist as well as aleatory techniques, and even Stravinsky made a celebrated belated conversion, writing all his late compositions in the 12-tone style. But by the 1960s serialism appeared to have run its course. The style which had seemed so logical, so high-tech, so exquisitely abstract, proved in the end barren and incomprehensible to all but the most dedicated musicians. It was succeeded in the avant-garde by minimalism. Sometimes called "neo-tonal," minimalist music is so simple and repetitious that it induces hypnotism rather than apathy.

SEVRES

The French town of Sèvres, along the road from Paris to Versailles, is where French porcelain production moved in the mid-18th century under the patronage of the king. Sèvres was then granted a monopoly for the manufacture of "porcelain in the style of the Saxon, that is to say, painted and gilded with human figures." The reference here is to Meissen, where the secret of porcelain was rediscovered around the turn of the 18th century and production developed under the patronage of the Saxon king. When Meissen went into decline around 1760, Sèvres took over European leadership from the Germans.

The distinctive style of porcelain developed at Sèvres features brilliantly colored enamel grounds in dark blue, turquoise, yellow, green, and a rose-pink named for

Madame Pompadour, with gilded and garlanded medallions and panels containing rococo pastoral scenes à la Boucher. Opulent, showy, and expensive—"a particularly French fusion of prettiness and elegance"—Sèvres porcelain was marked with the crossed Ls of the royal cipher. Typical products from the royal factory were large vases, figurines, and commemorative bowls.

In the last years before the French Revolution of 1789, Sèvres fought to maintain its primacy by imitating Wedgwood jasper ware as it had earlier copied Meissen. In 1793,

Sèvres wine cooler (c. 1790) from a service made for Louis XIV (*J. Paul Getty Museum*)

Sèvres became a state factory, with "RF" (République Française) replacing the royal Ls. During the Napoleonic era, Bonaparte replaced the Bourbons as chief patron and customer of Sèvres, now producing in the neoclassical Empire style, with occasional Egyptian and other exotic motifs celebrating France's imperialist victories.

In the 19th century, Sèvres employed artists including the sculptor Auguste Rodin. Like most of the world's great porcelain manufactories, Sèvres went through art nouveau and art deco periods. In the latter 20th century, now located in the Paris suburb of St. Cloud, the Sèvres factory produces mainly copies from its heyday, the opulent, elegant ancien régime, its mark again featuring the royal Ls. Authentic Sèvres can be bought new only from the factory store, its Paris boutique, and Baccarat shops in Japan. Only about 5,000 pieces are produced annually, many of these for state and diplomatic purposes, so prices are proportionately grand. As for antique Sèvres (rose Pompadour is the most valuable), fakes have always been so common and often so skillful as to render the market very uncertain.

SEZESSION

This Austrian version of art nouveau, founded in 1897 under the leadership of Gustav Klimt, drew heavily on the new schools of symbolism and psychoanalysis, the latter a homegrown phenomenon. There were earlier movements under the same name (meaning secession or to withdraw), including one in Berlin formed by a group of artists who left the Academy of Fine Arts when Kaiser Wilhelm called their work "art from the gutter." In the United States around the turn of the century, an important group under Alfred Stieglitz styled itself the "Photo-Secession." The Austrian group, while likewise divorcing itself from the academic art establishment, also enjoyed mainstream popularity and success, even receiving important commissions. (Art critic Hilton Kramer describes Klimt as "court painter" to the Viennese upper middle-class.)

Klimt's allegorical canvases of voluptuous women, often with hooded or closed

eyes, against a richly textured, kaleidoscopic background of mosaic and arabesque, continue to fascinate. Whether they are asleep, narcotized, or in some sort of sexual thrall, Klimt's women represent typical fin-de-siècle icons of the alluring temptress, expression of the suppressed subconscious. The utterly improbable ornamental patterning, in particular, makes the naturalistic figures seem even more dreamlike, emblematic of dark subterranean passions. (Freud's *Introduction to Psychoanalysis* could or should have been illustrated by Klimt, someone once said.)

After Klimt, the best known Sezessionists were architects Otto Wagner and Jozef Olbrich. Another Viennese architect, Adolf Loos, wrote a personal manifesto entitled *Ornament and Crime* (1908), describing excessive use of ornamentation as "criminal and perverted"—seceding in effect from the Sezessionists. The movement gradually became more conservative, splitting in 1911 in disagreement over the growing trend to expressionism.

Frank Lloyd Wright's biographer Brendan Gill points out that Wright's Unity Temple and other projects in Chicago (but curiously, none in New York) are based on Sezessionist models, particularly in their external art nouveau–style ornamentation. And American architect Louis Sullivan was designing in this style even before the Sezessionists.

This style is discussed in books on art nouveau and symbolism.

SHAKER

For a sect with such a small membership (an estimated 4,000 to 6,000 at its peak in 1840), the Shakers have enjoyed a disproportionate share of attention and influence in America. Founded by Ann Lee, an illiterate working-class woman who came from England in 1774 with a handful of followers, the Shakers were an offshoot of the Quaker movement, called "shaking Quakers" for their shuffling, leaping dances when seized by the Holy Spirit. (Officially, they called themselves the United Society of Believers in the First and Second Appearance of Christ.)

In America, Mother Lee gathered converts who accepted her as Christ's second coming in feminine incarnation. These Shakers established communities, which, for their holding of property in common and especially for their rule of celibacy, rank as monastic. Having lost four children in childhood, Mother Lee believed men and women should live together in the innocence of brother and sister—with safeguards such as separate quarters and even separate entrances into buildings. Pouring all their love and faith into their communities, the Shakers created a lifestyle and a style in pure, unadorned objects, handcrafts, and architecture that still command admiration. "Truth made visible," the Shaker style has been called. Their distinctive gambrel-roofed meeting houses, their superlative barns and their living quarters (with pegs on the walls everywhere to hang cloaks, hats, even chairs; they said they hung everything but people, leaving that for the world to do) can still be seen in New Lebanon, New York; Pittsfield, Massachusetts; Canturbury, New Hampshire; Sabbathday Lake, Maine; and Pleasant Hill, Kentucky. (Shaker Heights, the prosperous Cleveland suburb, is the site of another former Shaker community.)

Far from rejecting modern progress (like the Amish, with whom they are sometimes confused), the Shakers invented labor-saving devices such as the circular saw and the clothes pin, which they freely shared with all. Highly productive, they marketed

their surpluses, whether stoves (considered the best available), maple candy, homespun cloth, medicinal herbs, brooms, and baskets. Perhaps most distinctive of all Shaker crafts are their much admired oval wooden box and the ladder-back chair (built, as mystic Thomas Merton once said, "by someone capable of believing that an angel might come and sit on it"). Shaker carpentry in general is characterized by built-in cabinets, exposed joinery, and an absence of veneer.

After their initial growth and expansion, the Shakers went through a more conservative phase when their shaking (a source of great curiosity to outsiders; Charles Dickens, on a visit to the United States, reported disappointment at not seeing the Shakers "shake") was formalized into a simple dance. Then there was a mid-19th-century revival, with revelations and communications from the spirit world, but in the 20th century the Shakers have declined steadily. In 1957 they decided not to accept new members, leaving only a handful of old sisters living in museum villages.

Of the extensive literature available on the subject, including at least three handsome coffee-table books, *The Shakers: Hands to Work Hearts to God* by Amy and Ken Burns is recommended.

SHANG

The earliest named Chinese dynasty, the Shang ruled in the Yellow River Valley from around 1800 to 1100 B.C. They are known to have built large walled towns, and to have created a system of writing, but they are best remembered for their masterpieces in bronze, which have seldom been equaled. Shang bronze was cast (by the *cire perdue* or lost wax method) in simple massive shapes (mostly ritual containers and pouring vessels, one of which is depicted on p. 33), their surfaces decorated with intricate stylized motifs: tigers, dragons, snakes, and other fabulous animals but few human figures. Scholar William Watson points out many striking resemblances between Shang and pre-Columbian motifs, and also compares the decorative spirals of the Shang to some found in Celtic Britian.

There are many Shang bronzes, unearthed by archeologists only in the 20th century, in U.S. collections—notably the Freer Gallery of Art in Washington, D.C., and the Nelson-Atkins Museum in Kansas City. The Shang Chinese also carved the same motifs on objects for cult use made of bone, ivory, turquoise, and especially jade. The latter, considered the hardest stone in nature, is not found in China but was so highly valued for its magical properties that it was imported great distances from central Asia.

Shang Civilization by Kwang-chih Chang is detailed and well illustrated.

SHI'ISM

The political revolutionaries of Islam, Shi'ites trace their origins to a dispute over the succession to Muhammad in the early years of the faith. They profess allegiance to the prophet's direct descendants through his son-in-law Ali—the so-called 12 imams, all of whom were martyred. Historically, therefore, the Shi'ites have cast themselves as a persecuted minority—their holidays, shrines, and pilgrimages all revolving around the martyred imams—in social and political rather than theological revolt against the Sunni Islamic mainstream and majority.

Shi'ism has been chiefly important historically as a source of political unrest. During the Crusades, the European Christians discovered and used the split between the Sunni Turks and the Fatimid Shi'ites in Egypt. In modern times there are three different groups of Shi'ites. First and most important are the Imamis of Persia, who accord the person of the imam a personal religious authority denied by the Sunni to the caliph. (Muslims generally have no priests, except the Shi'a, who submit to the authority of mullahs or spiritual guides and ayatollahs, the imam's regents or vicars.) Other Shi'ite groups are the Zaides in Yemen, and the Isma'ili, who included the Fatimids and another offshoot once called the Assassins. A small group of Isma'ili who fled to India in the 19th century continues to pay homage to an Aga Khan as the living imam.

As the Persian state religion since the 16th century, Shi'ism became identified with Persian nationalism. The imams were even said to be of Persian blood by marriage to the daughter of the last Zoroastrian king. Historically, Shi'ism was also associated with the Persian cultural renaissance under the Safavids, who were not so strict as the Arabs about representation of animals and humans, both appearing in their illuminated manuscripts, rugs, and other media.

Shi'ism as a nationalistic movement has flowered again in Iran after fundamentalists overthrew the last shah in 1979, the first successful Muslim revolt against a modernizing Western-style government. The Ayatollah Khomeini, the Iranian Shi'ite leader whose black turban denoted descent from the seventh imam, also sometimes styled himself *the* Imam (elsewhere imam simply means a religious man, but Iranians reserve the title for direct descendants of Ali). Fiercely puritanical and xenophobic, Khomeini advocated direct rule by the clergy and a universal Islamic state to stand up to the "satanic superpowers." Targeting his enemies more specifically, he preached death to the Christian "cross-worshippers," to Zoroastrian "fire-worshippers" (meaning domestic non-believers), to the heretical Baha'i, and especially to the Israelis, whom he accused of plotting to emasculate Islam.

Today Shi'ites constitute only 10 to 15 percent of the Islamic world, considering themselves a persecuted minority even where they are the majority, as in Iraq and Bahrain. Ironically, the most important Persian Gulf oil deposits lie in Shi'ite areas, even in Saudi Arabia which has only a small Shi'ite population. Another critical Shi'ite group lives in Lebanon, constituting 30 to 35 percent of the population, including the most radical elements of that war-torn society. But they are not alone, according to historian Moojan Momen, in targeting American imperialism and Zionism as scapegoats. Shi'ite fundamentalism is proving increasingly popular even to Sunnis who would like to rid their religion and lifestyle of Western influences.

Moojan Momen's *An Introduction to Shi'a Islam* describes the complex genealogy and beliefs of Shi'ism, such as the Occultation (meaning not dead; just invisible to man) of the twelfth imam. *The Spirit of Allah; Khomeini and the Islamic Revolution* by Amir Taheri is a reasonably balanced account of recent Iranian history.

SHINTOISM

It was thanks largely to the persistence of its ancient religion of Shintoism (from *shintao*, or way of the gods), Oriental scholar Ernest Fenollosa suggests, that Japan managed to maintain a separate identity despite China's long-standing cultural dominance

in the region. A form of nature idealization, Shintoism (which has no scriptures) holds that nature's manifestations possess a form of consciousness, with the sun goddess (from whom the Japanese emperor is traditionally believed to descend) holding pride of place. The second major aspect of the religion is family worship, the family also being writ large to include the emperor as supreme father. Other important Shinto values are cleanliness, purity, and obedience.

Besides household and village spirits, the Shinto pantheon includes emperors and heroes, to whom sacrifices—including the supreme sacrifice, *hara-kiri*—are made. Because of its identification with Japanese militarism in World War II, the U.S. occupation forces banned Shintoism as a state cult (but not as a private religion) after the war. It survives in contemporary Japan as a body of traditional rituals, festivals, and customs observed by 65 million believers, many of them also Buddhists. (The late emperor Hirohito's public funeral in 1989 was interrupted for a private Shinto ritual, while his grandson's 1993 wedding incorporated Shinto elements.)

SIOUX

The hard-riding, tepee-dwelling Indians most familiar to us, thanks to Hollywood films, are the Sioux. Of all the Plains Indians (of whom they will be considered here as representative), certainly the Sioux have burned their image most searingly on the American conscience and consciousness. By fiercely resisting Anglo Manifest Destiny for 40 years, from 1850 through Custer's Last Stand in 1876 to their own, at Pine Ridge, South Dakota, in 1890, they survive in popular legend and in countless movies (a recent example is *Dances with Wolves*, 1991) as the archetypal Native American warriors.

Highly skilled with horse and rifle (both of which they acquired from the white man), the Sioux developed a culture of bravery and audacity to the point of self-destruction. Their religious rituals such as the sun dance involved incredible feats of endurance, even self-mutilation. (Remember the 1970 movie, *A Man Called Horse?*)

As buffalo-hunting nomads, the Sioux and other Plains Indians developed decorative arts and crafts that were eminently portable. Their tepees, conical, collapsible skin tents ranging from 12 to 30 feet across, were often painted with ceremonial designs

An Oglala Sioux warrior (c. 1877) photographed by W. H. Jackson *(San Diego Museum of Man)*

and narrative scenes featuring pictographic figures. The Sioux were also justly famous for their embroidery with porcupine quills and beads, which were attached to buckskin

garments in finely drawn patterns, usually geometric. (In the late 19th century, the Sioux repertoire of design was enlarged by copying from Oriental rugs carried west by wealthier settlers.) They developed pipe-smoking to a high art (their pipes are a small-scale form of sculpture) and created a unique sign language, a necessity for communication among the many different linguistic groups on the Plains.

The Sioux warrior's greatest work of art was probably himself. Much artistry went into his face-painting and coiffure, his fringed leather shirt, bone breastplate, beaded buckskins, leggings, and above all his great war bonnet of eagle feathers and ermine.

The adoption of the horse and the gun increased Sioux mobility and created a more flamboyant culture, but it also increased restlessness and strife. As their traditional way of life was being destroyed and they were being herded into government reservations, the Sioux developed a millenarian religion featuring "ghost dancing." These ceremonies, which they believed would purify the ground for the return of the buffalo and the resurrection of their dead, aroused anxiety among Anglos. In December 1890, as they were gathering near Wounded Knee for a ghost dance, hundreds of Sioux men, women, and children were killed by U.S. Cavalry, one of the great crimes of the opening of the West.

About 40,000 Sioux remain today on reservations in the Dakotas, Minnesota, Montana, and Nebraska. Not surprisingly, they still rank among the most militant of Native Americans. Some prefer to call themselves Lakota, although technically this is only one of several Sioux subgroups.

Bury My Heart at Wounded Knee by Dee Brown, once a bestseller, is a highly polemical account of American crimes against the Indians, with the Sioux taking pride of place among the victims. *The Mystic Warriors of the Plains* by Thomas E. Mails is a big, glossy picture-history of the Sioux.

SOCIAL DARWINISM

The U.S. publication of Darwin's theory of evolution on the eve of the Civil War had an enormous impact on American thoughts, beliefs, and political folklore, shattering Jeffersonian ideals of natural equality. Evolution was not a new concept in 1860, according to historian Richard Hofstadter; Hegel had already applied it to philosophy and Marx to politics. But Darwin with his catch phrases, "the survival of the fittest" and "the struggle for existence," struck a responsive chord in the American psyche. Applying the laws of nature to society, the survival of the fittest seemed to explain and rationalize the crueler aspects of industrialization and other forms of exploitation. Even more, it provided a conservative justification for unbridled individualism and laissez-faire government, rejecting government intervention to ameliorate socio-economic equities as meddling with the course of nature. As a result, Hofstadter writes, the post–Civil War United States, "with its rapid expansion, its exploitative methods, its desperate competition and its peremptory rejection of failure…was like a vast human caricature of the Darwinian struggle for existence and survival of the fittest."

In American literature, Jack London was strongly influenced by Darwinian ideas, glorifying violence, swagger, and Nordic supremacy. Another spinoff was eugenics, a movement organized around the turn of the century to improve the race by eliminating the unfit. (Some even went so far as to argue that the poor, by definition unfit,

should be eliminated.) On the world stage, Social Darwinism became an obvious rationale for colonialism and imperialism, the "white man's burden," and the Final Solution, with nations as well as peoples engaged in Darwinian combat. (Nazi dictator Adolf Hitler is reported to have nourished a full set of Social Darwinist prejudices; his Italian ally Mussolini believed war would improve the race.) It took two world wars to finally discredit the application of Darwin's theories to society.

Social Darwinism in American Thought by Richard Hofstadter is the standard work on the subject.

SOCIALISM

Imagine a society in which competition for scarce resources is replaced by cooperation, where thanks to communal control of production everyone's basic needs are met and fraternity and equality grow apace....This is the utopian socialist dream, an idealistic philosophy which in practice has multiple variants. There is the "scientific" socialism propounded by Marx and Engels (see MARXISM); the respectable contemporary European socialist movement; the European fascist movements, which also called themselves socialist; Third World socialism with its contradictory goals of modernization and preservation of traditional values; and then there is America, the only country in the world where *socialism* is a dirty word.

In Europe where it was invented, socialism has a long and respected history. So widely accepted were socialist programs that Bismarck, a leading conservative, co-opted them into a form of state socialism that persists to this day. The European socialist movement had aspirations to become a great international brotherhood, until the First World War when socialists of different countries broke ranks to enter the trenches against one another. In the mid-20th century, the socialist parties governing Europe are not very different from American parties except for their comprehensive social welfare programs; some even call themselves "Christian Socialists" and maintain ties with the church.

In the United States, the 19th century saw a variety of socialist experiments, sects seeking to redress their grievances by all manner of socio-economic tinkering. Among these were the Owenites and the Fourierists, the Oneida and Amana colonies, and the Shakers, who also combined socialism with religion. The American labor movement (unlike the European) has always been emphatically anti-socialist and pro-capitalist, but an American Socialist Party was founded in 1901, capturing six percent of the presidential vote in 1912 before it was split by the Bolshevik revolution and went into terminal decline. (Norman Thomas, by the way, second-generation American socialist leader and perennial presidential candidate, was a Presbyterian minister before going into politics.)

On leaving the realm of theory to become bogged down in the reality of communism, socialism came to be identified as anti-American, "un-American," to the extent that something like "socialized medicine" cannot even be rationally discussed. Or perhaps, as leading American socialist Michael Harrington suggests, Americanism is merely a rival form of socialism.

Harrington has written several books on the subject, including *Socialism*.

American auto workers as heroes of (capitalist) labor, in detail from Diego Rivera's mural *Detroit Industry* **(1932–33)** *(Detroit Institute of Arts)*

SOCIALIST REALISM

Established in the 1930s as the official canon for arts in the former Soviet Union, social-ist realism is not realism at all, according to art historian Linda Nochlin, but rather an idealized neoclassicism. Its purpose was above all inspirational and propagandistic, to provide heroic role models (such as Alexander Gerasimov's statue of Lenin) for the building of socialism. Whether or not the writer or artist was successful was a political rather than an aesthetic judgment, and the penalty for failure was extreme—not just inability to exhibit or publish, but re-education, exile, even death. The finest short-story writer of his day, Isaac Babel, persisting in the "heroism of silence," perished in a Stalinist prison camp in 1941. Although music does not lend itself so easily to political inter-pretation, the great Russian composers Shostakovich and Prokofiev were both con-demned for "formalism," or exalting form over content and feeling.

There is also a movement called "social realism," which might be described as the watered-down version of socialist realism for leftist artists in the West in the 1930s. The Americans Ben Shahn and Jack Levine and the Mexicans Diego Rivera and José Orozco worked in this tradition of didactic art, depicting class issues and political abuses, suf-fering, and injustice.

Yet another variant is capitalist realism, the invention of some former East German artists (chief among them Gerhard Richter and Sigmar Polke)—on embracing Western materialism in the 1960s. An offshoot of pop art with a duller palette and a more sardonic mood, capitalist realism enjoyed a vogue among California collectors.

See *Social Realism: Art as a Weapon*, edited by David Shapiro. Igor Golomstock's *Totalitarian Art* provides an excellent description of socialist realism in Stalin's Russia, and a telling comparison with Hitler's Germany.

SOCRATIC

Everyone knows of Socrates, the Greek philosopher sentenced to drink hemlock in 399 B.C. for impiety, nonconformism, and corruption of the youth of Athens. Actually, his real crime, as St. Augustine was one of the first to suggest, may have been mocking others, exposing their ignorance and inadequacy by what has come to be called the "Socratic method" of inductive discourse. As a contemporary reproached him, the ancient philosopher was always examining everybody but was never willing to render an account of himself.

The Socratic method of structured questions to solicit discourse survives today mainly as an instructional technique in American law schools. In practice, it can be a devious method whereby law professors bait their insecure students, posing questions in such a way as to elicit wrong answers, then leading the miserable student on to total confusion. After that miserable student passes the bar, some would say he or she then uses this same techcnique to make a mockery of the concept of justice.

Radical American journalist I. F. Stone learned Greek late in life to come to his own terms with *The Trial of Socrates*, siding, surprisingly, with the Athenian state against the nonconformist philosopher.

SPODE

The Spode family firm, established in England in 1776, is generally credited with finalizing the formula for bone china, the most important British contribution to ceramics and the standard British porcelain to this day. By adding calcined ox bone to soft-paste china, the Spodes found around 1800 that they could produce a dazzlingly white, thin, and

One family's Spode heirlooms *(courtesy Kriemhilde Schneider)*

translucent yet relatively strong china, much more economically than the state-subsidized German (see MEISSEN) and French (see SEVRES; LIMOGES) factories.

In design, Spode tended to copy Oriental and Italianate models, producing table-

ware and tea and dessert services with meticulously painted landscapes, birds, and flowers. The last Spode died in 1829 but the firm continues to this day, successfully producing fine bone china (one contemporary pattern is called "Sheffield," inspired by a Georgian silver pattern), available for sale at better American emporia of gracious living.

For background, see Leonard Whiter's *Spode: A History of the Family, Factory and Wares from 1733 to 1833.*

STEUBEN

The great pioneers of glass production in the United States were nearly all Germans: Caspar Wistar, who started a factory in New Jersey in 1739 to produce glass in the German folk tradition; Henry Stiegel, whose Pennsylvania glassworks (est. 1763) produced wares equal to those imported from Europe; and John Amelung, in Maryland from 1784, whose ornate rococo creations are among the most prized American antique glassware. Later came Louis C. Tiffany, whose art nouveau glass was celebrated the world over. After Tiffany, however, the only major American glass producer to survive was Steuben, founded in 1903 by an Englishman but named for a German hero of the American Revolution.

Steuben produced colored art glass in European design traditions until the Depression, when it cut back at first to colorless pure crystal. A division of Corning Glass since 1918, Steuben then adapted for fine design purposes a new glass formulation that had proved too soft for industrial use. The first samples of this clear, thick glass were crisply engraved in art deco, zigzag, and streamline moderne styles. Then in 1937 Steuben commissioned leading American and European artists (including Matisse and Dalí) to create designs in crystal for expensive limited editions, for sale only in exclusive shops. (Possibly out of pique, Tiffany's declined to stock it.) This remains the marketing strategy of Steuben, now best known for producing glass objects of absolutely minimal utility, such as paperweights and figures in heavy crystal. (The firm no longer makes stemware, but there is a market for "previously owned" pieces, some of them quite valuable.)

James S. Plaut's *Steuben Glass* is a standard reference with handsome illustrations.

STOICISM

The Stoics, as they were called after the lecture hall in Athens used by their leader, Zeno, advocated an almost Oriental spirit of resignation and passivity as the appropriate response to a world full of danger and suffering. Stoicism enjoyed a mainstream vogue in the Roman Empire under the Emperor Marcus Aurelius, then found fertile ground through the whole Hellenistic world during the decline of the Romans. (The same conditions also gave rise to a competing philosophy, Epicureanism, which went to the opposite extreme of hedonism.)

In common parlance, "stoic" is synonymous today with passivity, impassiveness, and imperturbable calm—not typically American characteristics. (The writer is indebted to Alan and Theresa von Altendorf in their book on *Isms* for identifying *Star Trek*'s Mr. Spock as a stoic.) On the historical scales, the Stoics weigh in as metaphysical idealists

whose theory of innate ideas would influence later philosophers, particularly Descartes; whose belief that human dignity required rights has come down to us through Roman law; and who first coined the grammatical terminology of language.

SUFISM

The word *sufi* comes from the wool in the penitential garments worn by this Islamic group, the great mystics and missionaries of their faith. A revivalist movement arising in the 11th century to challenge Sunni or mainstream orthodoxy and dogmatism, the Sufis practiced asceticism to achieve religious ecstasy and an intimate personal experience of God. Emphasizing love instead of fear, they struck a responsive emotional chord in the populace, enjoying great popularity.

The zeal of the Sufis also made them successful proselytizers, and an effective vehicle for the expansion of Islam through Africa and as far east as Indonesia. More than just converting new recruits, the Sufis also established mendicant and monastic orders that took an active role in maintaining the new Islamic communities.

In Persia, the brilliant Safavid civilization was originally based on Sufism. Sufi ideas and images found artistic expression in a Persian literature suffused with love and passion. (Interestingly enough, the language of earthly passion is also used to express communion with the divine.) Sufi imagery is even said to be perceptible in carpets of the era, at least to experts like Jon Thompson, who reports that Boston's Museum of Fine Arts has a famous example.

When Sufism first arose, it drained off vitality from Sunni orthodoxy. Gradually, it too declined and became institutionalized, after reaching its apogee in the 17th and 18th centuries. Critics object that Sufism encouraged the worship of saints and miracles, contrary to the teachings of the Koran. At their extreme, the Sufis gave rise to whirling dervishes and the fakirs of India, seekers of religious intoxication.

Sufism became known to some Westerners through the writings of Russian-born mystic and esotericist Georgei Gurdjieff. Anne Marie Schimmel covers Sufism in *Mystical Dimensions of Islam*.

SUNG

A thousand years ago, Sung China (population 100 million) was considered the most civilized and accomplished nation in the world. In strictly Chinese terms, the Sung period (960–1279) set standards of classical perfection—refinement and sophistication, serenity and nobility are words used to describe Sung culture—for all posterity. The supreme expression of Sung art was landscape painting on the theme of the grandeur and mystery of nature, with man constituting only a small, insignificant figure swallowed up in eternity. Mist and rain, great cloud formations, gnarled trees, and craggy mountains—these are all major elements of Sung landscape art, monochrome ink on silk, and of the poetry which developed in close relation to it. (Oriental expert Ernest Fenollosa refers to Sung poets, who were often painters as well, as the Chinese Wordsworths.)

This was also a golden age in ceramics, with the transition from T'ang earthenware to true porcelain. Sung ceramics are usually monochrome, in subtle shades with

Chinese landscape art at its apogee: *A Solitary Temple Amid Clearing Peaks*, probably a Yüan-era copy of a Sung original by Li Ch'ing *(Nelson-Atkins Museum of Art)*

abstract designs beautifully adapted to simple shapes. Two well-known types are Ting ware, which is fine white porcelain, fired face down and its unglazed lip bound with silver or bronze; and celadon, a porcelain or porcelaineous stoneware with a clear gray-green glaze applied over an incised surface. The result, in texture as well as color, is very like jade. (The 19th-century artist Whistler tried very hard to re-create the color and effect of Sung glaze in his paintings.)

Politically, the 10th to 13th centuries were a difficult time in China, with the Sungs trying to buy off rather than fight the northern tribes threatening them. Barbarians continued to hold most of the former T'ang empire, and in 1126 they broke through from the north and captured the emperor. (Famous in his own right as a painter of bird and flower scenes, this emperor died in captivity.) The Sung court then moved south to Hangchow, a beautiful lake country much celebrated in art and poetry, where the reduced dynasty survived another 150 years until it was overcome by the Mongols.

SUPREMATICISM

This was a short-lived modern movement, a "one-man performance" begun in Russia on the eve of the Bolshevik revolution by artist Kasimir Malevich. Declaring his purpose to liberate art from the "ballast of the representational world," Malevich extolled simple geometric forms as keys to the mystery of the universe. The straight line, for example, symbolizes man's ascendancy over nature, while the square, the basic suprematist element, constitutes a sort of a window on infinity.

In 1915 Malevich exhibited in Petrograd a black square painted on a white ground—not simply an empty square, he explained, but rather "the experience of objectlessness." (He also announced that year that he had caused objects to disappear like smoke.) In his most notorious painting, *White on White* (c. 1918), the square is said to lose even its vestigial materiality, merging into nirvana. The constructivist Alexander Rodchenko was so outraged by this painting (now in New York's Museum of Modern Art) that he produced a black on black canvas which he declared to symbolize the death of all artistic *isms*.

The wheels of international art lubricated by glasnost, the first comprehensive exhibition of work by Malevich ("The artist who came in from the cold") was held at Washington's National Gallery in 1991, sponsored by a whole roster of corporate malefactors of great wealth. Another exhibit in 1992 of Russian revolutionary art at the Guggenheim in New York featured both Malevich and Rodchenko without mentioning their dispute or differentiating suprematicism from constructivism, prompting the question whether it really matters. It would in any case be difficult to name the winner in this skirmish in the history of modern art, for the Russian revolution eventually swept all before it.

Although he considered art purely spiritual and "useless," objecting to constructivist perversion of it for utilitarian and propaganda purposes, Malevich did support the revolution. He also returned to representational art at the end of his life, depicting himself as a Renaissance prince in bold primary colors. The Soviet authorities allowed him to continue teaching until his death in 1935 when, his final artistic statement, he was buried in a coffin decorated with suprematist forms.

The best of accessible sources is Aaron Scharf's essay in *Concepts of Modern Art*, edited by Nikos Stangos.

SURREALISM

Surrealism arose in France in the early 1920s out of the dada movement, itself a reaction against the futility and destruction of World War I. The surrealists, who considered themselves philosophers first and only secondarily poets and artists, rejected the French Cartesian tradition ("I think, therefore I am") and the even more pessimistic Pascalian version ("Man is but a worm who thinks"). Instead, inspired by Freudian discoveries and the abundant contemporary evidence of human irrationality, they argued that man is above all a "sleeper." To establish contact with the world of dreams and the unconscious, they experimented with automatic writing and free association, also relying heavily on magic, superstition, surprise, and novelty. The result of their efforts, a mixture of dream and reality, they called "surreality."

From dadaism, the surrealists took over the role of *enfants terribles*, outrageous provocateurs engaging bourgeois society in a perpetual dare. They also rejected all authority, cultural as well as political. Not only did they denounce the literary establishment with gratuitous viciousness; they also flung down a challenge to the avant-garde cubists—"I'll smash your guitar." Politically they were very left-wing, subscribing to the Communist Party line in its most repressive period. But since they were not very good followers, many of the surrealists soon lapsed into deviant Trotskyism.

Much of what the surrealists wrote seems today like a lot of boring nonsense, a pretentious pose. Only in the field of art did the madness and exaltation they cultivated result in distinctive creations, dreamscapes full of wit and whimsy. Surrealist artists are generally subdivided into two or three categories, such as the abstractionists or "emblematics" (Joan Miró and André Masson) and the illusionists or "descriptives" (René Magritte, Yves Tanguy, Salvador Dalí). The abstractionists were given to spidery lines, biomorphic shapes, and other iconographic accretions. The illusionists juxtaposed dissociated objects, sometimes even on different scales, suggesting secret affinities among them. Magritte and Tanguy were especially adept at translating literary ideas into images, while

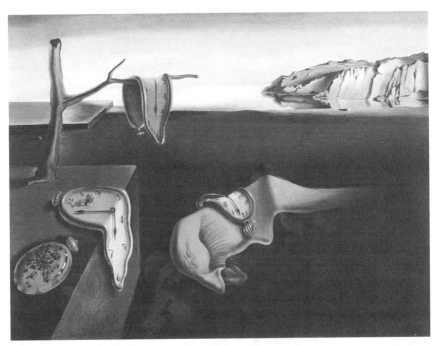

Improbable objects depicted with photographic realism: Dalí's *The Persistence of Memory* **(1931)** *(Museum of Modern Art)*

Dali explored states of abnormal psychology. (Reordering the history of art in terms of kinship to themselves, they claimed Giorgio de Chirico as a "proto-surrealist" and Paul Klee as a "para-surrealist.")

There was also a surrealist cinema, most notably the 1928 collaboration of Dali and fellow Spaniard Luis Buñuel, *Un chien andalou*. Neither about dogs nor Andalusia, the film proceeds from one shocking, unrelated image to another. But the filmmakers had a falling out, and Dali's reactionary politics—he supported Franco and welcomed Hitler as a surrealist innovator—soon brought him into disrepute. After a long hiatus due to the Spanish Civil War and the Second World War, Buñuel resumed making films, including the late surrealist classics *Viridiana* (1961) and *The Exterminating Angel* (1962).

As a group the surrealists were long-lived (André Breton, their chief ideologist, died in 1966; Max Ernst survived until 1976, and Dali to 1989), but they found themselves cut off, literally and artistically, by World War II. Many of them took refuge during the war in New York, where they had had a successful show in 1938 at the Museum of Modern Art, but they found few American converts, and a basically unsympathetic climate here for their arcane ideas. After the war, the abstract expressionists played with the surrealist idea of automatism, but rejected surrealist imagery, which relies on an almost photographic realism and classical perspective, no matter how bizarre the objects represented or how incongruous their juxtaposition. With historical hindsight, museum curator William S. Rubin calls surrealism "a kind of anti-modernist reaction situated parenthetically between the great abstract movements prior to World War I [cubism] and after World War II [abstract expressionism]."

If surrealism per se and its ideologues were too Old World for America, its influence nonetheless trickled down into U.S. design, advertising, and fashion. In everyday usage, the word has become almost as common a descriptive adjective as "romantic," signifying a timeless kind of slant or insight that may be perceptible in a modern photo, a 15th-century painting, or black humor.

Maurice Nadeau's *History of Surrealism*, which focuses primarily on the philosophy of surrealism, is dusty reading. On surrealist art, see William S. Rubin's excellent catalog for the 1968 MOMA exhibition, *Dada, Surrealism, and Their Heritage*. Richard Martin's *Fashion and Surrealism* explores commercial American manifestations of the style.

SWEDENBORGIAN

Emanuel Swedenborg was a Swedish thinker of the Enlightenment, a man of positively Bunyanesque achievement who is said to have mastered all known knowledge, writing copiously on everything from physiology and mining to astronomy. He was the first to discover the function of the cerebellum, he anticipated magnetic theory, and he designed an 18th-century airplane that later proved airworthy, according to devotees. Whatever the case, it is for his spiritual trips that Swedenborg is remembered, for he claimed ESP and precognition, walking with angels and talking with the dead, including some quite

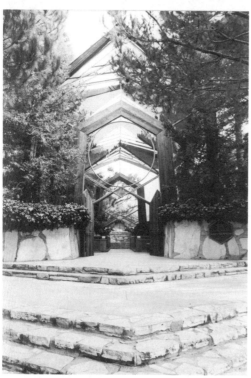

famous people (he even reported direct communication with the Lord). Some consider him the greatest medium in modern times.

Swedenborg created a trans-denominational community of like-minded Christians who accepted his concept of "cosmic rapport" as the basis of physical and mental health, even economic well-being. It was only after his death that the Swedenborgian Church of the New Jerusalem was founded, never claiming any significant numbers but feeding into every conceivable strain of radicalism.

In American history, Swedenborg influenced some distinguished groups such as the transcendentalists, as well as faith healers, mesmerists, and spiritualists. Ralph Waldo Emerson wrote an essay on Swedenborg, whom he called a "mad magus"; Henry James, Sr.,

The Wayfarers Chapel (Lloyd Wright, 1949), Palos Verdes, California, a "religious greenhouse"

(father of both the novelist and the psychologist-philosopher) was helped through a severe mental crisis by the chance discovery of Swedenborg's works; 19th-century novelist William Dean Howells and 20th-century poet Robert Frost both came from Swedenborgian backgrounds.

An eloquent architectural expression of the Swedenborgian belief in cosmic rapport or "correspondences" between man, nature, and the beyond, is the Church of the New Jerusalem's Wayfarers Chapel in Palos Verdes, California, described by G. E. Kidder Smith as "a religious greenhouse."

There are only a few thousand American Swedenborgians today.

The literature on Swedenborg appears to be all inspirational.

SYMBOLISM

This literary movement arose in France in the 1890s as an extreme reaction against that country's strong classical conventions of clarity and logic (see CARTESIAN). Where the French romantics had relaxed the rules only somewhat, investing greater emotionality into still conventional forms, the symbolists threw out both form and content to invent their own. (In literature, art professor Meyer Schapiro once remarked, innovators in form like the symbolists are rare; most great novelists, for example, continue to use the same form as their predecessors.)

The symbolist art par excellence was poetry, and Stéfane Mallarmé its high priest. Abandoning meter, rhyme, context, syntax, even sense, Mallarmé made significance a private, deliberately ambiguous, highly esoteric matter.

Daguerreotype of Edgar Allan Poe (photographer unknown, c. 1848), French culture hero (J. Paul Getty Museum)

Intoxicated by language, he wrote poetry that is inaccessible to analysis and irreducible to ideas, as Arnold Hauser put it in *The Social History of Art*, leaving images, sounds, and symbols. This is "an art so subjective and interior," historian Wylie Sypher writes, "that nothing can be stated; it can only be evoked." In the final analysis, Mallarmé proved that poetry can be appreciated even without understanding its meaning, as generations of college students can attest after seeking in vain for clues to the mystery. The symbolists mixed sense data, describing, for example, the color of vowels (Arthur Rimbaud) or the sound of darkness. They talked of an art approaching music, and particularly esteemed Wagnerian opera with its symbolic leitmotifs.

In the visual arts, French symbolist painters Gustave Moreau (who talked about "reading" a work of art) and Odilon Redon gave form to chimeras and dreams, allegories and riddles, symbols of the fertile dream or unconscious realm being explored at the same time by Freud and others. Symbolist canvases are full of visual metaphors: snakes, serpents, severed heads, and femmes fatales such as Ophelia and Salomé (but very few males)—the fin-de-siècle world of rarefied decadence. Art for art's sake, it had little appeal or following outside of France.

Although Americans tend to identify symbolism with the more effete expressions of European culture, the French claim some of us as brothers under the skin—in particular, poet Edgar Allen Poe and artist Albert Pinkham Ryder. It comes as something of a surprise to the American student in France to find Poe (pronounced *edgairpo*, all one word) idealized as the very model of Baudelaire's poet accursed, a lamented victim of provincial American materialism.

One country where symbolism enjoyed a surprising vogue was Russia. There the movement seems to have been an extension rather than a rejection of romanticism, seeking inspiration in sadness and despondency. In the first decade of the 20th century, according to historian Suzanne Massie, the Russian literary establishment was completely dominated by symbolists. Symbolist influence is said to be apparent in the early work of artist Marc Chagall, even in the music of Alexander Scriabin.

See Edward Lucie-Smith's *Symbolist Art* in the Thames & Hudson series.

SYNCHROMISM

Sometimes called the first independent American movement in abstract modern art, synchromism was an offshoot of cubism founded in Paris in 1913 by artists Stanton Macdonald-Wright and Morgan Russell. Obsessed with the idea of correspondences between music and art, Russell is said to have hit on the title of the movement by taking the word *symphony* and replacing *-phony* (sound) with *-chrome* (color). By adding color, particularly intensely contrasting and complementary shades, to an increasingly abstract cubist geometry, the synchromists created what they considered visual rhythms and harmonies. They even theorized about arranging colors in groups and intervals like musical chords, sometimes dismissed as a rather crackpot idea.

As expatriates, Macdonald-Wright and Russell were, of course, heavily influenced by European modernism. Some of the ideas they formulated were domesticated at home by the regionalist painter Thomas Hart Benton and the futurist Joseph Stella.

I can resist everything except temptation.

Oscar Wilde

T'ANG

The T'ang dynasty (618–905) was one of national unity, reuniting China's largely Confucian north with its Buddhist-Taoist south. Thanks to military prowess, the T'angs also expanded to the west. The result in the short run was a great cultural flowering that has been compared to the Italian Renaissance, although tensions between basically different world views would later resurface. It was also a period of prosperity and luxury, fueled by commerce with the Persian Gulf and Indian subcontinent—trade that also brought with it new cultural stimuli and motifs.

It was during the T'ang dynasty that the Chinese discovered how to make porcelain, a formula they kept secret for nearly a millennium. Surviving ceramics, however, are generally earthenware in a range of colors. We also have T'ang earthenware tomb figures, typically glazed in earthy greens and yellows, which became popular in Europe and were widely counterfeited. Nearly every major American museum has some of these, usually one of the muscular horses that were also at the base of T'ang economic and military power.

T'ang sculpture is considered more dramatic, more "baroque" than work under previous dynasties. And with the decline of Buddhism, sculpture would give way to painting, the medium in which Chinese nature worship found its supreme expression. T'ang-era artists developed great virtuosity in brush strokes, modulating from solid to

hair-thin, rough to smooth, then adding color. Two of the greatest Chinese painters of all time lived in the T'ang eighth century. (None of their original paintings is known to have survived, but there are some Sung copies.)

TAOISM

There is no real equivalent in Western languages for *Tao*, which is usually translated as "the way" but sometimes also as meaning providence, God, or the irrational life force. Psychologist Carl Jung, who was interested in all religious phenomena, broke the word down into its constituent Chinese characters for "head" (consciousness) and "going," or "the conscious way." In any case, Taoism dates back to the legendary figure of Lao-tse, considered contemporary with Confucius (sixth century B.C.) and popularly supposed to be the author of the *I Ching* or *Book of Changes*. Taoism and Confucianism have what the Chinese call a yin-yang relationship: the former is mystical, idealistic, and imaginative, conducive to poetry and art, and highly individualistic, while the latter is practical, ethically oriented, and conformist. Withdrawing from the world in search of transcendence and harmony with nature, Taoists have historically exercised a strong influence on Chinese art and literature. Also traditionally associated with alchemy, magic charms, and secret societies, Taoism was prohibited by the Chinese communist regime.

THEOSOPHY

Astral projection, the lost continent of Atlantis, karma and reincarnation—these concepts have all become common currency in the United States thanks largely to the Theosophical movement. In a generic sense, Theosophists (from the Greek for "divine wisdom") believe in the absolute reality of God and an essentially spiritual universe. In this sense, neo-platonists, Gnostics, and Swedenborgians may be considered Theosophists. The Theosophical society was founded in 1875 by Helena Blavatsky, the wife of a Russian general who had traveled in the Orient and acquired a bowdlerized understanding of its religions. Besides esoteric knowledge, Mme. Blavatsky claimed to be a medium with direct illumination from the Hindu masters. She was an eclectic, incorporating among other features in her occult cosmology the lost continent of Atlantis, based on a single reference in Plato. Along with Hindu concepts of reincarnation came the notion of astral planes on which adepts live consciously after physical death.

Thanks to Blavatsky and her successor Annie Besant, Theosophy became the main channel through which the ideas of Hinduism and Buddhism reached the West in the late 19th century. Inevitably there were defections from the movement over time: the German Rudolf Steiner left to found his own Anthroposophy movement with emphasis on education, and a French group called themselves Rosicrucians. But the overall movement continued to grow, attracting among others two major European abstract artists, Wassily Kandinsky and Piet Mondrian.

American Theosophists, rejecting the Blavatsky-Besant focus on Oriental thought for a more universal approach, founded a colony in Point Loma, California, in 1897 under yet another formidable matriarch, Katherine Tingley. (Later, Annie Besant also tried to found a colony in California, which for its special spiritual properties was considered the possible cradle of a new civilization.) But after the death of the founding mothers, and the rejection of organized religion by Besant's appointed successor, Jiddu

Krishnamurti, remaining members of the movement drifted into polite worldly coexistence in places like Pasadena, California, advertising their discussion sessions in the Sunday newspaper book review section.

TIFFANY

There is Tiffany's (& Co.), and then there is Tiffany. First in order of gestation is the Fifth Avenue jewelers, arbiters of New York taste for over 150 years. Founded by Charles L. Tiffany in 1837, first as a stationer and purveyor of "fancy goods" on lower Broadway, Tiffany's has been the place for generations of cosmopolites to get silver, that little diamond bracelet, and, of course, engraved invitations. Besides its social cachet, Tiffany's has always set standards—as, for example, that sterling shall constitute 925 parts silver out of 1000 (eventually adopted as the U.S. standard). There is the standard six-pronged "Tiffany ring," designed for optimal display of fine stones. Then there are preferences, more or less snooty—that everyone should have a good set of pure white china, that men should not wear diamond rings (at least, Tiffany's would sell none for them), and that cultured pearls are simply not acceptable (Tiffany's sold only Oriental pearls long after cultured pearls had taken over the market).

More than just a store, Tiffany's is a museum of the accoutrements of wealth and class in America. Its annual catalog, *The Blue Book*, is a social register of the very best things. The store was even enshrined in popular folklore by Truman Capote's *Breakfast at Tiffany's* (1958), a semi-precious tale of a young woman looking wistfully through the windows (sort of a class barrier) of the great upper-crust emporium at Fifth Avenue and 57th Street.

In the Tiffany family chronicle, Louis Comfort Tiffany, son of the founder, ranks as a sort of hot-house flower, an imprac-

The Tiffany lamp (c. 1910): prisms of colored glass to refract the new glare of electricity *(Metropolitan Museum of Art)*

tical artist and aesthete who lived on a grand and somewhat exotic scale. This is the Tiffany whose name is synonymous the world over with style, the most distinctive American practitioner of art nouveau. Born in 1848, L. C. Tiffany studied art and began as an interior designer for clients like the Vanderbilts, Mark Twain, even the White House. His paintings were good if not remarkable. His interiors (if one can judge from old photos) substituted Byzantine and Merovingian for Victorian clutter. (One exception may be Tiffany's own New York studio, a cavernous sort of mosque with hanging ornaments and a huge grotto-like fireplace in the center.)

It was rather as an artist in glass that L. C. Tiffany made his fame, if not his fortune. Experimenting with luster and iridescence, he came up with what he called *favrile*

(variously translated as old English or French for "handmade") glass, one of several techniques he patented. Appearing marbled, mottled, and congealed in color, favrile glass assumed extraordinary shapes, sometimes in the art nouveau tradition of plant forms such as tulips and lilies but stretched and molded into almost surrealistic creations.

Best known today is Tiffany's leaded glass. His company created huge mosaic landscapes, such as the Maxfield Parrish mural in the old Curtis Publishing Building in Philadelphia, and windows (some beautiful examples of which are in New York's Metropolitan Museum of Art), even church windows featuring religious themes. But it is the leaded-glass lamp that made Tiffany's name—brass-based, with a leaded-glass shade using motifs from nature—dragonflies, wisteria, lilies, cobwebs, and peacocks—little captive prisms of color to refract the harsh glare of electric light, which was newly available around the turn of the century.

Tiffany had always subsidized his enterprises (variously called Tiffany Associates and Tiffany Studios) with his personal fortune. His business was never particularly profitable, because of his insistence on perfection and uniqueness, and by the end of his life he allowed it to lapse into bankruptcy. Most of Tiffany's interiors have been demolished, and later generations find his favrile glass merely a curiosity, but his lamps have survived as coveted collector's items, widely and crudely copied in Third World workshops.

For a good, gossipy history of (primarily the Fifth Avenue) Tiffany's, see Joseph Purtell's *The Tiffany Touch*. There are several large-format picture books on the life and creations of Louis Comfort Tiffany. The most ubiquitous of these is by Robert Koch, *Louis Comfort Tiffany, Rebel in Glass*. The writer prefers Tessa Paul's *The Art of Louis Comfort Tiffany*.

TOLTEC

Two of the most distinctive sculptural forms in pre-Columbian art, the "Chacmool" and monumental Atlantean column-figures, were both created by the Toltec whose empire was powerful in Mexico between the 10th and 13th centuries. A warrior aristocracy, they were predecessors of the Aztec, with whom they share the Nahuatl language, an apocalyptic cosmogony, and the practice of human sacrifice by heart excision. Their capital

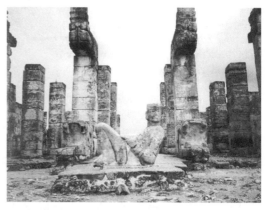

The Chacmool, Toltec sentinel or temple guardian at Chichén Itzá in the Yucatán *(C. Dunlap)*

was at Tula, 40 miles northwest of Mexico City, where numerous surviving Atlantean columns supported the now-missing roof of their palace.

As the Maya declined around the 10th century, the Toltec gradually extended their influence south into the Yucatán. The ceremonial city of Chichén Itzá in the Yucatán is classified by anthropologists as "Toltec Maya," or a colonial extension of the Toltec state into Mayan territory. Chichén Itzá has several features in common with the Toltec

capital at Tula: a reclining Chacmool, or sacred Toltec sentinel (also interpreted as a messenger taking offerings to the gods); warrior effigies, although much smaller at Chichén Itzá; and last but not least, Quetzalcoatl, the feathered serpent god of wind and rain.

TRANSCENDENTALISM

For the first generations of European settlers in North America, the vast land was a source of fear rather than wonder, representing a great and possibly hostile heartland of darkness to be overcome, civilized, and tamed. It took the transcendentalists, after the great westward thrust was half over, to discover the great glory and beauty of the American landscape.

Transcendentalism began as a religious protest in 1836. The founders, all New England Yankee Unitarians, considered even their relatively enlightened church too lacking in what would be called today affirmation. Rejecting the Puritan legacy of original sin and eternal damnation, they sought religion instead in nature, of which their God was the "Over-Soul" or universal mind. In the argument over biblical miracles, they believed the true miracle was life.

Chief among the transcendentalists was Ralph Waldo Emerson, whose classic, *Nature*, was published in 1836. Behind him came Henry David Thoreau, feminist Margaret Fuller, and pedagogue Bronson Alcott, better known to most of us as the father of Louisa May. Starting from religion, they developed transcendentalism into a somewhat vague and mystical philosophy, drawing on European romanticism, neo-platonism, Kantian idealism, and Oriental philosophy. They even tried to put their beliefs into practice. Thoreau's retreat to Walden Pond is, of course, one of the great journeys of discovery in American literature. (The Puritans had sacrificed the spiritual to the economic, Thoreau believed, endeavoring to reverse the process.)

The transcendentalists were also involved in the experimental collective endeavors at Brook Farm and Fruitlands, both of which eventually failed. In their day, these philosophers earned as much ridicule as admiration. A major barrier to acceptance was their tendency to analogize natural and spiritual functions, physical and moral laws, to see the world as a mirror of the soul. Gravity is truth, they would say, or a farm is a mute gospel. Bronson Alcott even described the universe as a vast spinal column—the kind of statement that even sympathizers called "moonshine." On the radical fringe, Jones Very, a transcendentalist poet who claimed inspiration from the Holy Ghost, had to exchange his Harvard teaching position for a mental ward. Even the ever-dignified Emerson was caricatured by contemporaries Herman Melville in *Pierre* (1852) and *The Confidence Man* (1857) and Nathaniel Hawthorne in *The Blithedale Romance* (1852).

What made the transcendentalists most vulnerable, and most appealing in retrospect, was their "cosmic optimism," their "philosophy of good hope." Their magazine, *The Dial*, was devoted to "measuring the hours of sunlight only." There is little question that they overrated the beneficence of nature and perfectibility of man, at the same time underrating his capacity for evil, but they were also attuned to social criticism and action. As Margaret Fuller pointed out, America by 1840 was already "spoiled by prosperity, stupid with the lust of gain, soiled by crime in its willing perpetuation of slavery...."

The transcendentalists were important cultural enablers, tirelessly opening doors

for others, always encouraging American cultural independence—dismayed, as Emerson put it, that "where nature is so grand, genius should be so tame." Emerson himself welcomed the publication of Walt Whitman's *Leaves of Grass* (1855) as a new and authentic American voice, although he cannot have been comfortable with many of its expressions. But it is Thoreau, with his concepts of the simple life, of conservation and civil disobedience—marching to a "different drummer," he said—who remains the transcendentalist prophet for today.

American composer Charles Ives, whose oeuvre includes a Concord Piano Sonata, has been called a transcendentalist in music—out of phase, in the words of literary figure Guy Davenport, "like a lost battalion of an army...long after the war was over."

The standard work on the subject is really a collection of writings: *The Transcendentalists: An Anthology*, edited by Perry Miller. For a more analytical approach, try *Transcendentalism in America* by Donald N. Koster or *American Transcendentalism 1830–1860* by Paul F. Boller.

TROMPE l'OEIL

The expression is French, meaning to trick or fool the eye, but the concept goes back at least to the Romans, who painted gardens and classical vistas, richly detailed, on blank walls. The idea was to use perspective and other gimmicks to make a two-dimensional plane look like 3-D, to make indoors look like outdoors (or vice versa), or to suggest the presence of something which is absent.

During the Renaissance, many buildings were furnished with elaborate visual or architectural conceits: doors, windows, balconies, even whole galleries painted where there were none. The baroque carried this further, adding painted or sometimes sculpted people to the *mise-en-scène*, looking down from balconies or loggias. ("Who is the actor and who the spectators," writes Miriam Milman, "in this face-to-face encounter between reality and fiction?") The baroque also specialized in simulated domes, in ceilings painted as if one could look right into the heavens. In a Franconia, Germany, chapel crucifixion

George Washington is said to have tipped his hat to artist Charles Willson Peale's sons, depicted in *Staircase Group* (1795) (Philadelphia Museum of Art)

scene, the tip of the woodcarved cross seems to pierce the painted heavens, causing great hunks of stone to (appear to) fall on the Last Judgment.

In the early days of American independence, Charles Willson Peale painted his sons in a staircase in such a realistic fashion, with an actual step at the bottom, that George Washington is said to have absent-mindedly tipped his hat in passing the picture. (One of the Peale boys, named Raphaelle, grew up to become a major artist in the trompe l'oeil genre.)

During the 20th century, trompe l'oeil enjoyed a revival thanks to the surrealist movement with its odd, dreamlike paintings, presenting visual fact as fantasy. And it has also become a popular decorating technique, useful to make small rooms look larger and richer by the addition of painted doors, windows, or detailing such as molding and cornices. Plain surfaces can also be painted to look like marble (the Germans call this "farmer's marble," and there is a lot of it in their churches; in the United States, "marbleizing" became a popular technique in the 19th and 20th centuries to give walls a richer look at less expense), tile, silk, or possibly a bearskin rug on the floor.

The difficulty in defining trompe l'oeil is to distinguish it from art, and vice versa. Why for example do most people consider art the ceiling of the Sistine Chapel, which certainly employs perspective and other tricks to create an illusion of reality? Is it because the Sistine incorporates various levels of reality and multiple viewpoints? Or the difference may be in the intention: trompe l'oeil deliberately tests one's senses of perspective and humor, its purpose usually being playful rather than serious, a visual pun without pretension to high art.

Martin Battersby suggests another useful distinction between trompe l'oeil and art, that you want to reach out and touch the former to see if it is real. This requires that spectator and composition exist in the same scale, dimension, and perspective, with the same light sources.

Miriam Milman's *Trompe-l'Oeil: Painted Architecture* and Martin Battersby's *Trompe l'Oeil: The Eye Deceived* are both excellent.

TUDOR

The Tudors came to power in England in 1485 after a long period of civil war. (The name Tudor is that of a Welsh adventurer whom the widow of Henry V secretly married.) By strengthening the monarchy and centralizing administration, they introduced a period of relative peace and prosperity. Using their newfound naval power to establish markets and colonies, they forged a new national identity and empire.

It was under the Tudors that the Renaissance reached England, belatedly, via Protestant Germany and Holland rather than directly from Italy, the lines of cultural transmission following religious boundaries. It was in 1533, shortly after Luther launched the Reformation in Germany, that Henry VIII broke with the Pope, ostensibly over the issue of divorce. Religious dissension continued, heretics were burned at the stake, and monasteries and other church property were looted. But the first steps were taken toward creating a reformed national church, chiefly via the creation of *The Book of Common Prayer*, one of the most significant Tudor achievements.

The Tudor period lasted until the death of Henry VIII's daughter Elizabeth I in 1503, but her reign is generally differentiated as Elizabethan. There is a striking dif-

ference in feeling: where the Elizabethan age was feminine, the Tudor era was deeply masculine, as epitomized by the person of Henry VIII. Tall and broad (he measured 6 feet 4 inches tall, and his suit of armor was 54 inches around the waist), square-shoul-dered in his ermine-lined capes, with a codpiece over his vitals, he was known for his lusty appetites and, of course, his six wives.

The ranks of the old feudal nobility having been thinned by the Wars of the Roses, the Tudors created a new aristocracy of courtiers dependent on royal grace. Eager to claim status, these parvenus began building themselves manor houses (life had become secure enough that medieval fortifications were no longer required) in what has come to be called the Tudor style. This was still very medieval and Gothic, asymmetrical rather than classically balanced, Renaissance only in detailing. Roofs were steep, with lots of gables and windows, and walls decoratively half-timbered, often very fancifully. Windows were mullioned, with many small diamond-shaped panes of the newly avail-able glass. Inside, walls were paneled, wainscoted, or hung with tapestries. Where houses were made of brick, these were also arranged in decorative patterns. Tudor furniture was still very medieval and blocky, the most memorable article being a massive four-poster bed with copious drapery.

In the United States, Washington Irving started a vogue for Tudor when he rebuilt his home in Tarrytown, New York, in that style in 1835. To this day, country-club sub-urbs like Westchester, N.Y., are full of large Tudor mansions, half-timbered or stone, with gables, dormers, rambling rooflines, and sometimes even battlements. On a more modest level, the middle-American urban gentleman went in for Tudor cottages, some of them with pseudo-thatched roofs.

The 1960s *Batman* TV series used a Tudor-style mansion in Pasadena, California, presumably to evoke a slight Gothic shudder, while in the long-running *Dallas* TV series, the Ewing family homestead was in a transitional style called "Tudorbethan."

Jasper Ridley's *The Tudor Age* is a good general introduction. See also the *Connoisseur Period Guides.* A new biography, *The Reign of Henry VIII* by David Starkey, prepared for the 500th anniversary of Henry's birth, describes him as a typical Renaissance man, rejecting the Charles Laughton image of a gluttonous boor tossing drumsticks over his shoulder.

TURKISH RUGS

The Seljuk, a tribe of Turkoman nomads, brought their distinctive style of knotted car-pet with them when they migrated south in the 10th century to settle eventually in what is now Turkey. (Redoubtable warriors, they conquered Persia along the way and won a major battle against the Byzantines in 1071, thereby helping precipitate the Crusades.) Marco Polo reported seeing Seljuk rugs on his famous travels, and the rug soon became a luxury item in Europe, thanks to the crusaders who took some home with them as souvenirs. (A later Turkish dynasty, the Ottomans, attempted unsuccessfully to invade Europe in the 16th century, leaving tents full of carpets—a great windfall for European connoisseurs—when they fled from their encampment outside Vienna.)

Turkish rugs differ from Persians in that they have a different kind of knot (called ghiordes) and geometric rather than curvilinear patterning. During the Renaissance, Turkish rugs appeared frequently in the background of European paintings, even becom-

ing known as "Holbein" or "Lotto" carpets for their popularity with those artists. These early Turkish weaves were usually of the type known in the trade as Ushak or Bergama. Named for a town on Turkey's Adriatic coast, Bergamas with their greater variety of geometric motifs and colors (a mixture of red, yellow, and ivory with a rare cornflower blue) are more like Caucasian rugs than later Turkish production.

Another type of small, prayer-sized Turkish rug from the 17th and 18th centuries is known as Transylvanian. Although made in Turkish Anatolia, these rugs survived as wall hangings in the Lutheran fortress churches of Romanian Transylvania, Europe's Maginot line against the Turks.

A peasant industry in origin, Turkish weaving was patronized and subsidized by the Ottoman sultans, who even established workshops to create large, superior quality carpets for palaces and visiting royalty. The most famous of these workshops was at Hereke, 42 miles from Istanbul, where classical Persian models (especially the Kirman) were copied in the finest silks and woolens. There was no specific Hereke design; these rugs are recognizable by their high quality and calligraphic signatures. Production having ceased with World War I, Herekes are now valuable antiques.

Among the general public, the best-known Turkish rug today is probably the Bokhara—strictly speaking a Turkoman rather than a Turkish rug, made by nomadic tribesmen and named for their marketing center of Bokhara in Uzbekistan. These rugs are usually a dark brick red (bull's blood, someone once said) with black patterning. The predominant design motif is the gol or gul, a sort of flattened octagon repeated in rows in the center field. The gol is actually a tribal coat of arms, which accounts for its numerous minor variations. The best of these rugs are made by the Tekke, once the predominant tribe in the Uzbekistan area; subjugated by the czars in the late 19th century, they fled to Afghanistan and Persia. Today you can get authentic Bokharas from Afghanistan, as well as cheaper copies produced in Pakistan. (Rug expert Carolyn Bosly relates that when Pakistan first started to copy Bokharas in the 1930s, the wool came from old British army socks and the rugs soon fell apart.)

Another well-known Bokhara rug is called Ersari. You may also hear of "Princess" and "Royal" Bokharas; these are meaningless designations used by merchants to impress gullible clients.

P. R. J. Ford's excellent book, *Oriental Carpet Design*, has a chart of 34 gols from the various Turkoman tribes. See also Carolyn Bosly's *Rugs to Riches: An Insider's Guide to Buying Oriental Rugs.*

Literature is my Utopia.

Helen Keller, The Story of My Life

UNITARIAN

Although Unitarianism was one of many strains in Europe's Protestant Reformation, it seems a particularly American phenomenon in its liberalism, idealism, and progressivism. After the American Revolution, when the grip of Puritanism began to loosen, the Unitarian church began to take shape in Boston among former Congregationalists meeting in recently abandoned Anglican churches. (Boston's Old Stone Church was the first of these, in 1787.)

The central tenet of Unitarianism is rejection of the Trinity. Unitarians also reject Calvinist doctrines of predestination and human depravity, indeed the very Calvinist notion of God himself. As cultural historian Vernon Parrington put it, "Instead of debasing man to a mean creature, subject to a God of wrath, [Unitarians] professed to discover a loving Father in the human heart...."

Unitarianism emphasizes brotherhood, the perfectibility of man and progress of mankind, and the individual's role in redemption, his ability to achieve salvation by his own efforts. The American church, which is organized on congregational lines, has no dogma or central governing authority. Clergy are conceived as genuine ethical leaders. In general, the church is more ethically and socially minded than religious, fostering respect for free inquiry and tolerance.

In 1805 Harvard University became essentially Unitarian. Never very large, the

Unitarian church has nevertheless counted many distinguished Americans among its membership, including four U.S. presidents as well as Ralph Waldo Emerson, Henry Wadsworth Longfellow, and Oliver Wendell Holmes. (Emerson, who left the church for transcendentalism, considered it "pale, shallow religion.") Boston has remained the church's heart, with isolated groups elsewhere, generally in affluent urban areas. In the 20th century the Unitarian church (called the Unitarian Universalist Association since 1961) has experienced a decline in membership, remaining aloof from revivalism ("anyone born in Boston has no need to be born again") and other popular currents.

E. M. Wilbur is the author of *Our Unitarian Heritage*.

UTOPIAN

Thomas More gave the name of utopia, meaning literally nowhere, to his early-16th-century political romance about a country free of crime, poverty, and other miseries, at once a critique of existing society and an imagined ideal. There had been earlier examples of "non-places," such as that discussed at length in Plato's *Republic*, christened retroactively a utopia. As utopias go, Plato's was aristocratic and authoritarian, the future posing as an idealization of the past. For the next 1,500 years, utopia would be conceived of in Christian terms, as the kingdom of heaven. It was only after More that utopias tended to become humanistic and secular, and were often associated with socialist ideas.

The great heyday of utopian imagination was inspired by the Industrial Revolution with its chamber of socio-economic horrors. The 19th century in particular produced myriad schemes for paradise on earth; among the most famous American literary utopias was Edward Bellamy's variant in *Looking Backward* (1888), a socialist version of the world in A.D. 2000. Many of these schemes were pure escapism, but others tried to make the leap into reality, particularly in the United States, which seemed to offer the clearest field for radical socio-economic experimentation. Economic historian Robert Heilbroner counts at least 178 utopian groups in U.S. history, including Brook Farm, the Shakers, and the Oneida and Amana communities, to name only the better known.

In the 20th century, utopianism became once again a literary exercise, with new twists. Aldous Huxley's *Brave New World* (1932) was a satire on the future, while George Orwell's *Nineteen Eighty-Four* (1949) was a cautionary tale inspired by contemporary excursions into totalitarianism. Then there was escapist utopianism, as in James Hilton's *Lost Horizon* (1933), born of the Depression. The latest trend seems to be toward futuristic, sci-fi utopianism.

The literature on utopianism is particularly rich. See Stewart H. Holbrook's *Dreamers of the American Dream*.

Why drag in Velázquez?

James McNeill Whistler

VERISMO

Italian for "realism," verismo or verism is a late 19th-century genre in art and litera-ture. It is typically applied to that most grandly extravagant and unrealistic of media—opera—which in the last decades of the century began a shift away from traditional mythological and historical themes toward everyday, "real-life" melodrama. Although verismo literally means realism, in opera it involves "low-life" settings, often with vio-lence. An early opera in the genre is Bizet's *Carmen* (1875), starring a fickle female who works in a cigar factory and who becomes an object of pathological desire to an unfor-tunate soldier. A second verist classic is Leoncavallo's *I Pagliacci* (1892), another tale of jealousy and murder, set in a circus.

 The great verist composer was Giacomo Puccini who, instead of gods and heroes, democratized the opera repertoire with the impoverished artists and poets of *La Bohème* (1896). Puccini's *Tosca* (1900) is considered the apogee of verismo. Although the time and place are historical, the characters—the fiery, jealous singer Tosca, who kills for love, and her lover Cavaradossi, the first tenor to sing blood-stained, having been tor-tured offstage—are portrayed realistically. After *Tosca*, Puccini set to music two stories by the American David Belasco, both exotic by European standards: *Madame Butterfly* (1904) and *Girl of the Golden West* (1910). (The latter was once described as "Wild West Wagner.")

It is only in subject matter, however, that verist opera is by any stretch of the imagination "realistic." Musically, this is the last gasp of romanticism, complete with melodies that break one's heart and musical motifs signaling emotional states.

VERNACULAR

According to *Webster's*, a vernacular is a regional native language or everyday spoken dialect or idiom, as opposed to a standard literary language. In architecture, the same word is frequently applied to regional types of buildings (type as opposed to style; both a church and a home, for example, might be in the same style, such as Gothic). There are several well-known examples of American vernacular architecture, beginning with the New England "saltbox," a house with a lean-to addition resulting in a longer roof with a different pitch on one side. In the South, there is the "dogtrot" with a central hallway running the width of the house, and the "shotgun," so-called because, lacking a central hall, any shot fired into it would penetrate each of the side-by-side rooms. The California bungalow, which (despite its Indian name) is a hybrid offshoot of the Swiss chalet, Japanese rustic, and the Arts and Crafts movement, is also considered a vernacular type. In an urban setting, the Charleston (South Carolina) "single" is a town house turned sideways to maximize use of deep narrow city lots. The most popular and frequently copied vernacular type in America is probably the Cape Cod cottage, a one-and-a-half-story house with shingles or clapboard siding and dormer windows under the roof. Finally, some even include as vernacular architecture roadside commercial

Freeway Dinosaurs (1964–84) erected at a truckstop in Cabazon, California, by Clarence Bell *(Tony Russell)*

structures shaped like ducks, hot dogs, even dinosaurs. These odd constructions have acquired a collective name of their own: "ducks."

See Jim Kemp's *American Vernacular: Regional Influences in Architecture and Interior Design.*

VICTORIAN

This is a good example of a period, and a long one at that, which is also readily identifiable as a style and synonymous with an attitude. The key to these various manifestations is Victoria herself, Queen of England from 1837 to 1901. She and her beloved consort, Prince Albert, made a national religion of cozy family domesticity, supremely conventional and correct. Solemnity, propriety, and prudery were the watchwords of the period, a time so uptight about bodily functions that it was considered more refined to call a leg a limb and the dead "deceased" or "departed." Chief among the departed was the sainted Albert, who died young, leaving Victoria to become a connoisseur of mourning.

As a period, the Victorian years were characterized by accelerating industrialization and the triumph of imperialism. The first half of the century was relatively prosperous and stable, peaking with an international exhibition in London in 1851. Later, the dislocations and dysfunctions of the Industrial Revolution, such as child labor and growing extremes of poverty, would become increasingly and painfully apparent.

The operative description of Victorian style, whether in interior decor or literature, is overstuffed and sentimental. This was the golden age of dolls, the time when valentines were invented. Victorians were romantics, but their romanticism was transformed by prudery into sentimentality. They were also incredibly eclectic, filling their parlors and their novels with gimcracks, knickknacks, and whatnots, the fruits and evils of mass production and imperialism. Even Victorian painting is cluttered with narrative and detail (see also PRE-RAPHAELITE). As for fashion, the Victorian style of tight bodices and voluminous skirts dictated a feminine role of ornamental inactivity for those who could afford it.

Victorian architecture was a mixture of classical, Gothic, and Italianate, eclectically combined in energetic anarchy cluttered with detail. In interior decor as in exterior, every surface tended to be covered, draped, and decorated in a profusion of pattern and texture from beveled glass and lace curtains to ornate wainscoting and sprightly wallpaper. Central to any home was the hearth, its mantel a clutter of pictures and mementoes providing the solace of the familiar. In furniture, the American rocking chair was popular, along with the footstool, the ottoman, the Morris chair, wicker, brass bedstands, and mahogany four-posters. (According to style maven Stephen Calloway, Victorian, now enjoying one of its periodic revivals of popularity, is an easy period look to re-create.)

The great name in Victorian literature is Charles Dickens, who crammed the novel (itself a product of romanticism tempered by realism) with the picturesque and the grotesque, the humor and the squalor of industrialization. The development of offset lithography brought an explosion of print, allowing serialization and mass distribution of Dickens's prolific output. His novels *Oliver Twist* (1839), *A Christmas Carol* (1843), *David Copperfield* (1850), and *Great Expectations* (1861) are classics of English literature that bear the particular imprint of their time, the Victorian era.

In U.S. architecture, Victorian is usually subdivided into Italianate, which has a flat

Brightly clad San Francisco Victorians, a late-19th-century "gift to the street" *(C. Dunlap)*

roof, tall doors and windows, often bay windows; Eastlake or Stick Style, with a gabled roof, recessed decorative panels, colored siding and strips for accent; and Queen Anne, also gabled, with big bay windows and greater ornamentation including decorative wreaths and garlands. The great Mother Lode of American Victorian is San Francisco, where some 15,000 structures survive. Ironically, the city's large gay population took over the process of reclaiming and restoring these homes—the American architectural metaphor for "family"—in the 1960s.

There are many books on Victorian interior decor; see *American Victorian* by Lawrence Grow and Dina von Zweck. *The Other Victorians* by Steven Marcus examines the underside of Victorian literature, pornography, while Lytton Strachey's *Eminent Victorians* probes the mysteries of Victorian character (Florence Nightingale, for example, a lifelong hypochondriac, got out of bed to go to the Crimean War). For a general introduction to Victorian culture, Peter Conrad's *The Victorian Treasure House* is recommended. *Painted Ladies: San Francisco's Resplendent Victorians* by Elizabeth Pomada et al. is an attractive picture book.

Oscar
Was Wild
But Thornton
Was Wilder

Arthur Berger, cited by Willard Espy, An Almanac of Words at Play

WATERFORD

In the annals of glass production, the English have specialized in cut crystal, as the chemical composition of their glass lends itself to this type of decoration. Beginning in the 18th century, rims and feet of vessels were scalloped and notched, then stems were fluted and diamonds, triangles, and crescents in relief were added to major surfaces. This is the style popularly associated with Waterford, an Irish glasshouse (established 1784) that imported and cut ready-made glasses from England. Waterford glass, which is sometimes incorrectly supposed to have a slightly bluish tinge, died out in the 19th century but has been revived. A quality for which Waterford

A modern Waterford trifle bowl *(courtesy Nick Mercury)*

crystal is famous is its "ring," resonant F- and G-sharp notes due to the proportion of lead oxides.

WEDGWOOD

If you recognize any china or pottery at all, it is likely to be one of the popular creations of this English firm, which is said to have changed the eating habits of a nation. The key man here is Josiah Wedgwood, a fourth-generation potter and true man of the Enlightenment who organized model villages and provided social insurance for his workers, who favored independence for the American colonies and abolition of slavery. Somehow he also found the time to make numerous innovations in pottery production and design.

Wedgwood's first invention was a brilliant green glaze, applied to attractive fruit and vegetable shapes, similar to majolica (which the family firm also produced in the late 19th century). But he first became widely known for his "creamware," a lightweight cream-colored earthenware with attractive border designs or printed patterns, also known as Queen's Ware for Queen Charlotte who ordered a set. Catherine the Great of Russia liked it so much she ordered a dinner service for 50, hand-painted with English scenes, some of which survives in the Hermitage Museum in Leningrad.

A small recent souvenir dish in Wedgwood's distinctive blue and white jasper (courtesy Jill Mercury)

The most distinctive and easily recognized Wedgwood creation is the so-called jasper ware, vitreous stoneware typically blue (but also black, white, yellow, or maroon) with designs in white relief. Wedgwood produced vases in jasper (most famous is the Portland Vase, copied from a first-century relic, now in the British Museum), and plaques or medallions resembling cameos, which may be found on Chippendale, Sheraton, and other furniture. Jasper was especially suited to adapt in ceramics the neoclassical designs the Adam brothers were currently popularizing in interior decor.

According to design expert Adrian Forty, Wedgwood used the neoclassical style to create acceptance for his technically innovative new products, and although he claimed to be making exact reproductions from antiquity, Forty points out, Wedgwood actually re-interpreted and "improved" classical designs, adapting them to new products with no equivalent in ancient Greece or Rome. In any case, Wedgwood's blue-and-white jasper ware became so popular that it was copied everywhere, for example by Sèvres in a finer porcelain.

Wedgwood jasper has been produced continuously since 1775. Queen's Ware is still one of the firm's most important products, along with porcelain, which Wedgwood has produced continuously only since the late 19th century. (Two popular patterns,

"Columbia 575" and "Turquoise Florentine," are over a century old.) The firm, which was family-controlled until going public in 1967, included among its holdings the Franciscan Tableware Factory in California.

For anyone interested in marks, be advised that "Wedgwood & Co." is not authentic (the firm never used "& Co."), and that if a piece says "Made in England," it is 20th century.

The standard source is *Wedgwood* by Wolf Mankowitz.

WIENER WERKSTATTE

This is the Austrian version of the English Arts and Crafts movement, founded a generation later. Disturbed by the decline of craftsmanship, Josef Hoffmann, a professor at Vienna's School of Applied Arts, started in 1903 a string of studios or workshops (Werkstätte) where artists in various fields, from pottery to furniture and book design, worked together.

There were similar German Werkstätte movements at about the same time; that based in Dresden resulted in the construction of a garden city at Hellerau, while members of the one in Darmstadt helped build a Jugendstil artists' colony there. But the finest expression of the movement is the art nouveau Palais Stoclet in Brussels, to which members of the Wiener Werkstätte contributed their labor. (This villa also has a mural by Klimt of the Sezession movement.)

Around World War I many of the Viennese artisans emigrated to the United States. In 1922 an exhibit of their work was put on at the Art Institute of Chicago. Particularly influential in the United States were the Viennese ceramicists and Hoffmann himself, whose furniture anticipates art deco.

See Werner J. Schweiger's *Wiener Werkstätte: Design in Vienna 1903–1931*. Lillian L. Christensen's *A Design for Living: Vienna in the Twenties* is a memoir by a student in Hoffmann's school.

WILHELMINIAN

Boastful, rude, self-willed, impetuous, feckless, dogmatic, aggressive, conceited, exhibitionistic, priggish, and childishly excitable—these are the terms in which Kaiser Wilhelm II is described by those who knew him best. Even his father considered him vain and presumptuous, with "an overweening estimate of himself," while his mother longed to be able to padlock his mouth to prevent his highly impolitic pronouncements.

It is one of the great misfortunes of modern history that this troubled, unstable personality—alternately swinging from megalomania to depression—occupied the German imperial throne from 1888 to 1918; and that in many ways the country over which he ruled so imperiously matched him. As a boy, Wilhelm had been deeply impressed by Bismarck's victory parades after the wars (1866 against Austria, 1870–71 against France) which resulted in German unification as the Second Reich (the first being the Holy Roman Empire). Bismarck's wars also made the country rich; the first German economic miracle was financed by reparations from France. The result was a boom mentality of parvenu vulgarity, rampant with speculation and status-seeking.

Wilhelminian vulgarity became visible through the many highly derivative new edifices constructed in and around Berlin, chiefly in a neo-baroque style. The surviving signature of the style is probably the Kaiser Wilhelm (I) Memorial Church, which historian Gerhard Masur describes as one of few buildings actually improved by bombing. In art, the emperor was as might be expected a philistine, hostile to modernism, prompting wholesale secession from the art establishment.

Wilhelminian Germany was an accident looking for a place to happen, and that place became battlefield Europe. For 25 years Wilhelm had posed as a warrior king, given to bravado and impulse, indulging in showmanship rather than leadership. While he alone was not responsible for World War I, and probably did not even want it, his constant interference (as immortalized in the peremptory notes he was wont to scribble in the margins of state papers) hastened and prolonged it. Forced to abdicate in 1918, he lived his last years in exile.

The Kaiser by Virginia Cowles is a highly readable popular biography, with a pronounced British bias.

WINDSOR

Look through any picture book of American art, and if there is a chair depicted in a painting, most likely it is a Windsor. Our colonial forefathers sat for their portraits in these chairs (sometimes a whole family on a Windsor settee). Whistler's mother is (probably) sitting in one, and if Grant Wood's *American Gothic* farmers were seated, they would most certainly be in Windsor rocking chairs.

As the name implies, the Windsor chair is English in origin, possibly named for the market town of Windsor where it was sold beginning in the 17th century. The town is best known as the site of Windsor Castle, thus linking the chair however indirectly to the British royal family. (The family also lent its name to the Windsor knot, a large and extravagant fashion of knotting a tie, popularized by the late Duke of Windsor.) But this is a chair for every man, woman, even child (there are Windsor cradles and high chairs)— easy and inexpensive to make, strong

An 18th-century Windsor, the American chair for everyman, woman, even baby, named after the British royal family *(Metropolitan Museum of Art)*

yet light, running the scale from plain to elegant, and finally, unchanging.

Typically the Windsor chair has a back constructed of vertical sticks or spindles in

various designs, set (there are no screws or nails) in a solid, saddle-shaped plank seat, with distinctively turned legs at a raked angle to the seat. This basic model may have a high back, a low back (common in inns and public buildings; a modern version called the captain's chair is popular in bars), or arms extending in one continuous hoop from the back. American Windsors (and the style enjoyed greater refinement and popularity here than in Britain) are often made of different woods—the seat of elm, the bow of ash, the legs of beech—and painted.

Colonial Philadelphia was such an important center of Windsor chair production that it is sometimes called the "Philadelphia chair." During the Federal period, there were 17 carpenters in that city alone specializing in Windsor chairs, according to Robert C. Smith in *World Furniture*. Connecticut was another important center of Windsor chair production. True aficionados can identify where an American Windsor was made from arcane distinctions such as ring turnings on legs (Rhode Island) or spindles swelling in the middle (Connecticut).

Joseph T. Butler's *Field Guide to American Antique Furniture* is a good source for identifying the different American Windsors.

Where are the snows of yester-year?

François Villon

YUPPIE

It was late 1983 when a new American generation and lifestyle first burst onto the national consciousness. There was some debate at first over what to call this affluent, well-educated group of baby boomers, born between 1946 and 1964. Yumpies, or young upwardly mobile professionals, and YAPs, young American professionals, were finally dropped in favor of yuppies, young urban professionals. (The latter has the onomatopoeic advantage of resembling predecessor prototypes: hippies, yippies, and preppies.) Yuppies have not been around long enough for us to achieve historical perspective, but we can at least identify clusters of characteristics and attributes.

True offspring of Reagan-era economic affluence, yuppies were above all ambitious, acquisitive, and materialistic. They postponed marriage 10 or more years to enjoy their freedom and affluence to the max. (Or if they married, or were just living together, they postponed childraising. This gave rise to another acronym, dink—double-income-no-kids.) Work was the big yuppie preoccupation; a typical yuppie conversation was peppered with expressions like networking, the fast track, the bottom line, and dead meat.

As fruits of all this labor, yuppies were heavily into status symbols, chiefly cars (the curiously sedate Beamer, or BMW, and the Volvo were the models of choice) and cuisine: Brie, Cajun chicken, sushi, and always Perrier, for yuppies were into fitness. As

workaholics with an extreme absorption in their bodies, their big hangout was the health club, which also functioned as a sexual marketplace. (Another good place to pick up a compatible partner, an advice columnist suggested, was shopping for a Rolex watch or a Burberry raincoat.)

Yuppies didn't have much time or inclination for culture, so two enterprising young writers wrote a pithy manual relating a good portion of world civilization to specifically yuppie concerns like programming and marketing, cellulite and corn futures. Judy Jones and William Wilson write in *An Incomplete Education*, for example, that one can think of Conrad's Marlow as sort of like Ted Koppel, "perpetually on the lookout for a knotty problem"; of Proust's magnum opus as "novel as flotation tank"; of Don Giovanni as, of course, life in the fast lane. Nor have yuppies yet produced much in the way of culture themselves, unless you count the television series *thirtysomething* that described their everyday life with all the reverence (as writer Hendrik Hertzberg put it in *Esquire*) of *Masterpiece Theatre*. Or perhaps yuppies are just like the rest of us, but with money and taste. The protagonist of Bret Easton Ellis's monumentally distasteful novel, *American Psycho* (1991), is a yuppie mass murderer, and the 1992 movie *Bob Roberts* features a yuppie fascist running for the U.S. Senate.

In 1984 it seemed that yuppies were everywhere; there were Southern yuppies, French yuppies, Chinese yuppies, Afro-yuppies. By 1988 *Esquire* magazine was predicting yuppie extinction, and "Where have all the yuppies gone?" became a familiar refrain as the recession of the early 1990s curtailed their conspicuous consumption. Maybe they just mainstreamed. The 1992 election of a senior baby boomer (Bill Clinton, born 1946) as president of the United States suggested yet another lifestyle designation: oumpie, or older upwardly mobile professional.

The Yuppie Handbook by Marissa Piesman and M. Hartley has been called a take-off of the classic *Preppy Handbook*.

We're marching to Zion
To beautiful beautiful Zion

Hymn

ZAPOTEC

The Zapotec were an early agricultural people in the Oaxaca region of Mexico. There they constructed one of the great cities of pre-Columbian antiquity, Monte Albán, a mountain-top acropolis variously dated from 900 B.C. to A.D. 1000, and a later religious center, Mitla (13th century A.D.).

The Zapotec worshipped a combined jaguar-serpent fertility god, conducted some human sacrifices, and had a cult of the dead, entombing deceased nobles with gold, jade, obsidian, turquoise, and other precious objects. (Many of these can now be seen in museums in

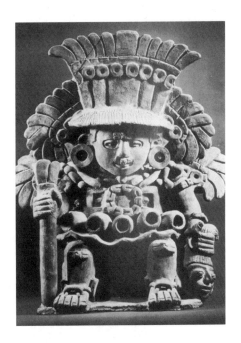

Terra-cotta funerary urn from Monte Albán, A.D. 600-1000 *(National Museum of Anthropology, Mexico City)*

Oaxaca City and Mexico City.) The Zapotec are also well known for their funerary pot-
tery, anthropomorphic clay vessels that scholar George Kubler calls the most highly artic-
ulated use of clay in America.

The Mixtec from the north gradually replaced the Zapotec at Monte Albán in the
10th to 14th centuries A.D. The Zapotec moved south to the Isthmus of Tehuantepec,
where they survived as autonomous members of the Aztec confederation until the Spanish
conquest. Today there are some 300,000 Zapotec-speaking people in the Oaxaca and
Tehuantepec regions.

In the very recent past the Zapotec have become known as weavers of rugs and
blankets, copying Navajo styles in special workshops for gringo consumption. A Zapotec
"Wild West" collection sells in better interior design shops for $150–$500 for mid-size
rugs. The bright colors and fringe reveal, in case of doubt, that these are not Navajo
rugs.

ZIONISM

The Jewish dream and hope of a return to the holy land of Palestine goes back to the
Babylonian captivity in the sixth century B.C. Over the centuries, anti-Semitism and
persecution of Jews in the Diaspora (meaning *dispersal*)—notably in Europe during the
Crusades, in 15th-century Spain, in eastern Europe and Russia during the 17th cen-
tury, and in Hitler's Europe—combined to help keep the Jewish identity and dream of
a homeland alive. Perhaps ironically, the movement that ultimately resulted in the
restoration of a Jewish state in Palestine arose in response to anti-Semitism in a coun-
try where Jews were neither very numerous nor highly discriminated against—turn-of-
the-century France, where prejudice took anti-Semitic form in the Dreyfus Affair.

Zionism (from the word for *hill*, signifying Jerusalem) was the brainchild of an
Austro-Hungarian Jewish journalist covering the Dreyfus trial, Theodor Herzl. His 1896
pamphlet, called *The Jewish State*, resulted the following year in the first world Zionist
conference in Basel, where the Jews' millenarian dream (a typical fin-de-siècle phenom-
enon, according to writer Hillel Schwartz) took its first steps toward realization.

For the next 50 years Zionism would be constantly embroiled in internal dissen-
sion as well as power politics. Chiefly a secular, Western movement, it was relatively
indifferent to the concerns of Orthodox Jews to maintain their orthodoxy and of Reform
Jews to assimilate. There was also a passionate debate over whether to take an active
or passive stance (i.e., waiting for divine intervention) in the process of history. Confirmed
activists who rejected assimilation as an illusion, the Zionists sought at the same time
the physical preservation and spiritual renewal of the Jewish people.

Assuming the role of moral arbiter of the imperialist world order, the British offered
the Zionists Uganda as a homeland in 1905. Then out of the shifting alliances and vicis-
situdes of great-power politics came the Balfour Declaration of 1917 whereby the British,
who had a mandate over Palestine, revived the hope that the Jews might one day return
there. But it took the Holocaust, the murder of six million Jews by the supposedly civ-
ilized Germans, to bring this hope to fulfillment. Seizing the moment, radical Jewish
and Zionist factions proclaimed the state of Israel in 1948. The Zionist movement main-
tained thereafter a separate existence from the new state, continuing to aid immigra-
tion and promote cultural and educational activities.

Unfortunately, realization of the Zionist dream is not the end of the story. Thanks

only to American patronage has the Israeli state survived in a sea of hostile Arabs, millions of them dispossessed by the Jews. Nor did the creation of Israel put an end to internal divisions; highly Orthodox Jews continue to consider Israel a fraudulent man-made contrivance, usurping the sovereignty of the Messiah who alone may rule the Holy Land. And finally, the reestablishment of a Jewish homeland has not resolved the problem of anti-Semitism, which in the communist and Arab worlds now goes under the name of anti-Zionism.

ZOROASTRIAN

The oldest of the revealed world religions, Zoroastrianism arose in the south Russian steppes during the late Stone Age. Since then it has undergone great vicissitudes, serving as the state religion of Persia for many centuries, then declining into a scattered and persecuted minority sect, chiefly important for its great influence on other major religions.

Zoroaster (his name in Greek; Zarathustra in Persian, and also in Friedrich Nietzsche's German tale, *Thus Spake Zarathustra*), prophet of the religion which bears his name, is considered the first religious teacher in history to preach a last judgment, resurrection, and everlasting life, with salvation for rich and poor alike based on the sum total of one's thoughts, words, and deeds. This was also the first religion requiring a personal moral choice between good and evil, truth and falsehood. It also anticipated monotheism, centering around the wise god Ahura Mazda (who later acquired a whole pantheon of lesser deities).

Zoroastrianism is usually identified with fire-worship for the great eternal fires burning in its temples, tended by magi or priests (from their ranks came the magi who traveled to Bethlehem; also the source of the word *magic*). Fire is one of the three sacred elements, along with water and earth, which with their exquisite ecological consciousness Zoroastrians take great care not to pollute. They also observe rigorous personal cleanliness and purity laws. Fires are put out with sand, to avoid contaminating water. So great is the Zoroastrian reverence for water that until modern times the devout were unwilling to travel by boat. Perhaps most extreme to the average Westerner is the Zoroastrian practice of laying the dead out on great "towers of silence," to be devoured by vultures rather than to pollute either earth or fire (by cremation).

Zoroastrianism enters history with the Medes and Persians, becoming the state religion of Sassanid Persia. (The large amount of silver plate surviving from the Sassanids is evidence of the Zoroastrian injunction to spend two-thirds of the day consulting wise men and tilling the soil, and the last third eating, resting, and enjoying.) But in the Safavid and Islamic periods, Zoroastrians were subject to persecution and forced conversion. One group of them, the Parsis, migrated in the 10th century to India, where they survived and prospered under British rule (numbering some 150,000 today). In Persia by the 19th century fewer than 10,000 Zoroastrians remained. Many took refuge among Theosophists and Bahais, who offered them membership in a larger spiritual community.

In modern-day Persia, which at least until recently used to celebrate as its New Year the Zoroastrian festival of Nowruz (a pagan survival just as the Christian Christmas and Easter have pagan elements), it is a supreme Shi'ite insult to call someone a "Zoroastrian fire-worshipper."

Zoroastrians: Their Religious Beliefs and Practices by Mary Boyce is a learned, fascinating introduction; the ecologically minded will be particularly interested.

BIBLIOGRAPHY

Titles of particular interest are in boldface type.

Adams, Henry. *Mont-Saint-Michel and Chartres*. New York: Gallery Books, 1985.

_____. *Thomas Hart Benton: An American Original*. New York: Knopf, 1989.

Ahlstrom, Sydney E. *A Religious History of the American People*. New Haven: Yale University Press, 1972.

Aldred, Cyril. *Egyptian Art*. New York: Thames & Hudson, 1988.

Allsopp, Bruce. *Romanesque Architecture*. New York: John Day, 1971.

Altendorf, Alan von, and Theresa von Altendorf. *Isms: A Compendium of Concepts, Doctrines, Traits and Beliefs*. Memphis: Mustang Publishing Co., 1991.

Andrews, Wayne. *American Gothic*. New York: Vintage Books, 1975.

Anfam, David. *Abstract Expressionism*. New York: Thames & Hudson, 1990.

Aprà, Nietta. *Empire Style: 1804–1815*. New York: World Publishing, 1973.

_____. *The Louis Styles*. New York: World Publishing, 1972.

Arnold, Thomas, ed. *The Legacy of Islam*. London: Oxford University Press, 1968.

Arrington, Leonard J., and Davis Bitton. *The Mormon Experience: History of the Latter-Day Saints*. New York: Knopf, 1979.

Atasoy, Nurhan. *The Art of Islam*. New York: Abbeville Press, 1992.

Atkins, Robert. *ArtSpeak*. New York: Abbeville Press, 1990.

_____. *ArtSpoke*. New York: Abbeville Press, 1993.

Auerbach, Erich. **Mimesis: The Representation of Reality in Western Literature**. Garden City, N.Y.: Doubleday, 1953.

Auping, Michael. *Abstract Expressionism: The Critical Developments*. Buffalo, N.Y.: Albright-Knox Art Gallery, 1987.

Axelrod, Alan, ed. *The Colonial Revival in America*. New York: W. W. Norton, 1985.

Bainton, Roland H. *The Horizon History of Christianity*. New York: American Heritage, 1964.

Baker, Kenneth. *Minimalism: Art of Circumstance*. New York: Abbeville Press, 1988.

Banham, Reyner. *The New Brutalism*. London: Architectural Press, 1966.

_____. *Theory and Design in the First Machine Age*. Cambridge: MIT, 1980.

Baring, Anne and Jules Cashford. *The Myth of the Goddess*. London: Viking Arkana, 1991.

Barron, Stephanie, ed. *Degenerate Art: The Fate of the Avant-Garde in Nazi Germany*. Los Angeles: Los Angeles County Museum of Art, 1991.

Barzun, Jacques. *Classic, Romantic and Modern*. Chicago: University of Chicago Press, 1975.

_____. *A Stroll with William James*. New York: Harper & Row, 1983.

Basil, Robert, ed. *Not Necessarily the New Age: Critical Essays*. Buffalo: Prometheus Books, 1988.

Battcock, Gregory, and Robert Nickas, eds. *The Art of Performance: A Critical Anthology*. New York: Dutton, 1984.

Battersby, Martin. *Trompe l'Oeil: The Eye Deceived*. New York: St. Martin's Press, 1974.

Bayley, Stephen. *Taste: The Secret Meaning of Things*. New York: Pantheon Books, 1991.

Bazin, Germain. *Baroque and Rococo*. New York: Thames & Hudson, 1987.

_____. *Dictionnaire des styles*. Paris: Somogy, 1987.

Bechert, Heinz, and Richard Gombrich, eds. *The World of Buddhism*. London: Thames & Hudson, 1991.

Beckett, Jane, and Deborah Cherry, eds. *The Edwardian Era*. London: Phaidon Press, 1987.

Bell, Daniel. *The Radical Right*. Garden City, N.Y.: Doubleday, 1964.

Bell, Quentin. *On Human Finery*. New York: Schocken Books, 1978.

Benét, William Rose. *The Reader's Encyclopedia*. New York: Thomas Y. Crowell, 1965.

Berenson, Bernard. *Italian Pictures of the Renaissance*. 2 vols. New York: Phaidon, 1957.

Berlant, Anthony, and Mary H. Kahlenberg. *Walk in Beauty: The Navajo and Their Blankets*. Boston: New York Graphic Society, 1977.

Bingham, Hiram. *Lost City of the Incas*. New York: Atheneum, 1975.

Birmingham, Stephen. *The Grandees: America's Sephardic Elite*. New York: Harper & Row, 1971.

_____. *"Our Crowd": The Great Jewish Families of New York*. New York: Harper & Row, 1967.

Birnbach, Lisa, ed. *The Official Preppy Handbook*. New York: Workman, 1980.

Bloch, Marc. *Feudal Society*. Chicago: University of Chicago Press, 1963.

Boardman, John. *Greek Art*. London: Thames & Hudson, 1989.

Boller, Paul F. *American Transcendentalism, 1830–1860*. New York: G. P. Putnam's Sons, 1974.

Boorstin, Daniel. The Americans. Vol. 1: **The Colonial Experience** (1958). Vol. 2: **The Democratic Experience** (1973). Vol. 3: **The National Experience** (1965). New York: Random House.

Bosly, Caroline. *Rugs to Riches: An Insider's Guide to Buying Oriental Rugs*. New York: Pantheon Books, 1980.

Bouret, Jean. *The Barbizon School and 19th Century French Landscape Painting*. Greenwich, Conn.: New York Graphic Society, 1973.

Bowman, John S. *Treasures of the Smithsonian*. Washington, D.C.: Smithsonian Books, 1983.

Boyce, Mary. *Zoroastrians: Their Religious Beliefs and Practices*. London: Routledge & Kegan Paul, 1985.

Bozeman, Adda. *Politics and Culture in International History*. Princeton: Princeton University Press, 1960.

Braudel, Fernand. Civilization and Capitalism, 15th–18th Century. Vol. 1: *The Structures of Everyday Life*. New York: Harper & Row, 1985.

Braunfels, Wolfgang. *Monasteries of Western Europe*. Princeton: Princeton University Press, 1972.

Breeze, Carla. *Pueblo Deco*. New York: Rizzoli, 1990.

Bronowski, J. *The Ascent of Man*. Boston: Little, Brown & Co., 1973.

Bronowski, J., and Bruce Mazlish. *The Western Intellectual Tradition*. New York: Dorset Press, 1986.

Brooks, H. Allen. *Frank Lloyd Wright and the Prairie School*. New York: George Braziller, 1984.

Brooks, Van Wyck. *The Confident Years: 1885–1915*. New York: Dutton, 1952.

_____. **The Flowering of New England: 1815–1865**. New York: Modern Library, 1936.

_____. *New England: Indian Summer, 1865–1915*. New York: Dutton, 1940.

Brown, Curtis F. *Star-Spangled Kitsch*. New York: Universe Books, 1975.

Brown, Dee. *Bury My Heart at Wounded Knee*. New York: Holt, Rinehart & Winston, 1970.

Brown, R. Allen. *The Normans*. New York: St. Martin's Press, 1984.

Budge, E. Wallis. *Babylonian Life and History*. New York: AMS Press, repr. of 1925 ed.

Bullock, Alan. *The Humanist Tradition in the West*. New York: W. W. Norton, 1985.

Bullough, Donald. *The Age of Charlemagne*. London: Elek Books, 1965.

Burckhardt, Jacob. *The Civilization of the Renaissance in Italy*. 2 vols. New York: Harper & Row, 1958.

Burman, Edward. *The Inquisition: Hammer of Heresy*. London: Thorsons, 1984.

Burns, Amy Stechler, and Ken Burns. *The Shakers: Hands to Work, Hearts to God*. Aperture Books, 1987.

Butler, Joseph T. *Field Guide to American Antique Furniture*. New York: Henry Holt, 1986.

Calloway, Stephen, and Elizabeth Cromley, eds. *The Elements of Style*. New York: Simon & Schuster, 1991.

Calloway, Stephen, and Stephen Jones. *Style Traditions*. New York: Rizzoli, 1989.

_____. *Royal Style: Five Centuries of Influence and Fashion*. Boston: Little, Brown and Co., 1991.

Cameron, Elisabeth. *Encyclopedia of Pottery and Porcelain, 1800–1960*. New York: Facts on File, 1986.

Cantor, Norman. *Inventing the Middle Ages: the Lives, Works and Ideas of the Great Medievalists of the Twentieth Century*. New York: William Morrow, 1991.

Cashman, Sean Dennis. *America in the Gilded Age*. New York: New York University Press, 1984.

Cerwinske, Laura. *Russian Imperial Style*. New York: Prentice-Hall, 1990.

_____. *Tropical Deco: The Architecture and Design of Old Miami Beach*. New York: Rizzoli, 1981.

Chang, K. C. *Shang Civilization*. New Haven: Yale University Press, 1980.

Charleston, Robert J., ed. *World Ceramics: An Illustrated History*. New York: Crescent Books, 1990.

Childe, V. Gordon. *What Happened in History*. Baltimore: Penguin Books, 1964.

Christensen, Lillian L. *A Design for Living: Vienna in the Twenties*. New York: Viking, 1987.

Clabaugh, Gary K. *Thunder on the Right: The Protestant Fundamentalists*. Chicago: Nelson-Hall, 1974.

Clark, Kenneth. *Civilisation*. New York: Harper & Row, 1969.

_____. *The Nude: A Study in Ideal Form*. Garden City, N.Y.: Doubleday Anchor, 1959.

_____. *The Romantic Rebellion: Romantic versus Classic Art*. New York: Harper & Row, 1973.

Coleridge, Anthony. *Chippendale Furniture: The Work of Thomas Chippendale and his Contemporaries in the Rococo Style*. New York: C. N. Potter, 1968.

Commager, Henry Steele. *The American Mind*. New Haven: Yale University Press, 1961.

Condit, Carl W. *The Chicago School of Architecture*. Chicago: University of Chicago Press, 1964.

Conrad, Peter. *The Victorian Treasure-House*. London: Collins, 1973.

Coon, Carleton. *The Story of Man*. New York: Knopf, 1954.

Corn, Wanda M. *Grant Wood: The Regionalist Vision*. New Haven: Yale University Press, 1983.

Covarrubias, Miguel. *The Eagle, the Jaguar, and the Serpent: Indian Art of the Americas*. New York: Knopf, 1954.

Cowles, Virginia. *The Kaiser*. New York: Harper & Row, 1963.

Craven, Roy C. *Indian Art*. New York: Thames & Hudson, 1985.

Creel, H.G. *Confucius and the Chinese Way*. New York: Harper, 1960.

Crim, Keith, gen. ed. *The Perennial Dictionary of World Religions*. San Francisco: Harper, 1990.

Crook, J. Mordaunt. *The Dilemma of Style*. Chicago: University of Chicago Press, 1987.

Cumming, Elizabeth, and Wendy Kaplan. *The Arts and Crafts Movement*. New York: Thames & Hudson, 1991.

Cunliffe, Marcus. *The Literature of the United States*. Middlesex: Penguin Books, 1961.

Curl, James Stevens. *The Egyptian Revival*. London: Unwin Hyman, 1982.

Daly, Gay. *Pre-Raphaelites in Love*. New York: Ticknor & Fields, 1989.

Daniel, Glyn, and Colin Renfrew. *The Idea of Prehistory*. Edinburgh: University Press, 1986.

D'Antonio, Michael. *Heaven on Earth: Dispatches from America's Spiritual Frontier*. New York: Crown, 1992.

Davenport, Guy. *The Geography of the Imagination: Forty Essays*. San Francisco: North Point Press, 1981.

Davidson, Abraham A. *The Story of American Painting*. New York: Abrams, n.d.

Dawes, Nicholas M. *Lalique Glass*. New York: Crown, 1986.

_____. *Majolica*. New York: Crown, 1990.

Deutscher, Isaac. *The Prophet Outcast: Trotsky, 1929–40*. New York: Oxford University Press, 1963.

Dijkstra, Bram. *Idols of Perversity: Fantasies of Feminine Evil in Fin-de-Siècle Culture*. New York: Oxford University Press, 1986.

Dockstader, Frederick. *Indian Art in America*. New York: Promontory Press, 1974.

Dorfles, Gillo. *Kitsch: the World of Bad Taste*. New York: Universe Books, 1969.

Draper, Theodore. *The Roots of American Communism*. New York: Harcourt, Brace and World, 1977.

Drexler, Arthur, ed. *The Architecture of the Ecole des Beaux-Arts*. New York: Museum of Modern Art, 1977.

Ducher, Robert. *Caracteristique des styles*. Paris: Flammarion, 1988.

Dunan, Marcel, ed. *Larousse Encyclopedia of Ancient and Medieval History*. New York: Harper & Row, 1963.

Duncan, Alastair. *Art Deco*. New York: Thames & Hudson, 1988.

Durant, Will. *The Story of Philosophy*. New York: Pocket Books, 1961.

Ebenstein, William, and Edwin Fogelman. *Today's Isms*. Englewood Cliffs, N.J.: Prentice-Hall, 1967.

Edwards, A. Cecil. *The Persian Carpet*. London: Longwood Publishing Group, 1975.

Eisen, Jonathan, ed. *The Age of Rock: Sounds of the American Cultural Revolution*. New York: Vintage Books, 1969.

Erikson, Erik H. *Young Man Luther*. New York: Norton, 1962.

Fazzini, Richard. *Ancient Egyptian Art in the Brooklyn Museum*. New York: Thames & Hudson, 1989.

Feest, Christian F. *Native Arts of North America*. New York: Oxford University Press, 1980.

Fell, Barry. *Bronze Age America*. Boston: Little, Brown, 1982.

Fenollosa, Ernest F. **Epochs of Chinese and Japanese Art**. 2 vols. New York: Dover, 1963.

Ferber, Linda S., and William H. Gerdts. *The New Path: Ruskin and the American Pre-Raphaelites*. Brooklyn: Brooklyn Museum, 1985.

Fiedler, Leslie. **Love and Death in the American Novel**. New York: Stein & Day, 1966.

Filoramo, Giovanni. *A History of Gnosticism.* Cambridge, Mass.: Blackwell, 1990.

Fischer, David H. **Albion's Seed: Four British Folkways in America**. New York: Oxford University Press, 1989.

Fleming, John, and Hugh Honour. *Dictionary of the Decorative Arts.* New York: Harper & Row, 1986.

Fleming, John, Hugh Honour, and Nikolaus Pevsner. *The Penguin Dictionary of Architecture.* London: Penguin, 1991.

Ford, P. R. J. *Oriental Carpet Design.* London: Thames & Hudson, 1992.

Forty, Adrian. *Objects of Desire.* New York: Pantheon Books, 1986.

Frampton, Kenneth. *Modern Architecture; A Critical History.* New York: Thames & Hudson, 1992.

Freeman, Margaret B. *The Unicorn Tapestries.* New York: Dutton, 1976.

Friedell, Egon. *A Cultural History of the Modern Age.* 3 vols. New York: Knopf, 1954.

Friedman, Mildred, ed. *De Stijl: 1917–1931, Visions of Utopia.* Oxford: Phaidon, 1982.

Furst, Peter T., and Jill L. Furst. *North American Indian Art.* New York: Rizzoli, 1982.

Gans-Ruedin, Erwin. *Modern Oriental Carpets.* London: Thames & Hudson, 1971.

Garner, Philippe. *The World of Edwardiana.* London: Hamlyn, 1974.

Gaustad, Edwin. *A Religious History of America.* New York: Harper & Row, 1974.

Gay, Peter. *The Enlightenment: An Interpretation.* 2 vols. New York: W. W. Norton, 1977.

Gerdts, William H. *American Impressionism.* New York: Abbeville Press, 1984.

_____. *Art Across America: Two Centuries of Regional Painting.* 3 vols. New York: Abbeville Press, 1990.

Gill, Brendan. *Many Masks: A Life of Frank Lloyd Wright.* New York: Ballantine Books, 1988.

Gilliatt, Mary. *Period Style.* Boston: Little, Brown, 1990.

Gillon, Werner. *A Short History of African Art.* New York: Penguin Books, 1991.

Girouard, Mark. *Cities and People.* New Haven: Yale University Press, 1985.

_____. *The Return to Camelot: Chivalry and the English Gentleman.* New Haven: Yale University Press, 1981.

_____. *Sweetness and Light: The Queen Anne Movement, 1860–1900.* New Haven: Yale University Press, 1983.

Glazer, Nathan. *American Judaism.* Chicago: University of Chicago Press, 1989.

Glimcher, Mildred, and Jean Dubuffet. *Jean Dubuffet: Towards an Alternative Reality.* New York: Abbeville Press, 1987.

Gloag, John. *Georgian Grace: A Social History of Design from 1660–1830.* New York: Macmillan, 1956.

_____. *Victorian Comfort: A Social History of Design from 1830 to 1900.* New York: Macmillan, 1961.

Goetzmann, William H., ed. *The American Hegelians: An Intellectual Episode in the History of Western America.* New York: Knopf, 1973.

Gold, Herbert. *Bohemia: Where Art, Angst, Love, and Strong Coffee Meet.* New York: Simon & Schuster, 1993.

Golomstock, Igor. *Totalitarian Art.* New York: HarperCollins, 1990.

Gombrich, E. H. *The Story of Art.* 14th ed. New York: Prentice-Hall, 1985.

Grant, Michael. *From Alexander to Cleopatra: The Hellenistic World.* New York: Scribner's, 1982.

Graymont, Barbara. *The Iroquois.* New York: Chelsea House, 1988.

Griffiths, Paul. *A Concise History of Avant-Garde Music.* New York: Oxford University Press, 1978.

Grow, Lawrence, and Dina von Zweck. *American Victorian: A Style and Source Book.* New York: Harper & Row, 1984.

Guggenheim Museum. *The Great Utopia: The Russian and Soviet Avant-Garde, 1915–1932.* New York: Guggenheim Museum, 1992.

Guilbaut, Serge. *How New York Stole the Idea of Modern Art.* Chicago: University of Chicago Press, 1983.

Guinness, Desmond, and Julius Trousdale Sadler. *Palladio: A Western Progress.* New York: Viking Press, 1976.

Hadas, Moses. *Humanism.* New York: Harper, 1960.

Hafner, Katie, and John Markoff. *Cyberpunk: Outlaws and Hackers on the Computer Frontier.* New York: Simon & Schuster, 1991.

Hale, Nathan G. *Freud and the Americans: The Beginnings of Psychoanalysis in the United States, 1876–1917.* New York: Oxford University Press, 1971.

Hall, James. *Dictionary of Subjects and Symbols in Art.* New York: Harper & Row, 1979.

Hamilton, George H. *The Art and Architecture of Russia.* New Haven: Yale University Press/Pelican History of Art, 1992.

Hamlin, Talbot. *Greek Revival Architecture in America*. New York: Dover, 1964.

Handlin, David P. *American Architecture*. London: Thames & Hudson, 1985.

Harrell, David Edwin. *All Things Are Possible: The Healing and Charismatic Revivals in Modern America*. Bloomington: Indiana University Press, 1975.

Harrington, Michael. *Socialism*. New York: Saturday Review Press, 1972.

Harris, Cyril M., ed. *Illustrated Dictionary of Historic Architecture*. New York: Dover, 1983.

Harris, Marvin. *Cannibals and Kings: The Origins of Cultures*. New York: Random House, 1977.

_____. *Cows, Pigs, Wars and Witches: The Riddles of Culture*. New York: Random House, 1974.

Hauser, Arnold. **Mannerism**. New York: Knopf, 1965.

_____. **The Social History of Art**. 4 vols. New York: Vintage Books, 1985.

Hayward, Helena, ed. *World Furniture: An Illustrated History*. New York: Crescent Books, 1990

Heckscher, Morrison H., and Leslie G. Bowman. *American Rococo*. New York: Metropolitan Museum of Art, 1992.

Heilbroner, Robert L. *The Worldly Philosophers*. New York: Simon & Schuster, 1968.

Hennesey, James. *American Catholics*. New York: Oxford University Press, 1981.

Hess, Thomas B., and John Ashbery, eds. *Avant-Garde Art*. New York: Macmillan, 1968.

Hibbard, Howard. *The Metropolitan Museum of Art*. New York: Harper & Row, 1980.

Hiesinger, Kathryn, ed. *Art Nouveau in Munich*. Philadelphia: Philadelphia Museum of Art, 1988.

Higgins, Reynold. *Minoan and Mycenaean Art*. London: Thames & Hudson, 1989.

Hilton, Timothy. *The Pre-Raphaelites*. London: Thames & Hudson, 1987.

Hitchcock, Henry-Russell. *The Architecture of Henry H. Richardson and His Times*. New York: Museum of Modern Art, 1936.

Hobsbawm, Eric. *The Jazz Scene*. New York: Pantheon Books, 1993.

Hofstadter, Richard. *The Age of Reform: From Bryan to F. D. R.* New York: Vintage Books, 1961.

_____. *The American Political Tradition*. New York: Random House, 1948.

_____. *Anti-Intellectualism in American Life*. New York: Knopf, 1963.

_____. *Social Darwinism in American Thought*. Boston: Beacon Press, 1967.

Holbrook, Stewart H. *The Age of the Moguls*. Garden City, N.Y.: Doubleday, 1953.

_____. *Dreamers of the American Dream*. Garden City, N.Y.: Doubleday, 1957.

Hollander, Anne. *Moving Pictures*. New York: Knopf, 1989.

Hollis, Christopher. *The Jesuits: A History*. New York: Macmillan, 1968.

Honour, Hugh. *Neo-classicism*. Middlesex: Penguin Books, 1968.

_____. *Romanticism*. New York: Harper & Row, 1979.

Honour, Hugh, and John Fleming. **The Visual Arts: A History**. New York: Abrams, 1991.

Hostetler, John. *Amish Society*. Baltimore: Johns Hopkins Press, 1980.

Hudson, Winthrop S. *Religion in America*. New York: Scribner's, 1981.

Hughes, H. Stuart. *Consciousness and Society: The Reorientation of European Social Thought, 1890–1930*. New York: Vintage Books, 1961.

Hughes, Robert. *The Shock of the New*. New York: Knopf, 1980.

Hughes, Robert, and Julie Silber. *Amish: The Art of the Quilt*. New York: Knopf, 1990.

Huizinga, J. *The Waning of the Middle Ages*. New York: Doubleday Anchor, 1989.

Ingle, Marjorie. *Mayan Revival Style*. Salt Lake City: Peregrine Smith Books, 1984.

Jacobsen, Charles W. *Oriental Rugs: A Complete Guide*. Rutland, Vt.: Charles E. Tuttle, 1971.

Jameson, Fredric. *Postmodernism or, The Cultural Logic of Late Capitalism*. Durham, N.C.: Duke University Press, 1991.

Jászi, Oscar. *The Dissolution of the Habsburg Monarchy*. Chicago: University of Chicago Press, 1964.

Jencks, Charles. *Post-Modernism: The New Classicism in Art and Architecture*. New York: Rizzoli, 1987.

_____. *What is Post-Modernism?* New York: St. Martin, 1988.

Jenkyns, Richard. *The Legacy of Rome: A New Appraisal*. New York: Oxford University Press, 1992.

Jones, Judy, and William Wilson. *An Incomplete Education*. New York: Ballantine Books, 1987.

Jones, Mablen. *Getting It On: The Clothing of Rock 'n' Roll*. New York: Abbeville Press, 1987.

Jordan, Anne D. *The Seventh-Day Adventists: A History*. New York: Hippocrene Books, 1988.

Josephy, Alvin M. *The Indian Heritage of America*. Boston: Houghton Mifflin, 1991.

Jung, C. G. *Psyche and Symbol: Selections from the Writings of C. G. Jung*. New York: Doubleday, 1958.

Kallir, Jane. *The Folk Art Tradition: Naive Painting in Europe and the United States*. New York: Viking Press, 1981.

Kaufman, Alice, and Christopher Selser. *The Navajo Weaving Tradition*. New York: Dutton, 1985.

Kaufmann, Walter, ed. *Existentialism from Dostoevsky to Sartre*. New York: NAL, 1956.

Kazin, Alfred. *An American Procession*. New York: Knopf, 1984.

_____. *On Native Grounds*. New York: Reynal & Hitchcock, 1942.

Keller, Sharon R. *The Jews: A Treasury of Art and Literature*. New York: Hugh Lauter Levin, 1992.

Kemp, Jim. *American Vernacular: Regional Influences in Architecture and Interior Design*. New York: Viking Penguin, 1987.

Kennedy, Roger G. *Greek Revival America*. New York: Stewart, Tabori & Chang, 1989.

Ketchum, Richard M., ed. *The Horizon Book of the Renaissance*. New York: American Heritage, 1961.

Kimball, Fiske. *The Creation of the Rococo Decorative Style*. New York: Dover, 1980.

Klein, Lawrence R. *The Keynesian Revolution*. New York: Macmillan, 1966.

Koch, Robert. *Louis Comfort Tiffany: Rebel in Glass*. New York: Crown, 1982.

Koch, Wilfried. *Baustilkunde*. Munich: Orbis Verlag, 1988.

Koehler, Wolfgang. *Gestalt Psychology*. New York: Liveright, 1947.

Koestler, Arthur. *The Lotus and the Robot*. New York: Macmillan, 1961.

Koster, Donald N. *Transcendentalism in America*. Boston: Twayne Publishers, 1975.

Kostof, Spiro. *America by Design*. New York: Oxford University Press, 1987.

Kramer, Hilton. *The Age of the Avant-Garde*. New York: Farrar, Straus & Giroux, 1973.

Kruta, Venceslas, Otto Herman Frey, Miklos Szabo, and Barry Raftery. *The Celts*. New York: Rizzoli, 1991.

Kubach, Hans Erich. *Romanesque Architecture*. New York: Rizzoli, 1988.

Kubler, George. *The Art and Architecture of Ancient America*. New Haven: Yale University Press/Pelican History of Art, 1992.

Lacey, Robert. *Aristocrats*. Boston: Little, Brown, 1983.

Lancaster, Clay. *The Japanese Influence in America*. New York: W. H. Rawls, 1963.

Larkin, David, June Sprigg, and J. Johnson. *Colonial: Design in the New World*. New York: Stewart, Tabori & Chang, 1988.

Lasch, Christopher. *The Culture of Narcissism*. New York: Norton, 1979.

Lassiter, Barbara B. *American Wilderness: The Hudson River School of Painting*. Garden City, N.Y.: Doubleday, 1978.

Leibovitz, Annie. *Photographs, 1970–1990*. New York: HarperCollins, 1991.

Levine, Lawrence W. *Highbrow/Lowbrow: The Emergence of Cultural Hierarchy*. Cambridge: Harvard University Press, 1989.

Lewis, Bernard, ed. *The World of Islam*. New York: Thames & Hudson, 1991.

Lipman, Jean, and Alice Winchester. *The Flowering of American Folk Art, 1776–1876*. Philadelphia: Courage Books, 1987.

Lippard, Lucy, ed. *Pop Art*. New York: Praeger, 1966.

Lipset, Seymour M. *The First New Nation: The U.S. in Historical and Comparative Perspective*. Garden City, N.Y.: Doubleday Anchor, 1967.

Livingstone, Marco. *Pop Art: A Continuing History*. New York: Abrams, 1990.

Loth, Calder, and Julius T. Sadler. *The Only Proper Style: Gothic Architecture in America*. Boston: New York Graphic Society, 1975.

Lucie-Smith, Edward. *DuMont's Lexikon der Bildenden Kunst*. Cologne: DuMont Buchverlag, 1990.

_____. *Furniture: A Concise History*. New York: Thames & Hudson, 1985.

_____. *Symbolist Art*. London: Thames & Hudson, 1985.

McAlester, Virginia, and Lee McAlester. *A Field Guide to American Houses*. New York: Knopf, 1990.

MacColl, Gail, and Carol McD. Wallace. *To Marry an English Lord*. New York: Workman, 1989.

Machiavelli, Niccolo. *The Prince*. Any edition.

McLaughlin, Jack. *Jefferson and Monticello*. New York: Holt, 1988.

McLuhan, Marshall. *Understanding Media*. New York: McGraw-Hill, 1964.

McPhee, John. *Basin and Range*. New York: Farrar, Straus & Giroux, 1981.

Maddex, Diane, ed. *Built in the U.S.A.: American Buildings from Airports to Zoos*. Washington, D.C.: Preservation Press, 1985.

Mails, Thomas E. *The Mystic Warriors of the Plains*. New York: Mallard, 1991.

Malraux, André. *The Voices of Silence*. Princeton: Princeton University Press, 1978.

Mankowitz, Wolf. *Wedgwood*. Leicester, England: Magna, 1992.

Marcus, Greil. *Lipstick Traces: A Secret History of the Twentieth Century*. Cambridge: Harvard University Press, 1989.

Marcus, Steven. *The Other Victorians*. New York: W. W. Norton, 1966.

Marion, John L. *The Best of Everything*. New York: Simon and Schuster, 1989.

Marks, Robert W. *The Dymaxion World of Buckminster Fuller*. New York: Reinhold, 1960.

Marquis, Alice Goldfarb. *The Art Biz*. Chicago: Contemporary Books, 1991.

Martin, Richard. *Fashion and Surrealism*. New York: Rizzoli, 1987.

Marty, Martin E., and R. Scott Appleby. *The Glory and the Power: The Fundamentalist Challenge to the Modern World*. Boston: Beacon Press, 1992.

Massie, Suzanne. *Land of the Firebird: The Beauty of Old Russia*. New York: Simon & Schuster, 1982.

Masters, Robert E. L., and Jean Houston. *Psychedelic Art*. New York: Grove Press, 1968.

Masur, Gerhard. *Imperial Berlin*. New York: Basic Books, 1971.

Mather, Christine, and Sharon Woods. *Santa Fe Style*. New York: Rizzoli, 1986.

Mathes, Charles. *Treasures of American Museums*. New York: Millard Press, 1991.

Megaw, Ruth, and Vincent Megaw. *Celtic Art from Its Beginnings to the Book of Kells*. New York: Thames & Hudson, 1989.

Menton, Seymour. *Magic Realism Rediscovered: 1918–1981*. Philadelphia: Art Alliance Press, 1983.

Meyer, Laure. *Black Africa: Masks, Sculpture, Jewelry*. Paris: Terrail, 1992.

Michener, James. *The Floating World*. Honolulu: University of Hawaii Press, 1983.

_____. *Japanese Prints from the Early Masters to the Modern*. Rutland, Vt.: Charles E. Tuttle, 1963.

Miller, Mary Ellen. *The Art of Mesoamerica from Olmec to Aztec*. New York: Thames & Hudson, 1986.

Miller, Perry, ed. *Transcendentalists: An Anthology*. Cambridge: Harvard University Press, 1950.

_____. *The New England Mind: From Colony to Province*. Cambridge: Harvard University Press, 1953.

Milman, Miriam. *Trompe-L'Oeil: Painted Architecture*. New York: Rizzoli, 1986.

Mitford, Nancy. *The Sun King*. New York: Harper & Row, 1966.

Momen, Moojan. *An Introduction to Shi'a Islam*. New Haven: Yale University Press, 1985.

Morris C., and A. Von Hagen. *The Inka Empire and Its Andean Origins*. New York: American Museum of Natural History, 1993.

Muller, Joseph-Emile. *Fauvism*. New York: Praeger, 1967.

Mumford, Lewis. *The Brown Decades*. New York: Dover, 1971.

_____. ***The City in History***. New York: Harcourt, Brace & World, 1961.

_____. *Sticks and Stones*. New York: Dover, 1955.

Munsterberg, Hugo. *The Arts of China*. Rutland, Vt.: Charles E. Tuttle, 1981.

_____. *Der indische Raum*. Munich: Naturalis Verlag, n.d.

_____. *Zen and Oriental Art*. Rutland, Vt.: Charles E. Tuttle, 1965.

Murray, Peter, and Linda Murray. *The Art of the Renaissance*. New York: Thames & Hudson, 1985.

Myers, Bernard S. *The German Expressionists*. New York: Praeger, 1966.

Nadeau, Maurice. *History of Surrealism*. Cambridge, Mass.: Belknap Press, 1989.

Naifeh, Steven, and Gregory W. Smith. *Jackson Pollock: An American Saga*. New York: C. N. Potter, 1988.

Nelson, E. Clifford, ed. *The Lutherans in North America*. Philadelphia: Fortress Press, 1975.

Nochlin, Linda. *Realism*. Middlesex: Penguin Books, 1982.

Nuttgens, Patrick. *The Pocket Guide to Architecture*. New York: Simon & Schuster, 1980.

Osborne, Harold, ed. *The Oxford Companion to the Decorative Arts*. New York: Oxford University Press, 1988.

Paglia, Camille. *Sex, Art, and American Culture.* New York: Vintage Books, 1992.

_____. *Sexual Personae.* New York: Vintage Books, 1991.

Panofsky, Erwin. **Meaning in the Visual Arts.** Chicago: University of Chicago Press, 1972.

_____. **Studies in Iconology.** New York: Harper & Row, 1972.

Papadakis, Andreas, Catherine Cooke, and Andrew Benjamin. *Deconstruction: Omnibus Volume.* New York: Rizzoli, 1989.

Parissien, Steven. *Adam Style.* Washington, D.C.: Preservation Press, 1992.

_____. *Regency Style.* Washington, D.C.: Preservation Press, 1992.

Parkinson, C. Northcote. *The Evolution of Political Thought.* New York: Viking Press, 1964.

Parrington, Vernon L. *Main Currents in American Thought.* 2 vols. New York: Harcourt, Brace & World, 1954.

Parry, Albert. *Garrets and Pretenders: A History of Bohemianism in America.* New York: Covici, Friede, 1933.

Pasztory, Esther. *Aztec Art.* New York: Abrams, 1983.

Paul, Tessa. *The Art of Louis Comfort Tiffany.* New York: Exeter Books, 1987.

Payne, Blanche. *History of Costume from the Ancient Egyptians to the Twentieth Century.* New York: Harper & Row, 1965.

Perlman, Bernard B. *Painters of the Ashcan School: The Immortal Eight.* New York: Dover, 1988.

Perls, Fritz. *Gestalt Therapy Verbatim.* Highland, N.Y.: Gestalt Journal, 1992.

Peters, Edward. *Inquisition.* New York: Free Press, 1988.

Pevsner, Nikolaus. *An Outline of European Architecture.* New York: Penguin Books, 1982.

_____. *Pioneers of Modern Design.* Middlesex: Penguin Books, 1986.

_____. *Studies in Art, Architecture and Design.* 2 volumes. Princeton: Princeton University Press, 1982.

Phillips, Sandra S., and Linda Weintraub, eds. *Charmed Places; Hudson River Artists and Their Houses, Studios and Vistas.* New York: Abrams, 1988.

Pierson, William H., Jr. *American Buildings and Their Architects: The Colonial and Neoclassical Styles.* Garden City, N.Y.: Doubleday, 1970.

_____. *American Buildings and Their Architects: Technology and the Picturesque, the Corporate and the Early Gothic Styles.* Garden City, N.Y.: Doubleday Anchor, 1980.

Pina-Chan, Roman. *The Olmec: Mother Culture of Mesoamerica.* New York: Rizzoli, 1989.

Plaut, James S. *Steuben Glass.* New York: Dover, 1972.

Poggioli, Renato. *The Theory of the Avant-Garde.* Cambridge: Harvard University Press, 1981.

Pomada, Elizabeth, Michael Larsen, and Morley Baer. *Painted Ladies: San Francisco's Resplendent Victorians.* New York: Dutton, 1978.

Poppeliers, John C., S. Allen Chambers, and Nancy B. Schwartz. *What Style Is It?* Washington, D.C.: Preservation Press, 1983.

Powell, T. G. E. *The Celts.* New York: Thames & Hudson, 1991.

Priestley, J. B. *The Edwardians.* New York: Harper & Row, 1970.

Purtell, Joseph. *The Tiffany Touch.* New York: Random House, 1971.

Quebedeaux, Richard. *The New Charismatics.* New York: Doubleday, 1976.

Quiney, Anthony. *Period Houses.* London: George Philip, 1989.

Raftery, Barry. *Celtic Art.* New York: Abbeville Press, 1989.

Randel, William Peirce. *The Evolution of American Taste.* New York: Crown, 1978.

Rawson, Hugh. *Wicked Words.* New York: Crown, 1989.

Read, Herbert. *The Meaning of Art.* Baltimore: Penguin Books, 1964.

Reitlinger, Gerald. *The Economics of Taste.* New York: Holt, Rinehart and Winston, 1961.

Renfrew, Colin. *The Cycladic Spirit.* New York: Abrams, 1991.

Rewald, John. *The History of Impressionism.* New York: Museum of Modern Art, 1980.

_____. *Post-Impressionism.* 2 vols. New York: Museum of Modern Art, 1978.

Reynolds, Donald M. *The Architecture of New York City.* New York: Macmillan, 1984.

Rheims, Maurice. *The Flowering of Art Nouveau.* New York: Abrams, 1966.

Rice, David T. *Art of the Byzantine Era.* New York: Thames & Hudson, 1985.

_____. *Islamic Art.* New York: Praeger, 1965.

Rice, Tamara Talbot. *A Concise History of Russian Art*. New York: Praeger, 1963.

Richter, Gert. *Kitsch-Lexikon von A bis Z*. Vienna: Bertelsmann, 1972.

Ridley, Jasper. *The Tudor Age*. Woodstock, N.Y.: Overlook Press, 1988.

Rose, Barbara. *Autocritique: Essays on Art and Anti-Art, 1963–1987*. New York: Weidenfeld, 1988.

Rosenberg, Bernard, and David Manning White, eds. *Mass Culture: The Popular Arts in America*. Glencoe, Ill.: Free Press, 1960.

Rosenberg, Harold. *The Tradition of the New*. New York: Horizon Press, 1959.

Rosenstiel, Leonie, ed. *Schirmer History of Music*. New York: Schirmer Books, 1982.

Rosten, Leo. *The Joys of Yiddish*. New York: McGraw-Hill, 1968.

Rostovtzeff, M. *Rome*. New York: Oxford University Press, 1960.

Roszak, Theodore. *The Making of a Counter-Culture*. Garden City, N.Y.: Doubleday, 1969.

Rowse, A. L. *The Elizabethan Renaissance*. 2 vols. New York: Scribner, 1972.

Rubin, William S. *Dada, Surrealism and their Heritage*. New York: Museum of Modern Art, 1968.

Rugoff, Milton. *America's Gilded Age*. New York: Holt, 1989.

Runciman, Steven. *Byzantine Civilization*. New York: World Publishing Co., 1961.

Rushton, Julian. *Classical Music: A Concise History from Gluck to Beethoven*. New York: Thames & Hudson, 1986.

Russell, Bertrand. *Wisdom of the West*. London: Rathbone Books, 1959.

Russell, John. *The Meanings of Modern Art*. New York: Museum of Modern Art, 1981.

Sacher, Howard M. *A History of the Jews in America*. New York: Knopf, 1992.

Sanders, Barry, ed. *The Craftsman: An Anthology*. Salt Lake City: Peregrine Smith, 1978.

Savage, George, and Harold Newman. *An Illustrated Dictionary of Ceramics*. New York: Van Nostrand, 1974.

Schapiro, Meyer. *Modern Art: 19th and 20th Centuries*. New York: George Braziller, 1978.

Schimmel, Annemarie. *Mystical Dimensions of Islam*. Chapel Hill: University of North Carolina Press, 1975.

Schjeldahl, Peter. *The Hydrogen Jukebox: Select Writings*. Berkeley: University of California Press, 1991.

Schuller, Gunther. *Early Jazz*. New York: Oxford University Press, 1986.

———. *The Swing Era*. New York: Oxford University Press, 1989.

Schwartz, Hillel. *Century's End: A Cultural History of the Fin de Siècle*. New York: Doubleday, 1990.

Schwartz, Paul Waldo. *Cubism*. New York: Praeger, 1971.

Schweiger, Werner J. *Wiener Werkstätte; Design in Vienna 1903–1932*. New York: Abbeville, 1984.

Seitz, William. *The Responsive Eye*. New York: Museum of Modern Art, 1965.

Selz, Peter, and Mildred Constantine. *Art Nouveau*. New York: Museum of Modern Art, 1976.

Sembach, Klaus J. *Jugendstil*. Cologne: Benedikt Taschen Verlag, 1990.

Sexton, Richard. *American Style*. San Francisco: Chronicle Books, 1987.

Shannon, David A. *The Decline of American Communism*. New York: Harcourt, Brace and World, 1959.

Shapiro, David, ed. *Social Realism: Art as a Weapon*. New York: Frederick Ungar, 1973.

Shearman, John. *Mannerism*. New York: Penguin Books, 1981.

Shepard, Martin. *Fritz*. New York: Second Chance, 1975.

Sieveking, Ann. *The Cave Artists*. London: Thames & Hudson, 1979.

Silberger, Julius. *Mary Baker Eddy: An Interpretive Biography*. Boston: Little, Brown, 1980.

Simpson, Alan. *Puritanism in Old and New England*. Chicago: University of Chicago Press, 1955.

Slesin, Suzanne, Stafford Cliff, and Daniel Rozensztrock. *Japanese Style*. New York: C. N. Potter, 1987.

Smith, G. E. Kidder. *The Architecture of the United States: The Plains States and Far West*. Garden City, N.Y.: Doubleday, 1981.

Smith, Lacey Baldwin. *The Horizon Book of the Elizabethan World*. New York: American Heritage, 1967.

Solodkoff, Alexander von. *Masterpieces from the House of Fabergé*. New York: Abrams, 1984.

———, and G. von Habsburg-Lothringen. *Fabergé: Court Jeweler to the Tsars*. New York: Tabard Press, 1988.

Sontag, Susan. *Against Interpretation and Other Essays*. New York: Farrar, Straus & Giroux, 1966.

Speltz, Alexander. *The Styles of Ornament*. New York: Dover, 1959.

Spengler, Oswald. *The Decline of the West*. New York: Knopf, 1962.

Sprigg, June, and David Larkin. *Shaker Life, Work, and Art*. New York: Stewart, Tabori & Chang, 1987.

Stangos, Nikos, ed. *Concepts of Modern Art*. New York: Thames & Hudson, 1989.

Stanley-Baker, Joan. *Japanese Art*. New York: Thames & Hudson, 1984.

Starkey, David. *The Reign of Henry VIII*. London: Collins & Brown, 1991.

Stern, Jane, and Michael Stern. *Encyclopedia of Bad Taste*. New York: HarperCollins, 1990.

_____. *Encyclopedia of Pop Culture*. New York: HarperCollins, 1992.

Stern, Robert A. *Modern Classicism*. New York: Rizzoli, 1988.

Steves, Rick, and Gene Openshaw. *Mona Winks*. Santa Fe, N.M.: John Muir Publications, 1988.

Stone, I. F. *The Trial of Socrates*. Boston: Little, Brown, 1988.

Stone, Peter F. *Rugs of the Caucasus: Structure and Design*. Chicago: Greenleaf Co., 1984.

Strachey, Lytton. *Eminent Victorians*. New York: Penguin, 1987.

Sypher, Wylie. *Rococo to Cubism in Art and Literature*. New York: Random House, 1960.

Szatmary, David P. *Rockin' in Time: A Social History of Rock-and-Roll*. Englewood Cliffs, N.J.: Prentice-Hall, 1991.

Taheri, Amir. *The Spirit of Allah: Khomeini and the Islamic Revolution*. Bethesda, Md.: Adler & Adler, 1986.

Talmon, Jacob L. *Romanticism and Revolt*. New York: Norton, 1979.

Tapié, Victor-Louis. *The Age of Grandeur; Baroque Art and Architecture*. New York: Praeger, 1961.

Taylor, A. J. P. *The Habsburg Monarchy, 1809–1918*. Chicago: University of Chicago Press, 1976.

Thompson, Jon. *Oriental Carpets: From the Tents, Cottages and Workshops of Asia*. New York: Dutton, 1988.

Tillotson, G. H. R. *Mughal India*. San Francisco: Chronicle Books, 1990.

Tisdall, Caroline, and Angelo Bozzolla. *Futurism*. New York: Thames & Hudson, 1989.

Tocqueville, Alexis de. *Democracy in America*. New York: Random House, 1944.

Tomkins, Calvin. *Post- to Neo-: The Art World of the 1980s*. New York: Holt, 1988.

Tregear, Mary. *Chinese Art*. New York: Thames & Hudson, 1985.

Troyen, Carol, and Theodore E. Stebbins. *Charles Sheeler*. 2 vols. Boston: New York Graphics Society, 1987.

Tytell, John. *Naked Angels: The Lives and Literature of the Beat Generation*. New York: Grove Press, 1986.

Vaughan, William. *Romantic Art*. New York: Thames & Hudson, 1991.

Venturi, Robert, Denise Scott Brown, and Steven Izenour. *Learning from Las Vegas*. Cambridge: MIT Press, 1977.

Waldberg, Patrick. *Surrealism*. New York: Oxford University Press, 1978.

Walker, John, ed. *National Gallery of Art*. New York: Abrams, 1984.

Watson, William. *Style in the Arts of China*. Middlesex: Penguin Books, 1974.

Wattenmaker, Richard J., et al. *Great French Paintings from the Barnes Collection*. In association with Lincoln University Press. New York: Knopf, 1993.

Watterson, Barbara. *Coptic Egypt*. Edinburgh, Scotland: Scottish Academic Press, 1988.

Watts, Alan. *The Way of Zen*. New York: Vintage, 1957.

Weber, Eva. *American Art Deco*. Greenwich, Conn.: Dorset Press, 1990.

Weber, Max. *The Protestant Ethic and the Spirit of Capitalism*. New York: Scribner's, 1958.

Wedgwood, C. V. *The Thirty Years War*. Garden City, N.Y.: Doubleday Anchor, 1961.

Wees, W. C. *Vorticism and the English Avant-Garde, 1910–1915*. Ann Arbor, Mich.: University Microfilms, 1972.

Weitzenhoffer, Frances. *The Havemeyers: Impressionism Comes to America*. New York: Abrams, 1986.

Wheeler, Mortimer. *Roman Art and Architecture*. New York: Thames & Hudson, 1985.

Whiteford, Andrew H. *North American Indian Arts*. Racine, Wisc.: Golden Press, 1973.

Whiter, Leonard. *Spode: A History of the Family, Factory and Wares from 1733 to 1833*. New York: Praeger, 1970.

Whitfield, Sarah. *Fauvism*. New York: Thames & Hudson, 1990.

Whitford, Frank. *Bauhaus*. New York: Thames & Hudson, 1984.

Whittall, Arnold. *Romantic Music: A Concise History*. New York: Thames & Hudson, 1987.

Wilbur, E. M. *Our Unitarian Heritage: An Introduction to the History of Unitarianism in America*. New York: AMS Press, 1952.

Wilkie, Angus. *Biedermeier*. New York: Abbeville Press, 1987.

Willett, Frank. *African Art*. New York: Thames & Hudson, 1985.

Wills, Gary. *Cincinnatus: George Washington and the Enlightenment*. Garden City, N.Y.: Doubleday, 1984.

Wilson, Edmund. *Axel's Castle: A Study in the Imaginative Literature of 1870 to 1930*. New York: Scribner's, 1959.

____. *The Shock of Recognition*. New York: Farrar, Straus & Cudahy, 1955.

____. *To the Finland Station: A Study in the Writing and Acting of History*. Garden City, N.Y.: Doubleday, 1953.

Wittfogel, Karl. *Oriental Despotism*. New Haven: Yale University Press, 1957.

Wölfflin, Heinrich. *The Art of the Italian Renaissance*. New York: Schocken Books, 1968.

____. **Principles of Art History**. New York: Dover, n.d.

____. *Renaissance and Baroque*. Ithaca, N.Y.: Cornell University Press, 1964.

Wolfe, Tom. *The Electric Kool-Aid Acid Test*. New York: Farrar, Straus & Giroux, 1968.

____. *From Bauhaus to Our House*. New York: Farrar, Straus & Giroux, 1981.

____. *The Painted Word*. New York: Farrar, Straus & Giroux, 1975.

Wood, Michael. *In Search of the Dark Ages*. New York: Facts on File, 1987.

Woolley, Leonard. *The Sumerians*. New York: W. W. Norton, 1965.

Zimmer, Heinrich. *The Art of Indian Asia*. 2 vols. Princeton: Princeton University Press, 1982.

____. *Myths and Symbols in Indian Art and Civilization*. Princeton: Princeton University Press, 1971.

____. *Philosophies of India*. Princeton: Princeton University Press, 1969.

INDEX